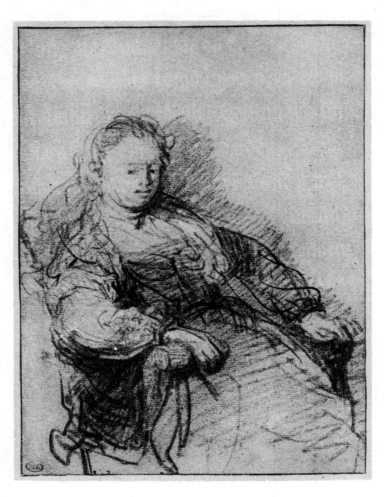

DRAWINGS OF REMBRANDT

With a Selection of Drawings by His Pupils and Followers

With an Introduction, Commentary, and Supplementary Material
by Seymour Slive
Professor of Fine Arts, Harvard University

Based on the Facsimile Series Edited by
F. Lippmann, C. Hofstede de Groot, and Others

In Two Volumes Volume One

Dover Publications, Inc., New York

Published in Canada by General Publishing Company, Ltd., 30 Lesmill Road, Don Mills, Toronto, Ontario.
Published in the United Kingdom by Constable and Company Limited, 10 Orange Street, London W. C. 2.

This Dover edition, first published in 1965, contains all the drawings from *Original Drawings by Rembrandt Harmensz van Rijn*, edited by F. Lippmann, C. Hofstede de Groot, and others, first published in four series from 1888 to 1911 (full bibliographical information is given on p. xi of the Introduction to this Dover edition). The Introduction, Commentary on the Plates, Biographical Notes, Key to Abbreviations and Bibliography, Lists of Plates, Concordances, and Indexes are entirely new, having been prepared especially for this Dover edition by Seymour Slive.

International Standard Book Number: 0-486-21485-0

Library of Congress Catalog Card Number: 65-12555

Manufactured in the United States of America

Dover Publications, Inc.
180 Varick Street
New York, N. Y. 10014

CONTENTS

INTRODUCTION

THANKS to the concerted efforts of devoted collectors, museum curators, and scholars, about 1,400 drawings by Rembrandt have been preserved and carefully catalogued. This number takes on astronomical proportions when we consider that today not a single drawing can be ascribed with certainty to Frans Hals or Vermeer. Probably neither Hals nor Vermeer was as prolific a draughtsman as Rembrandt—few artists were—but it is impossible to believe that Hals and Vermeer never made drawings. One day some may be found. Meanwhile the lacunae in their work can be attributed to the notoriously high mortality of old master drawings.

If time has successfully erased every trace of drawings by Hals and Vermeer, what has it done to Rembrandt's production as a draughtsman? To be sure, Rembrandt always enjoyed a much higher reputation than his two great contemporaries, and even when he was not esteemed in many circles, his works were generally recognized and discussed. Frans Hals and Vermeer were virtually forgotten during the eighteenth and part of the nineteenth centuries; this helps explain the disappearance of their drawings. However, we also know that the merits of a slight sketch, even by a master of Rembrandt's stature, can escape the untrained eye. The precious drawings owned by a collector are not necessarily the prized possessions of his heirs. Rembrandt's practice of drawing on anything at hand—sketches by him have been discovered on bills, printed pages, and on the backs of funeral announcements—does not enhance the importance of his drawings to the casual onlooker. How much has been lost as a result of negligence, ignorance, fire, shipwreck, or because of what insurance companies categorize as "acts of God"? We can only guess. Fifty per cent is a conservative estimate. By any count his output as a draughtsman was prodigious. He must have made drawings as readily as he breathed.

Like other artists he drew preparatory studies for his paintings and prints, but he did not make many drawings of this type. Those executed as finished works, complete in themselves, are even rarer. Most of Rembrandt's drawings were made to satisfy an insatiable urge to record what he saw with his inner, as well as his outer eye. Master draughtsmen from Dürer to Picasso have had the same compulsion, but none of them has responded to it as frequently and consistently as Rembrandt did.

The majority of his drawings can be compared to the notes, ideas and aphorisms jotted down by a great writer. Sometimes they are worked over and polished. They may inspire or find a place in more ambitious works. It is not necessary, however, to see their relation to larger projects in order to enjoy their quality or grasp their importance. Indeed their spontaneity and freshness have a direct appeal sometimes missing from more elaborately executed pieces.

The selection reproduced in these volumes gives an excellent idea of Rembrandt's unmatched range, depth, and human sympathy. It includes self-portraits and portraits; sketches of the humdrum activities on Amsterdam's busy streets; beggars and quacks, children at play, women gossiping, or people merely watching the passing scene; studies of Jewish types and Orientals; drawings of nudes, birds, domestic animals and captive wild beasts; copies of famous works of art, rare medals and exotic Moghul miniatures; views of towns and architectural monuments; studies of the landscape around Amsterdam and of the spacious Dutch countryside; drawings of episodes from classical mythology, ancient history, and, above all, the Bible. The largest group depicts Biblical themes.

Although it was Rembrandt's practice to sign and date his paintings and etchings, he hardly ever inscribed his name on his drawings. Only about two dozen bear his signature. In the final analysis most drawings must be ascribed to him on the basis of conclusions about their style. The general agreement of generation after generation of Rembrandt specialists about the authenticity of the bulk of his drawings, as well as about the main line of his development from his first bold efforts in Leiden to the majestic works of his last years, is one of the best proofs of the validity of stylistic criticism.

Some of Rembrandt's rare signed drawings were made expressly as contributions to the albums of friends, for example, the drawings of *Homer Reciting Verses* (223 [II, 6]) and *Minerva in Her Study* (279, [II, 54]) done for the *Album Amicorum* entitled "Pandora" which belonged to his friend and patron Jan Six. A few others may have been designed as presentation sheets. However, most of them needed no signature. They were made for Rembrandt's private use, not for the public or posterity. He saved and stored them in a systematic way. The inventory made of his effects in 1656, when he was declared insolvent and his property was sold at auction to pay his debts, reveals that he preserved them in bound books between blank pages, a method still favored by a few sensitive collectors. Twenty-four books of his drawings and two parcels of sketches are listed in the 1656 inventory. Some of the books are specifically described as containing drawings devoted to a single subject: nudes, figure studies, landscapes, animals, and so on. There is one significant exception. It is listed as "A book bound in black leather with Rembrandt's best sketches" (*een boeck inswart leer gebonden met de beste schetsen van Rembrant*).

The buyers of Rembrandt's drawings at the 1656 auction remain anonymous, but one of them may very well have been Jan van de Cappelle, the fine marine painter who was also a wealthy and avid collector. An inventory compiled of van de Cappelle's possessions after his death in 1679 lists, among other treasures, about seven thousand drawings; approximately five hundred of these were by Rembrandt—he owned almost as many original Rembrandts as are reproduced in this selection of the master's drawings. One of the portfolios in van de Cappelle's estate is described as containing one hundred and thirty-five drawings by Rembrandt of the life of women and children. Today about sixty Rembrandt drawings scattered in various collections fit this classification—a clue which helps estimate how many drawings have been lost.

From van de Cappelle's time until around the middle of the nineteenth century there was always a distinguished, if rather small, group of connoisseurs who treasured Rembrandt's drawings. As early as 1699 the French collector and critic, Roger de Piles, writes that Rembrandt's infinite number of drawn *pensées* are not less pungent or pointed than those by the best painters and, de Piles adds, he owns a great number of sketches which can conclusively prove that his assertion is impartial. In 1725 Jonathan Richardson, the English painter, collector, and critic, claimed that the touching solemnity of Rembrandt's drawing in his possession of *St. Peter's Prayer Before the Raising of Tabitha* (183 [I, 172b]) gives it "the utmost excellency that I think I ever saw, or can conceive is possible to be imagined." Similar quotations can be culled from a few other eighteenth-century and early nineteenth-century connoisseurs, but on the whole this international group expressed their esteem by acquiring Rembrandt drawings, not by writing about them. Pierre Crozat, the inspired eighteenth-century Parisian collector who purchased drawings and prints on a scale which has never been surpassed, owned three hundred and fifty-one Rembrandt drawings. Crozat never felt compelled to explain his extraordinary acquisitions.

The keen appreciation of Rembrandt drawings shown by de Piles, Richardson, Crozat, Sir Thomas Lawrence and a few others during the two centuries after Rembrandt's death never became a widespread vogue. His etchings and

paintings attracted much more attention than his drawings. The record of the publication of books about Rembrandt's works neatly summarizes the story.

The first book written about Rembrandt deals exclusively with his prints. It is the *catalogue raisonné* of Rembrandt's etchings, published in 1751 by Edmé François Gersaint. A catalogue of the paintings did not appear until eighty-five years later, when the pioneer work by John Smith was printed in 1836. Only after the middle of the nineteenth-century, when the public and scholars began to show a vigorous interest in every facet of Rembrandt's work, as well as many other aspects of Dutch art, was there an attempt to catalogue the master's drawings. A beginning was made in 1868 by Carel Vosmaer who included, in his monograph on the artist, a chronological list and a brief catalogue of over three hundred drawings arranged by subject. The second edition of Vosmaer's study, which appeared in 1877, listed about seven hundred drawings.

The next important milestone in the study of Rembrandt drawings was the publication in excellent facsimile reproduction of five hundred and fifty drawings attributed to Rembrandt by the editors: Friedrich Lippmann, Cornelis Hofstede de Groot, and others. Two editions were published, one in German, the other in English. The facsimiles were mounted on individual sheets and appeared, from 1888 through 1911, in four series:

I. *Original Drawings by Rembrandt Harmensz van Rijn, Reproduced in Phototype.* Edited by F. Lippmann with the assistance of W. Bode, Sidney Colvin, F. Seymour Haden and J. P. Heseltine. In four parts. London, Berlin, Leipzig, K. W. Hiersemann, 1888–92. (Seventy-five copies of a second edition of this First Series were printed at The Hague, Martinus Nijhoff, 1914–20.)

II. *Original Drawings by Rembrandt Harmensz van Rijn. Reproduced in Phototype by the Imperial Press at Berlin and Emrik & Binger at Haarlem.* Edited by F. Lippmann, continued by C. Hofstede de Groot. In two parts. London, Asher and Co., 1900–01.

III. *Original Drawings by Rembrandt Harmensz van Rijn. Reproduced in the Colours of the Originals by Emrik & Binger at Haarlem.* Edited by C. Hofstede de Groot. In two parts. The Hague, Martinus Nijhoff, 1903–06.

IV. *Original Drawings by Rembrandt Harmensz van Rijn. Reproduced in the Colours of the Originals by Emrik & Binger at Haarlem.* Edited by C. Hofstede de Groot. In two parts. The Hague, Martinus Nijhoff, 1910–11.

The grand work begun in 1888 by Lippmann is the basis of this new edition of Rembrandt drawings, and reproductions for the present volumes have been made directly from the facsimiles.[1] The entire contents of the four original series— five hundred and fifty drawings—are reproduced in the two present volumes in the same order they had in that first edition. They have been renumbered consecutively from 1 to 550, but the numbers assigned to them in the four original series also appear, in parentheses, throughout the present volumes.

The intention of the editors of the first edition was to publish all of Rembrandt's drawings in facsimile, one of the most laudable and boldest projects in the history of art-book publishing. It is difficult to think of a publisher who would dare undertake such a venture today. Publishers may find consolation in the fact that the project was never completed, but before publication ceased in 1911 fine facsimiles were made of the principal Rembrandt drawings in museums in Berlin, London, Paris, Amsterdam, Stockholm, Munich, and other cities, as well as many in the possession of distinguished private collectors. For the first time admirers of Rembrandt had access to a large body of reproductions of the drawings. Many of them have rarely been reproduced since their appearance in the first edition.

Most of the Lippmann–Hofstede de Groot full-size facsimiles capture much of the quality of the originals and successfully simulate the colors and textures of Rembrandt's papers and vellums, as well as subtle differences in the colors

[1]In those few cases where the facsimiles were considered less than faithful to the original drawings or otherwise unsatisfactory, the plates in the present volumes have been prepared from new photographs of the original drawings graciously provided by museums and collectors. These plates are 26 (I, 26); 28 (I, 28); 29 (I, 29); 45 (I, 45); 47 (I, 47); 62 (I, 62); 87 (I, 86); 110 (I, 108); 119 (I, 117); 121 (I, 119); 122 (I, 120); 131 (I, 127); 141 (I, 137); 159 (I, 152); 166 (I, 158); 175 (I, 165); 178 (I, 168); 197 (I, 184); 213 (I, 196); 230 (II, 13); 269 (II, 45); 279 (II, 54); 301 (II, 71); 303 (II, 73); 318 (II, 86); 321 (II, 89); 336 (III, 4); 349 (III, 17); 376 (III, 43); 378 (III, 45); 383 (III, 50); 434 (III, 96); 437 (III, 99); 447 (IV, 8); 524 (IV, 75); and 530 (IV, 81).

of his various inks, chalks and silverpoint. Of course, even the closest study of a facsimile, no matter how fine, can never be a substitute for a careful appraisal of an original, but this body of material enabled students to enjoy the qualities of Rembrandt's drawings in public and private collections scattered all over Europe, and it helped specialists as they worked on problems of chronology, attribution and interpretation.

Before the turn of the century a steady stream of books, catalogues, and articles devoted to all aspects of Rembrandt's work began to appear, and there is no indication that interest has diminished in our time. Drawings were not neglected during these years, and studies devoted to them form a veritable library.

It is difficult to overestimate the debt Rembrandt students owe to the tireless cataloguer Cornelis Hofstede de Groot, who continued the publication of the facsimile edition after Lippmann's death in 1903. Hofstede de Groot paid tribute to Rembrandt in 1906, the three-hundredth anniversary of the master's birth, with the publication of a *catalogue raisonné* of the drawings. His indispensable collection of documents and sources, *Die Urkunden über Rembrandt*, was also published in 1906, and his catalogue of the paintings appeared in 1915. W. R. Valentiner published two volumes of a catalogue of the drawings in the *Klassiker der Kunst* series (1925, 1934). Valentiner planned a third volume, to include Rembrandt's figure studies, nudes, animal drawings, and landscapes, but it never appeared; thus we are deprived of Valentiner's good judgment on these important categories. Two generations of scholars brought order to the Rembrandt drawing collections of the great European museums with the publication of catalogues of their rich holdings: Arthur M. Hind wrote about those at the British Museum in 1915; J. Kruse's copious notes on the Stockholm drawings were published posthumously in 1920; Jakob Rosenberg catalogued the Berlin drawings in 1930; Frits Lugt published the Louvre inventory in 1933; and M. D. Henkel was responsible for the Amsterdam catalogue of 1943. Special mention should be made of Lugt's *Mit Rembrandt in Amsterdam*, Berlin, 1920 (Dutch edition, 1915), in which the author ingeniously identifies, for the first time, the subjects of many of Rembrandt's landscape drawings. Studies by W. R. Valentiner, G. Falck, Horst Gerson, Ludwig Münz, Otto Benesch, and others, help identify some of the forty Rembrandt pupils who made drawings which are sometimes deceptively similar to their teacher's originals. The results of most of the work done in modern times on the drawings, as well as numerous important new discoveries and observations, are incorporated in Benesch's monumental six-volume corpus published from 1954–57. It is, by far, the most thorough and complete work on Rembrandt's drawings.

It goes without saying that research done since the first edition of the facsimiles was published has made some of the material included in that edition obsolete. Newly discovered facts and iconographical interpretations unknown to the earlier editors have thrown new light on numerous drawings.

In the original edition no date was assigned to a drawing unless it had been inscribed with one by the master himself. We have already heard that drawings dated by Rembrandt are exceedingly rare, but there is today general agreement about the master's development as a draughtsman. An attempt has therefore been made to give an approximate date to all the drawings. Familiarity with their chronology enables us to see which subjects the artist favored, as well as the graphic means he employed, during different phases of his career.

Many drawings have changed hands since the first edition was published, and an effort has been made to cite the present, or the last-known, owner in each case. It is noteworthy that a number of Rembrandt's drawings have crossed the Atlantic. Lippmann and Hofstede de Groot published their studies before American drawing collectors had become active on the international market. Not a single one of the 1,613 Rembrandt drawings listed in Hofstede de Groot's *catalogue raisonné*, published in 1906, belonged to an American collection. In our time, however, it has become possible to mount a comprehensive exhibition of Rembrandt drawings, showing the whole range of the artist's development and every category of his work, exclusively from American collections.

A group of sketches considered authentic in Lippmann's day are now generally regarded as the work of pupils, followers or copyists, or as downright forgeries. They have been excluded from Rembrandt's *œuvre*, but they have not been excluded from this new edition, for they indicate the tremendous impact of the artist's style on his followers and, when compared with his originals, they can only heighten our awareness of the quality of his authentic works. On the other hand it will be seen that there is not general agreement about all of the drawings which some specialists have rejected. A group included here deserves special reconsideration for entry into the canon of Rembrandt's genuine

drawings. Attention has been called to them lest some precious originals, or borderline cases worthy of appreciative regard and further investigation, fall into an unwarranted limbo. It should, however, be emphasized that the number of debatable works in these volumes is not high; the vast majority pose no problems.

Considerations of date, subject and attribution are discussed in the comments to the individual drawings. Prepared especially for this new edition, these comments also provide the collection, dimensions (in millimeters, height preceding width), medium, bibliographical references, and supplementary information for each drawing. Indexes and concordances have been compiled for the student who wishes to pursue problems related to specific drawings.

The primary purpose of this inexpensive edition of a sumptuous publication originally limited to one hundred and fifty copies, and now untraceable on the book market, is to enable as many people as possible to become familiar with the incredible richness and profound humanity of Rembrandt's drawings.

SEYMOUR SLIVE

Fogg Art Museum, Harvard University. May, 1964

KEY TO ABBREVIATIONS AND BIBLIOGRAPHY

Bartsch	Adam Bartsch, *Catalogue raisonné de toutes les estampes qui forment l'oeuvre de Rembrandt, et ceux de ses principaux imitateurs*, Vienna, 1797.
Benesch	Otto Benesch, *The Drawings of Rembrandt, A Critical and Chronological Catalogue*, London, 1954–57, 6 vols.
Begemann, 1961	E. Haverkamp-Begemann, review (of Otto Benesch, *The Drawings of Rembrandt*), *Kunstchronik*, vol. 14 (1961), nos. 1, 2, 3, pp. 10–28, 50–57, 85–91.
Bredius	A. Bredius, *The Paintings of Rembrandt*, Vienna–London, 1937.
Falck˙	G. Falck, "Ueber einige von Rembrandt übergangene Schülerzeichnungen," *Jahrbuch der preussischen Kunstsammlungen*, 45 (1924), Berlin, pp. 191 ff.
Gerson, 1936	Horst Gerson, *Philips Koninck*, Berlin, 1936.
Henkel, 1943	M. D. Henkel, *Catalogus van de Nederlandsche Teekeningen in het Rijksmuseum. I. Teekeningen van Rembrandt en Zijn School*, The Hague, 1943.
Hind, 1915	Arthur M. Hind, *Catalogue of Drawings by Dutch and Flemish Artists in the British Museum*, London, 1915, vol. 1.
Hind, 1923	Arthur M. Hind, *A Catalogue of Rembrandt's Etchings*, 2nd edition, London, 1923, vols. 1 and 2.
Hofstede de Groot	Cornelis Hofstede de Groot, *Die Handzeichnungen Rembrandts*, Haarlem, 1906.
Kruse, 1920	John Kruse and Carl Neumann, *Die Zeichnungen Rembrandts und seiner Schule im National-Museum zu Stockholm*, The Hague, 1920.
Lugt, 1920	Frits Lugt, *Mit Rembrandt in Amsterdam*, Berlin, 1920.
Lugt, 1931	Frits Lugt, "Beiträge zu dem Katalog der Niederländischen Handzeichnungen in Berlin," *Jahrbuch der preussischen Kunstsammlungen*, 52 (1931), Berlin, pp. 56 ff.
Lugt, 1933	Musée du Louvre, *Inventaire Général des Dessins . . . École Hollandaise*, par Frits Lugt, Tome III, *Rembrandt*, Paris, 1933.
Lugt, 1936	Frits Lugt, *Bibliothèque Nationale, Cabinet des Estampes, Inventaire Général des Dessins des Écoles du Nord*, Paris, 1936.
Lugt, 1950	*Inventaire Général des Dessins . . . École des Beaux-Arts*, Tome I, *École Hollandaise*, Paris, 1950.
Münz, 1952	Ludwig Münz, *Rembrandt's Etchings*, London, 1952, vols. I and II.
Neumann, 1918	Carl Neumann, *Aus der Werkstatt Rembrandts*, Heidelberg, 1918.
Neumann, 1919	Carl Neumann, *Rembrandt Handzeichnungen*, 3rd edition, Munich, 1919.
Rosenberg, 1930	E. Bock-Jakob Rosenberg, *Staatliche Museen zu Berlin, Die Zeichnungen alter Meister, Die niederländischen Meister*, Berlin, 1930.

Rosenberg, 1956–59 Jakob Rosenberg, reviews (of Otto Benesch, *The Drawings of Rembrandt*, vols. 1 and 2), *The Art Bulletin*, 38 (1956), pp. 63–70; (vols. 3–6) *The Art Bulletin*, 41 (1959), pp. 107–119.

Slive, 1953 Seymour Slive, *Rembrandt and His Critics: 1630–1730*, The Hague, 1953.

Valentiner W. R. Valentiner, *Rembrandt Des Meisters Handzeichnungen*, Berlin, Leipzig, and Stuttgart, n. d., vols. 1 and 2 (*Klassiker der Kunst* series, vols. 31 and 32).

Valentiner, 1924 W. R. Valentiner, *Nicolaes Maes*, Berlin and Leipzig, 1924.

Wichmann, 1925 *Rembrandts Handzeichnungen*, herausgegeben von Kurt Freise, Karl Lilienfeld, Heinrich Wichmann; vol. III, *Staatliches Kupferstich-Kabinett und Sammlung Friedrich August II zu Dresden*, Parchim, 1925.

List of Plates

LIST OF PLATES

*The numbers which appear in parentheses in this List of Plates and throughout the present volumes are the numbers assigned to the facsimiles in the four series of the original edition of this work.

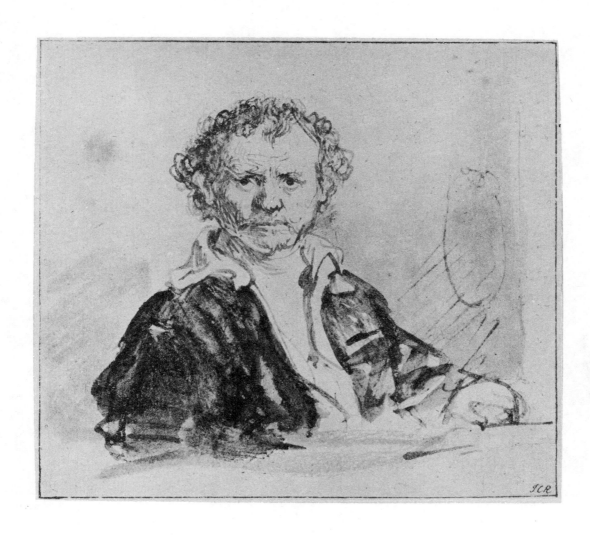

1 (*I, 1*). *Self-portrait. (Kupferstichkabinett, Berlin)*

Pen and bistre, wash, white body color: 123 × 137 mm.

The style as well as a comparison with the painted and etched self-portraits made in the mid–1630's support
Rosenberg's conclusion (1930, p. 230, no. 1553) that the drawing should be dated around 1635.

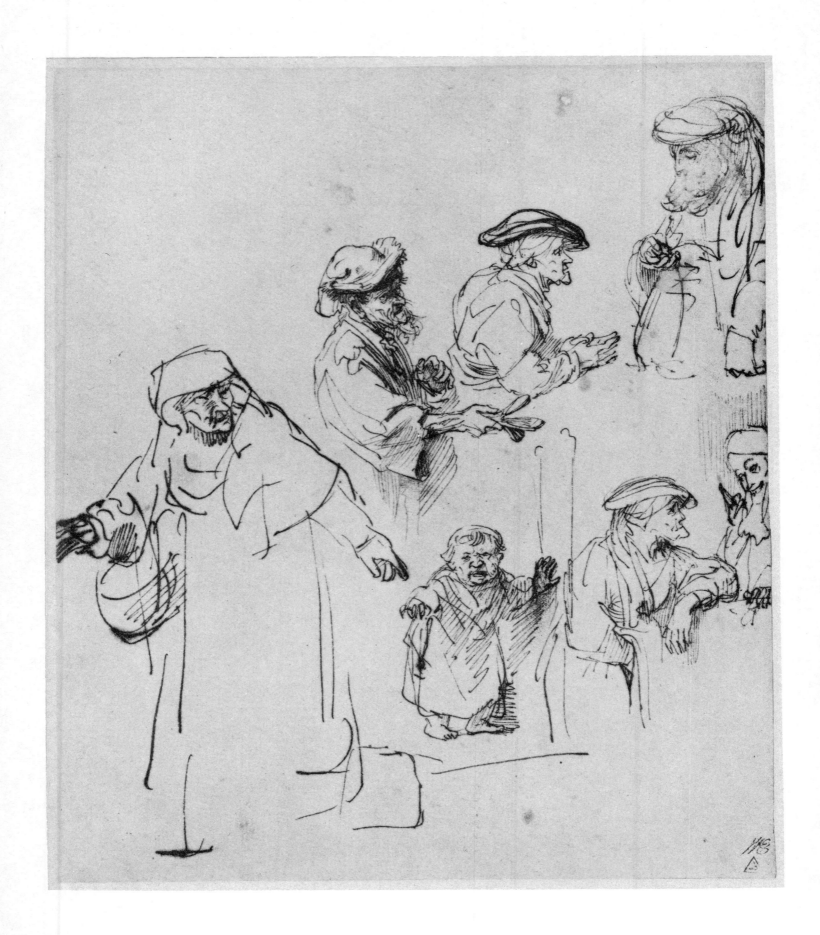

2 (*I, 2*). *Study of Seven Figures.* (*Kupferstichkabinett, Berlin*)
Pen and bistre, wash, white body color: 218 × 186 mm.
A sheet of studies made from life around 1635.

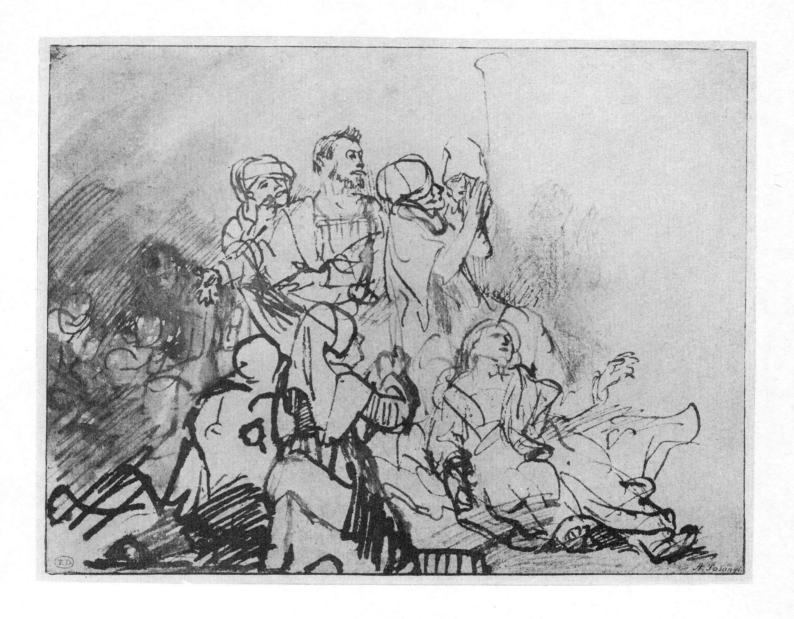

3 (*I, 3*). *Study for the Group of Sick People in* The Hundred Guilder Print. (*Kupferstichkabinett, Berlin*)
Pen and bistre, wash, white body color: 144 × 185 mm.

This early study (in reverse) for an important group in The Hundred Guilder Print *can be dated around 1640.*
The etching was finished almost a decade later—proof that Rembrandt was preoccupied with his most famous etching
for a long time.

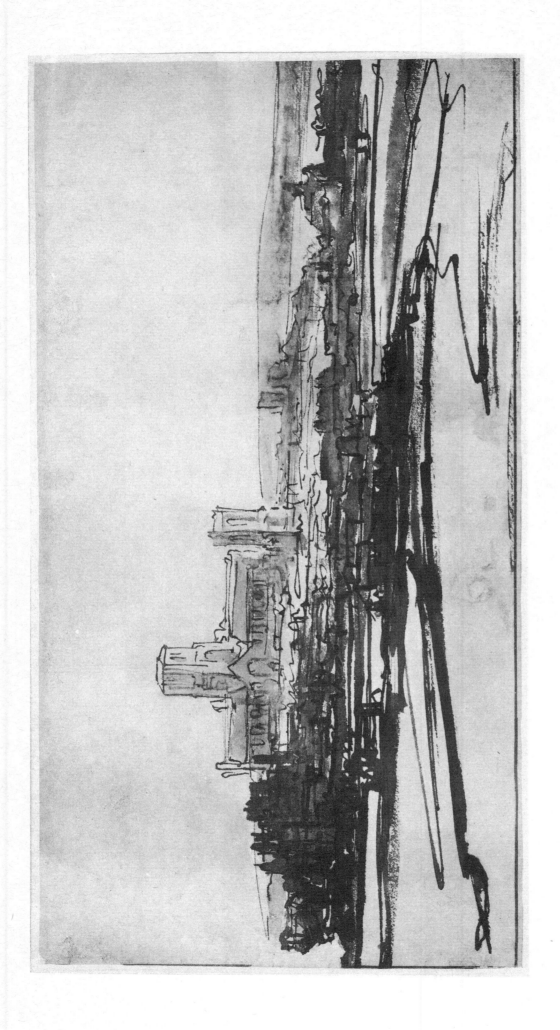

4 (I, 4). *View of London with Old St. Paul's, Seen from the North. (Kupferstichkabinett, Berlin)*

Pen and bistre, wash, white body color: 164 × 318 mm.

This view and others of sites around London made about 1640 led some specialists to conclude that Rembrandt visited England around this time (see J. Q. van Regteren Altena, "Rembrandt en Wenzel Hollar," De Kroniek van de Vriendenkring van het Rembrandt-huis, 13 [1959], pp. 81 ff.). However, proof that Rembrandt was ever in England is flimsy. His views of England were probably copies after prints or drawings (see Christopher White, "Did Rembrandt Ever Visit England?" Apollo, 76 [1962], pp. 177 ff.).

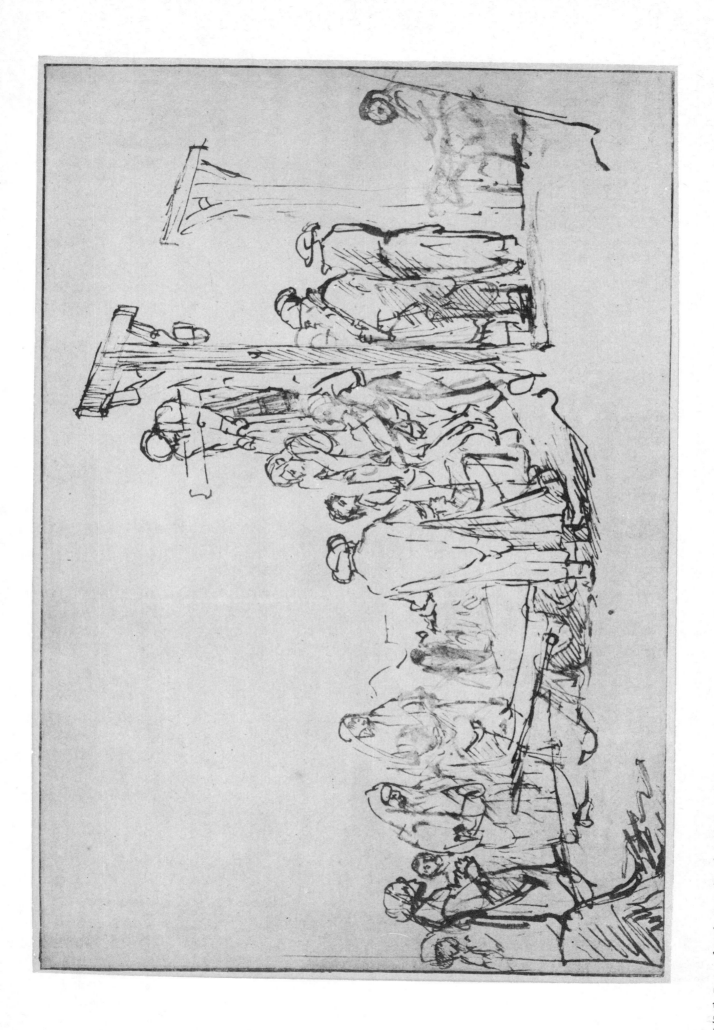

5 (I, 5). *Descent from the Cross. (Kupferstichkabinett, Berlin)*
Pen and bistre, white body color: 198 × 293 mm.
Made around 1650–55 when the artist was preoccupied with a series of scenes from the Life and Passion of Christ.

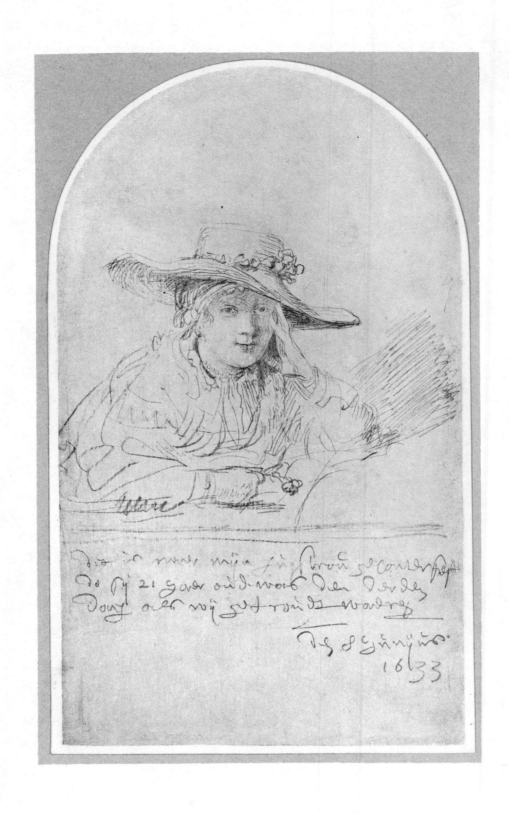

6 (*I, 6*). *Saskia van Uylenburch.* (*Kupferstichkabinett, Berlin*)

Silverpoint on white prepared vellum: 185 × 107 mm. On the lower part an inscription by the master's hand: "dit is naer mijn huysvrou geconterfeyt, do sy 21 jaer oud was, den derden dach als wij getroudt waren—den 8 Junijus 1633" (this is drawn after my wife, when she was 21 years old, the third day after our betrothal—the 8th of June 1633).

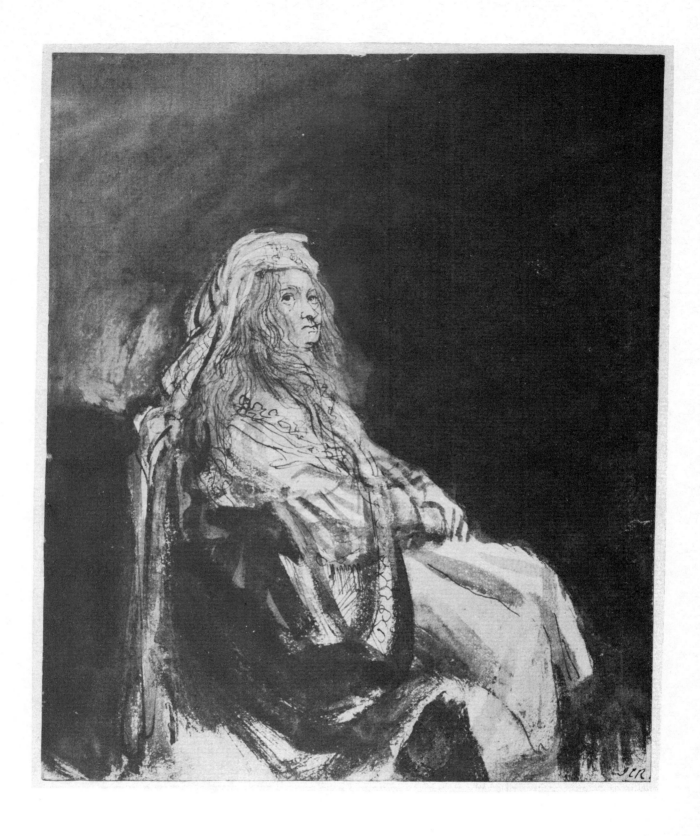

7 (*I, 7*). *Woman Seated, in an Oriental Costume.* (*Kupferstichkabinett, Berlin*)
Brush, pen and wash, white body color: 200 × 162 mm.

Although the drawing invites comparison with Rembrandt's etching called The Great Jewish Bride (*Bartsch 340*) *dated 1635, it cannot be called a preparatory study for the well-known print; see 235 (II, 18) for a study for the etching. The dramatic chiaroscuro effect is characteristic of Rembrandt's drawings during his first Amsterdam years.*

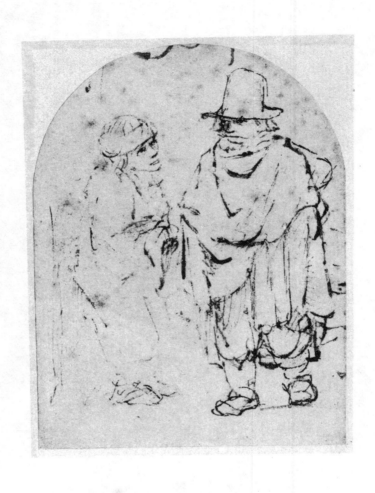

8 (*I, 8*). *A Man Approached by a Beggar.* (*Kupferstichkabinett, Berlin*)
Pen and bistre: 110 × 81 mm.
The rectangular form of the figures and the delicate luminosity of the line suggest a date around 1650.

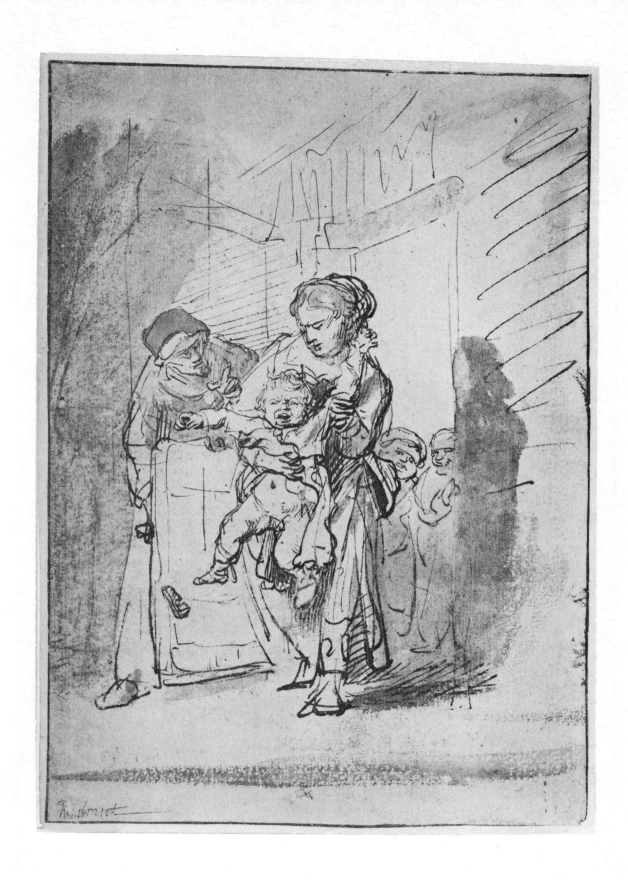

9 (*I, 9*). *The Screaming Boy.* (*Kupferstichkabinett, Berlin*)

Pen and bistre, wash, white body color, black chalk: 206 × 143 mm. Inscribed by a later hand: Rembrant.

Around 1635. This drawing of a screaming child struggling to free himself from the firm grip of a woman was a source of inspiration for the master's mythological painting of Ganymede Carried Away by the Eagle of Zeus (Gemäldegalerie, Dresden, 1635; Bredius 471). See 140 (I, 136) for a compositional sketch for the painting. A weak copy of this sheet is in Budapest; reproduced Neumann, 1919, figure 83.

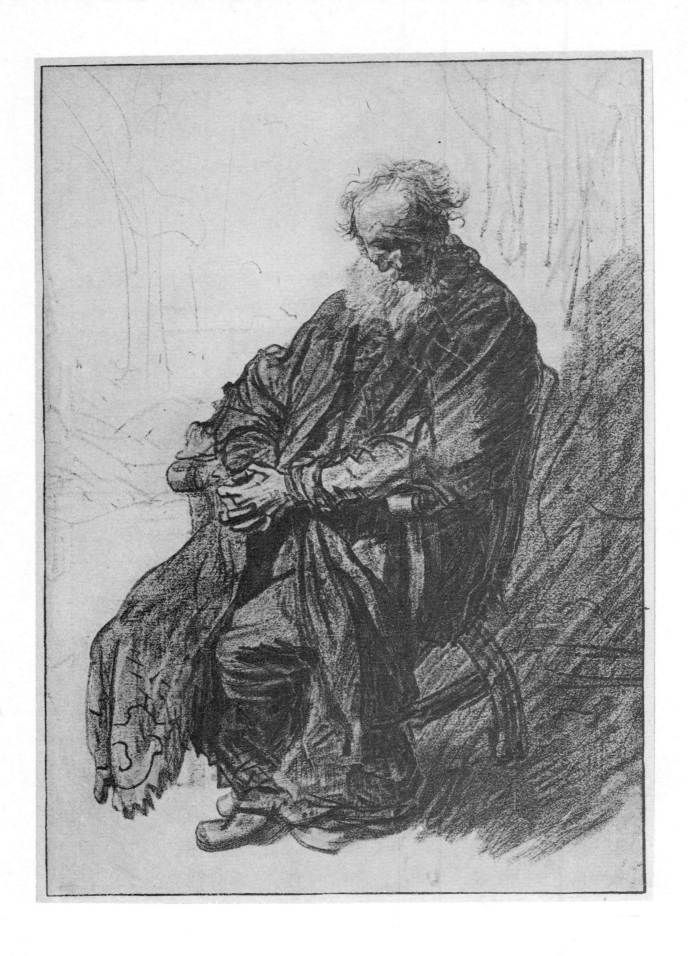

10 (*I, 10*). *Old Man Seated in an Armchair, Full-length.* (*Kupferstichkabinett, Berlin*)
Red and black chalk: 226 × 157 mm.
The drawing, made around 1631, was used by Rembrandt for his painting of A Scholar Seated in His Study,
*1633 (Bredius 431). This model frequently posed for Rembrandt around 1630–31: see 171 (I, 162a); 201 (I, 187b);
394 (III, 60b).*

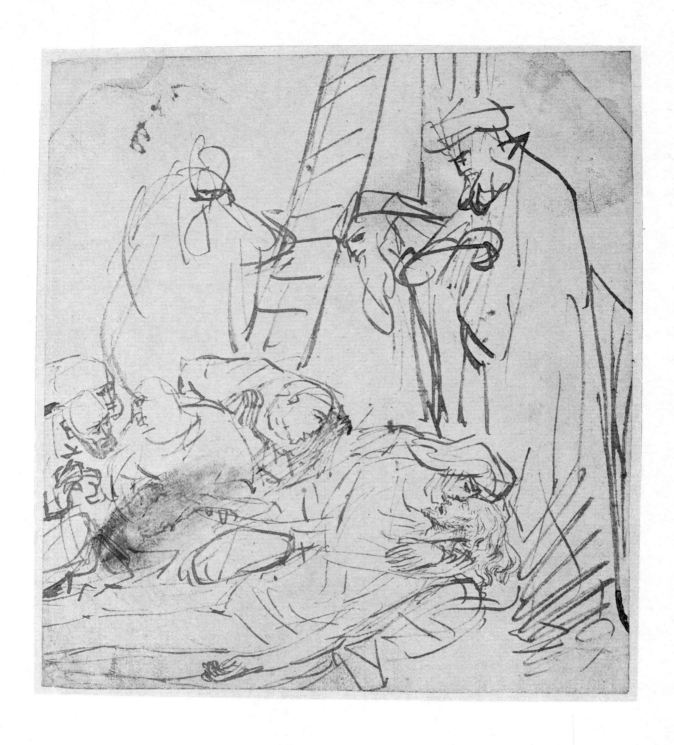

11 (*I, 11*). *The Lamentation Over the Dead Body of Christ.* (*Kupferstichkabinett, Berlin*)
Pen and bistre: 171 × 154 mm.

*A drawing on the verso (Three Couples, reproduced Benesch, figure 108) which is cropped, indicates that the sheet
was cut at the top. The dynamic line and pronounced emphasis upon outward signs of emotion suggest a date
around 1635.*

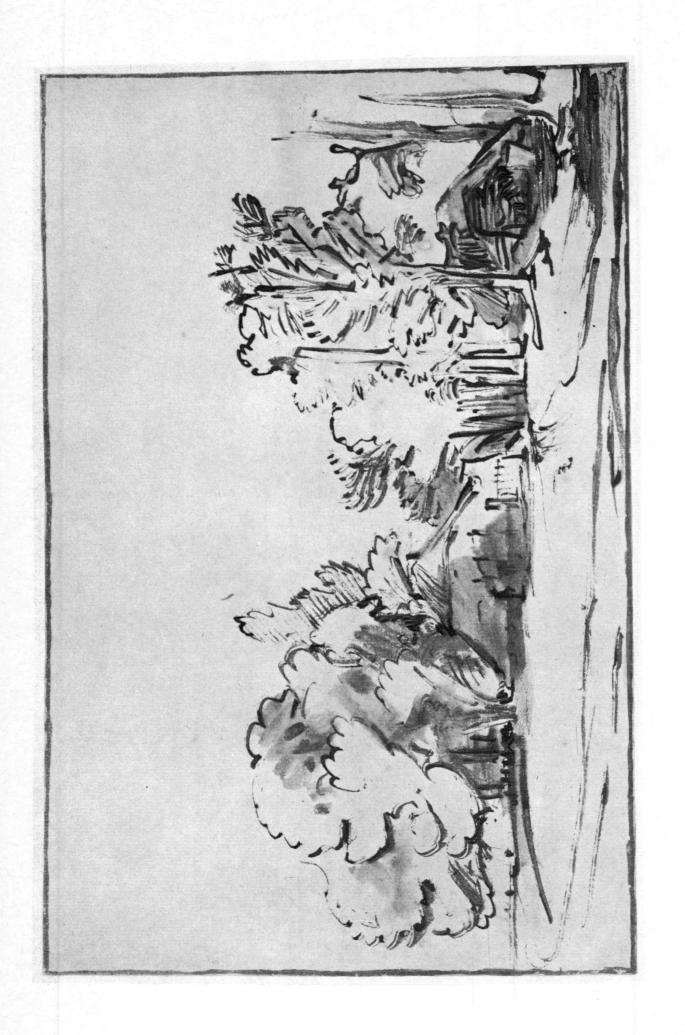

12 (I, 12). *Cottages Amongst High Trees. (Kupferstichkabinett, Berlin)*
Pen and brush in bistre, wash: 195 × 310 mm.
About 1655–60. One of Rembrandt's late studies of nature in which the sundrenched landscape and atmosphere are rendered with utmost economy.

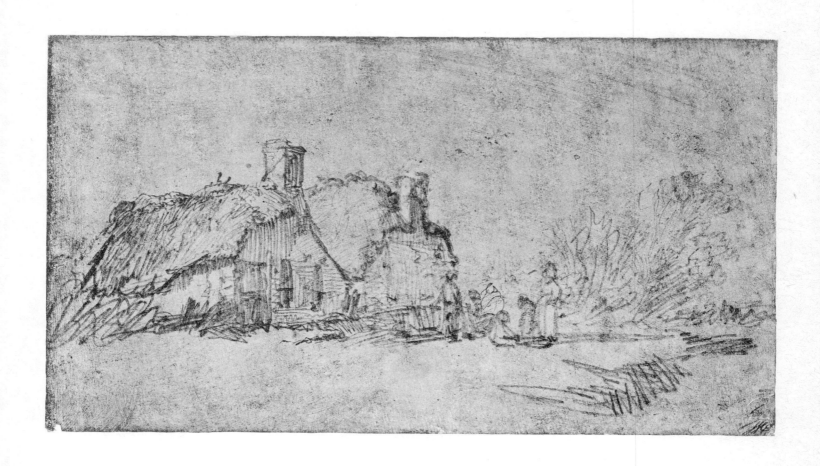

13 (*I, 13*). *Landscape with Two Cottages.* (*Kupferstichkabinett, Berlin*)
Silverpoint on white prepared vellum: 109 × 192 mm.
About 1635. An early landscape study. See the following number for the verso.

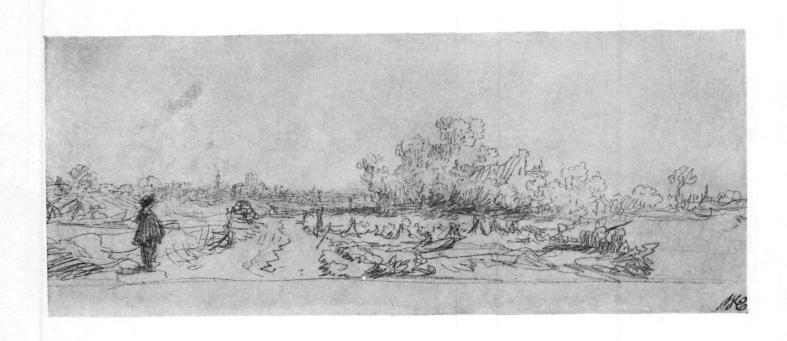

14 *(I, 14). Landscape with a Man Standing by a Road. (Kupferstichkabinett, Berlin)*
Silverpoint on white prepared vellum: 109 × 192 mm.
About 1635. Verso of 13 (I, 13).

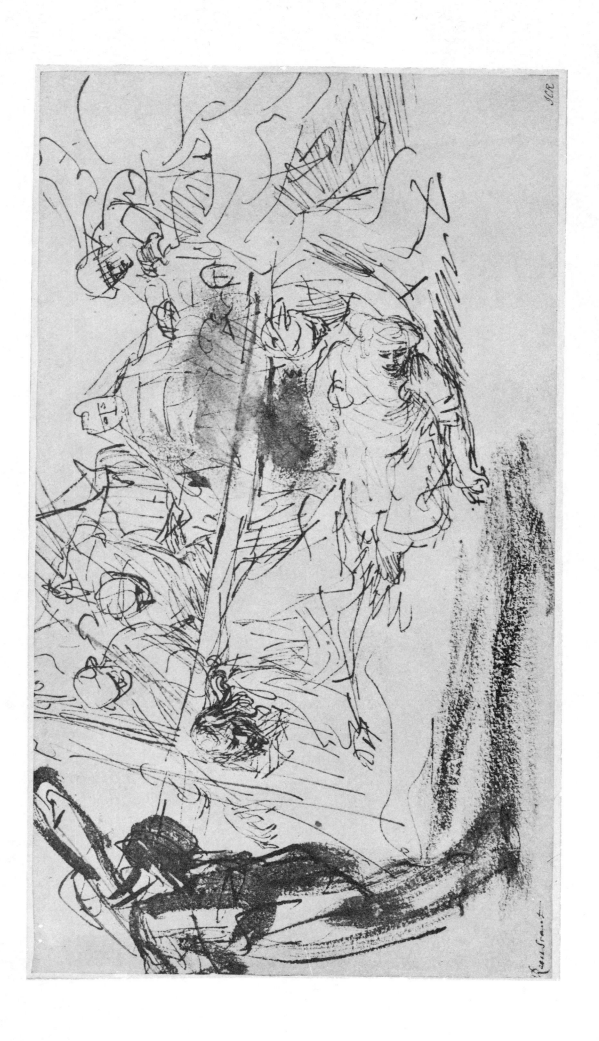

15 (I, 15). *Christ Carrying the Cross. (Kupferstichkabinett, Berlin)*
Pen and bistre, wash: 145 × 260 mm. Inscribed by a later hand: Rembrant.
An unmatched example of the bold and impulsive draughtsmanship of the mid-1630's.

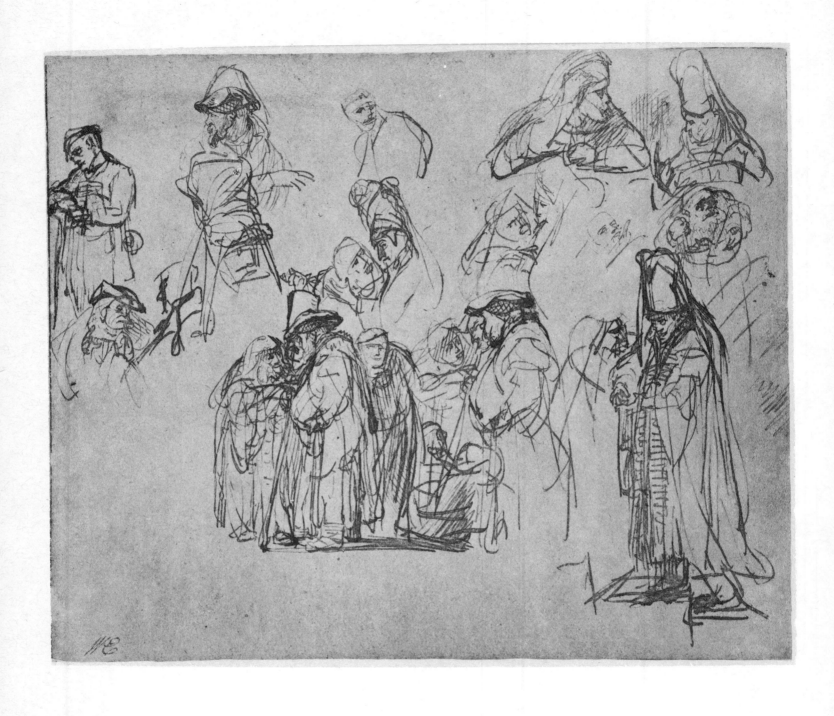

16 (*I, 16*). *Studies of Groups and Figures.* (*Kupferstichkabinett, Berlin*)

Pen and bistre: 167 × 196 mm.

Around 1637. Studies for Rembrandt's painting St. John the Baptist Preaching *now at Berlin-Dahlem
(Bredius 555). 78 (I, 78) and 212 (I, 195) are studies for the same painting.*

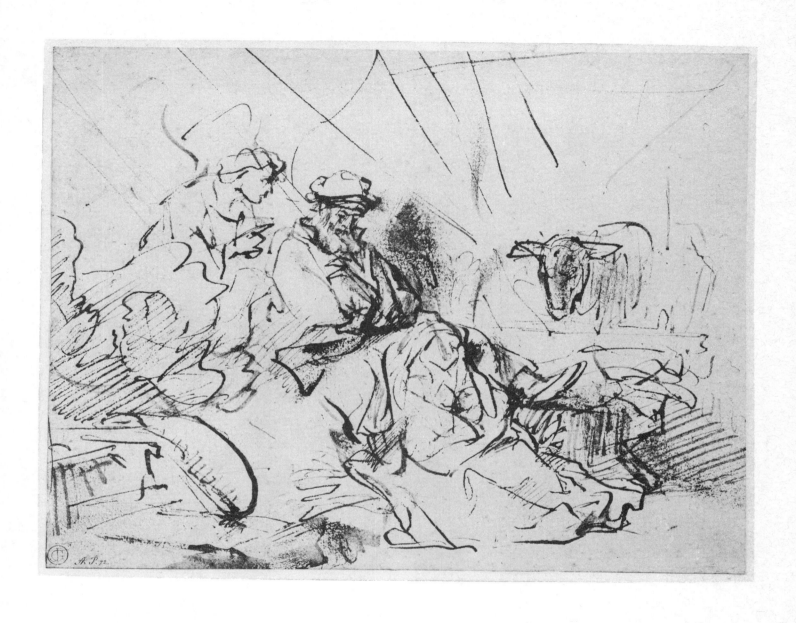

17 (I, 17). *The Angel Appearing to Joseph in His Dream.* (*Kupferstichkabinett, Berlin*)

Pen and bistre, wash, white body color: 145 × 187 mm.

About 1648–50. The drawing was probably used as a model for a painting now in Budapest (Catalogue, 1954, no. 236) which can be ascribed to a member of Rembrandt's circle.

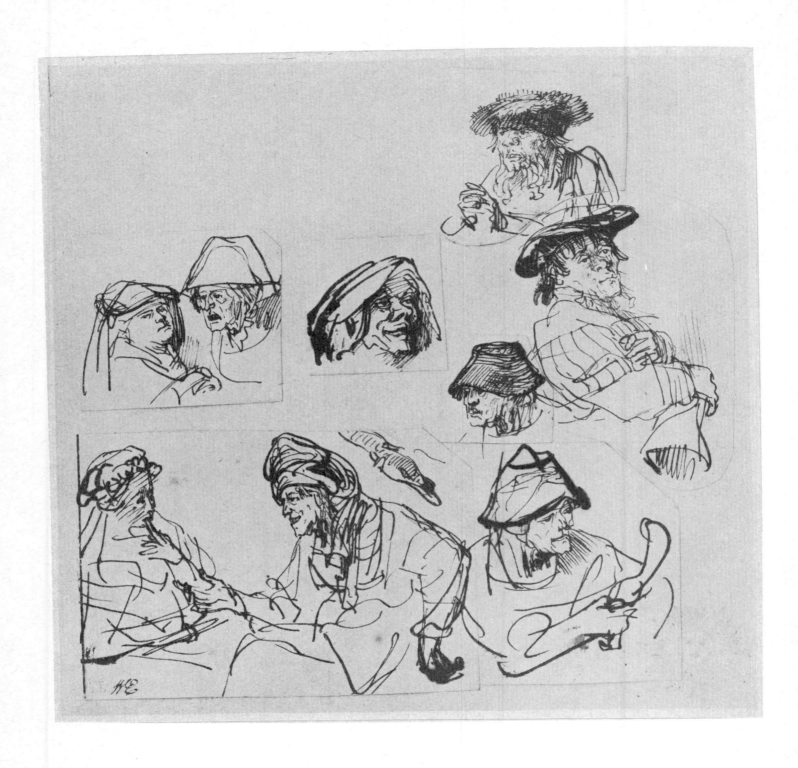

18 (*I, 18*). *Studies of Nine Figures. (Kupferstichkabinett, Berlin)*
Pen and bistre: 178 × 184 mm.
Seven pieces of paper pasted on one sheet. About 1635.

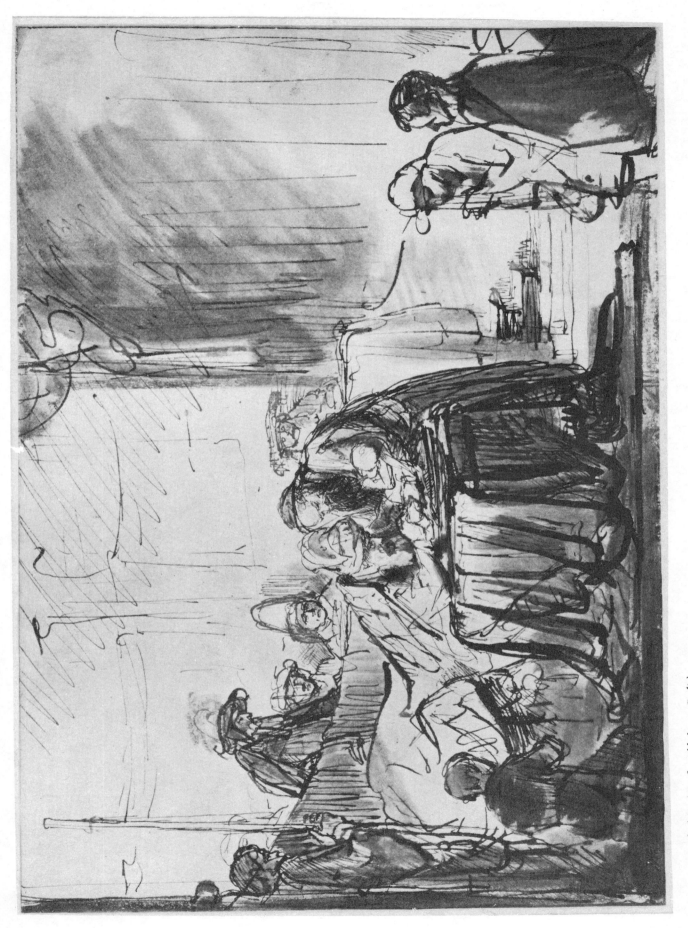

19 (I, 19). *The Circumcision of Christ. (Kupferstichkabinett, Berlin)*

Pen and bistre, wash, heightened with white: 203 × 287 mm.

Engraved by Naudet, who states that his print was made after a Rembrandt painting of 1639. The painting is not known and Naudet may have in fact based his print on the drawing. The drawing can be dated about 1645. It should be noted that Rembrandt received payment from the Stadholder in 1646 for a painting of The Circumcision (now lost); see Slive, 1953, pp. 25–26.

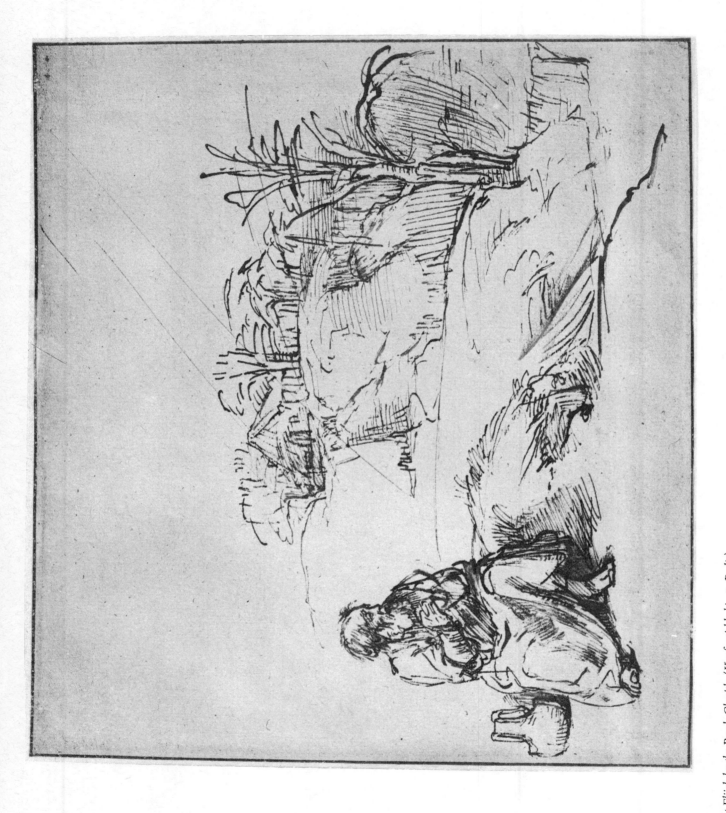

20 (I, 20). *The Prophet Elijah by the Brook Cherith. (Kupferstichkabinett, Berlin)*

Reed pen and bistre, wash, white body color: 205 × 233 mm.

About 1655. A few delicate lines radiating from heaven as well as Elijah's mood show that this is the moment the word of the Lord came unto the Prophet (I Kings 17).

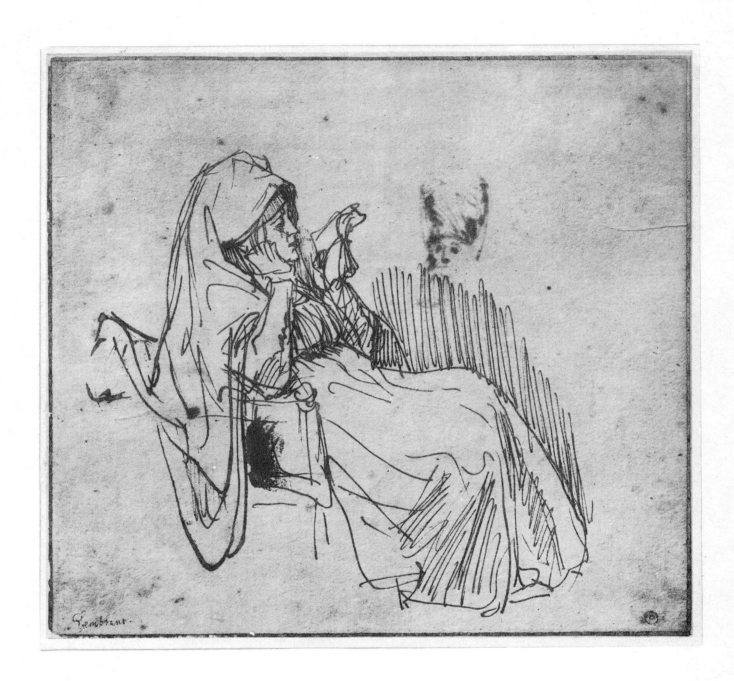

21 (*I, 21*). *Reading Woman Seated in an Armchair.* (*Kupferstichkabinett, Berlin*)

Pen and bistre, wash: 161 × 172 mm. Inscribed by a later hand: Rembrant.

About 1636–39. A masterful characterization of a short-sighted person reading. Traces of the sketch of a head on the verso of the drawing are visible on the recto. This is also noticeable in the reproduction. There is a close similarity in style to 147 (I, 142); however, the model is not the same.

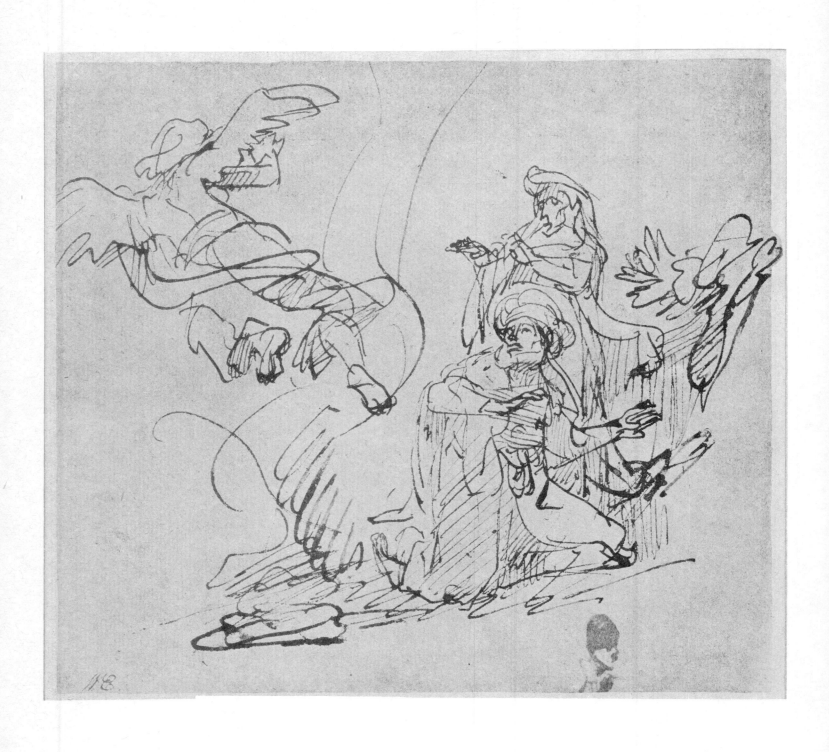

22 (I, 22). *The Angel Disappearing after Having Announced to Manoah and His Wife the Birth of Samson.*
(*Kupferstichkabinett, Berlin*)

Pen and bistre: 175 × 190 mm.

About 1637–40. Related to Rembrandt's painting of The Angel Leaving Tobit and His Family, *1637, Louvre,*
Paris (Bredius 503).

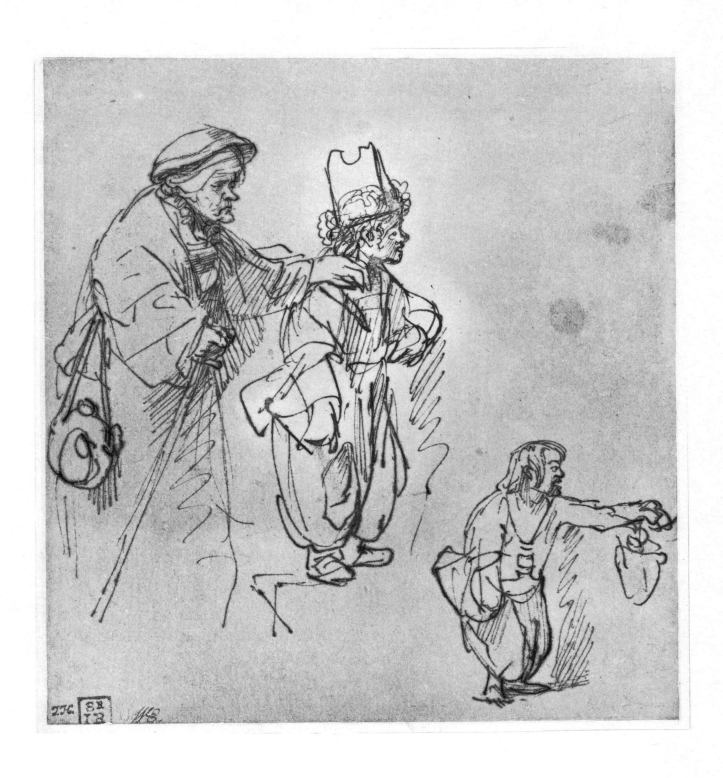

23 (*I, 23*). *Study of Three Figures.* (Kupferstichkabinett, Berlin)

Pen and bistre, partly covered with white: 185 × 170 mm.

About 1635. It has been suggested that the group on the left represents Hannah and Samuel. Rosenberg (1930, p. 234, no. 3772) rightly notes that this interpretation can be rejected because the old woman is blind and the Bible says nothing about the blindness of Hannah.

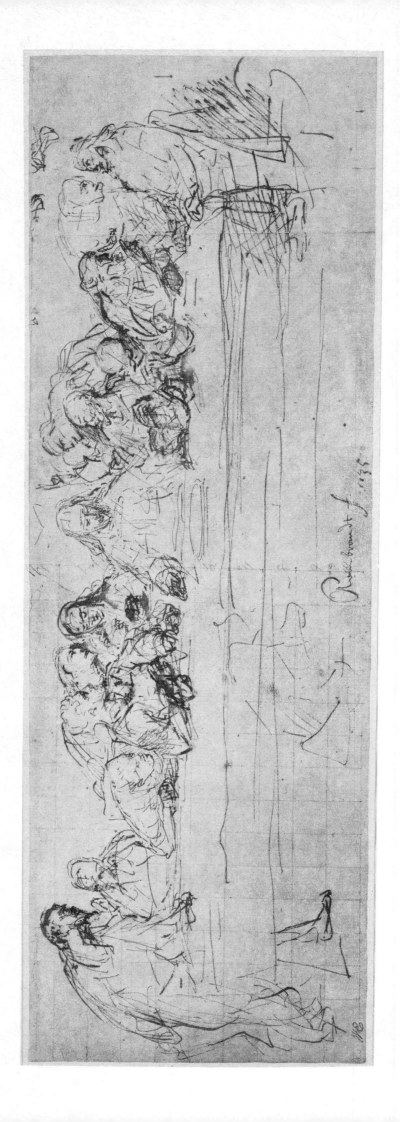

24 (I, 24). *Study after Leonardo's Last Supper.* (*Kupferstichkabinett, Berlin*)

Pen and bistre, wash, white body color: 128 × 385 mm. Signed and dated: Rembrandt f. 1635.

Probably the latest of Rembrandt's three extant copies after Leonardo's famous fresco; the others are reproduced 100 (I, 99) and 512 (IV, 65). Rembrandt did not know Leonardo's original painting in Santa Maria delle Grazie at Milan; he made his studies of the work from prints. In his drawings he altered the Italian Renaissance master's conception and imbued it with his own spirit; this one shows the greatest modification of Leonardo's composition. His close study of Leonardo's work had a lasting impact upon him. Traces of it can be seen in paintings made about two decades later (The Supper at Emmaus, Louvre, Paris [Bredius 578] and Julius Civilis, Nationalmuseum, Stockholm, 1662 [Bredius 482]).

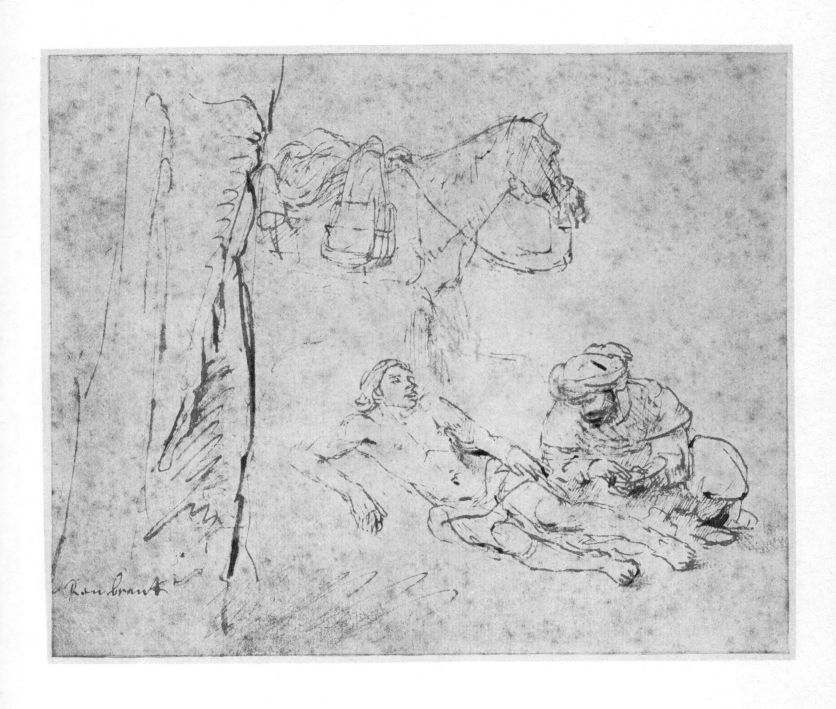

25 (*I, 25*). *The Good Samaritan.* (*Kupferstichkabinett, Berlin*)
Reed pen and bistre, some white body color: 164 × 195 mm. Inscribed by a later hand: Rembrant.
About 1650–55.

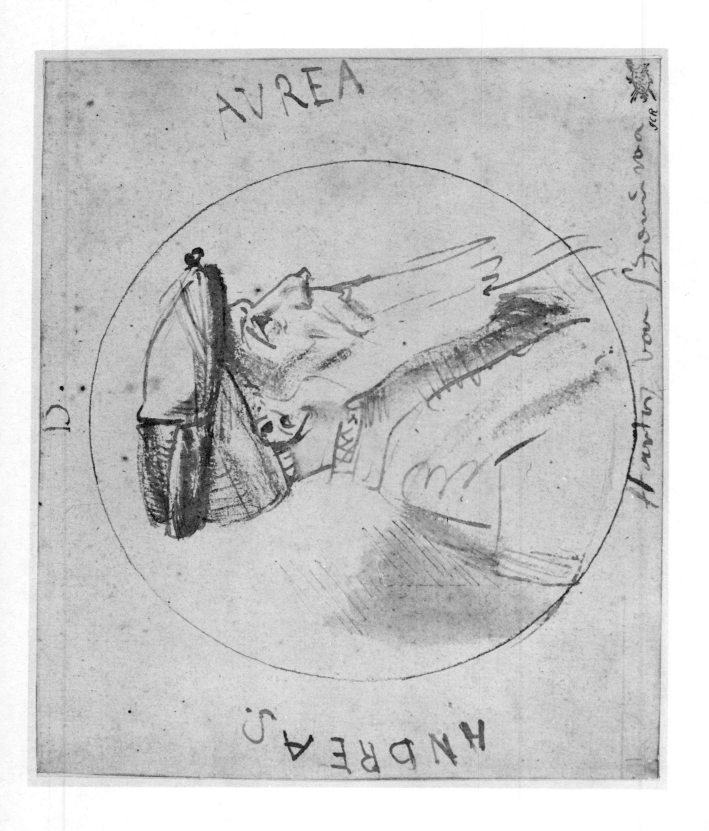

26 (I, 26). *Andrea Doria. (Kupferstichkabinett, Berlin)*

Pen and wash in bistre; the circle has been redrawn with red chalk: 168 × 205 mm. Inscribed around the portrait: Andreas D. Aurea. On the bottom of the sheet in Rembrandt's handwriting: Hartog van S(tad) genuwa (Duke of the City of Genoa). A copy after an unidentified medal. About 1655.

27 (*I, 27*). *Jacob's Dream, with Two Angels.* (*Kupferstichkabinett, Berlin*)

Pen in bistre: 200 × 191 mm.

About 1650. The drawing has been called the work of a pupil by Benesch (880), but Rosenberg (1930, p. 221,
no. 2696) rightly defends it and notes that the etchings of the early 1650's show the same delicate treatment.
See 192 (I, 180a) for what appears to be a somewhat later drawing, now in the Louvre, of the figure of Jacob.

28 (*I, 28*). *Thisbe Killing Herself Beside the Corpse of Pyramus.* (*Kupferstichkabinett, Berlin*)
Pen and bistre, wash, some white body color: 267 × 196 mm.
Benesch (*A27*) *expresses some hesitation about its authenticity, but the work has the qualities of an original made around 1640–45.*

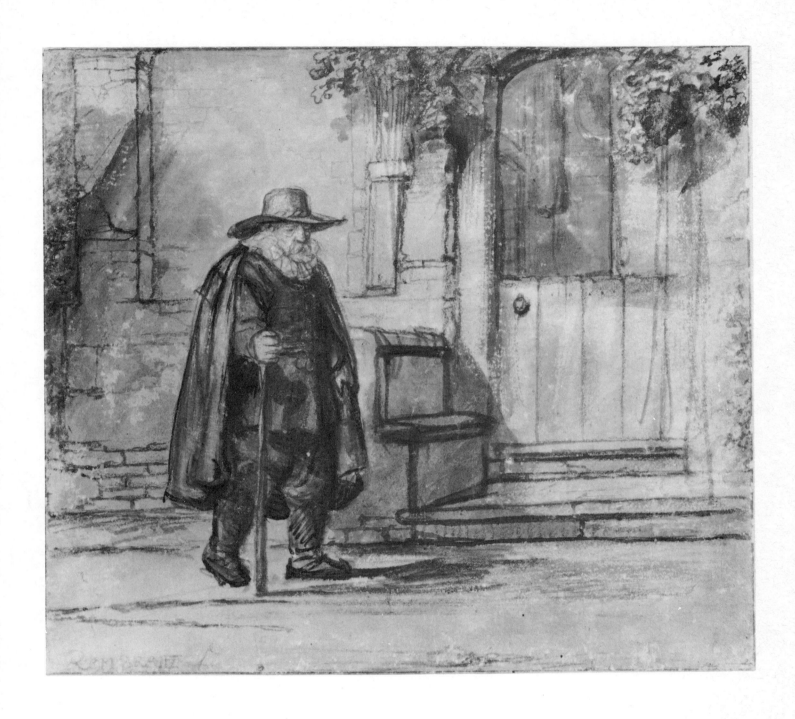

29 (*I, 29*). *An Elderly Man in a Wide-brimmed Hat Walking with a Stick. (Kupferstichkabinett, Berlin)*

Red chalk, pen and wash in bistre; some Indian ink washes by a later hand: 217 × 241 mm. Inscribed with red chalk by a later hand: Rembrant f.; traces of an earlier signature in red chalk are visible underneath.

Around 1640. The background has been reworked by a later hand, perhaps Nicolaes Maes (Valentiner [1924, pp. 58 ff.] erred when he attributed the entire drawing to Maes). The drawing has been called a study for a portrait of the Mennonite preacher Cornelis Claesz Anslo; but if the date of around 1640 is correct this identification must be discarded. Rembrandt's other portraits of Anslo (see 122 [I, 120]; 349 [III, 17]), both dated 1640, show Anslo as a younger and much more vigorous man.

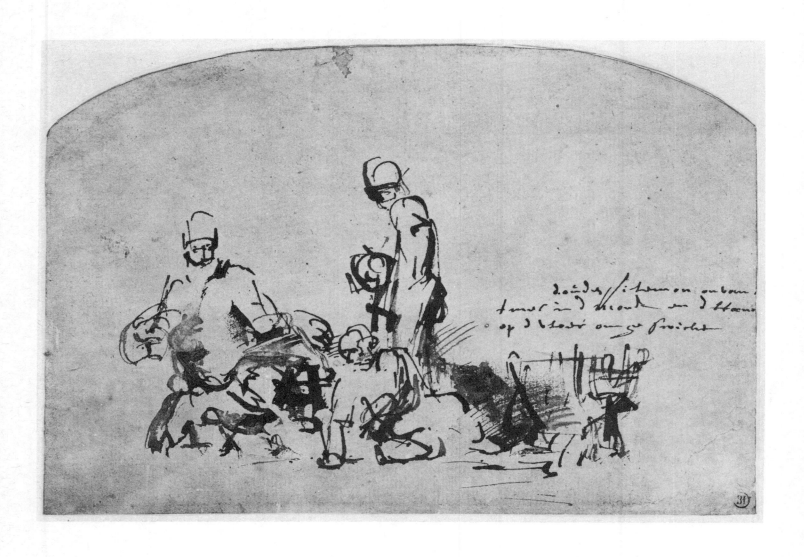

30 (*I, 30*). *Jupiter with Philemon and Baucis.* (*Kupferstichkabinett, Berlin*)

Reed pen and bistre, some white body color: 131 × 192 mm. Inscribed by Rembrandt: "d'ouden filemon van(g)/
t mes ind mond en d Haend / op de vloer omgeswicht" (*The old Philemon takes the knife in his mouth and
with his hand prowls on the floor*).

About 1655. Perhaps a study for one of the scenes from Ovid's Metamorphoses *which, according to Baldinucci,
were made by Rembrandt for the house of an Amsterdam merchant (see Slive, 1953, p. 109).*

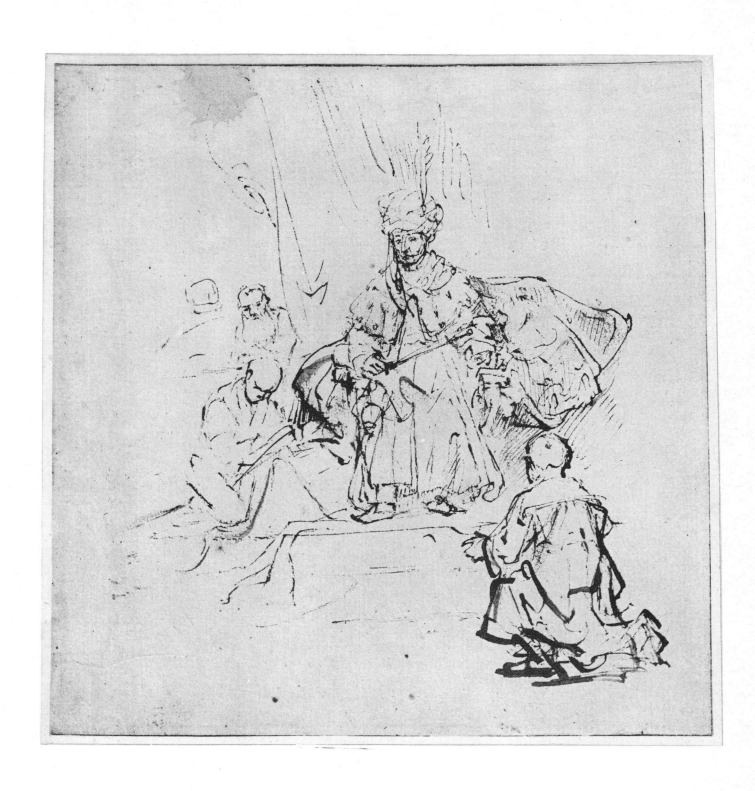

31 (*I, 31*). *Joseph Kneeling Before Pharaoh.* (*Kupferstichkabinett, Berlin*)
Reed pen and bistre, wash, white body color: 189 × 179 mm.
About 1655. The subject has also been interpreted as Haman receiving the order from Ahasuerus to exterminate the
Jews.

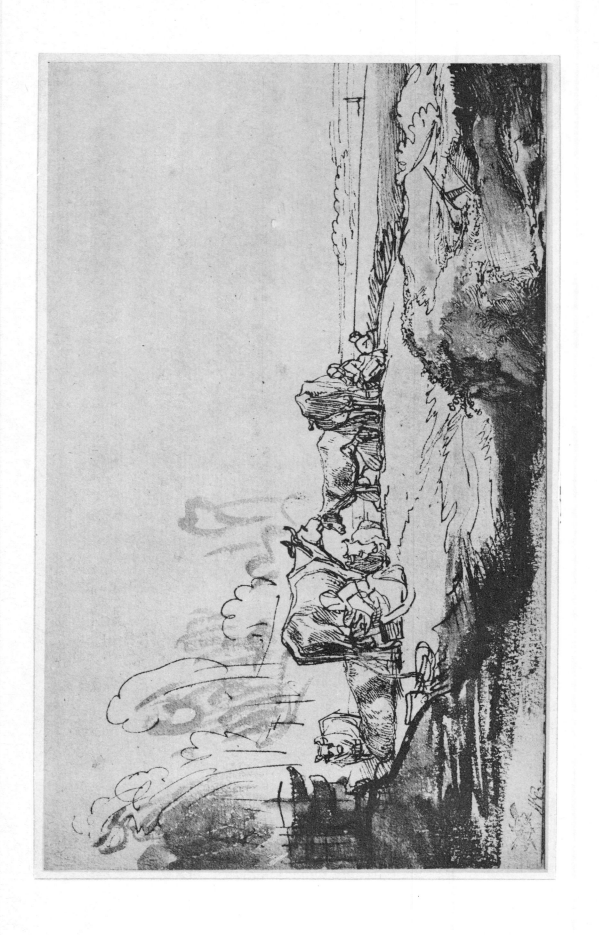

32 (I, 32). *The Milkmaids. (Kupferstichkabinett, Berlin)*
Pen and bistre, wash, white body color: 155 × 225 mm.
About 1637–40.

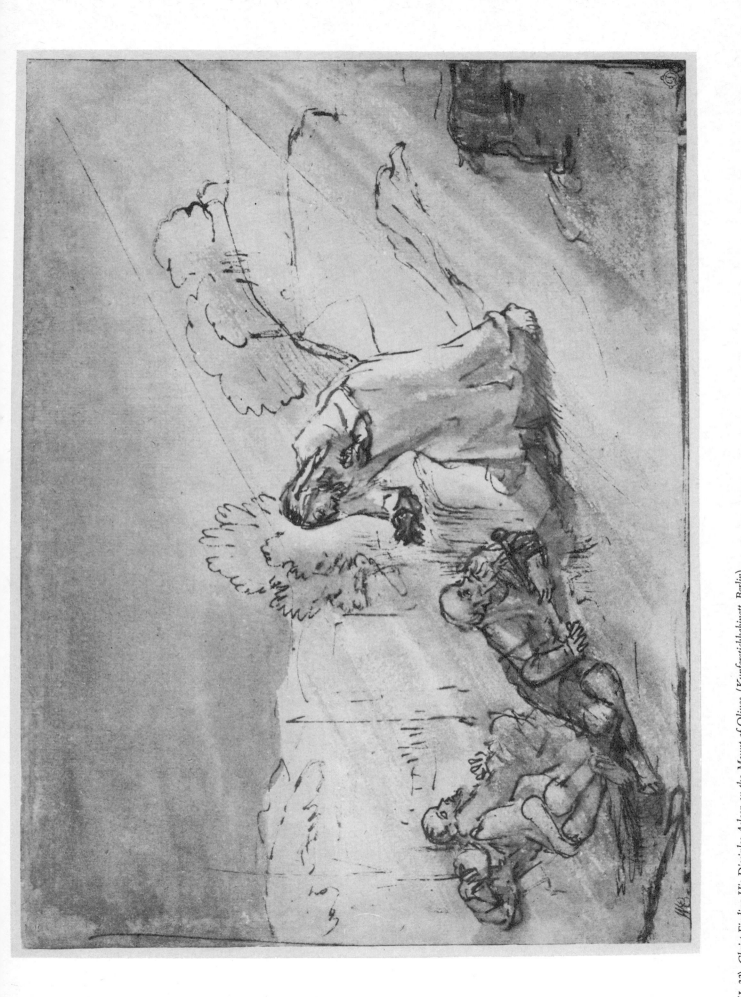

33 (I, 33). *Christ Finding His Disciples Asleep on the Mount of Olives.* (*Kupferstichkabinett, Berlin*)

Pen and bistre, wash: 178 × 243 mm.

About 1655. The scene shows Christ pleading for aid from his disciples: "Could ye not watch with me one hour?" (Matthew 26, 40).

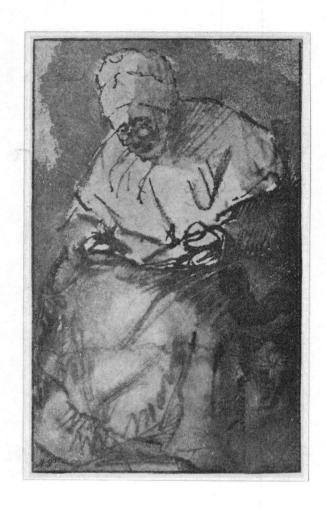

34 (*I, 34*). *An Old Woman Reading, Wearing Glasses.* (*Kupferstichkabinett, Berlin*)
Pen in bistre, wash: 120 × 72. A strip 3½ cm. wide at bottom and the right corners are later additions.
Doubtful (*see Rosenberg, 1930, p. 233, no. 2689*).

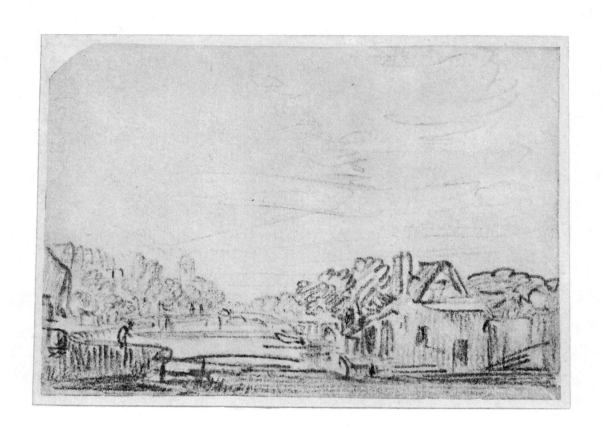

35 (*I, 35*). *A Canal with a Bridge in the Distance.* (*Kupferstichkabinett, Berlin*)
Black chalk: 99 × 138 mm.

*About 1640. Probably from the same sketchbook as 37 (I, 37). Lugt (1931, p. 60, no. 1106) suggests it may be a
view of the Oude Schans in Amsterdam.*

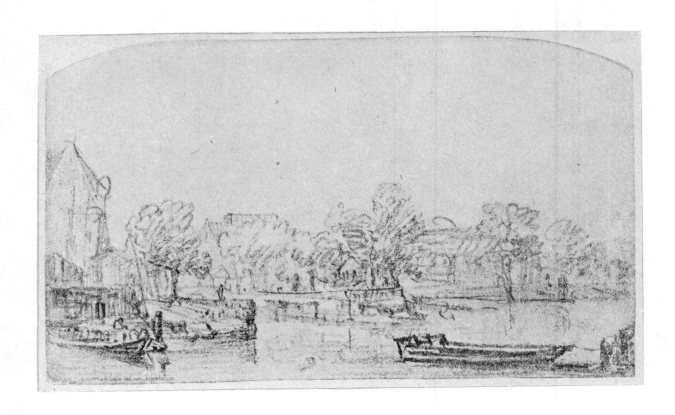

36 (*I, 36*). *View of a Canal with a Boat in the Right Foreground.* (*Kupferstichkabinett, Berlin*)
Black chalk: 94 × 156 mm.
Lugt (1920) writes that the drawing may represent the St. Anthoniessluis seen from Uilenburgh. About 1640.

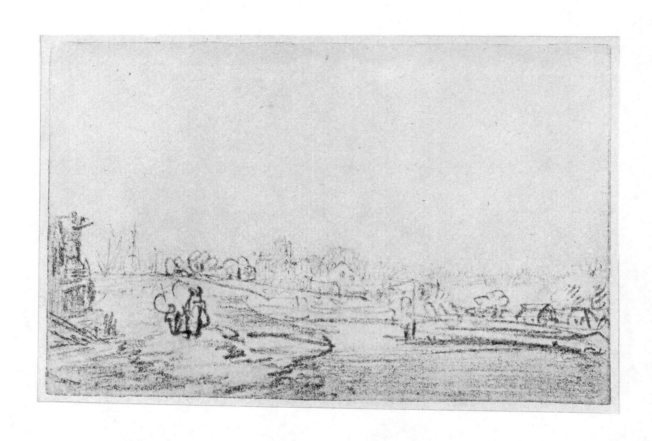

37 (*I, 37*). *Landscape with a Canal Leading Towards a Town in the Distance.* (*Kupferstichkabinett, Berlin*)
Black chalk: 100 × 150 mm.
About 1640. Probably from the same sketchbook as 35 (I, 35).

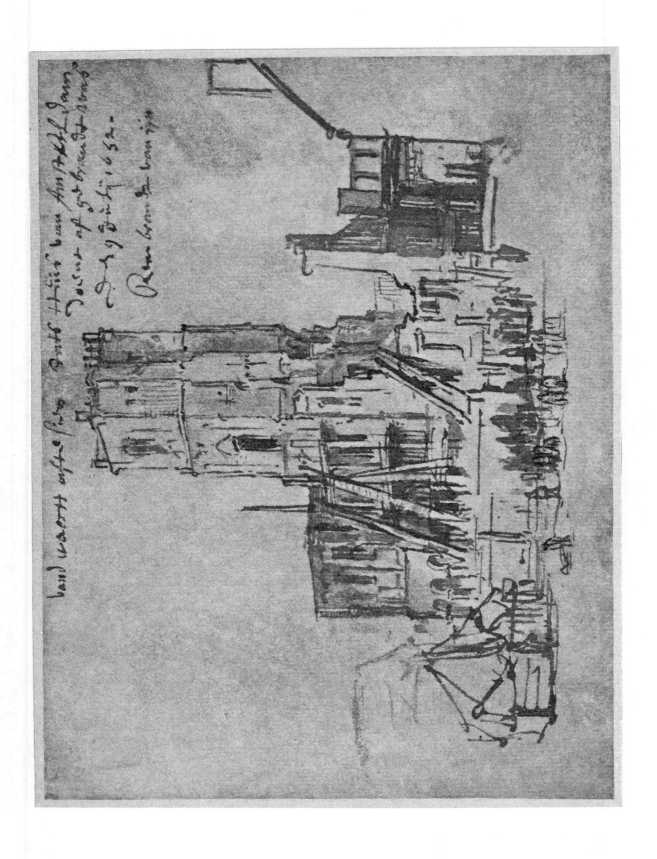

38 (I, 38). *The Old Town Hall at Amsterdam After Its Destruction by Fire in 1652. (Rembrandt Huis, Amsterdam)*

Pen and wash; touches of red chalk by another hand: 150 × 201 mm. Inscribed by Rembrandt: "vand waech afte sien stats huis van Amsteldam / doent afgebrandt was / den 9 Julij 1652. / Rembrandt van rijn" (As seen from the Weigh House, the Town Hall of Amsterdam after the conflagration of 9 July 1652. Rembrandt van Rijn).

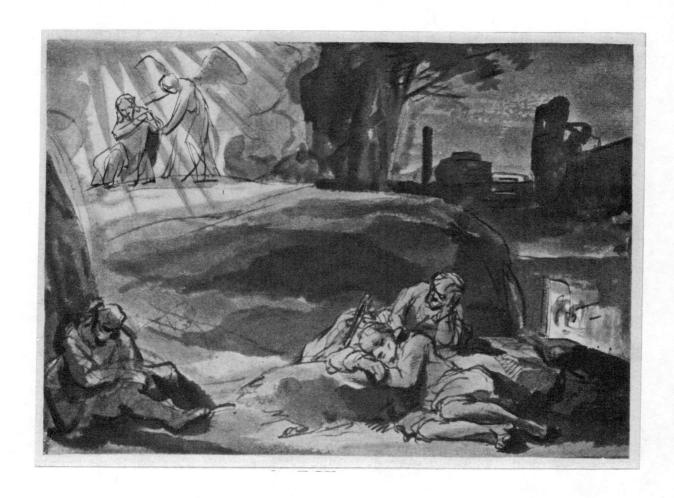

39 (*I, 39*). *Christ in the Garden of Gethsemane, the Disciples Sleeping in the Foreground.* (*Formerly D. Y. Cameron Collection, London*)

Pen and bistre, washes in bistre and Indian ink: 118 × 160 mm.

The connection Hofstede de Groot (991) mentions between the work and Rembrandt's late etching (Bartsch 75) is not compelling. Valentiner (446) relates it to drawings of the Good Samaritan (reproduced 206 [I, 190]; 345 [III, 13]; 383 [III, 50]). There is a similarity to 206 (I, 190) and 383 (III, 50), but the quality of this sheet is less good. It may be a copy after a lost work. The possibility that it is a drawing by Philips Koninck should also be considered. Not listed in Benesch.

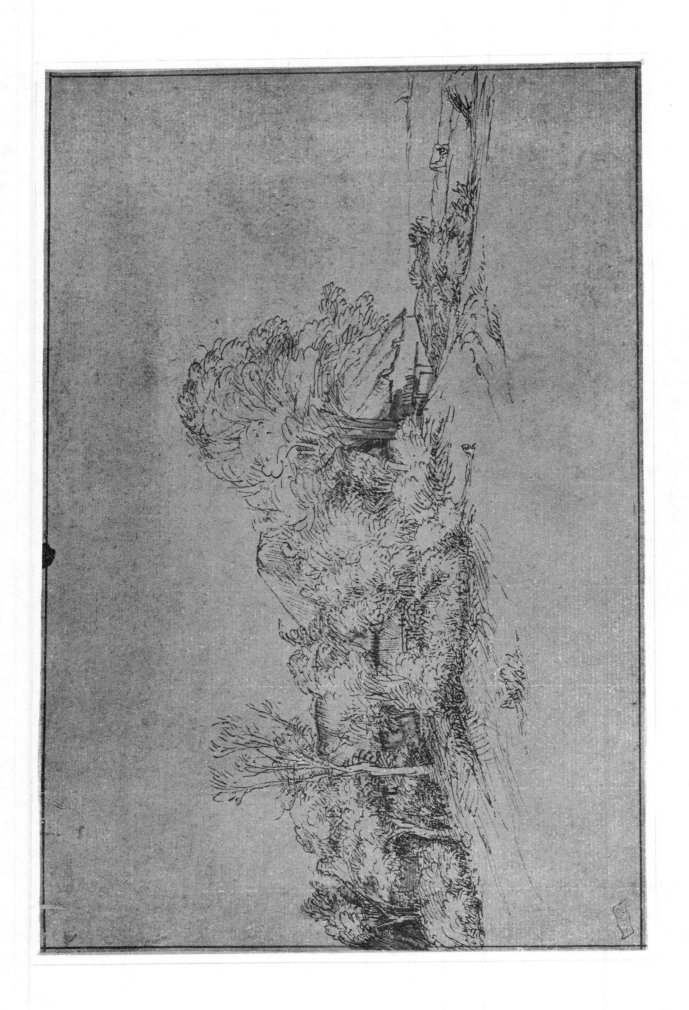

40 (I, 40). *Farmhouses with a Water Mill Amidst Trees.* (Museum, Groningen)
Pen and bistre, wash: 158 × 240 mm.
One of a large group of finely executed landscape drawings made around 1650.

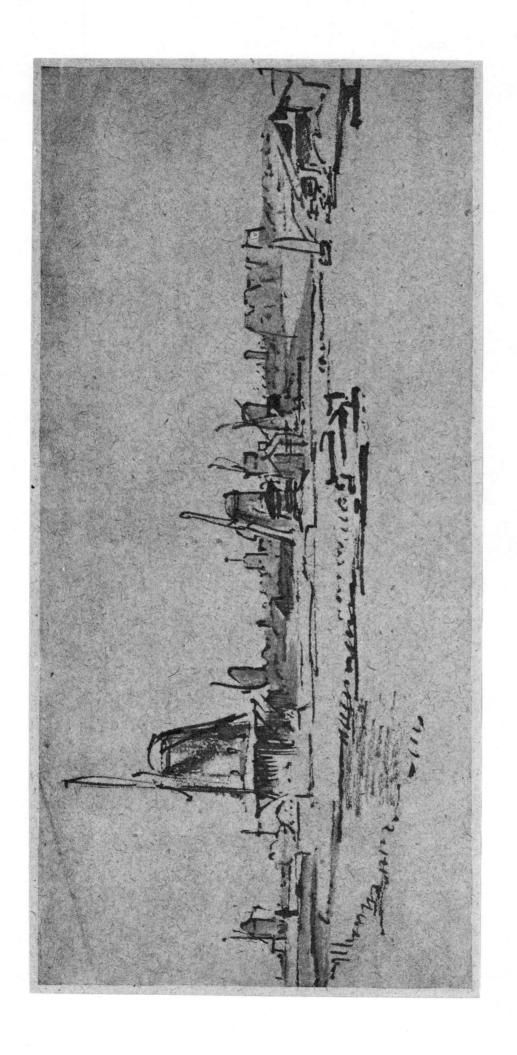

41 (I, 41). *Windmills on the West Side of Amsterdam. (Kobberstiksamling, Copenhagen)*

Reed pen and wash on grey paper: 120 × 263 mm.

On the obverse an inscription which probably was transcribed from an old mount: "Buiten Amsterdam aan de Wetering op de Stadspakhuizen te zien" (Outside of Amsterdam by the Wetering where the city's warehouses can be seen). The economic touch and luminosity suggest a date around 1655.

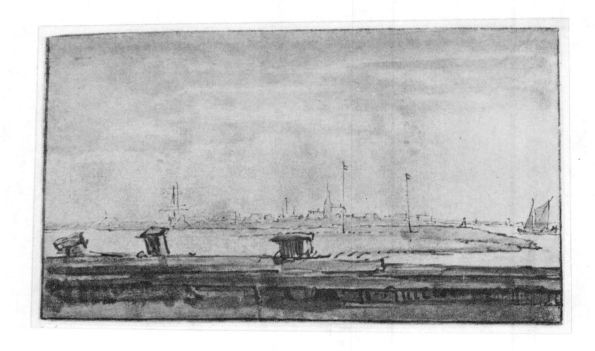

42 (*I, 42*). *View Over "Het IJ" Seen from the Diemerdijk.* (*Boymans-van Beuningen Museum, Rotterdam*)

Pen and bistre, wash; the grey wash added by another hand: 82 × 144 mm.

About 1650–53. See 56 (I, 56) and 497 (IV, 51) for other drawings of the same place made around the same time.

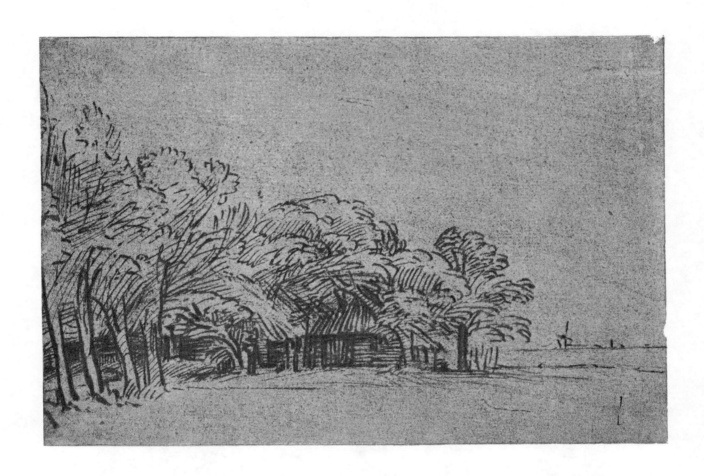

43 (*I, 43*). *Cottages Among a Clump of Large Trees.* (*Formerly J. P. Heseltine Collection, London*)
Reed pen and bistre: 113 × 165 mm.
Around 1653.

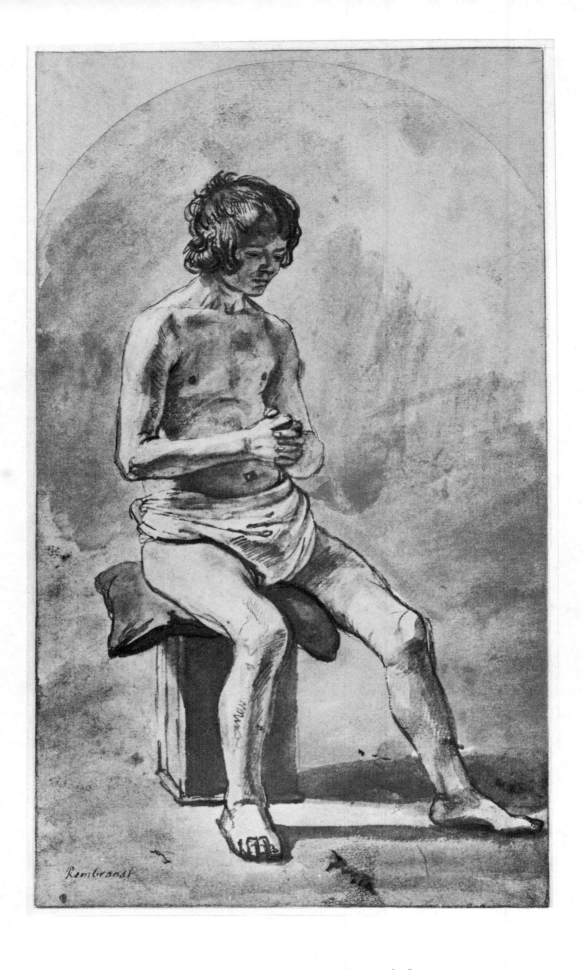

44 (I, 44). *Male Nude Seated on a Box, His Hands Clasped.* (Barber Institute of Arts, Birmingham, England)
Pen and brush in bistre, washes in Indian ink: 275 × 161 mm.
Probably a fine school drawing with some corrections by the master. See Lugt (1933, no. 1327) for drawings
attributed to the same hand. The study was probably made in Rembrandt's studio when the master was working on
his etching dated 1646 of the same model in a very similar pose (Bartsch 193).

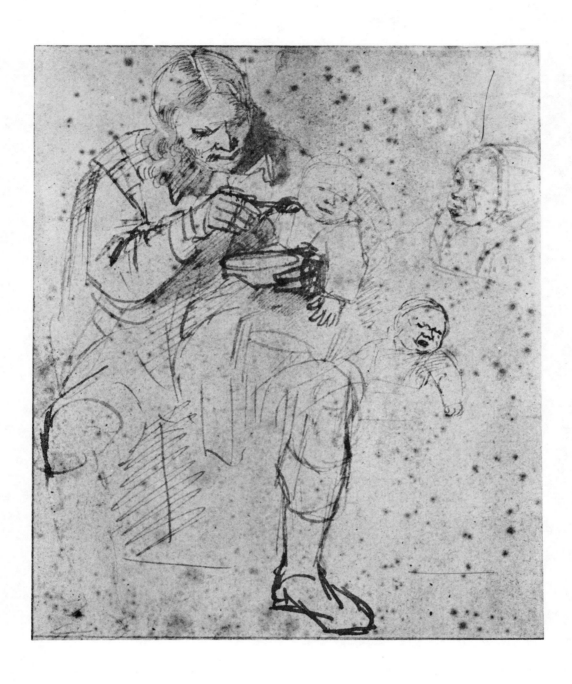

45 (*I, 45*). *The Widower. (Kobberstiksamling, Copenhagen)*

Pen and bistre, wash: 173 × 142 mm.

Around 1643. A striking example of Rembrandt's warmth and human sympathy. The title, however, is a traditional one, and it is fanciful to relate the drawing, as some critics have done, to Rembrandt's own personal life after the death of Saskia. Benesch (354) dates the drawing 1636–37.

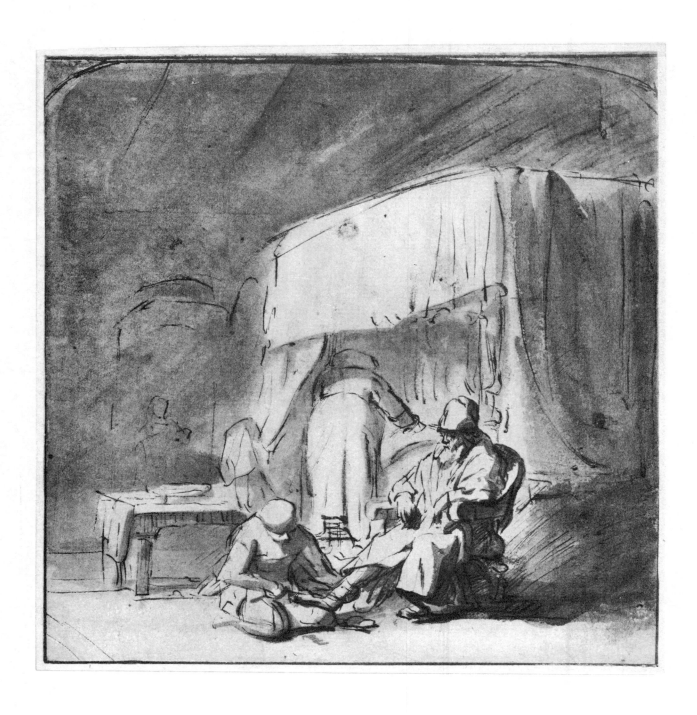

46 (*I, 46*). *Old Tobit*(?) *Having His Feet Bathed.* (*Formerly J. P. Heseltine Collection, London*)

Pen and wash in bistre: 170 × 162 mm.

About 1650. A better version, which includes a woman before a fireplace on the left, is in the University Library, Warsaw (Benesch 644). The subject is hard to decipher. Benesch notes that it may be taken from classical mythology: Odysseus disguised as a beggar having his feet bathed by his old nurse.

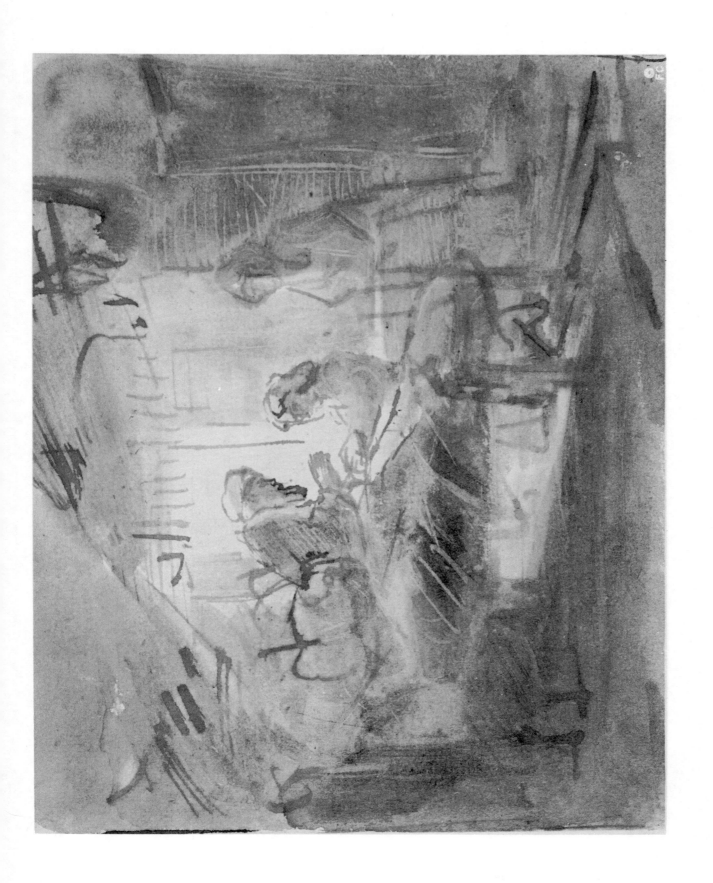

47 (I, 47). *Isaac Blessing Jacob. (Frick Collection, New York)*

Pen and bistre, wash; Indian ink washes appear to have been added later; 172 × 221 mm.

A difficult drawing to place. Valentiner (65) dates the work around 1647, but questions its authenticity. Benesch (1065) includes it in his corpus as an original, and suggests it should be dated around 1660-62.

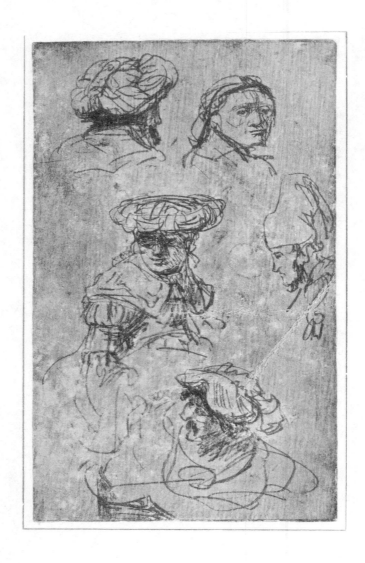

48 (*I, 48*). *Sketches of Five Heads.* (*Boymans–van Beuningen Museum, Rotterdam*)

Silverpoint on prepared vellum: 130 × 80 mm.

For verso of sheet see 49 (I, 49). About 1637. Begemann (1961, no. 341) suggests the woman in the middle is probably Saskia.

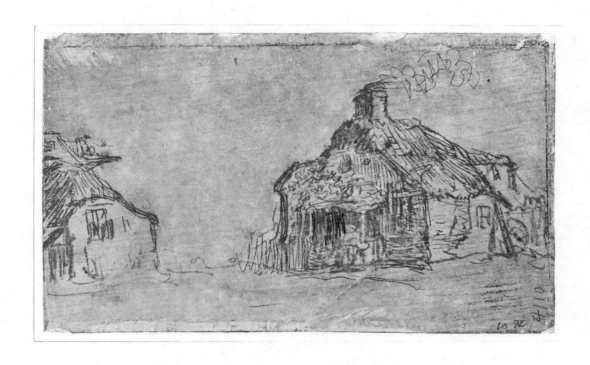

49 (*I, 49*). *Two Cottages*. (*Boymans-van Beuningen Museum, Rotterdam*)

Silverpoint on prepared vellum: 130 × 80 mm.

Verso of 48 (I, 48). Benesch (341) notes that the little cottage on the left is found in Rembrandt's painting of
The Mill (*National Gallery, Washington, D.C., reproduced Jakob Rosenberg*, Rembrandt, Cambridge, *1948,*
Vol. 2, *figure 144). The cottage is almost invisible in the painting; thus it is hard to make conclusions about this*
much discussed picture upon the basis of the drawing.

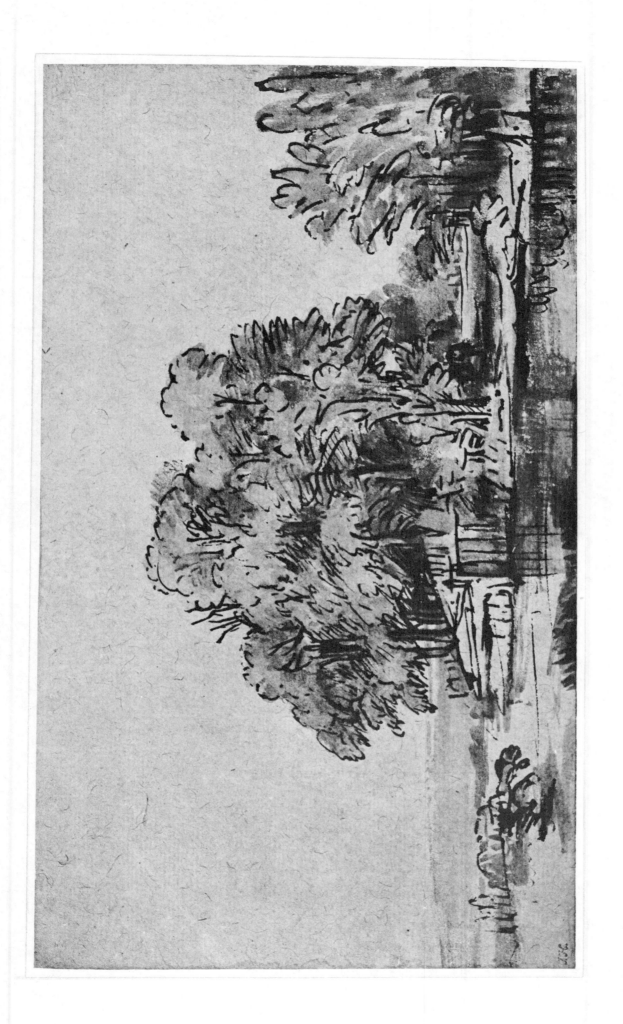

50 (I, 50). *A Group of Large Trees on the Edge of a Pond. (Louvre, Paris)*
Pen and bistre, wash: 145 × 250 mm.
About 1655.

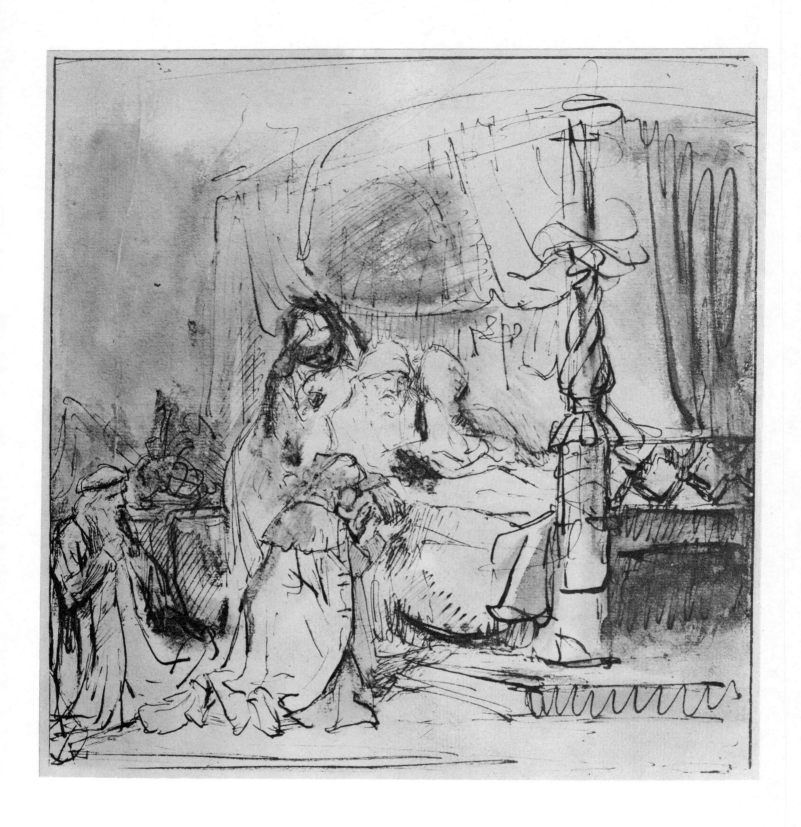

51 (*I, 51*). *David on His Deathbed Appoints Solomon His Successor* (?). (*Chatsworth Settlement*)

Pen and bistre, wash: 218 × 208 mm.

From the collection of Nicolaes Antoni Flinck (1646–1723), the son of Rembrandt's pupil Govert Flinck. The bulk of Nicolaes Flinck's choice collection of drawings was bought by the second Duke of Devonshire in 1723. Other Flinck drawings may have been acquired by the third Duke in 1754. Two hundred and twenty-five drawings at Chatsworth bear Flinck's mark. Most of the Chatsworth Rembrandts from his collection are of the highest quality. This sheet is one of the rare weak ones. It has been attributed to Arent de Gelder by Benesch, Mitteilungen der Gesellschaft für vervielfältigende Kunst, 45 (1922), p. 39, and to Govert Flinck by L. Münz, Die Graphischen Künste, N.F., II (1937), p. 103. There is not complete agreement about the subject of the drawing either. J. Nieuwstraten (Oud Holland, 80, 1965, p. 62) suggests that the drawing represents Bathsheba reminding the dying David of his promise that Solomon would be his successor (I Kings 1, 15 ff.).

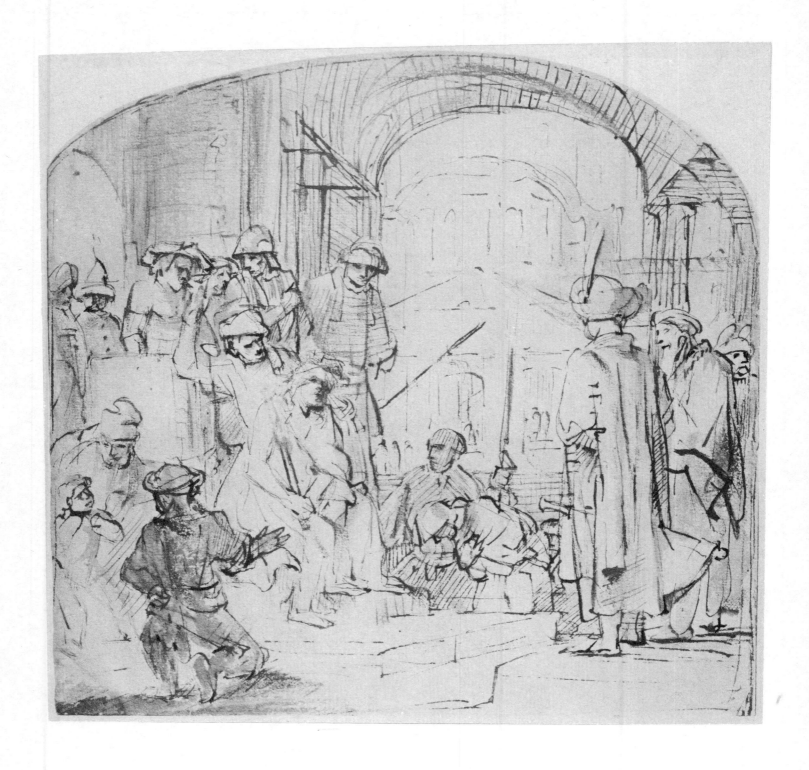

52 (*I, 52*). *The Mocking of Christ.* (*Chatsworth Settlement*)

Pen and bistre, wash: 195 × 198 mm.

Benesch (A82) has convincingly shown that this drawing is by an unidentified pupil of Rembrandt who followed the master's mature style. A mark of his technique is touches of shadow rubbed with the finger, a device which the master himself frequently used after 1650. His facial types have a schematic squareness and lack the finer gradations of expression. Benesch ascribed a series of ten drawings—most of which were once attributed to Rembrandt—to this anonymous master; all of them represent scenes from the life of Christ.

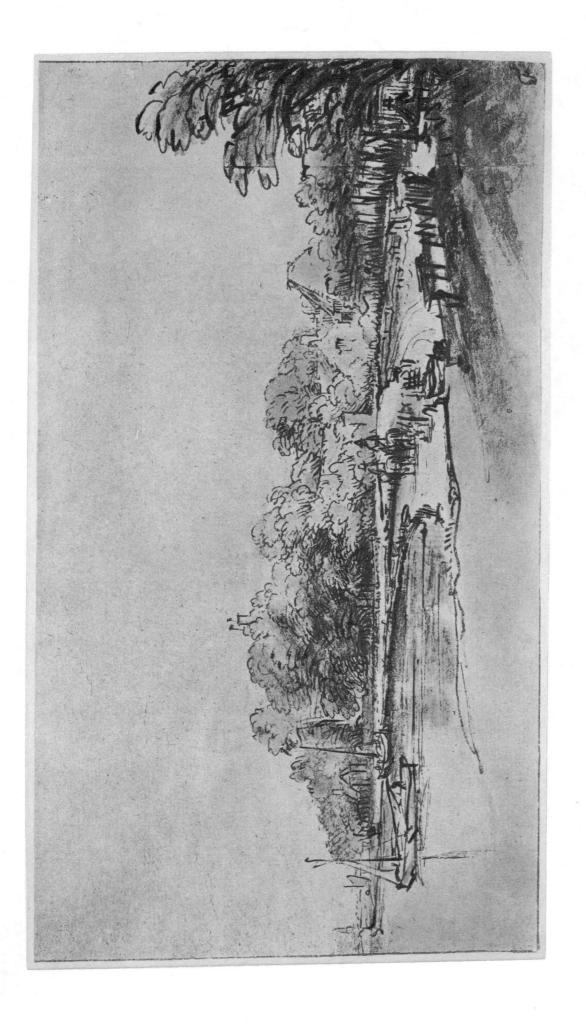

53 (I, 53). *The Bend in the Amstel River, with Kostverloren Castle and Two Men on Horseback. (Chatsworth Settlement)*

Reed pen and brush in bistre and Indian ink, washes in bistre and Indian ink, white body color: 136 × 250 mm. (The artist pasted a strip to the right of the sheet.)

About 1650–52. Lugt has shown (1920) that one of the artist's favorite walks was along the banks of the Amstel River. On this walk he frequently sketched near Kostverloren Castle; see 67 (I, 67); 71 (I, 71); 461 (IV, 18); and 466 (IV, 23) for other drawings of this motif.

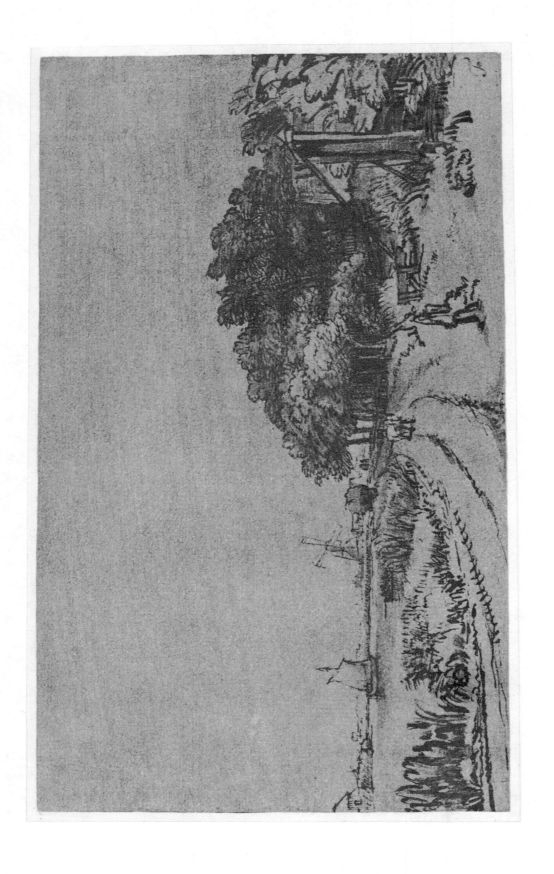

54 (I, 54). *The Amsteldijk near the Trompenburg Estate. (Chatsworth Settlement)*

Pen and wash in bistre, white body color, on brown prepared paper: 130 × 217 mm.

About 1650. The Trompenburg Estate was another motif Rembrandt drew more than once on his walks along the Amstel; see 64 (I, 64)
for a sketch made a bit to the right of this view.

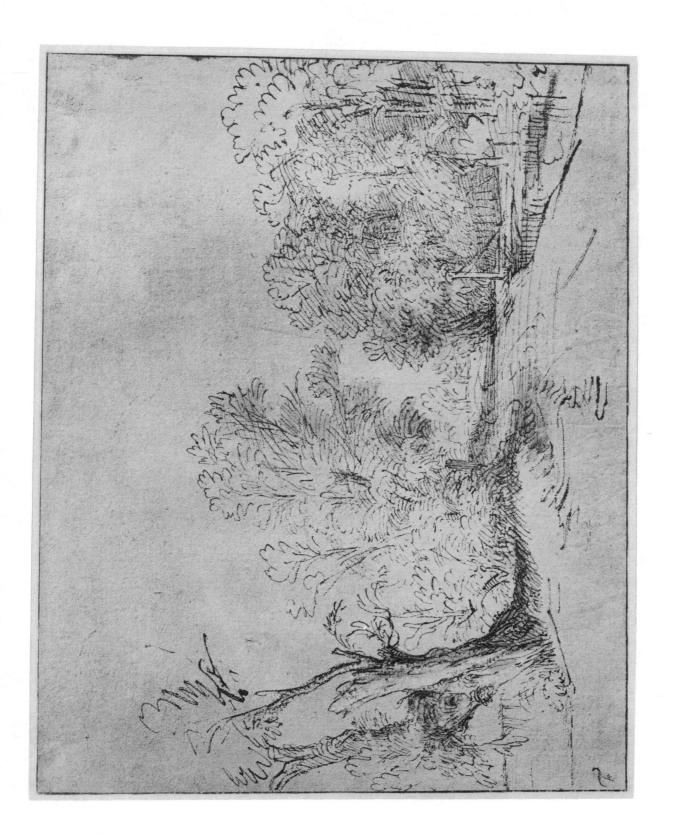

55 (I, 55). *A Road Through a Wood.* (*Chatsworth Settlement*)
Pen and bistre, wash: 156 × 200 mm.
About 1650.

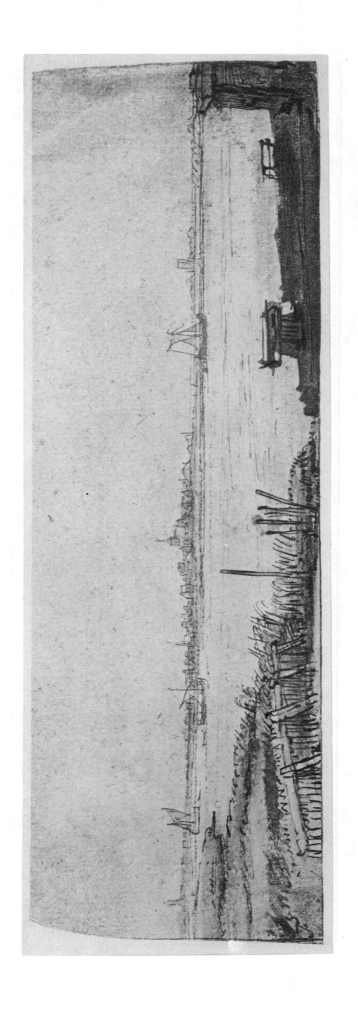

56 (I, 56). *View Over "Het IJ" from the Diemerdijk. (Chatsworth Settlement)*
Pen and wash in bistre, white body color, on greyish paper: 76 × 244 mm.
About 1650–53. See 42 (I, 42) and 497 (IV, 51) for other drawings by Rembrandt made at this site.

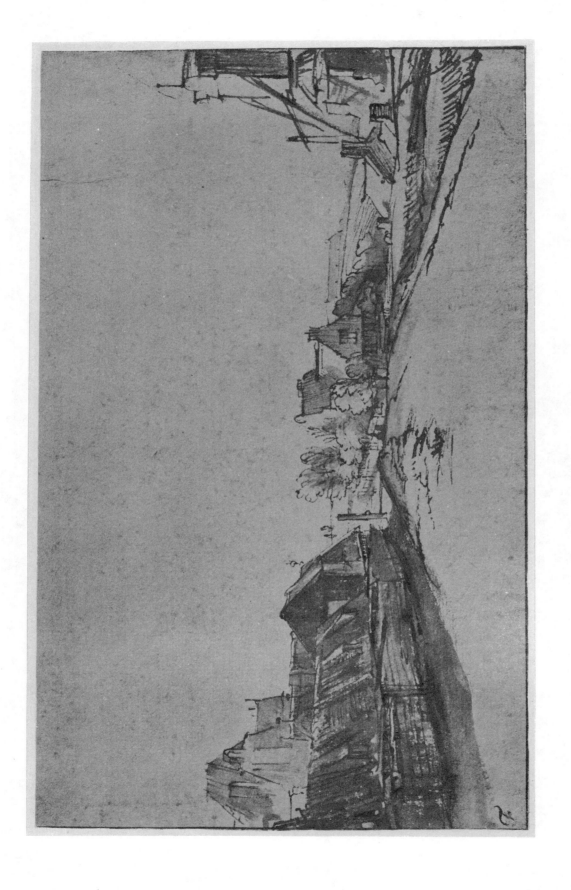

57 (I, 57). *The Bulwark "De Rose" and the Windmill "De Smeerpot." (Chatsworth Settlement)*
Pen and wash in bistre: 135 × 218 mm.

About 1650. There is a drawing by Rembrandt of the house with the two gables in the center of the composition at the Museum of Fine
Arts, Budapest (Benesch 1264).

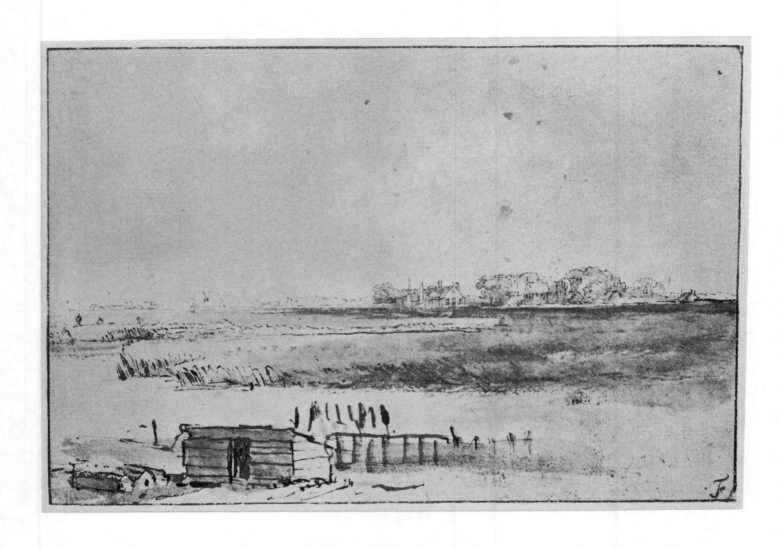

58 (*I, 58*). *View of Houtewaal.* (*Chatsworth Settlement*)

Pen and bistre, wash, white body color: 125 × 182 mm.

About 1650. Houtewaal is a little village near Amsterdam. On the verso of the sheet is a view of the road on the dike entering Houtewaal (see Benesch, figure 1486).

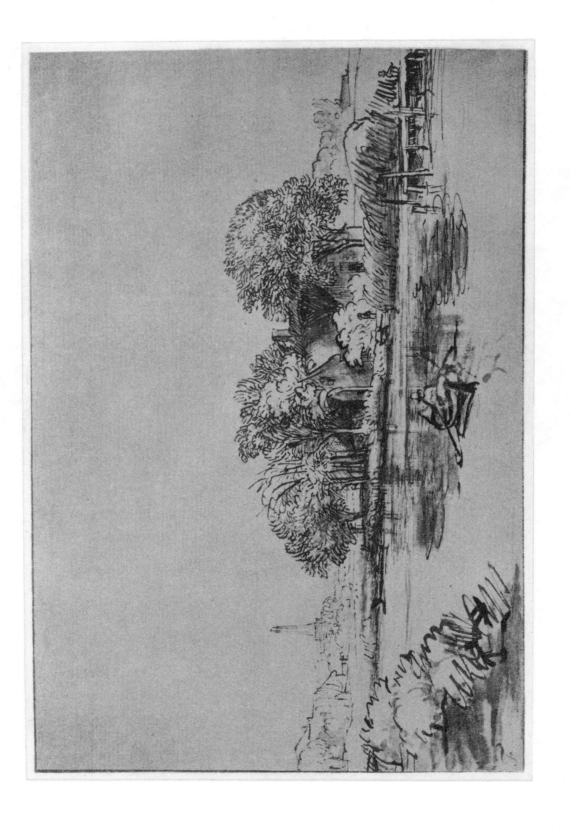

59 (I, 59). *A Farmhouse Among Trees Beside a Canal with a Man in a Rowboat.* (*Chatsworth Settlement*)

Pen and bistre, wash, white body color: 133 × 204 mm.

About 1650. The spire of the church of Oudekerk is seen in the distance.

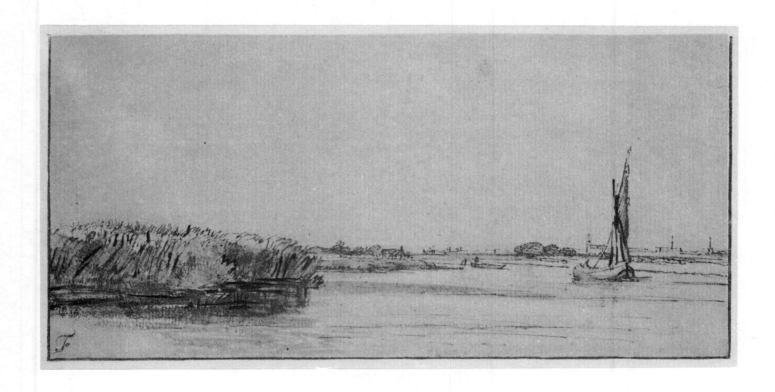

60 (*I, 60*). *View of a Lake with a Sailboat on the Right and High Reeds on the Left.* (*Chatsworth Settlement*)
Pen and wash in bistre: 88 × 181 mm.

About 1650. Lugt (1920) suggests that the lake is the Nieuwe Meer. The sloping capital "F" in the left corner is Nicolaes Antoni Flinck's collector's mark; it appears on many of the Rembrandt drawings at Chatsworth (see the comment to 51 [I, 51]).

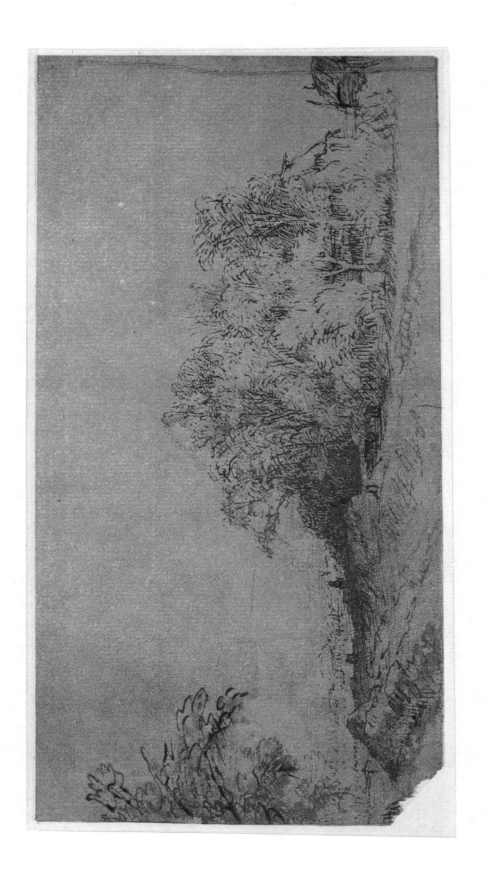

61 (I, 61). *A Group of Trees and Huts near a High Road. (Chatsworth Settlement)*
Pen and wash in bistre, some Indian ink wash: 110 × 219 mm.
About 1650. The torn lower left corner of the drawing is now repaired.

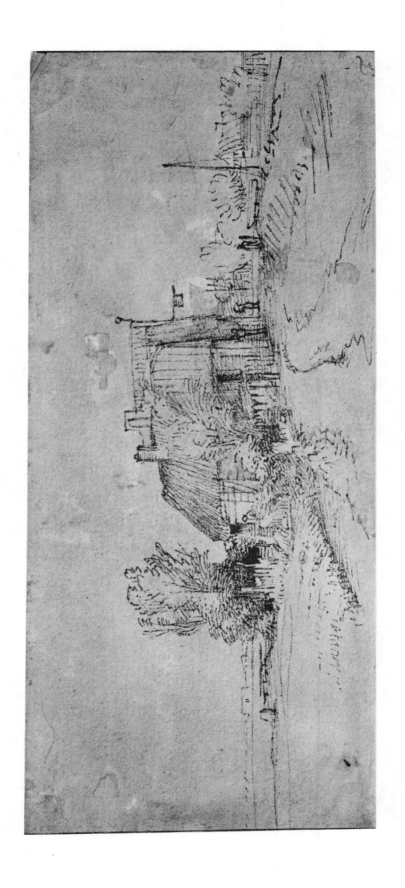

62 (I, 62). *An Inn Beside a Road.* (Chatsworth Settlement)
Pen and bistre, on light grey prepared paper: 100 × 226 mm.
About 1652.

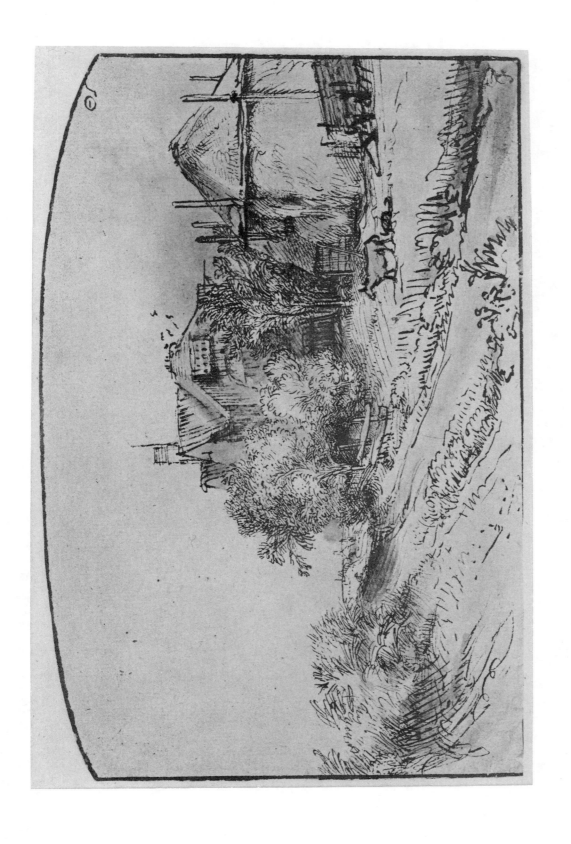

63 (I, 63). *A Hayrick near a Farm.* (Chatsworth Settlement)
Pen and bistre, wash: 128 × 200 mm.

About 1650. Signed on the back by a seventeenth-century hand: Rembrandt van Rijn.

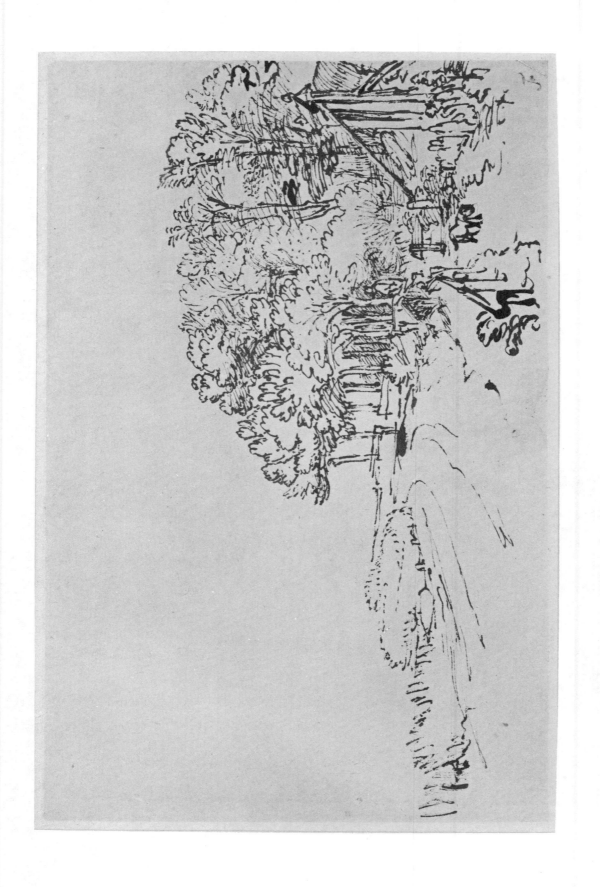

64 (I, 64). *The Amsteldijk near the Trompenburg Estate. (Chatsworth Settlement)*
Pen and bistre: 132 × 207 mm.

About 1650. See 54 (I, 54) for another sketch by Rembrandt of this motif.

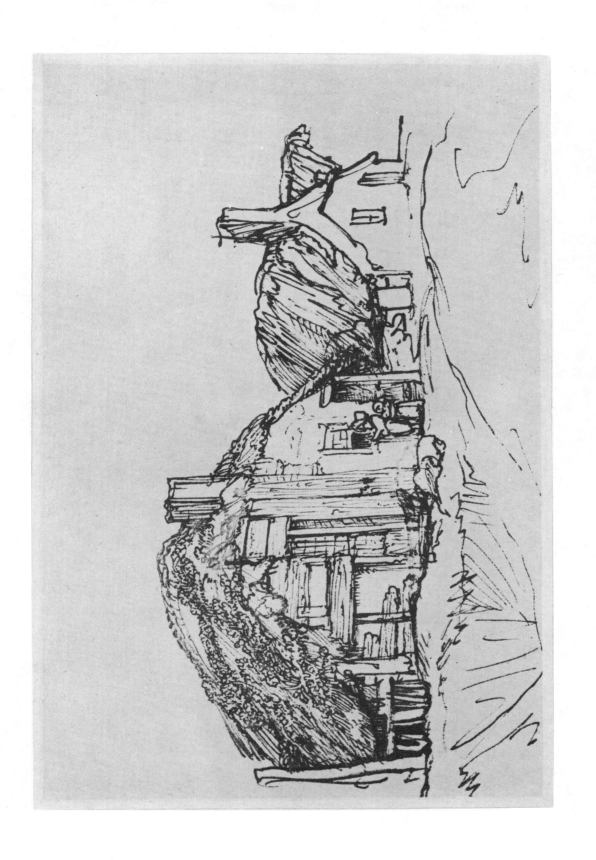

65 (*I, 65*). *Two Thatched Huts by a Road.* (*Chatsworth Settlement*)
Pen and bistre, white body color: 137 × 200 mm.
About 1640.

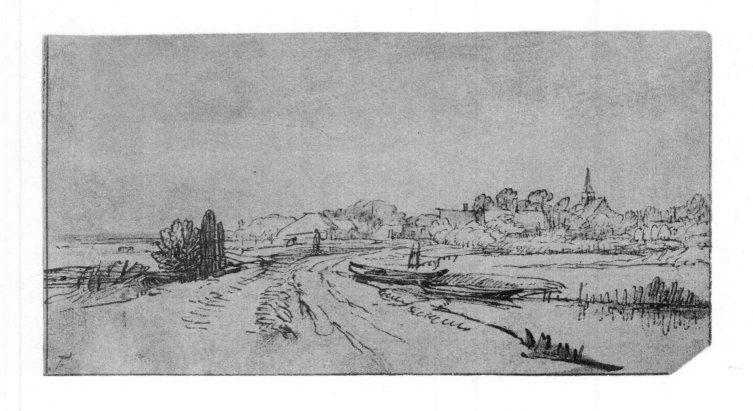

66 (*I, 66*). *View of Sloten.* (*Chatsworth Settlement*)
Pen and bistre, wash, white body color, on brown prepared paper: 96 × 180 mm.
About 1650.

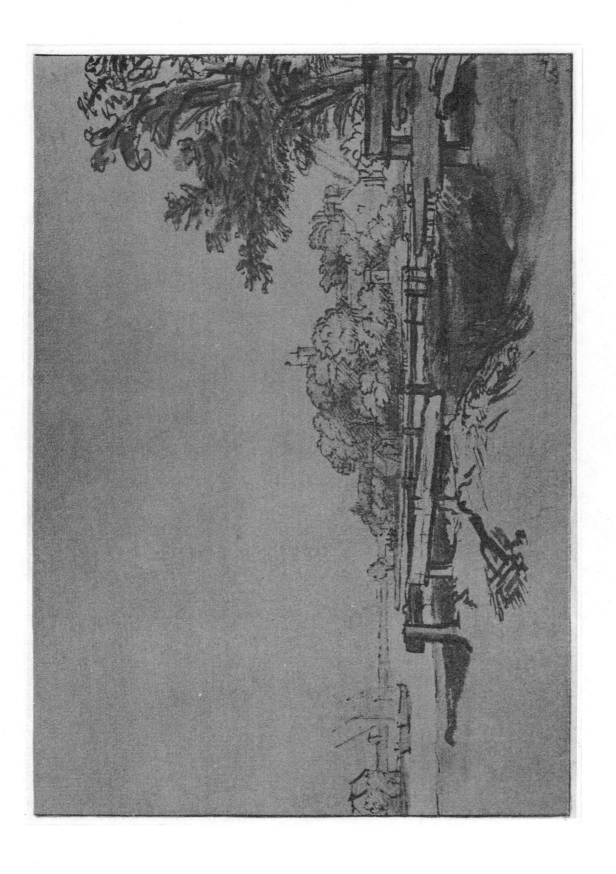

67 (I, 67). *The Bend in the Amstel River, with Kostverloren Castle and a Fence in the Foreground. (Chatsworth Settlement)*

Reed pen and wash in bistre, white body color, on reddish brown prepared paper: 145 × 212 mm.

About 1650. See 53 (I, 53); 71 (I, 71); 461 (IV, 18); 466 (IV, 23) for other drawings of this place.

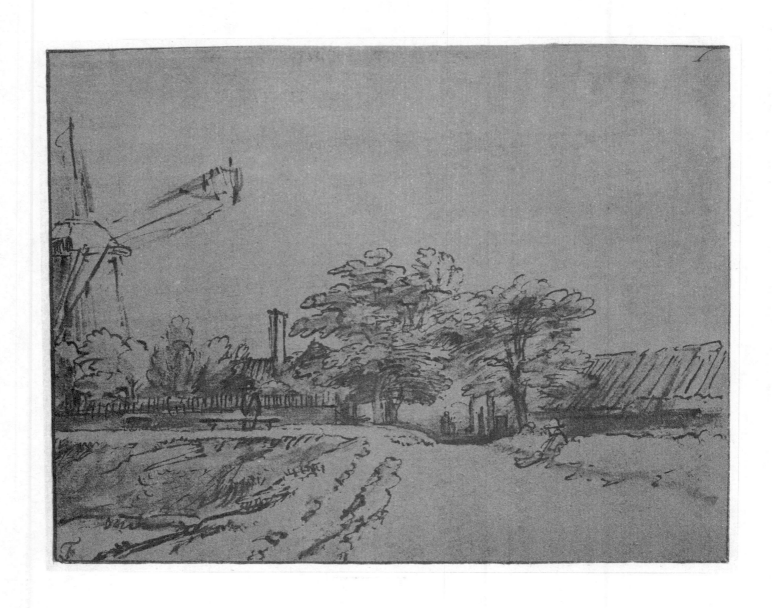

68 (*I, 68*). *The Rampart near the Bulwark Beside the St. Anthoniespoort.* (*Chatsworth Settlement*)
Pen and wash in bistre, brownish pen strokes in the slope, on brown prepared paper: 142 × 179 mm.
About 1650.

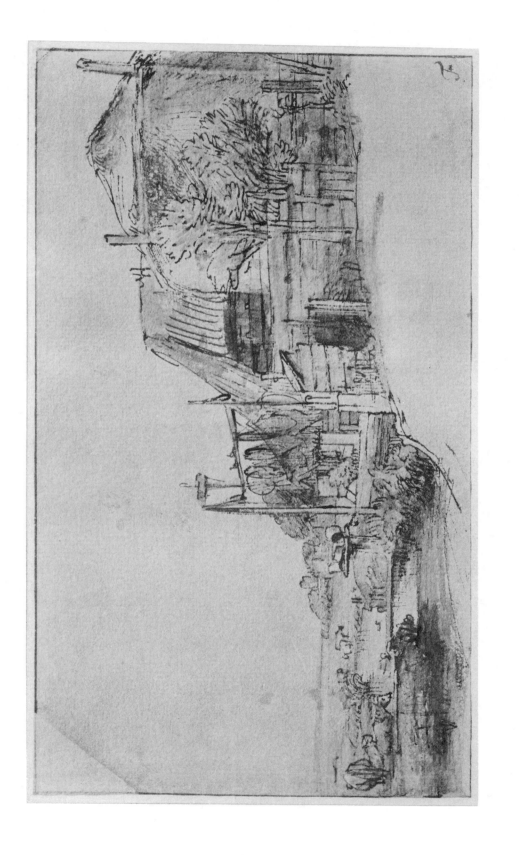

69 (I, 69). *A Farmstead with a Hayrick and Weirs Beside a Stream.* (*Chatsworth Settlement*)
Reed pen and bistre, wash, white body color: 116 × 202 mm.

About 1652. The verso bears a drawing of a tree (Benesch, figure 1524). Rembrandt drew the same farmstead more than once; see
70 (I, 70) for a view of it from the opposite side and 401 (III, 67) for one made from virtually the same position as this sheet.

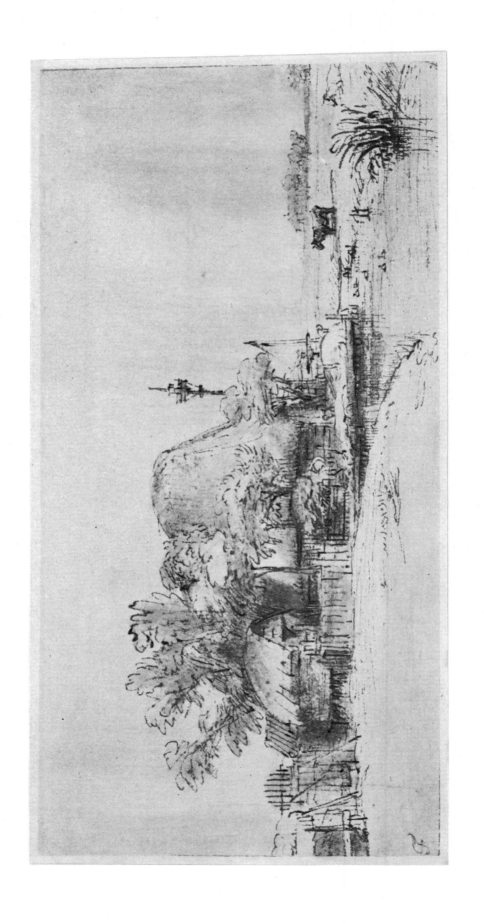

70 (I, 70). *A Farmstead Beside a Stream. (Chatsworth Settlement)*
Reed pen and bistre, wash: 108 × 220 mm.
About 1652. See 69 (I, 69) and 401 (III, 67) for other views of the farm.

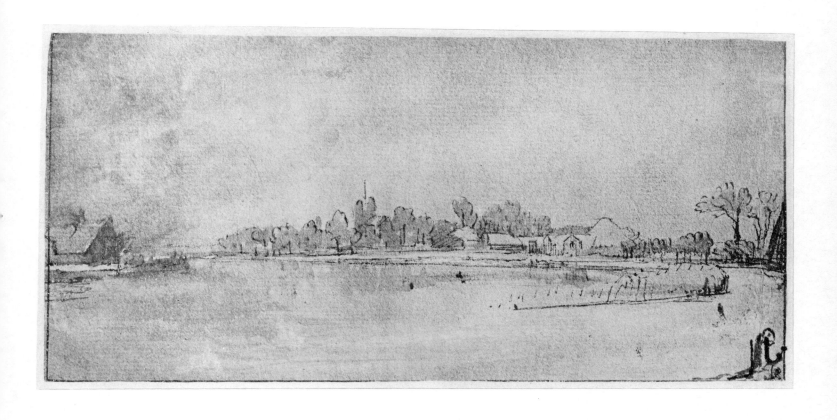

71 (I, 71). *The Bend of the Amstel River near Kostverloren Castle. (Chatsworth Settlement)*
Pen and bistre, wash, white body color: 97 × 199 mm.
About 1650. See 53 (I, 53); 67 (I, 67); 461 (IV, 18); 466 (IV, 23) for other views of the motif.

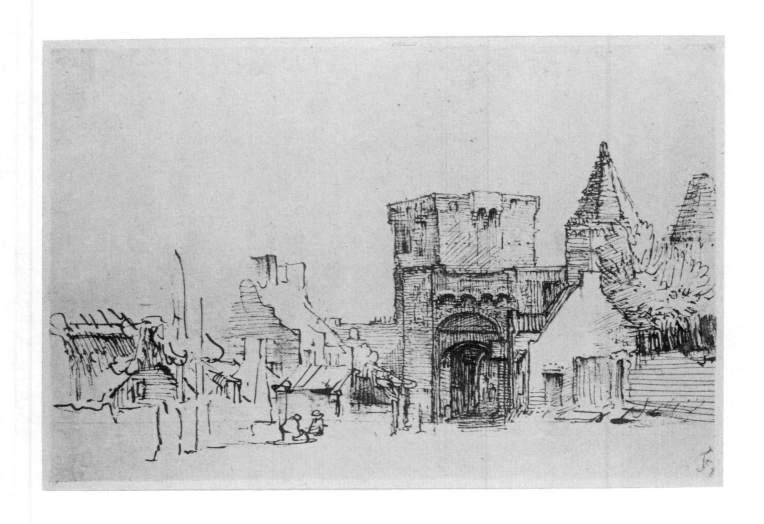

72 (*I, 72*). *The Rijnpoort at Rhenen.* (*Chatsworth Settlement*)

Pen and blackish brown ink, wash: 120 × 176 mm.

About 1648. See 173 (I, 163); 225 (II, 8); 277 (II, 52); 355 (III, 23) for other sketches of Rhenen's medieval gates and walls, which had a special attraction for Rembrandt. These drawings and those made of motives from Muiderberg, Utrecht and Arnhem prove that Rembrandt made a journey to the provinces of Utrecht and Gelderland. Benesch (823) maintains that these drawings fall into two groups—one made around 1647–48, and the other about 1652–53—and thus concludes that Rembrandt made two trips to the eastern provinces. It is, however, difficult to categorize the drawings into two firm groups. There is nothing in their style incompatible with others made in the late 1640's.

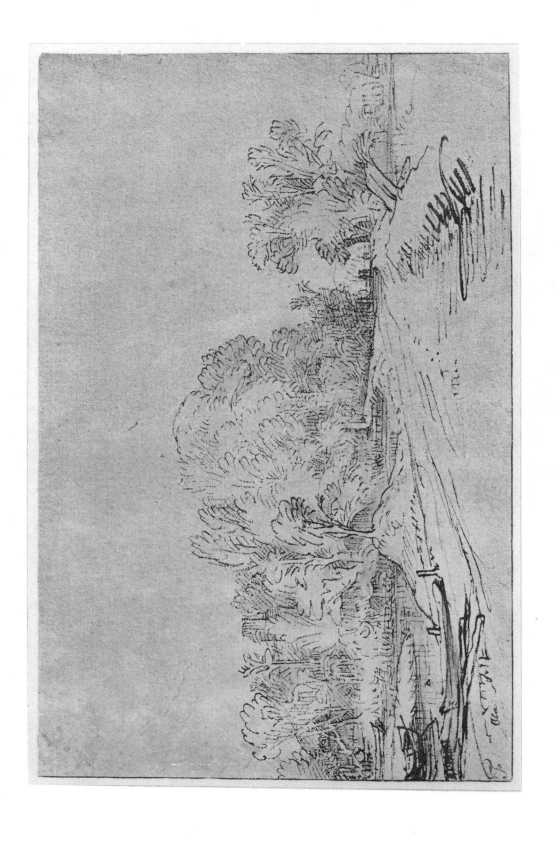

73 (I, 73). *A Canal near a Road with a Group of Trees in the Background. (Chatsworth Settlement)*
Pen and bistre, wash: 127 × 200 mm.
About 1650.

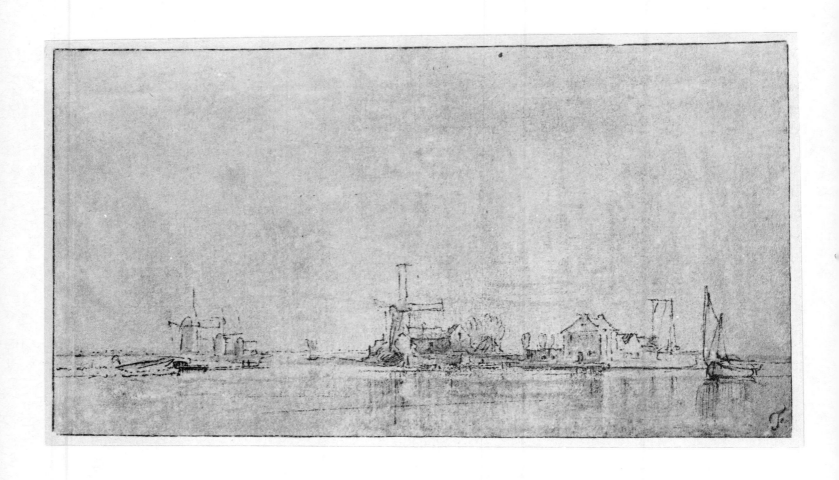

74 (*I, 74*). *The Omval at the River Amstel.* (*Chatsworth Settlement*)
Pen and wash in bistre, some Indian ink wash, on greyish brown prepared paper: 108 × 197 mm.
About 1650–53. On the verso, a man in a long coat seen from behind (reproduced Benesch, figure 1556).

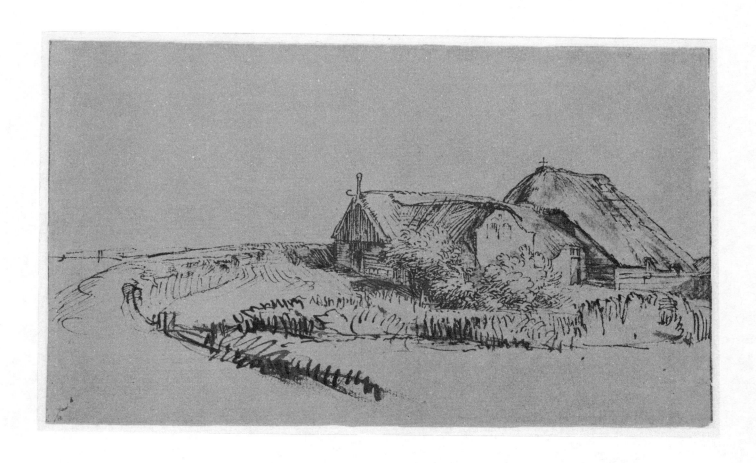

75 (*I, 75*). *Farmstead at the Diemerdijk.* (*Chatsworth Settlement*)

Pen and bistre, wash: 127 × 212 mm.

About 1650. The subject was identified by Lugt (1920) as a farm near the village of Diemen.

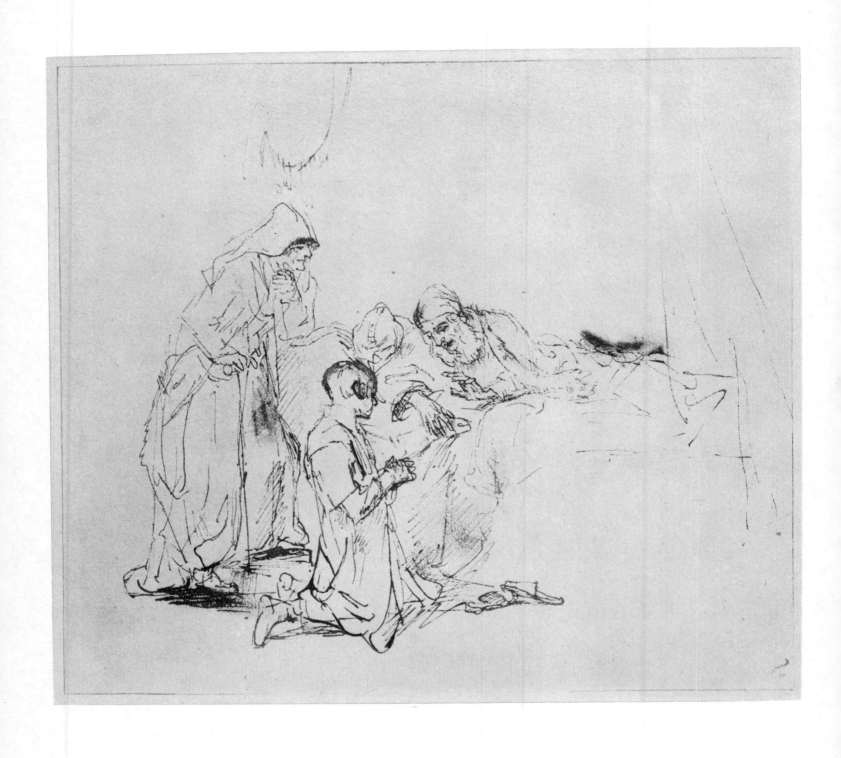

76 (*I, 76*). *Isaac Blessing Jacob.* (*Chatsworth Settlement*)

Pen and bistre: 175 × 201 mm.

Benesch's (891) date of about 1652 is more acceptable than Valentiner's (64) suggestion of around 1639. For another study of the composition see 280 (II, 55).

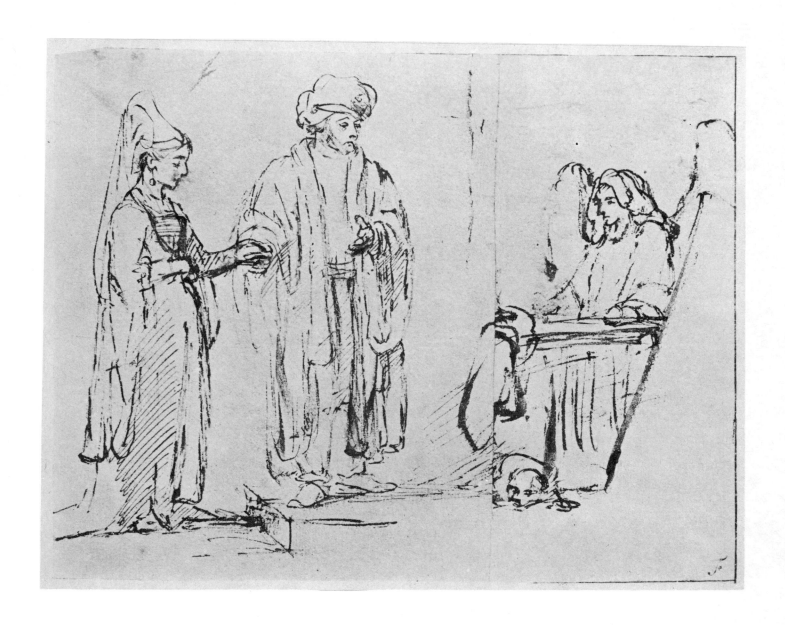

77 (I, 77). *Laban Guiding Leah or Rachel (left), an Angel Seated (right); fragments of two drawings pasted together. (Chatsworth Settlement)*

Pen and bistre: 144 × 180 mm. (left portion); 144 × 65 mm. (right portion).

Opinions differ about this sheet. Hofstede de Groot (828) dated the left portion about 1635, and the right about 1650. Valentiner (76) dated both about 1650 and suggested that the figure on the left represents Rachel, not Leah. Benesch (A80b) wrote that the left portion is certainly the work of a pupil. Rosenberg (1959, A80b) accepts both as original and endorses Valentiner's date.

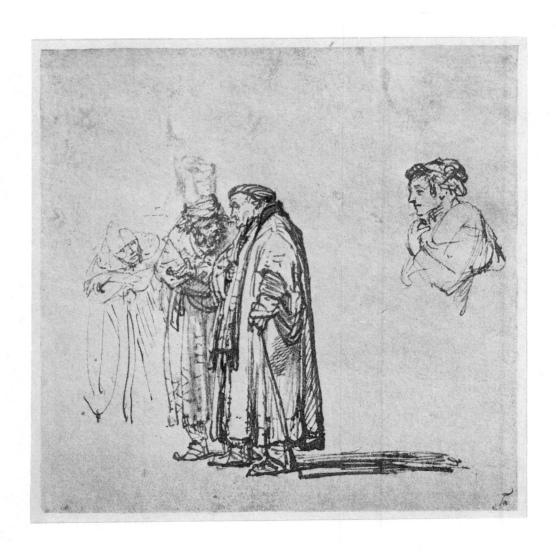

78 (*I, 78*). *Three Men in Discussion and the Bust of a Woman.* (*Chatsworth Settlement*)
Pen and bistre, wash: 127 × 126 mm.
Around 1637. Study for Rembrandt's painting St. John the Baptist Preaching, *Berlin–Dahlem (Bredius 555).*
The verso shows a sketch of an old man and studies of headgear (Benesch, figure 153). See 16 (I, 16) and
212 (I, 195) for more elaborate studies for the picture.

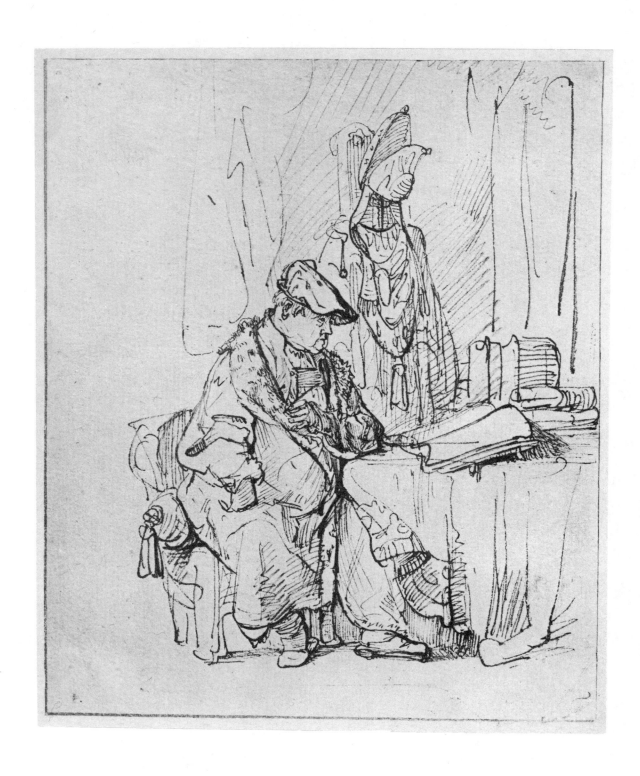

79 (*I, 79*). *A Man Seated at a Table Covered with Books.* (*Chatsworth Settlement*)
Pen and bistre: 183 × 150 mm.

About 1636–38. The seated figure has been variously identified as St. Gregory, St. Augustine (see Benesch no. 121)
and as an actor in the dressing room of the "Schouburg" of Amsterdam preparing to play the part of Bishop
Gozewijn in Vondel's play Gijsbrecht van Amstel (see H. van de Waal, "Rembrandt, 1956," Museum, 61
[1956] p. 204).

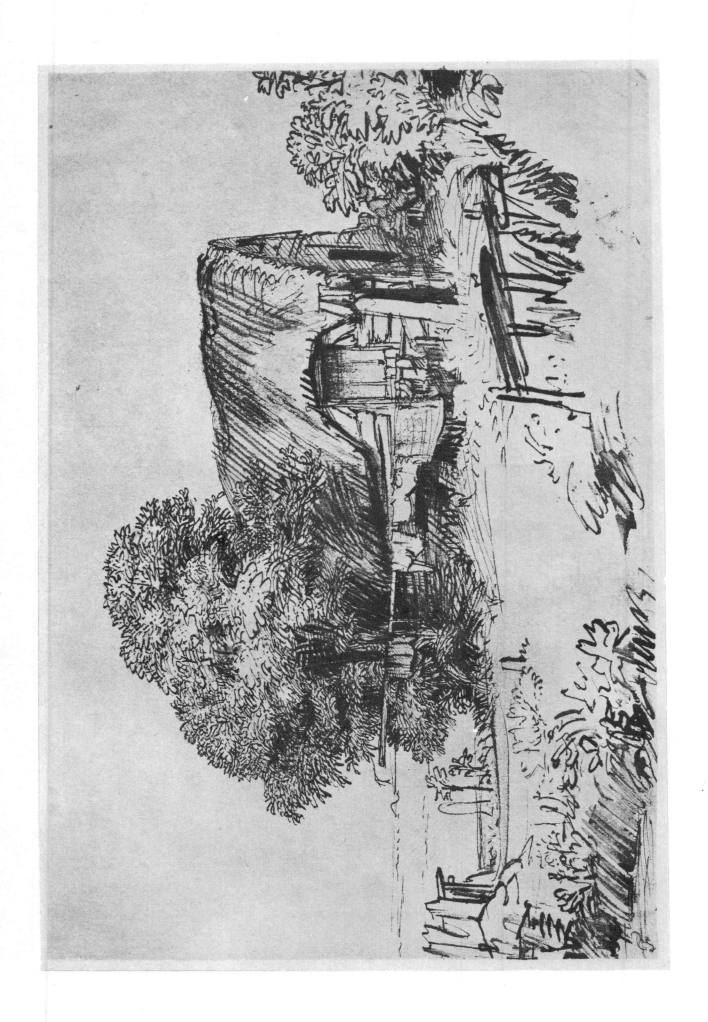

80 (I, 80). *A Thatched Cottage by a Tree. (Chatsworth Settlement)*
Reed pen and bistre: 175 × 267 mm.
About 1652.

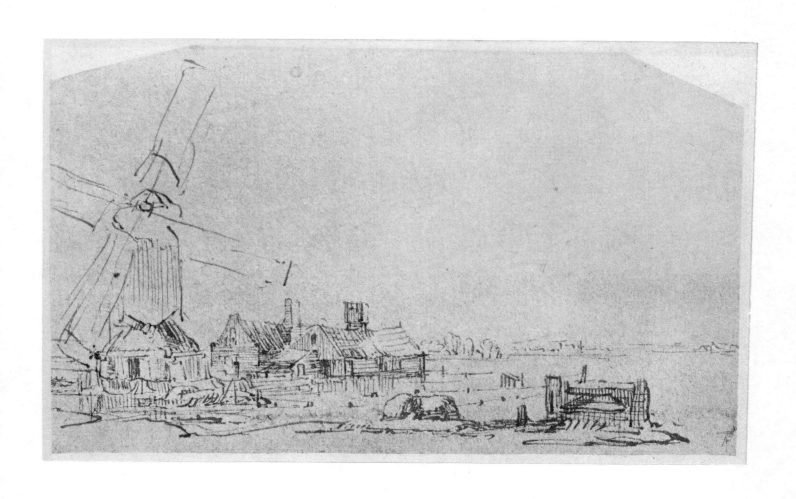

81 (*I, 81*). *Windmill with a Group of Houses.* (*Chatsworth Settlement*)

Pen and bistre: 112 × 184 mm.

About 1652. Lugt (1920) tentatively suggests that the windmill may be the one called "Het Molentje," which was a favorite excursion place near Amsterdam in Rembrandt's day.

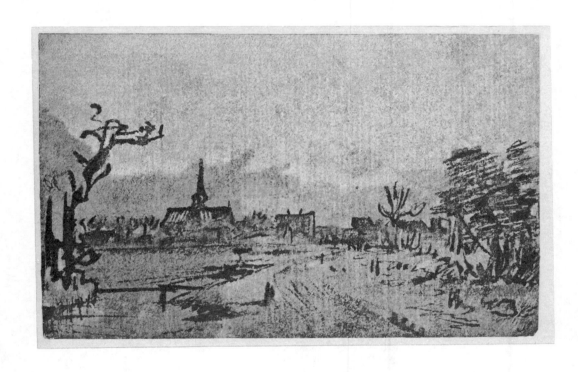

82 (*I, 82*). *Amstelveen.* (*Chatsworth Settlement*)

Pen and bistre, wash: 82 × 132 mm.

About 1655. Lugt (1920) identified the village as Amstelveen, the only one near Amsterdam with a church in the form of a Greek cross with a tower over the crossing. No. 83 (I, 82a) is from the same sketchbook.

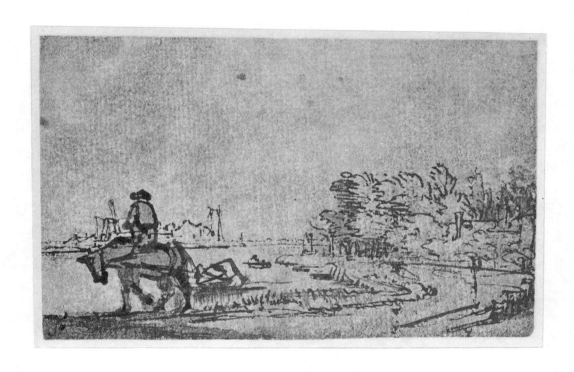

83 (*I, 82a*). *View Over the Amstel near the Omval, with a Horse Towing a Boat.* (*Chatsworth Settlement*)
Pen and bistre, wash: 82 × 132 mm.
About 1655. From the same sketchbook as 82 (I, 82).

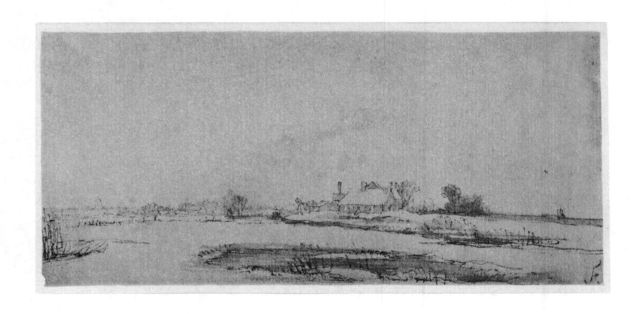

84 (*I, 83*). *Flat Landscape with a Farmstead in the Middle Distance.* (*Chatsworth Settlement*)
Pen and bistre, wash: 70 × 150 *mm.*
About 1650.

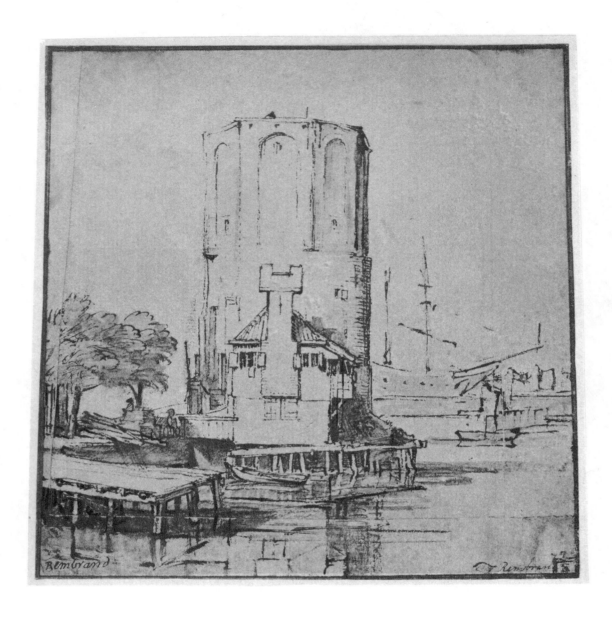

85 (*I, 84*). *The "Montelbaanstoren" in Amsterdam. (Rembrandt Huis, Amsterdam)*

Reed pen and bistre, wash: 145 × 144 mm. (enlarged on sides and bottom by the artist). Signed in two places by different and later hands: Rembrand, Rembrant.

About 1650. Lugt (1920) notes that the artist omitted the high pointed roof which was added to the tower in 1606. Rembrandt apparently wanted to emphasize the original squatness of the massive tower and was not impressed with the efforts made to modernize it. Rembrandt also deleted the new pointed roof from the tower "Swijght Utrecht" when he drew it a few years later; see 545 (IV, 95).

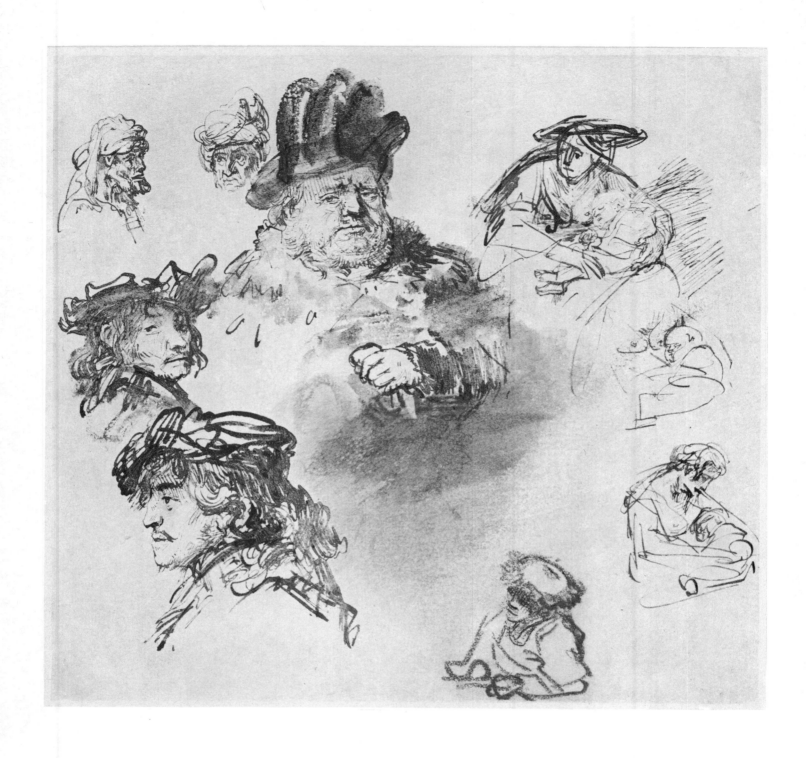

86 (*I, 85*). *Studies of Heads and Figures.* (Barber Institute, Birmingham, England)

Pen and wash, red chalk: 220 × 233 mm.

About 1636. This magnificent sheet of studies from life shows two of Rembrandt's favorite subjects: picturesque
types and studies of a mother with her infant.

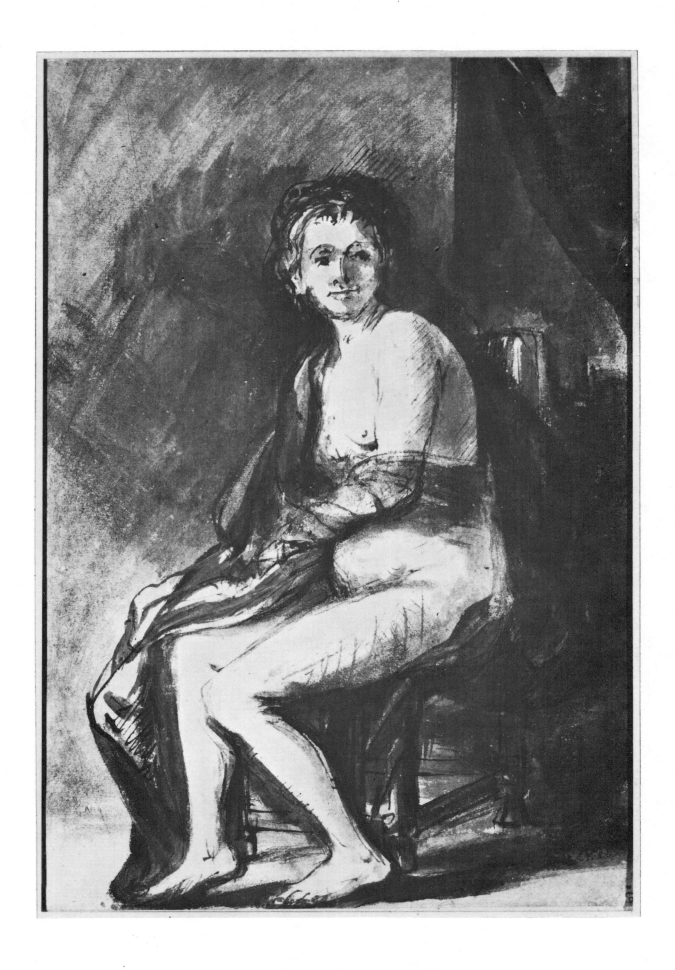

87 (*I, 86*). *Female Nude Seated on a Chair Before a Curtain.* (*Boymans-van Beuningen Museum, Rotterdam*)
Pen and wash in bistre, touches of red and white chalk, and some corrections with white body color: 285 × 190 mm.
Closely related to Rembrandt's etching Woman with an Arrow *of 1661 (Bartsch 202). Both the mood and the*
technique anticipate Goya's effects.

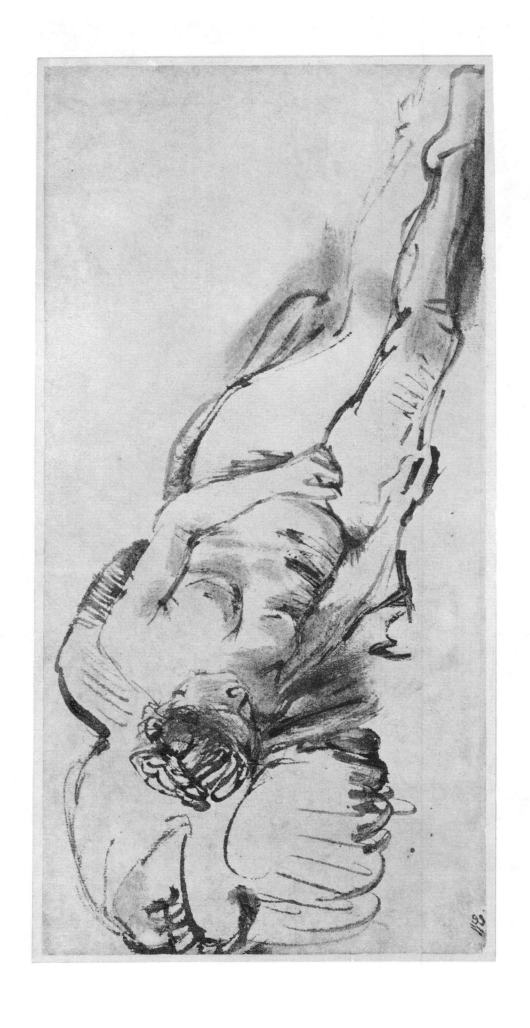

88 (I, 87). *Female Nude Asleep.* (Rijksprentenkabinet, Amsterdam)
Pen and brush in bistre, wash: 135 × 283 mm.

The pose and handling of the light connect this powerful study with the etchings Rembrandt made of female nudes in the late 1650's.

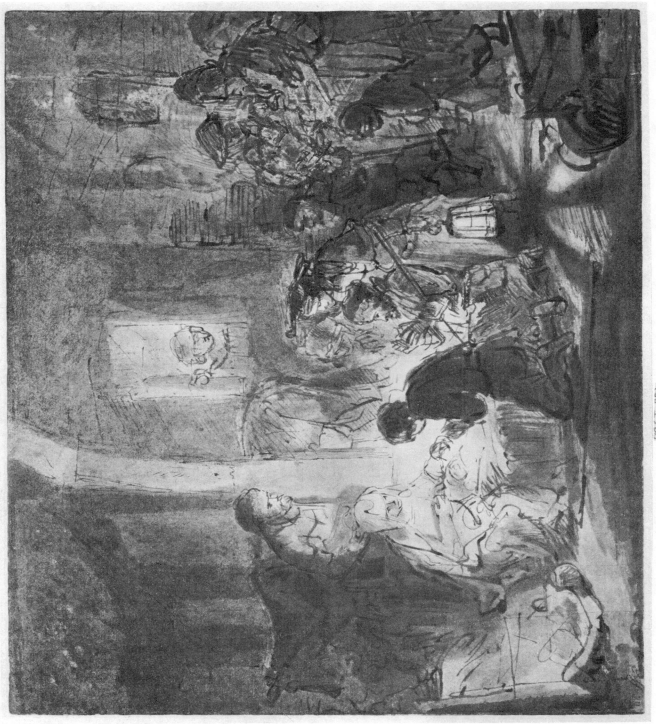

89 (I, 88). *Adoration of the Shepherds.* (Formerly Henry Oppenheimer Collection, London)

Pen and wash: 204 × 231 mm.

Probably a drawing by a pupil or follower closely related to Rembrandt's painting of the same subject dated 1646, now in the National Gallery, London. It is difficult to decide if it is a copy of a preliminary study, or a variant after the London painting.

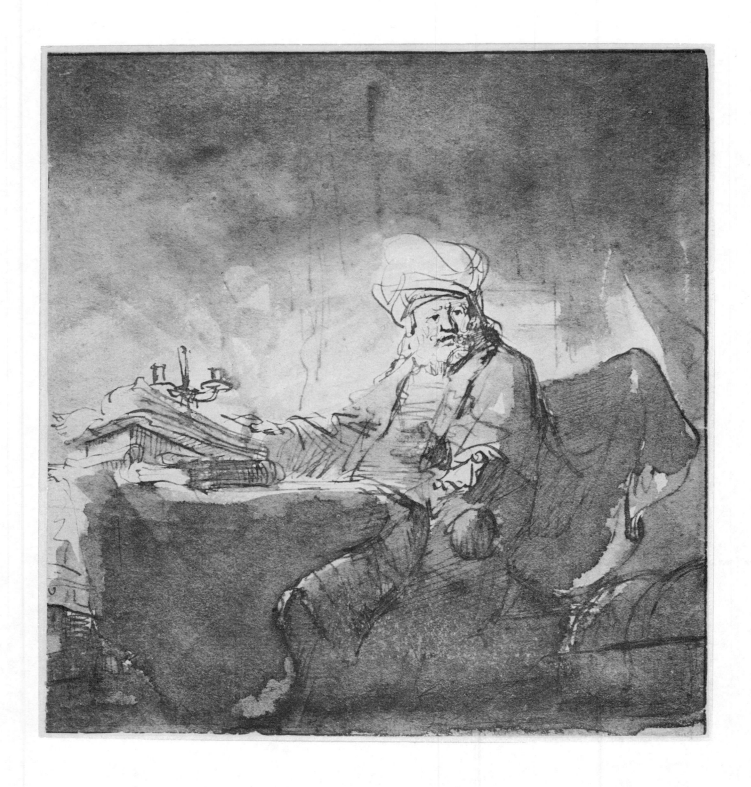

90 (*I, 89*). *A Man in Oriental Attire Seated at a Table Covered with Books.* (*Formerly J. P. Heseltine Collection, London*)

Pen and wash: 185 × 172 mm.

Valentiner (726) noted the relationship of the drawing to Rembrandt's etching of The Gold Weigher (*Bartsch 281*) *and the double portrait of* Anslo and a Woman (*1641, Berlin–Dahlem, Bredius 409*). *These observations are sensible, but weaknesses in the drawing make it difficult to make a firm attribution to the master. Perhaps it is a copy after a lost drawing made around 1638–40. A copy is at the Rijksprentenkabinet, Amsterdam; Henkel (1943, no. 116) ventures the name of Salomon Koninck for both drawings.*

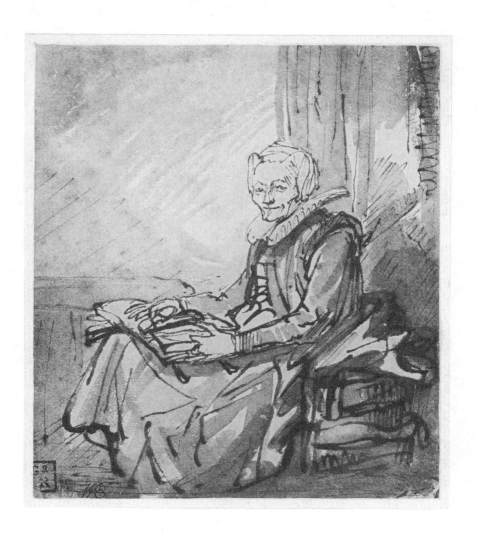

91 (*I, 90*). *Portrait of a Seated Old Woman with an Open Book on Her Knees.* (*Boymans–van Beuningen Museum, Rotterdam*)

Pen and bistre, wash: 125 × 105 mm.

About 1635–40. The lively drawing has the appearance of a preparatory study for a portrait. It has been suggested that the sitter is Margaretha de Geer (born 1583), wife of Jacob Trip. Rembrandt painted her twice in the early 1660's (both paintings now in the National Gallery, London, Bredius 394 and 395). There is a resemblance between the drawing and the paintings, but since about two decades separate the drawing and the late portraits, a firm identification cannot be made.

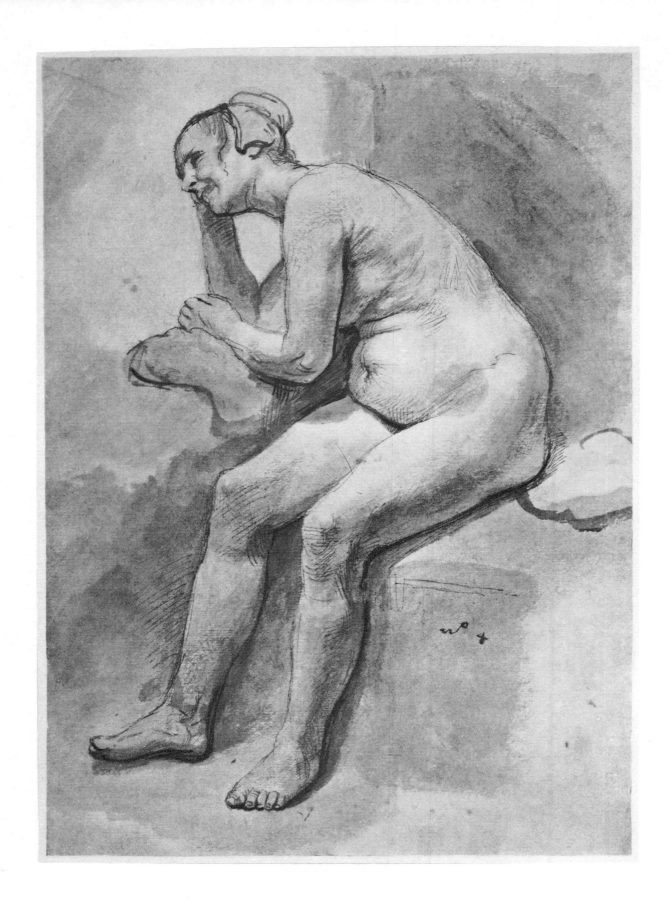

92 (*I, 91*). *Seated Female Nude Turned to the Left.* (*Louvre, Paris*)

Pen and wash in Indian ink: 262 × 186 mm. Inscribed: no. 4.

This striking study has been rightly questioned by W. Seidlitz ("Rembrandt's Zeichnungen," Repertorium für Kunstwissenschaft XVII, 1894, pp. 123, 126) and Benesch (A54). The hard contours and weaknesses in the drawing—in particular, the model's right arm—as well as the failure of the prominent shadows around the figure to create an atmosphere that envelops the nude, all point to the work of a pupil. Perhaps the drawing was made by Nicolaes Maes, who sometimes combined uncompromising naturalism with similar delicate hatching (see Hind, 1915, p. 89, no. 1, Nicolaes Maes, Five Studies of Women's Heads, reproduced Plate LVIII, 1).

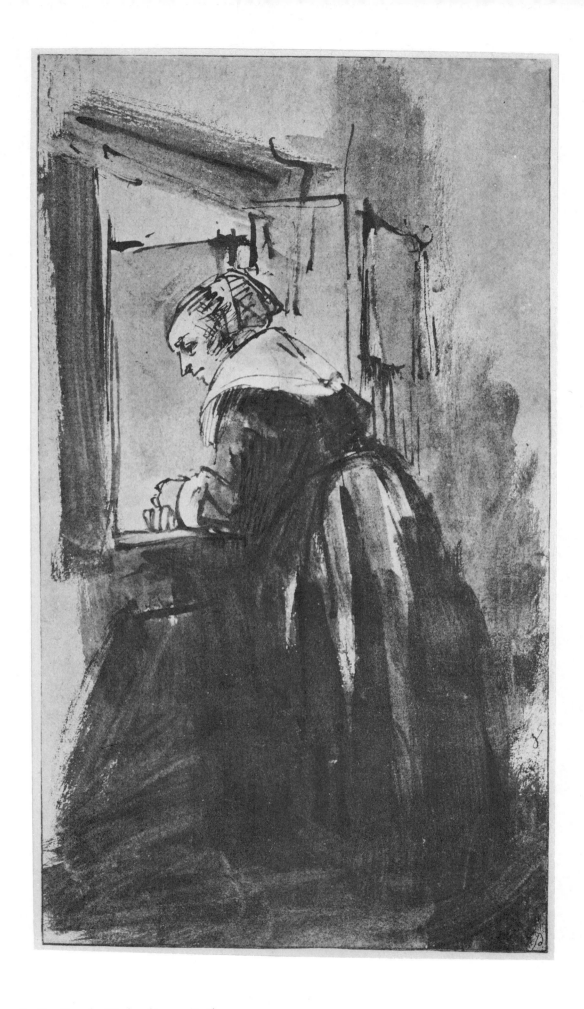

93 (*I, 92*). *A Woman Looking Out of a Window.* (*Louvre, Paris*)
Pen and brush in bistre: 292 × 162 mm.
About 1655. The model for this brilliant chiaroscuro study may have been Hendrickje Stoffels.

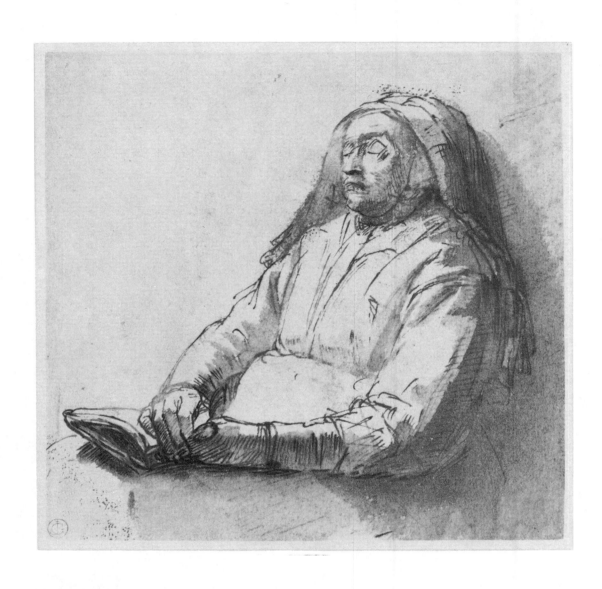

94 (*I, 93*). *Sleeping Woman with Her Hands Folded on a Book She Is Holding.* (*Formerly Henry Oppenheimer Collection, London*)

Pen and wash: 133 × 138 mm.

Probably by a pupil who worked with Rembrandt in the late 1640's. Not listed in Benesch.

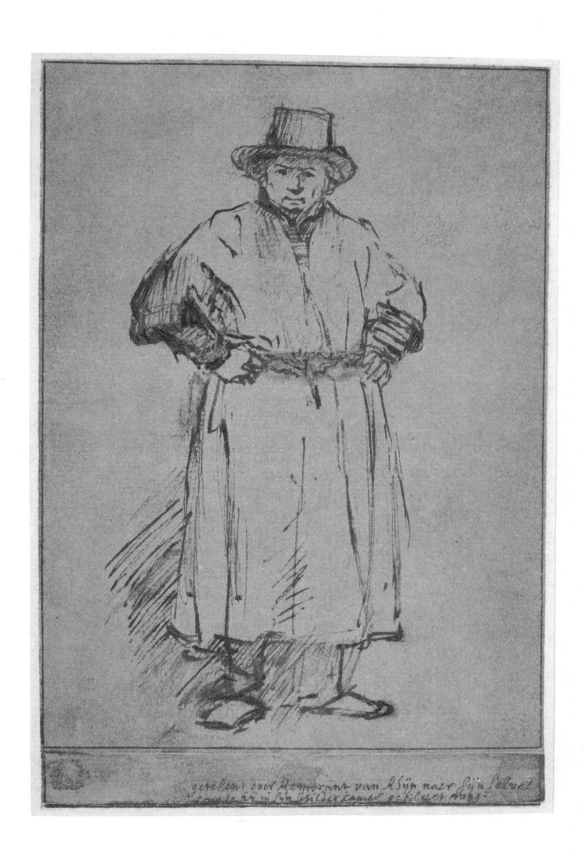

95 (*I, 94*). *Self-portrait in Studio Attire, Full-length.* (*Rembrandt Huis, Amsterdam*)

Pen and bistre: 203 × 134 mm. Inscribed (by C. Ploos van Amstel) on the attached strip of paper below:
"getekent door Rembrandt van Rhijn naer sijn selves sooals hij in sijn schilderkamer gekleet was" (*drawn by Rembrandt van Rijn after himself as he used to be dressed in his studio*).

About 1655. One of the master's most impressive self-portraits.

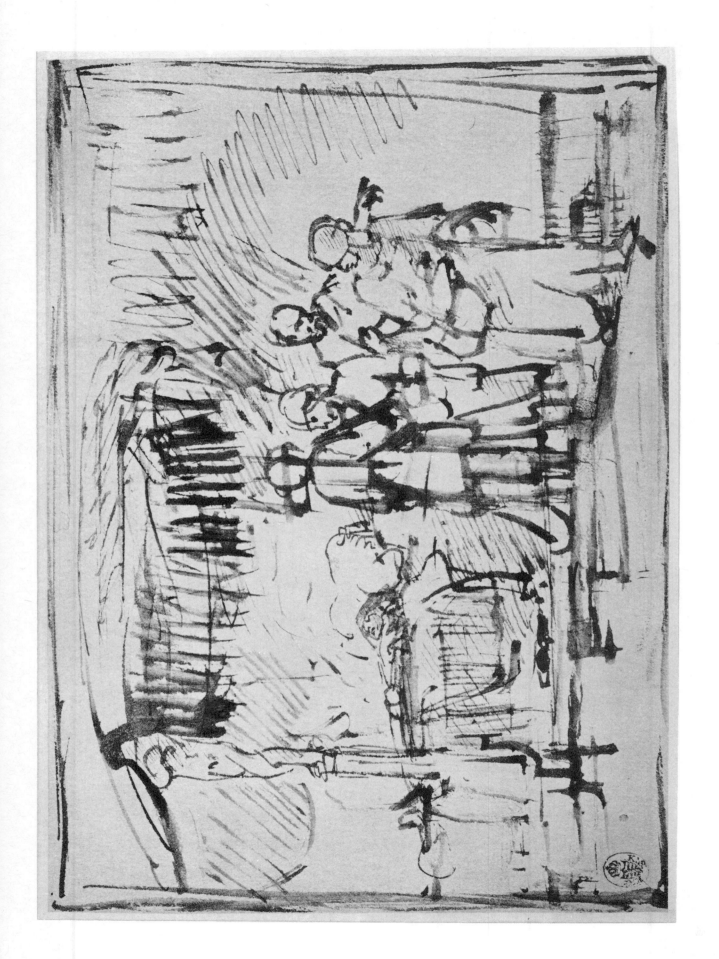

96 (I, 95). *St. Peter at the Deathbed of Tabitha.* (Kupferstichkabinett, Dresden)
Reed pen and bistre: 190 × 273 mm.

About 1660–65. An example of the artist's latest pen style where the reed sometimes achieves the effect of a brush. With a few strokes Rembrandt suggests the stillness of death and the immobility of the two figures who watch it. On the right St. Peter puts forth one of the weeping widows (Acts 9, 39 and 40).

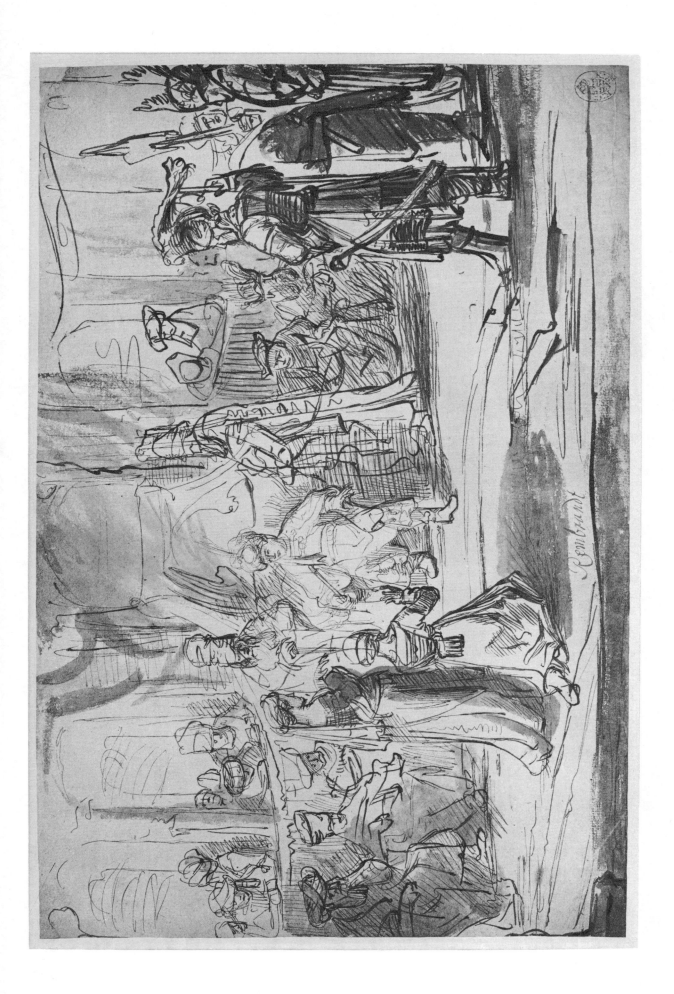

97 (I, 96). *The Judgment of Solomon.* (*Kupferstichkabinett, Dresden*)
Pen and bistre, wash: 193 × 320 mm. Inscribed by another hand: Rembrandt.

Copy after a lost original made around 1632–35. Hind's tentative suggestion that it may be by Philips Koninck was rejected by Gerson (1936, p. 174, Zeichnung LXV). There is a weaker version in the British Museum (Hind, 1915, no. 42).

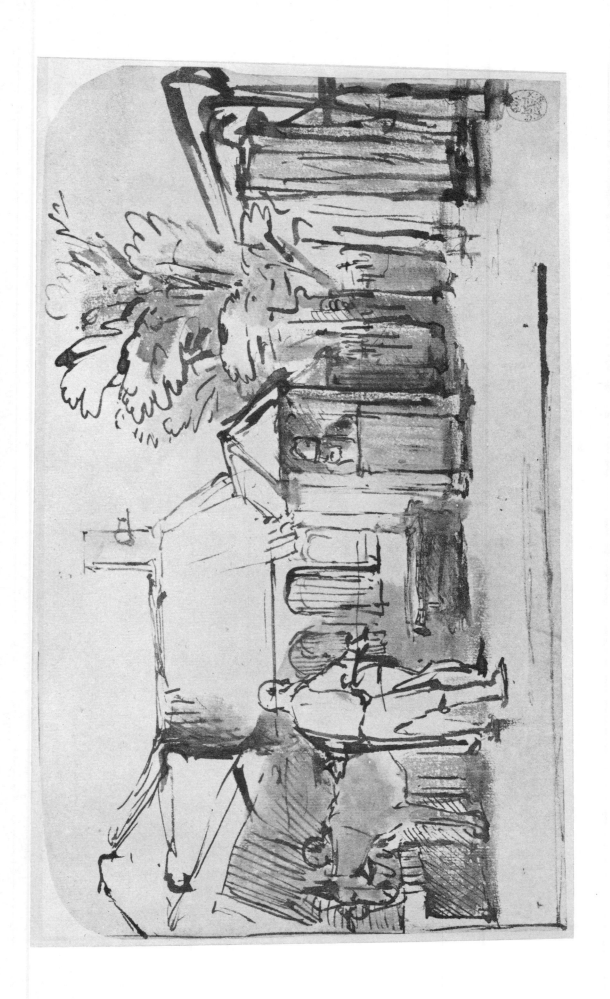

98 (I, 97). *The Departure of the Disobedient Prophet* (?). (*Kupferstichkabinett, Dresden*)

Pen and bistre, wash: 177 × 303 mm.

Probably a copy after a lost original made around 1655-58. J. Nieuwstraten (Oud Holland, 80, 1965, p. 63) notes that the story of the departure of the disobedient prophet is such an insignificant one (1 Kings 13, 23) that the traditional interpretation of the drawing as a representation of that scene is out of the question. He offers the plausible suggestion that the drawing depicts the two disciples getting the colt for Christ's entry into Jerusalem (Luke 19, 33 and 34).

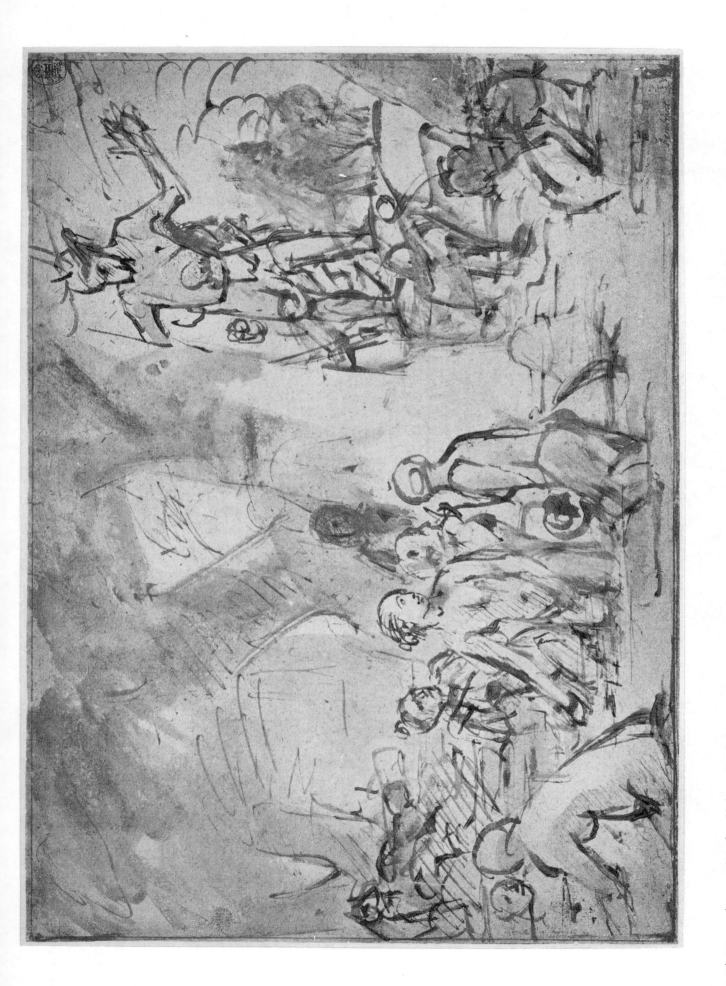

99 (I, 98). *Diana and Actaeon. (Kupferstichkabinett, Dresden)*

Pen and bistre, wash, white body color: 246 × 347 mm. Inscribed by a later hand: Rembrant.

About 1662–65.

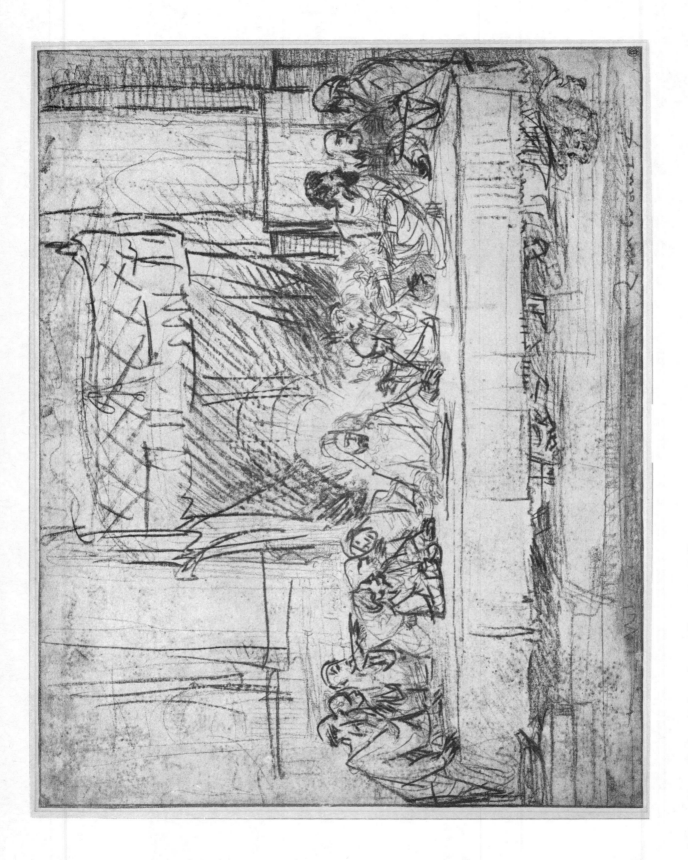

100 (I, 99). *Study after Leonardo's Last Supper.* (Robert Lehman Collection, New York)

Red chalk: 365 × 475 mm. Signed: Rembrandt f.

About 1635. Copy after an engraving (attributed to the Master of the Sforza Book of Hours) of Leonardo's fresco of The Last Supper in Santa Maria delle Grazie at Milan. This appears to be the earliest of Rembrandt's three extant studies after Leonardo's masterwork; see 24 (I, 24) and 512 (IV, 65) for reproductions of the other two. Valentiner (623B) suggests that a pupil made the careful copy beneath the bold chalk strokes; C. Neumann (1918) states that the bold strokes were made by Rembrandt during his late period; and Benesch, with good reason, finds both stages contemporaneous. The genuine signature also speaks for the full authenticity of this important drawing.

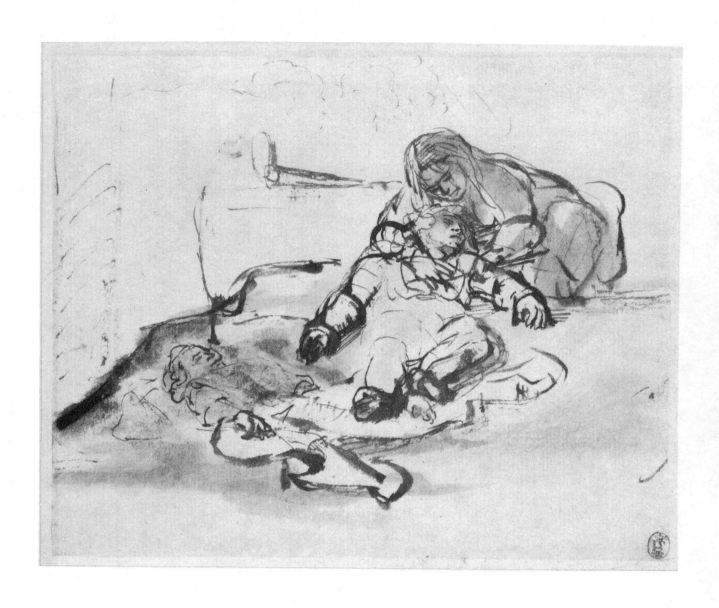

101 (*I, 100*). *Pyramus and Thisbe.* (*Friedrich August II Collection, Dresden*)

Pen and bistre, wash: 140 × 165 mm.

About 1636–40. The figure of Pyramus in the foreground was drawn first, and then covered with white. Pyramus'
young appearance and the difficulty of distinguishing the weapon pulled from the wounded body account for the
old identification of the composition as Hagar and Ishmael in the Desert. *Benesch (118) notes that the subject could*
be Niobe and Her Children.

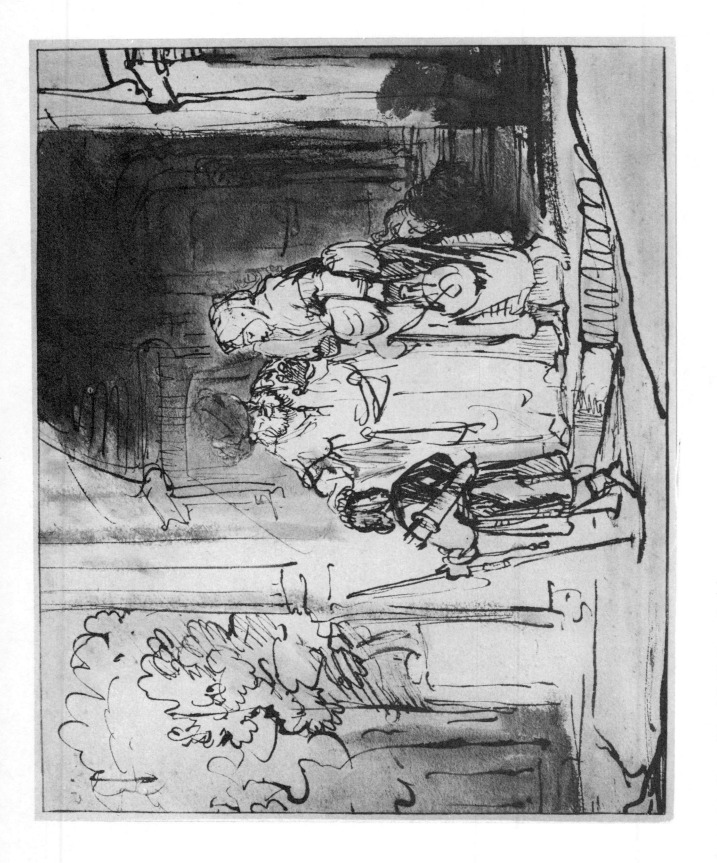

102 (I, 101). *Abraham Dismissing Hagar and Ishmael.* (British Museum, London)

Pen and wash in bistre, heightened with white. The figure of Abraham has been inserted by Rembrandt on another piece of paper:
185 × 236 mm.

About 1640–43. The story of Hagar was one of Rembrandt's favorite Biblical subjects; for a study of his treatment of this theme see
R. Hamann, Marburger Jahrbuch für Kunstwissenschaft, 8, 9 (1936).

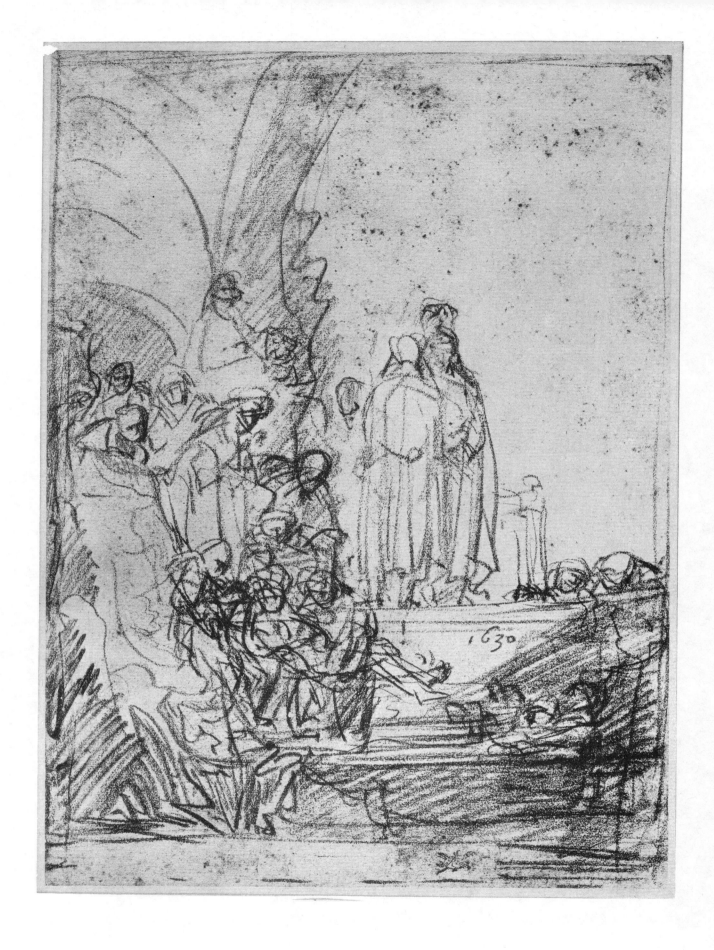

103 (*I, 102*). *The Entombment of Christ.* (*British Museum, London*)
Red chalk, heightened with white: 280 × 203 mm. Dated 1630.
Hofstede de Groot (891) noted that this early composition originally represented The Raising of Lazarus; *it was
probably inspired by Jan Lievens' etching of this subject (A. Bartsch,* Catalogue raisonné de toutes les
estampes qui forment l'œuvre de Rembrandt, et ceux de ses principaux imitateurs, *Vienna, 1797, second
part, p. 24, no. 3). It was transformed by Rembrandt himself into an Entombment.*

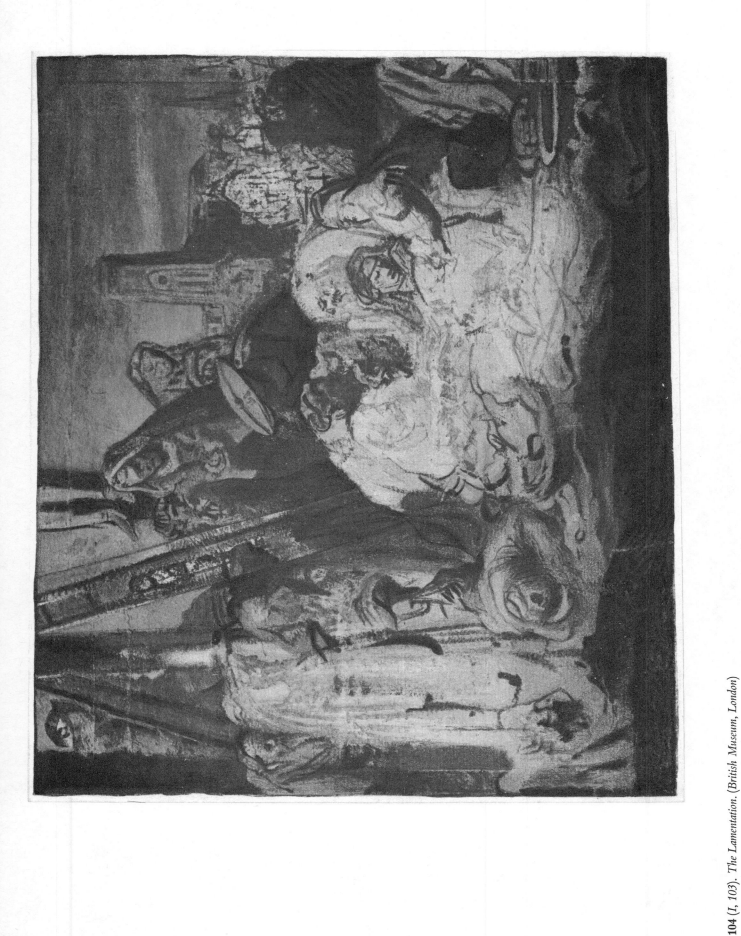

104 (I, 103). *The Lamentation. (British Museum, London)*
Pen and bistre, wash, red and black chalk, oil color: 216 × 253 mm. Made up by Rembrandt of several pieces of paper pasted on a single sheet.

A study for the grisaille of the same subject in the National Gallery, London. Begemann (1961, no. 154) notes that this drawing and the grisaille, both made around 1642, were probably studies for an etching which was not executed.

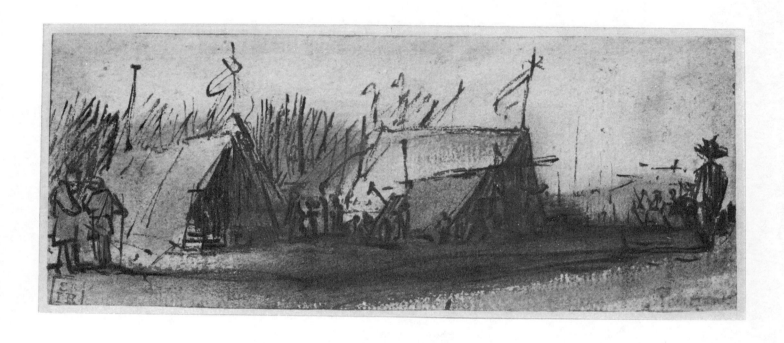

105 (*I, 104a*). *View of a Camp.* (*British Museum, London*)

Reed pen and bistre, wash: 77 × 195 mm. Inscribed by a later hand: Rembrant.

Lugt (1920) suggests that Rembrandt made the drawing in July, 1650, when William II attempted a siege of Amsterdam.

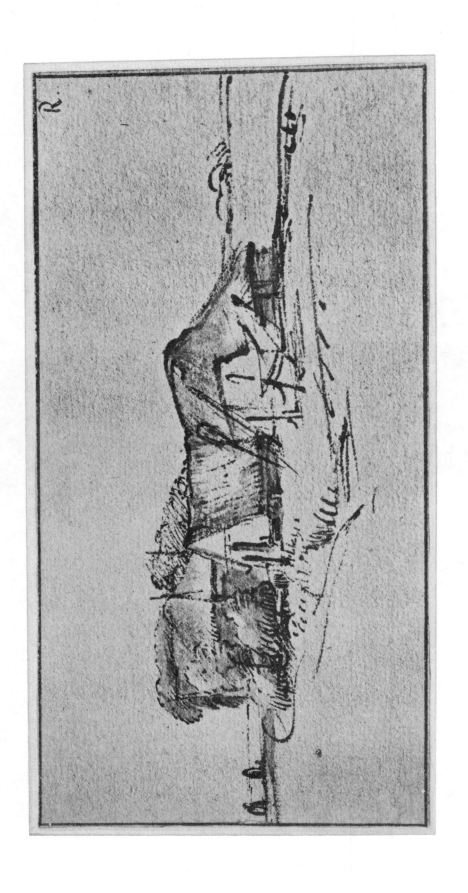

106 (*I, 104b*). *A Farmstead. (British Museum, London)*
Pen and bistre: 107 × 213 mm. Inscribed by a later hand: R.
About 1653.

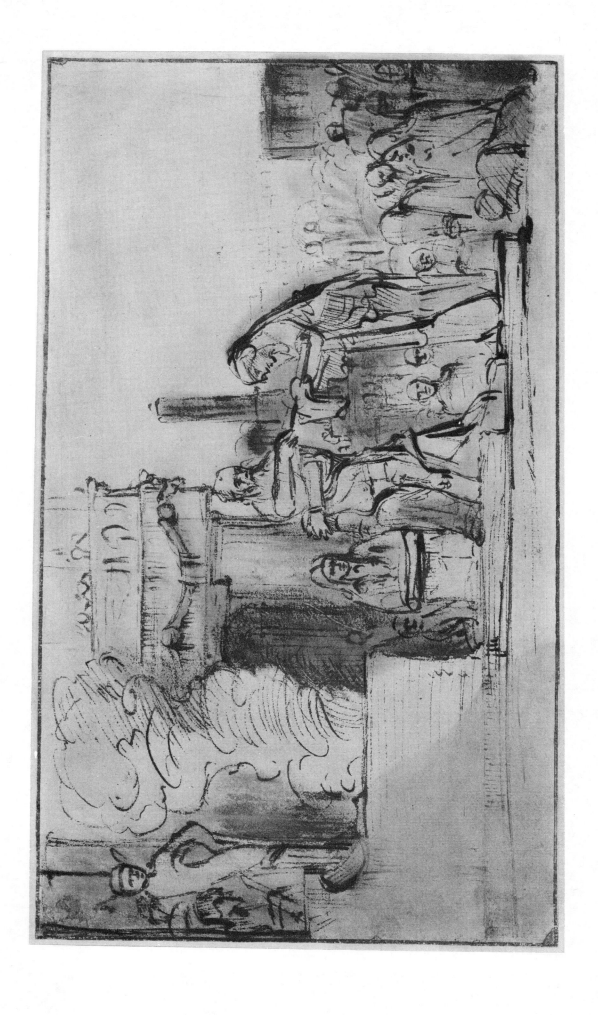

107 (I, 105). *The Sacrifice of Iphigenia. (British Museum, London)*
Pen and bistre, some wash: 187 × 327 mm.

Copy of a Rembrandt drawing made around 1655. A fragment of the original is in the Musée Communal, Besançon (Benesch 979). The subject has also been interpreted as The Sacrifice of Jephthah's Daughter.

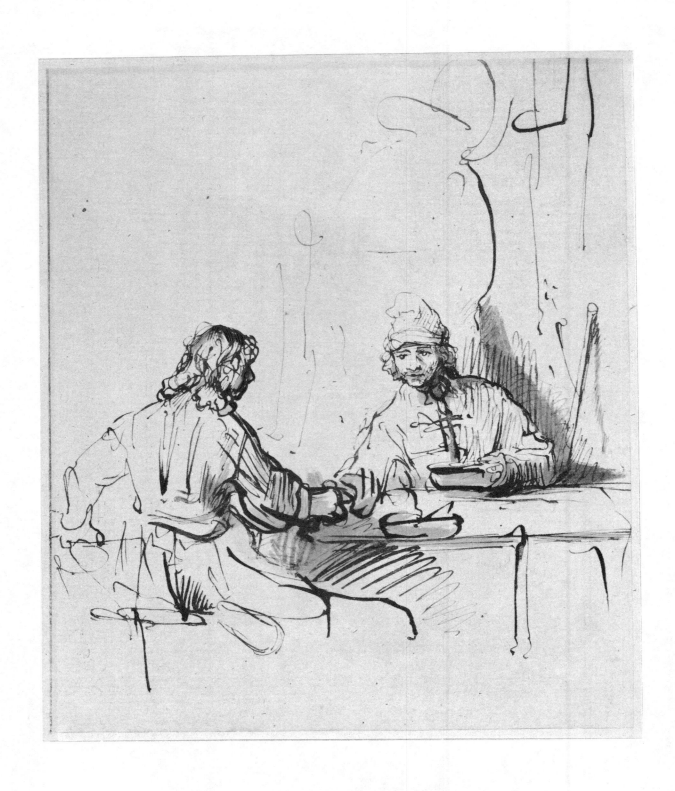

108 (*I, 106*). *Esau Selling His Birthright to Jacob.* (*British Museum, London*)

Pen and bistre: 189 × 160 mm.

A copy of an original by Rembrandt now in the Fodor Museum, Amsterdam; the original is reproduced
424 (III, 87).

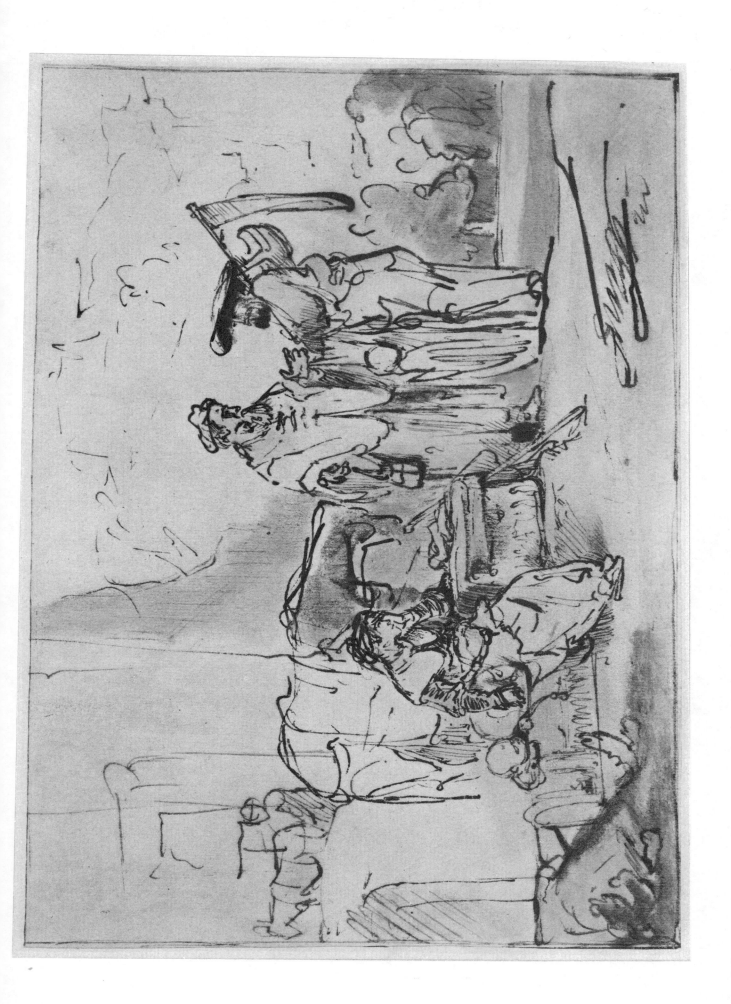

109 *(I, 107). A Man of Gibeah Offers Hospitality to the Levite and His Concubine. (British Museum, London)*
Pen and wash in bistre: 180 × 246 mm.
About 1645. See Lugt (1933, no. 1233) for a discussion of this theme and its treatment by members of Rembrandt's circle.

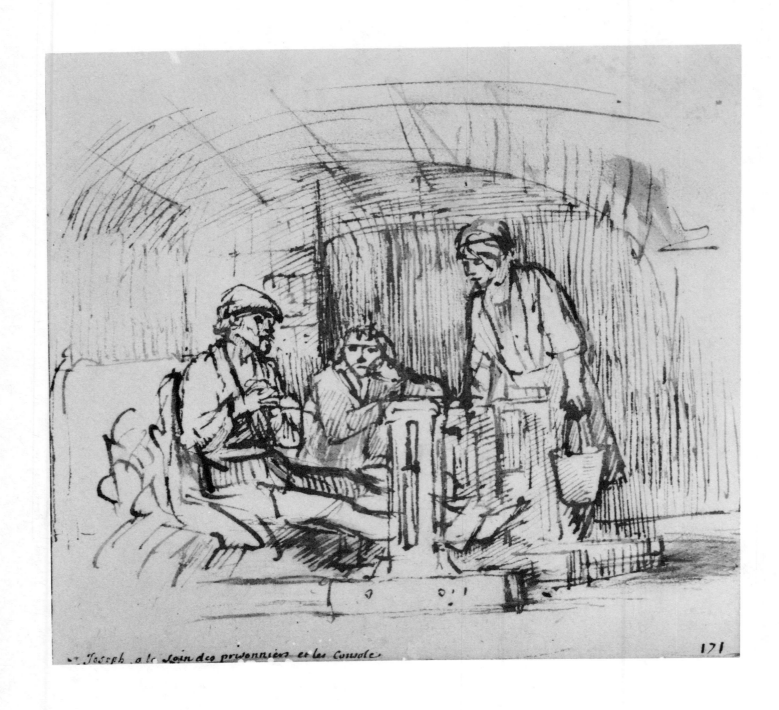

171

110 (*I, 108*). *Joseph Waiting on His Two Fellow Prisoners.* (*British Museum, London*)
Pen and bistre: 180 × 194 mm. Inscribed by an eighteenth-century hand: "Joseph a le soin des prisonniers et les console" *and* "171."
About 1655.

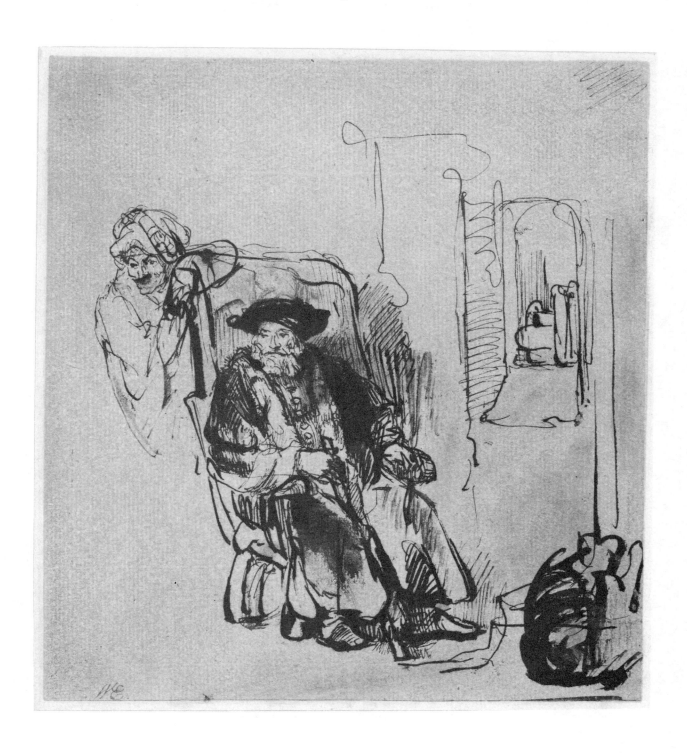

111 (*I, 109*). *Jacob and Rachel Listening to the Account of Joseph's Dreams.* (*British Museum, London*)
Pen and wash in bistre, touched with white body color: 180 × 163 mm.

About 1638. Begemann (1961, no. 528) gives an excellent analysis of the relationship of this sheet to drawings in the Baron Hatvany Collection, London (224 [II, 7]) and at Vienna (Benesch 526), Rembrandt's grisaille (Bredius 504) at the Rijksmuseum, Amsterdam, and the etching of 1638 (Bartsch 37). Valentiner (89) also dated the work around 1638. Benesch (528) suggests about 1642–43.

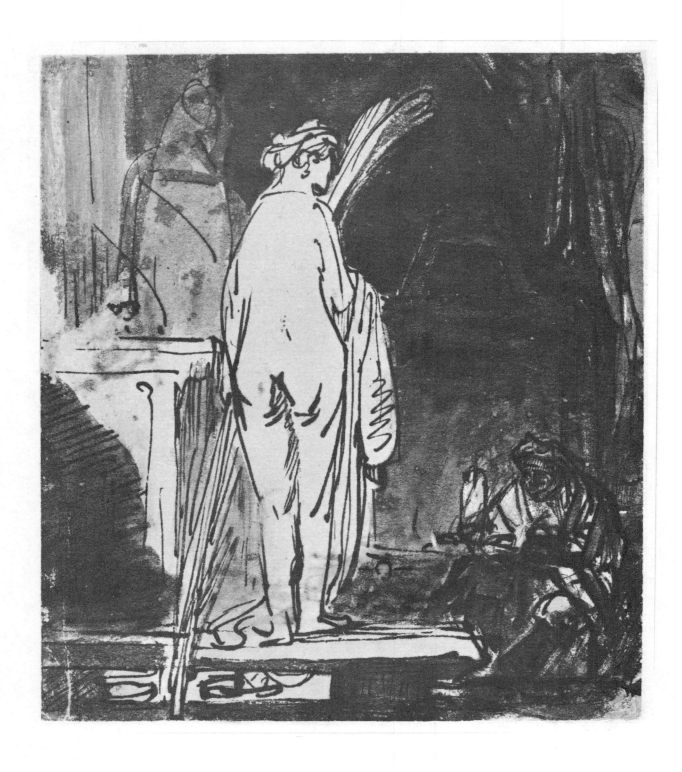

112 (*I, 110*). *An Artist Drawing from a Model.* (*British Museum, London*)

Pen and bistre, wash: 185 × 160 mm.

About 1640. Preparatory study in reverse for the etching of the same subject (Bartsch 192). Münz's argument
(1952) that both the drawing and etching are by Eeckhout can be rejected. On the verso of the sheet Joseph
Expounding the Prisoners' Dreams (*reproduced Benesch, figure 482*).

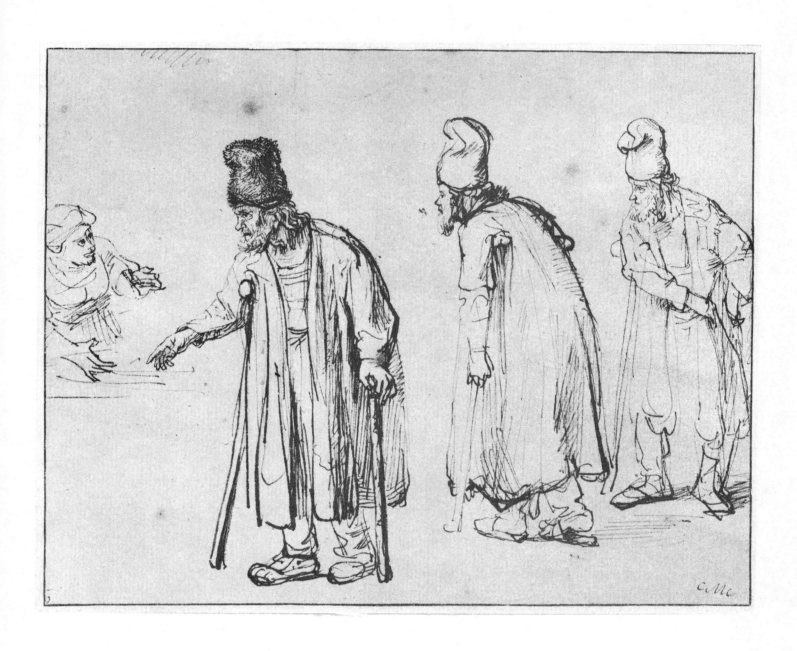

113 (*I, 111*). *Three Full-length Studies of an Old Man on Crutches, and of a Woman Seen in Half-length.*
(*British Museum, London*)

Pen and bistre: 152 × 185 mm.

About 1633.

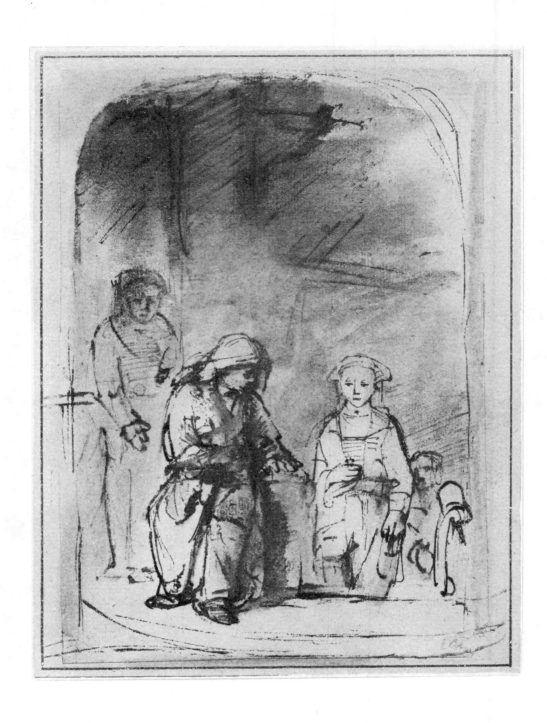

114 (*I, 112*). *The Widow's Mite*(?). (British Museum, London)

Pen and wash in bistre, white body color: 175 × 131 mm.

*About 1650–55. The subject is not certain; Hind (1915, no. 93) tentatively suggests Mary and the prophetess
Anna. Valentiner (394) calls it "no doubt an original." Not listed in Benesch.*

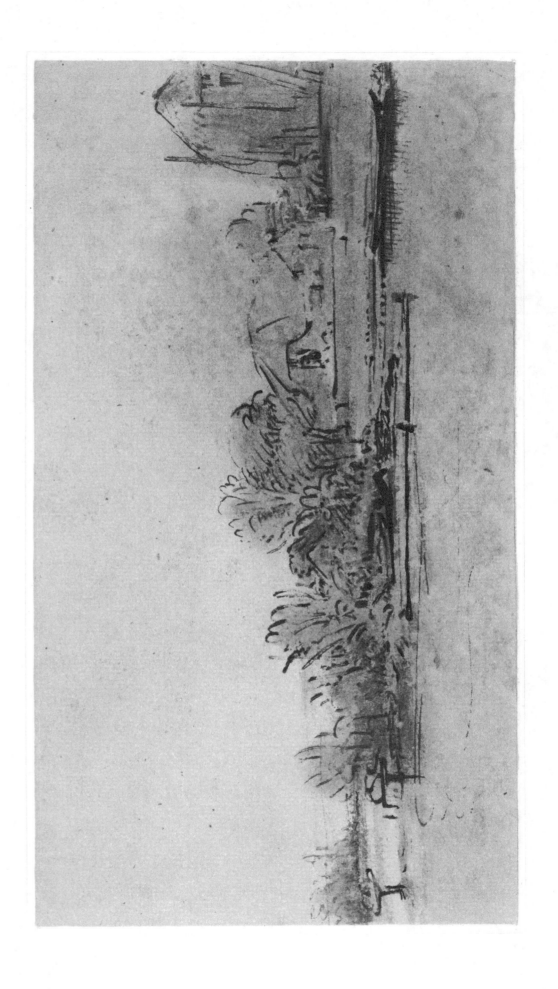

115 (I, 113). *Riverside Landscape, a Cottage and High Hayrick to the Right. (British Museum, London)*
Reed pen and bistre, wash: 132 × 239 mm.
About 1655.

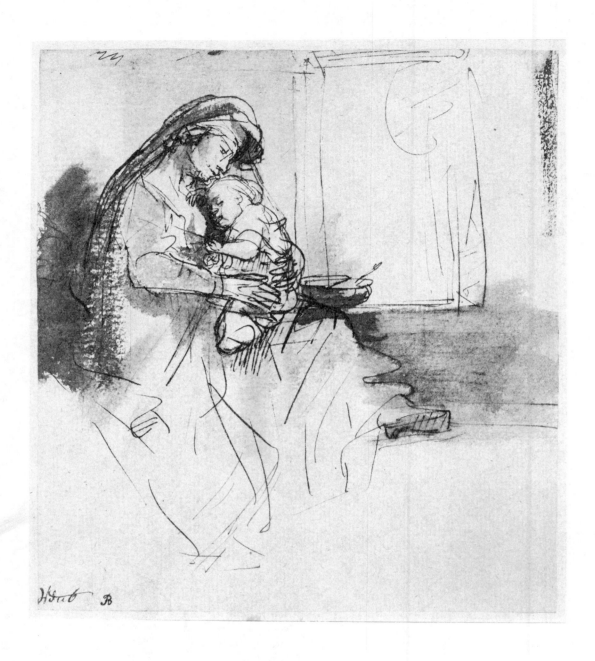

116 (*I, 114*). *The Virgin and Child Seated near a Window.* (*British Museum, London*)

Pen and bistre, wash: 155 × 137 mm. Inscribed in a later hand: Remb.

About 1635–37. Probably a study from life. On the verso a study of a winding staircase (reproduced Benesch, figure 129).

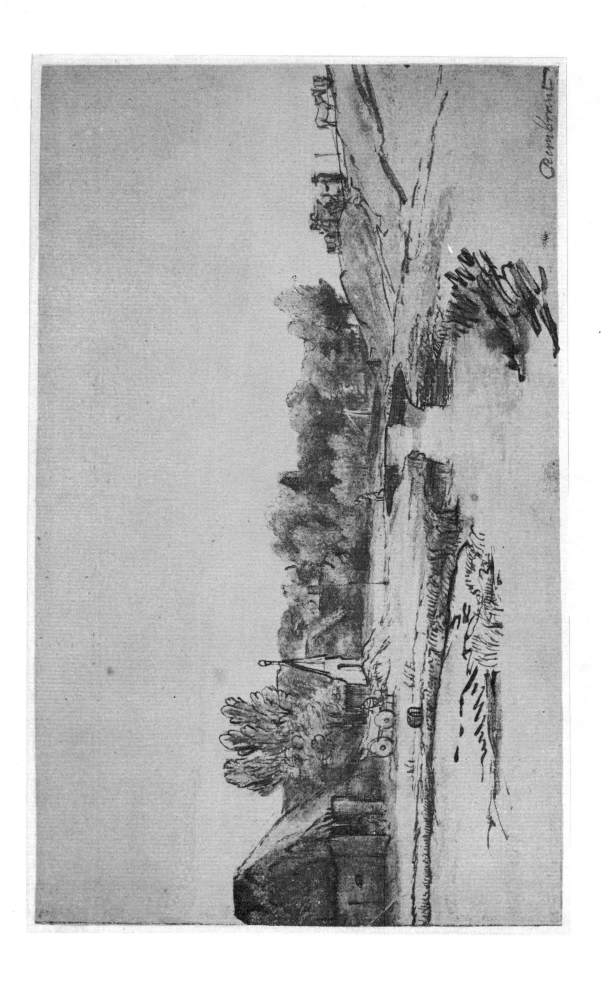

117 (I, 115). *Farm Buildings at the "Dijk."* (British Museum, London)

Pen and bistre, washes in bistre and Indian ink: 143 × 242 mm. Inscribed by another hand: Rembrant.

About 1648. Lugt (1920) identified the site as the great dike which protects the land from the Zuiderzee. A drawing at the Museum of Art, Rhode Island School of Design, Providence, Rhode Island (464 [IV, 21]), represents the same site from another point of view. Some students claim this drawing is by Rembrandt and that the sheet now in Providence is by a pupil. Others have taken the opposite view. Both can be considered autograph works by the master (see Benesch 832).

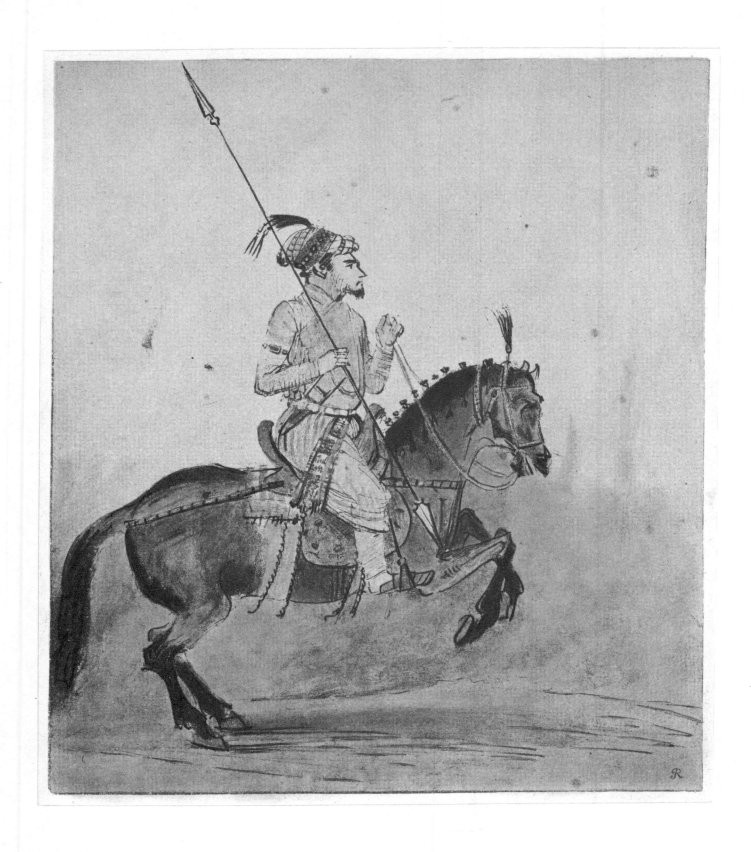

118 (*I, 116*). *Copy after an Unidentified Indian Miniature.* (British Museum, London)

Pen and bistre, washes in bistre and Indian ink, red chalk and yellow water color, heightened with white, on Japanese paper: 206 × 177 mm.

About 1655. One of Rembrandt's copies of Indian miniatures of the Moghul School; see the comment to 167 (I, 159).

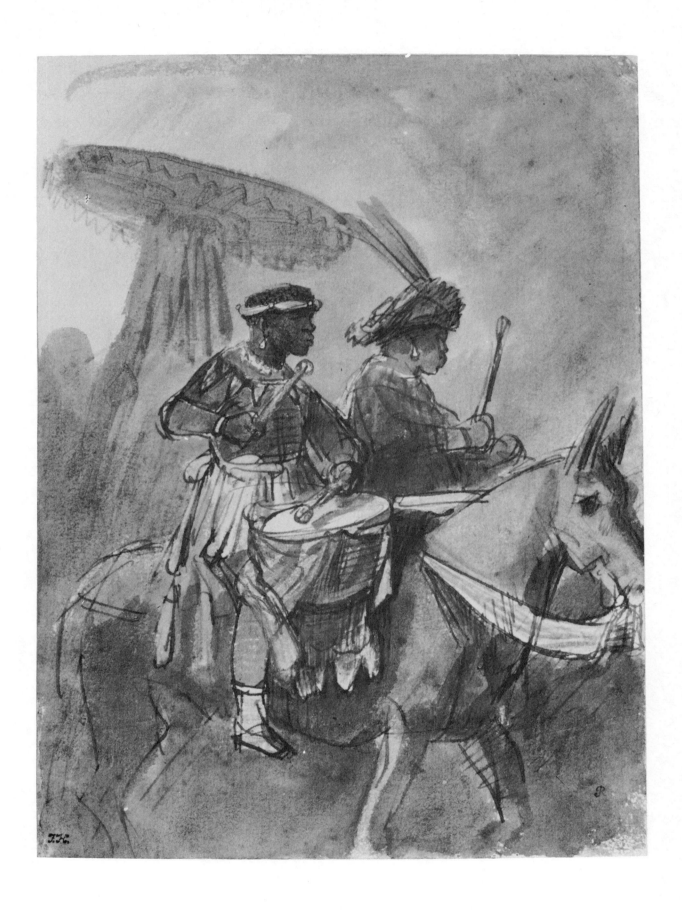

119 (I, 117). *Two Negro Drummers Mounted on Mules.* (British Museum, London)
Pen and wash in bistre, red chalk, yellow water color, heightened with white: 229 × 171 mm.

J. Q. *van Regteren Altena* (Oud Holland, 67, 1952, pp. 59–63) *suggests that this colorful drawing as well as others of officers (see 267* [II, 43] *), Negro musicians, and mummers were drawn in February, 1638, at The Hague during a pageant and tournament held to celebrate the second marriage of Wolfert van Brederode to a sister of the Princess of Orange.*

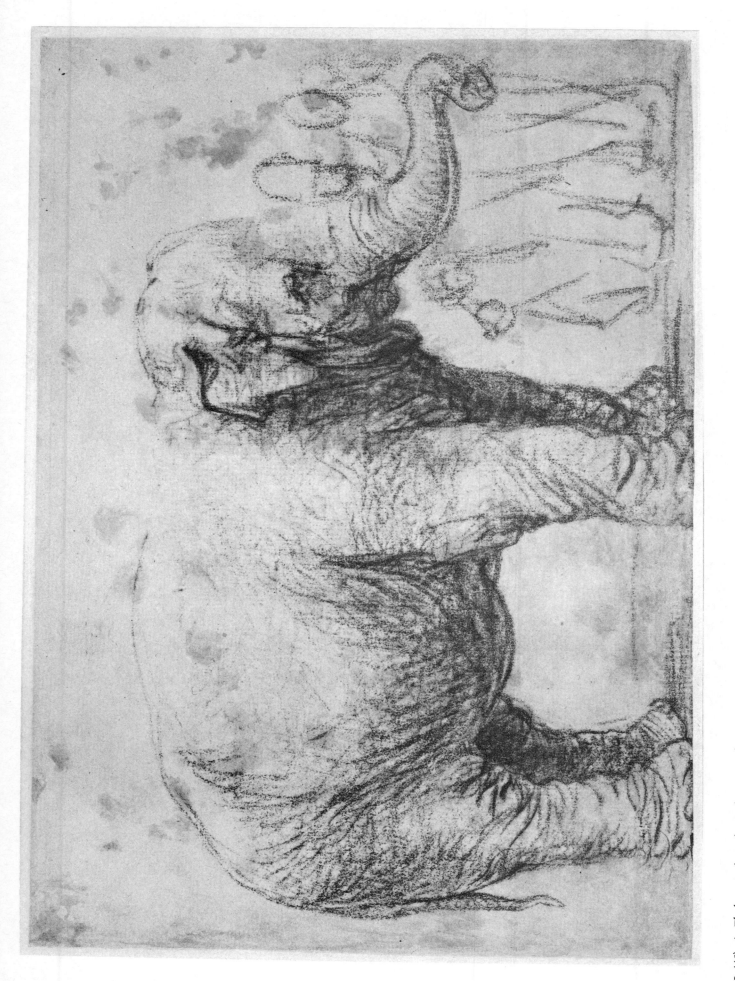

120 (I, 118). *An Elephant, in the Background a Group of Spectators.* (*British Museum, London*)
Black chalk: 178 × 256 mm.

About 1637. Rembrandt made this drawing and two others of elephants (both in the Albertina, Vienna) around the same time. A year later he incorporated the results of his study of this animal in the background of his etching Adam and Eve (Bartsch 28).

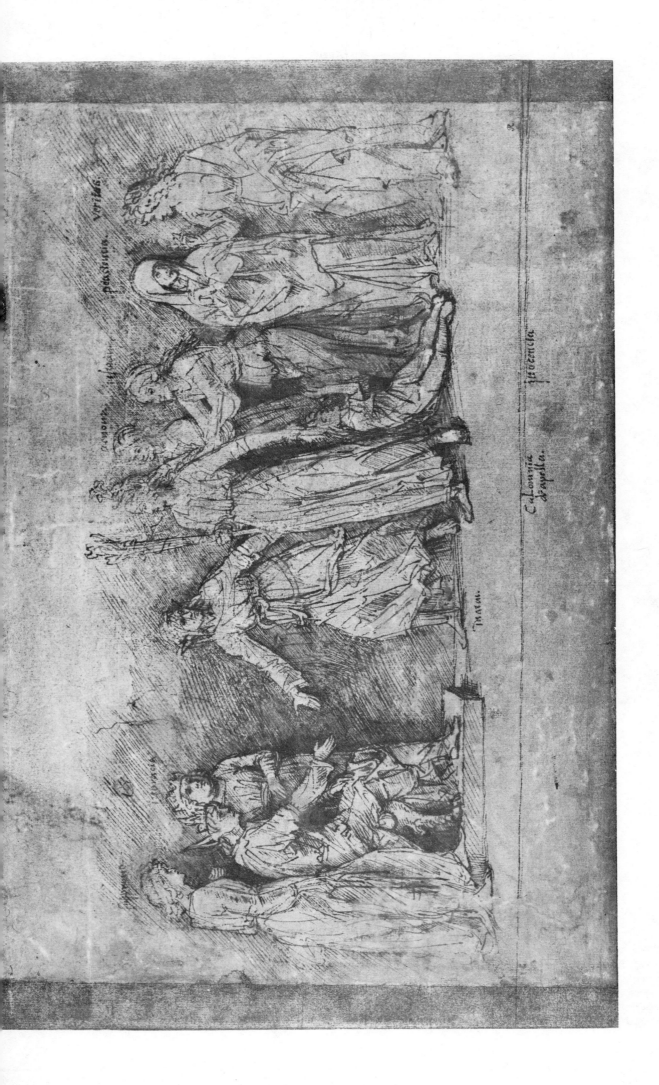

121 (I, 119). Copy after Mantegna's Calumny of Apelles. (British Museum, London)

Pen and bistre: 263 × 394 mm.

About 1655. Copy after a drawing attributed to Mantegna, also in the British Museum. Rembrandt's interest in Mantegna is seen in other works made around the same time: etching of The Holy Family, 1654 (Bartsch 8); The Anatomy Lesson of Dr. Deyman (Bredius 414); and The Entombment, a drawing in the collection of Walter C. Baker, New York, N.Y., which is a free copy after a Mantegna engraving (cf. Jakob Rosenberg, "Rembrandt and Mantegna," The Art Quarterly, Summer, 1956, pp. 153–161).

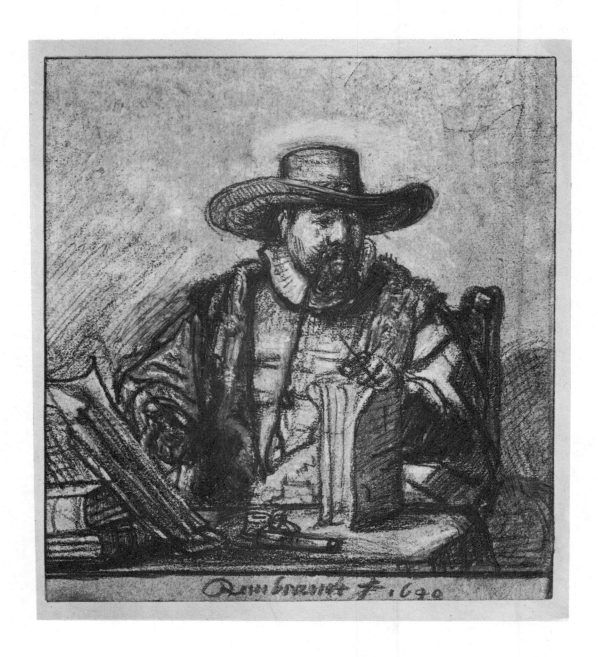

122 (*I, 120*). *Portrait of Cornelis Claesz Anslo.* (*British Museum, London*)

Red chalk, red wash, oil color, white body color: 157 × 143 mm. Signed and dated: Rembrandt f. 1640. The outlines are indented for transfer.

The drawing is a preparatory study for Rembrandt's etching of 1641 (Bartsch 271) of Anslo. The principal lines of the design were indented with a stylus by the master when he transferred it to the ground of his plate. On the back of the mount are inscribed in a contemporary hand Vondel's famous lines about Rembrandt's portrait of Anslo (see Slive, 1953, pp. 73 ff., and J. A. Emmens, "Ay Rembrandt, Maal Cornelis Stem," Kunsthistorisch Jaarboek, 1956, pp. 133 ff.). See 349 (III, 17) for another portrait of Anslo.

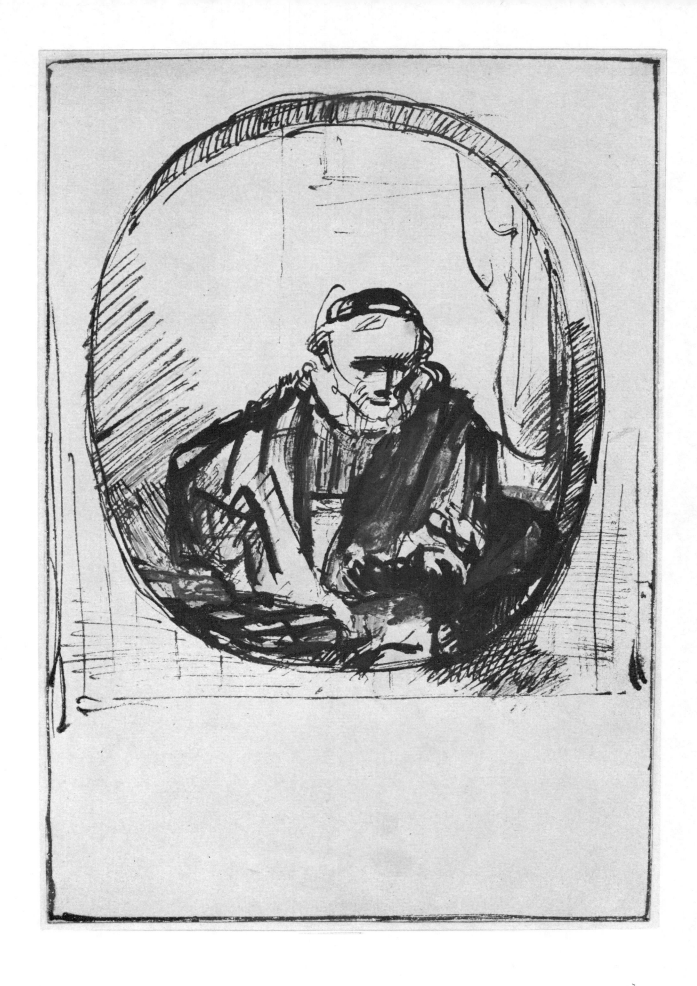

123 (*I, 121*). *Portrait of Jan Cornelisz Sylvius. (British Museum, London)*
Pen and wash in bistre, white body color: 283 × 193 mm.
Preparatory study for the etching of 1646 (Bartsch 280). This drawing and two others of the preacher (468 [IV, 24b]
and Benesch 762a) are posthumous studies; Sylvius died in 1638.

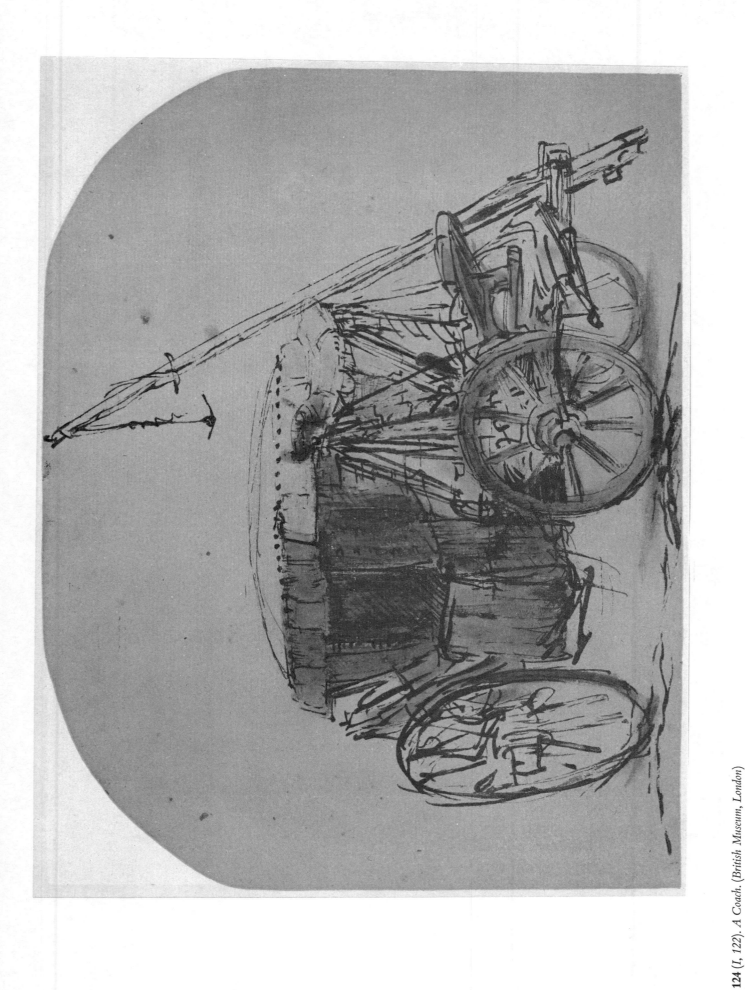

124 (I, 122). *A Coach.* (*British Museum, London*)
Pen and wash, bistre: 194 × 254 mm.

About 1655. Apparently related to the coach represented in the background of The Man on Horseback *now in the National Gallery, London (Bredius 255).*

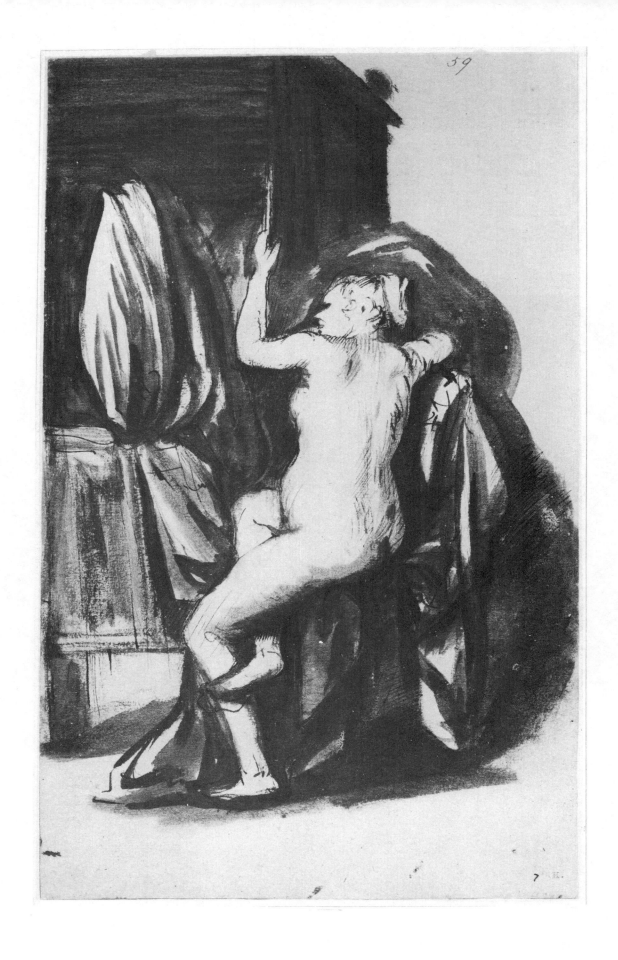

125 (*I, 123*). *Female Nude, with Her Left Hand Grasping a Sling.* (*British Museum, London*)
Pen and brush in bistre, wash in Indian ink, white body color: 298 × 193 mm.

About 1660–61. Preparatory study for the etching The Woman with an Arrow *of 1661 (Bartsch 202). In the etching the model's sling was transformed into an arrow. For another powerful study of the same model see 433 (III, 95).*

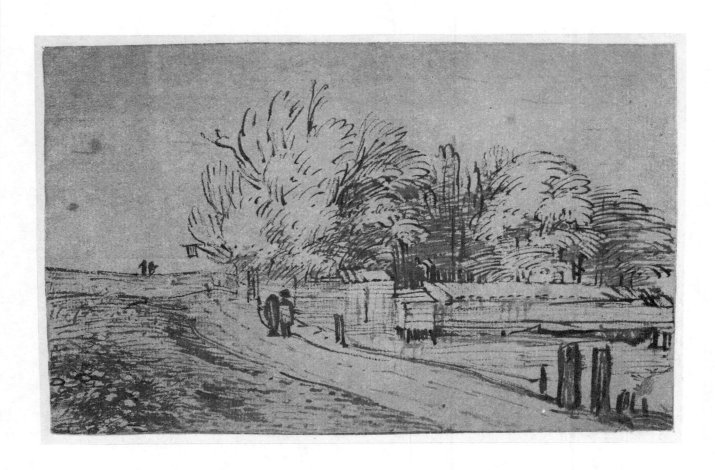

126 (*I, 124a*). *Landscape with a Road. (British Museum, London)*
Reed pen and bistre wash: 111 × 172 mm.
About 1653.

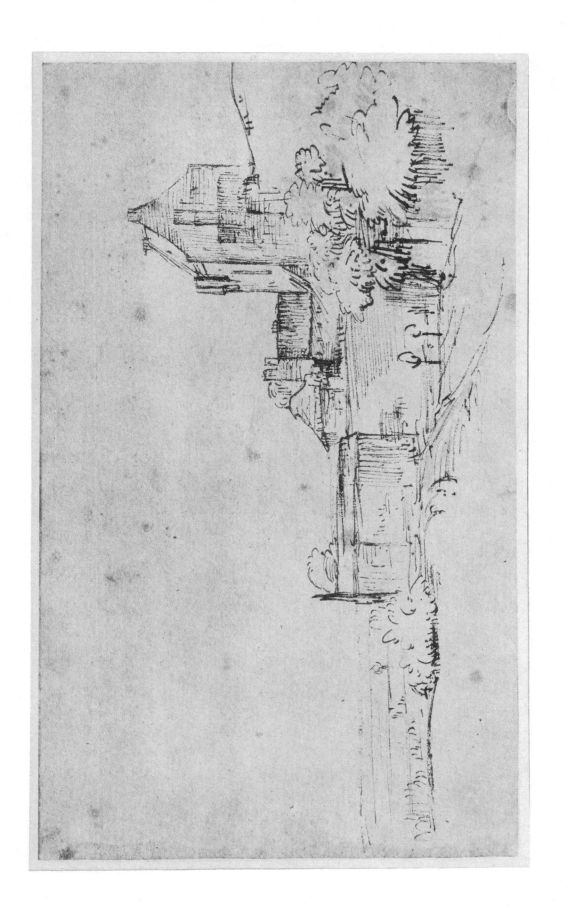

127 (I, 124b). *An Old City Gate. (British Museum, London)*
Pen and bistre: 132 × 225 mm.
About 1648.

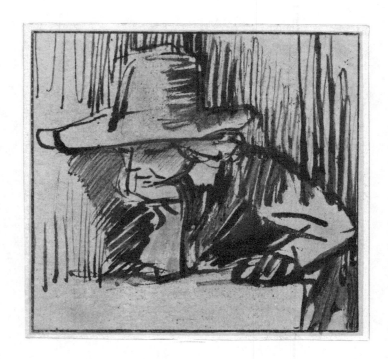

128 (*I, 125a*). *Boy in a Wide-brimmed Hat, Resting His Chin on His Right Hand.* (*British Museum, London*)
Pen and bistre, wash: 85 × 90 mm.

About 1655. It has been suggested that Rembrandt's son Titus is the model (see Valentiner 715) but it is hardly possible to base an identification on this summary sketch.

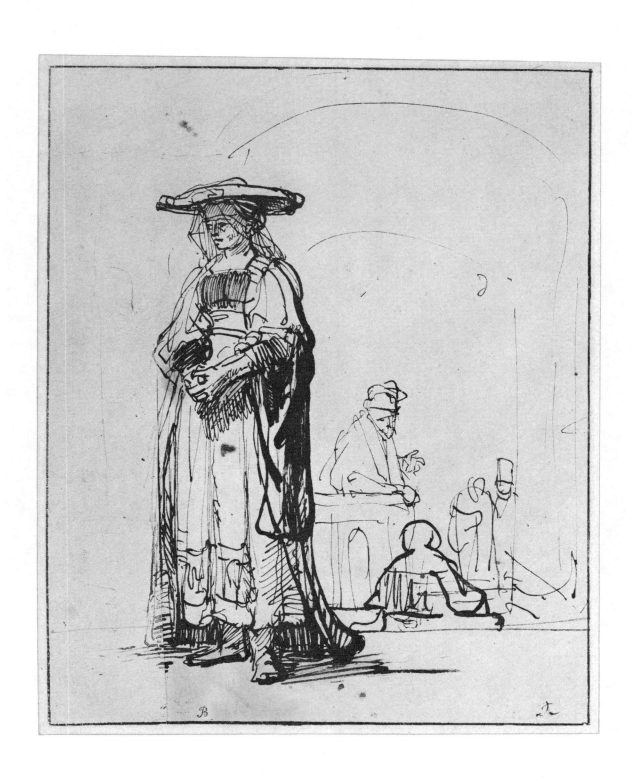

129 (*I, 125b*). *A Standing Woman with Folded Hands; Figures in the Background.* (British Museum, London)
Pen and bistre: 184 × 147 mm. (a strip with minor additions has been added on the left by another hand).
About 1640.

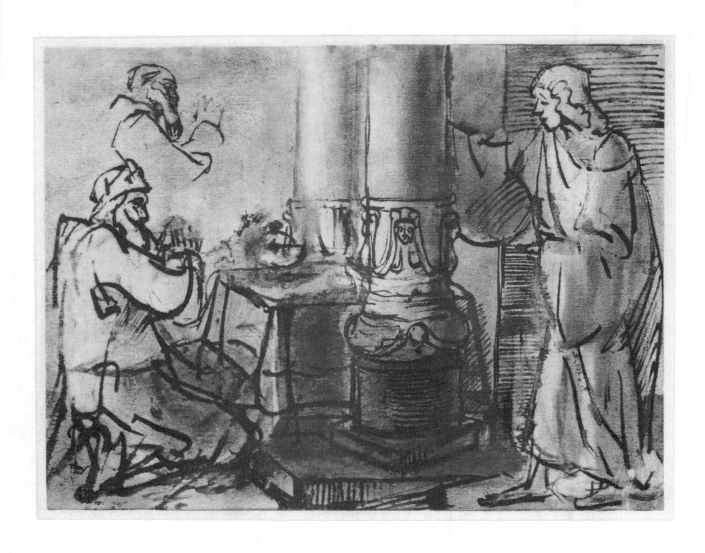

130 (*I, 126*). *Gabriel Appearing to Zacharias in the Temple.* (*British Museum, London*)

Pen and wash in bistre, white body color: 131 × 169 mm.

The drawing has been defended by Hind (1915, no. 82) and Valentiner (271). Not listed in Benesch. Seidlitz charged that it is a crude forgery (cited in Hind, op. cit.). Although there are some good qualities in the figure of Zacharias and the slight sketch above him, the rest of the drawing is poor. Hind argues that the drawing's distinguished provenance—it was part of Sir Hans Sloane's bequest in 1753 to the Museum—weakens the charge that it is a forgery. His argument is not a weighty one. There is no reason to assume that forgers were not making "Rembrandts" early in the eighteenth century when Rembrandt's drawings were admired by a small international circle of connoisseurs. This was enough to set the forgers to work. A school drawing of the same subject set in a larger space is at Dresden (reproduced Wichmann, 1925, no. 14).

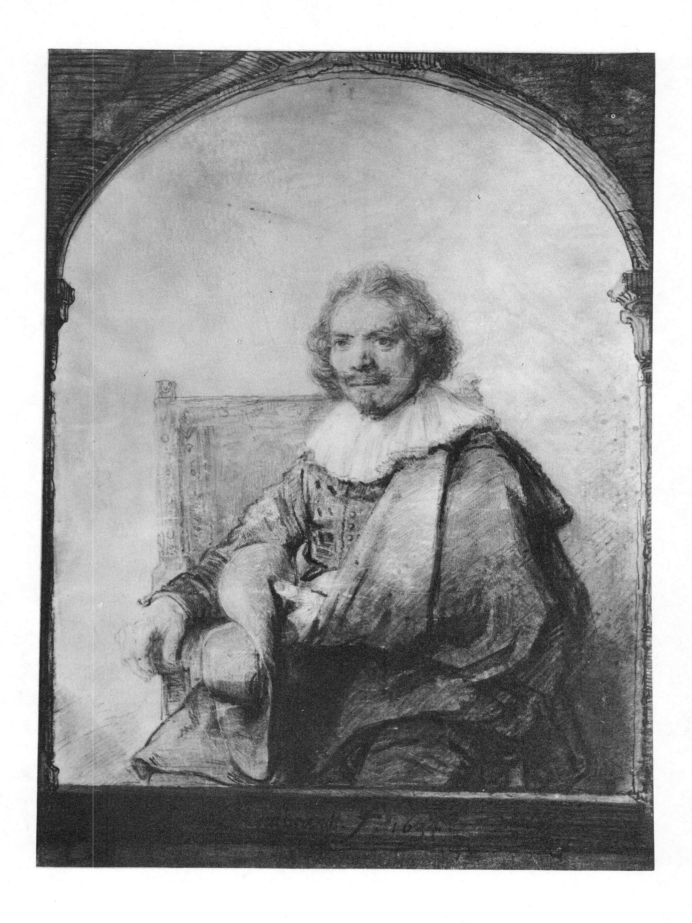

131 (*I, 127*). *Portrait of a Man in an Armchair, Seen Through a Frame.* (*Mr. and Mrs. Charles S. Payson Collection, New York*)

Black and red chalk, pen and wash in bistre, on vellum: 373 × 272 mm. Signed and dated: Rembrandt f. 1634.

Rembrandt's most finished portrait drawing. This fact, as well as the large size of the sheet, suggest it was made as a commissioned work or as a gift, and not as a preliminary study. The identification of the sitter by Bredius as Maurits Huygens on the basis of the similarity of the drawing to Rembrandt's painted portrait of Maurits Huygens (1632, Kunsthalle, Hamburg; Bredius 161) has not been accepted by other Rembrandt specialists.

L'ange quitte Manüé et sa femme, et s'éleve au milieu de la flame qu'il auoit excite 1807. 79

132 (*I, 128*). *The Angel Disappearing Before Manoah and His Wife.* (*Nationalmuseum, Stockholm*)

Reed pen and wash in Indian ink: 233 × 203 mm. The French inscription at the bottom is probably by the collector Crozat.

About 1655. Sketch for a modification, or for a new version of Rembrandt's painting dated 1641 of the same subject at the Gemäldegalerie, Dresden (Bredius 509); see F. Saxl, Rembrandt's Sacrifice of Manoah, Studies of the Warburg Institute, *9, London, 1939. Another study for the project is 361 (III, 29).*

133 (*I, 129*). *The Eye Operation*(?). (*Nationalmuseum, Stockholm*)

Pen and bistre, wash, white body color: 243 × 188 mm. Inscribed by a later hand: R.

About 1650–52. The subject has been connected with the story of Tobit (see R. Greeff, Rembrandts Darstellungen der Tobiasheilung, *Stuttgart, 1907, and Kruse, 1920, no. IV, 16). For the suggestion that it is a representation of the well-known Netherlandish genre theme "The Stone Cutting" see Benesch (1154); he compares it to Bosch's representation of this proverb in the Prado.*

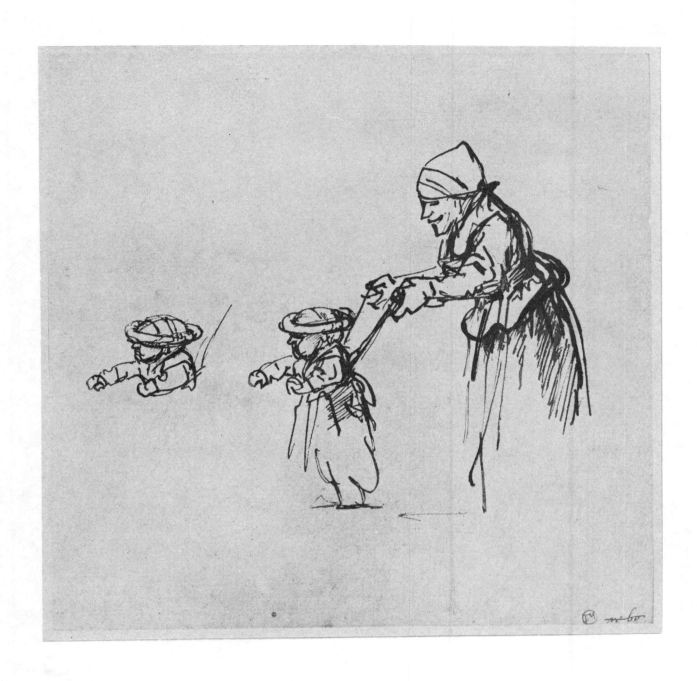

134 (*I, 130*). *An Old Woman Holding a Child in Leading Strings; on the Left a Separate Study of the Bust of the Child.* (*Nationalmuseum, Stockholm*)

Pen and bistre: 160 × 165 mm.

About 1645. A scene in the background of Rembrandt's etching of Studies of a Male Nude (*Bartsch 194*) *is executed in the same style and spirit. One of Rembrandt's numerous drawings of women and children; about sixty are known today.*

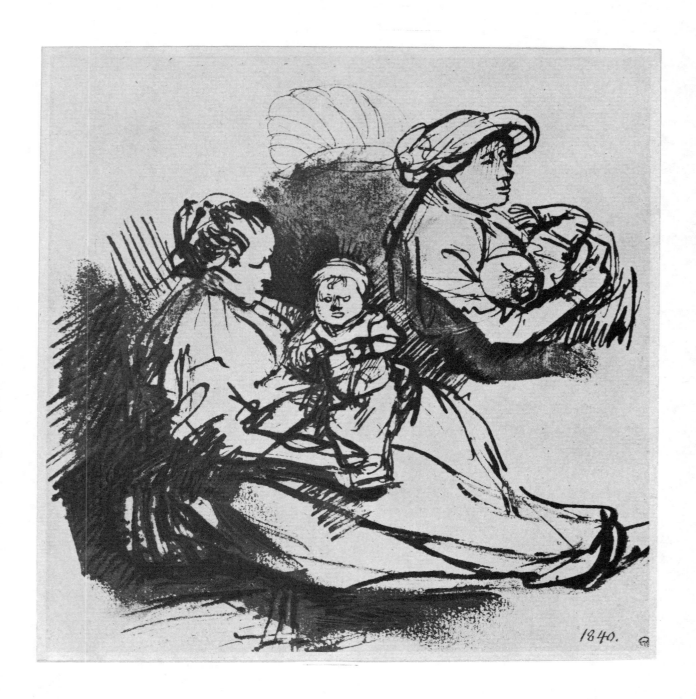

135 (*I, 131*). *Study of Two Women, One Seated with a Child on Her Lap, the Other Nursing a Baby.*
(*Nationalmuseum, Stockholm*)

Pen and bistre, wash: 165 × 164 mm.

*About 1635–40. A closely related drawing in the same museum is 234 (II, 17). Also see 316 (II, 84) and
337 (III, 5).*

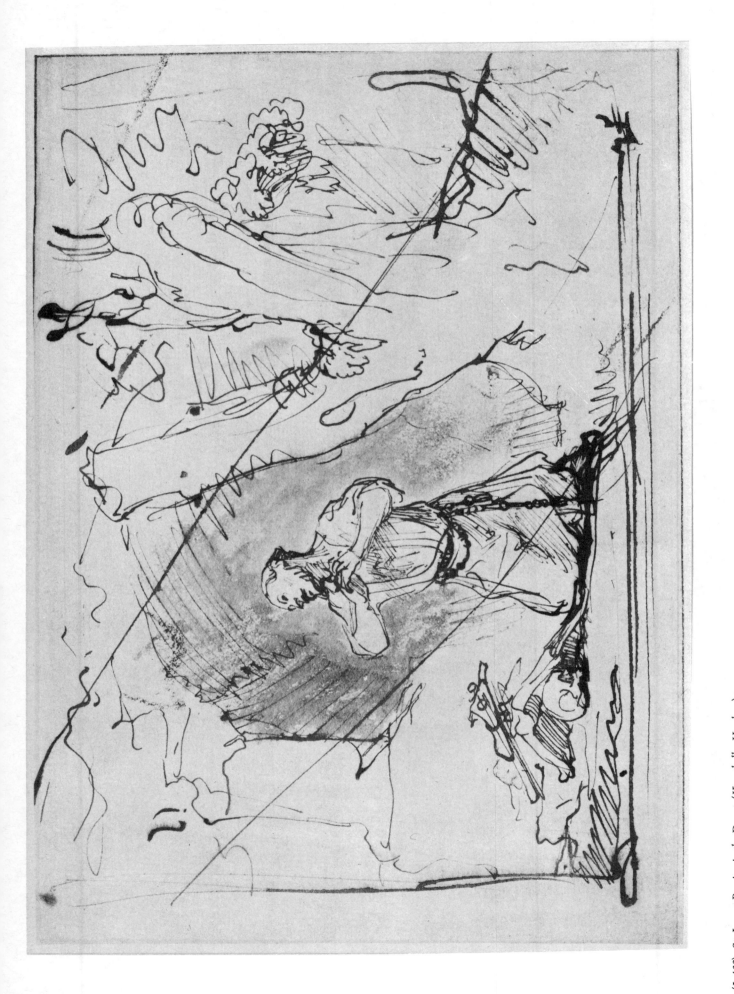

136 (I, 132). *St. Jerome Praying in the Desert. (Kunsthalle, Hamburg)*

Pen and wash in bistre: 172 × 245 mm.

The style suggests the 1640's, but it does not meet the standard of Rembrandt's authentic drawings. Probably a copy after a lost original. Not listed by Valentiner and called the work of a pupil by Benesch (A56).

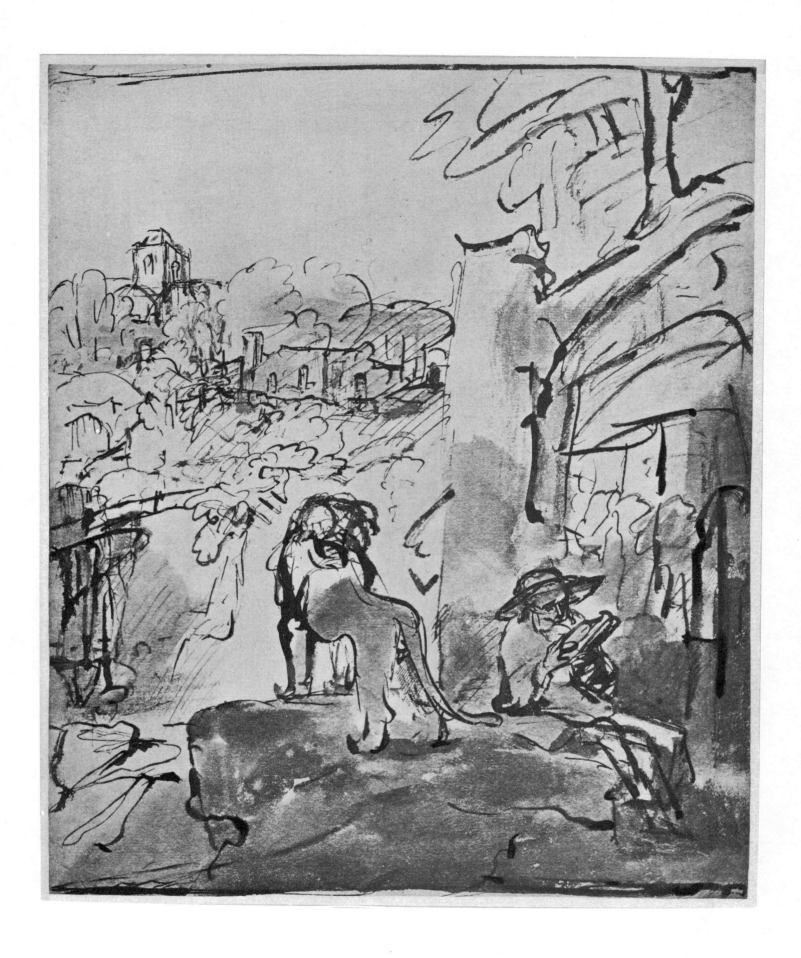

137 (*I, 133*). *St. Jerome Reading in a Landscape.* (Kunsthalle, Hamburg)
Reed pen and wash: 250 × 207 mm.
About 1652. Preparatory study (in reverse) for Rembrandt's etching of the same subject (Bartsch 104).

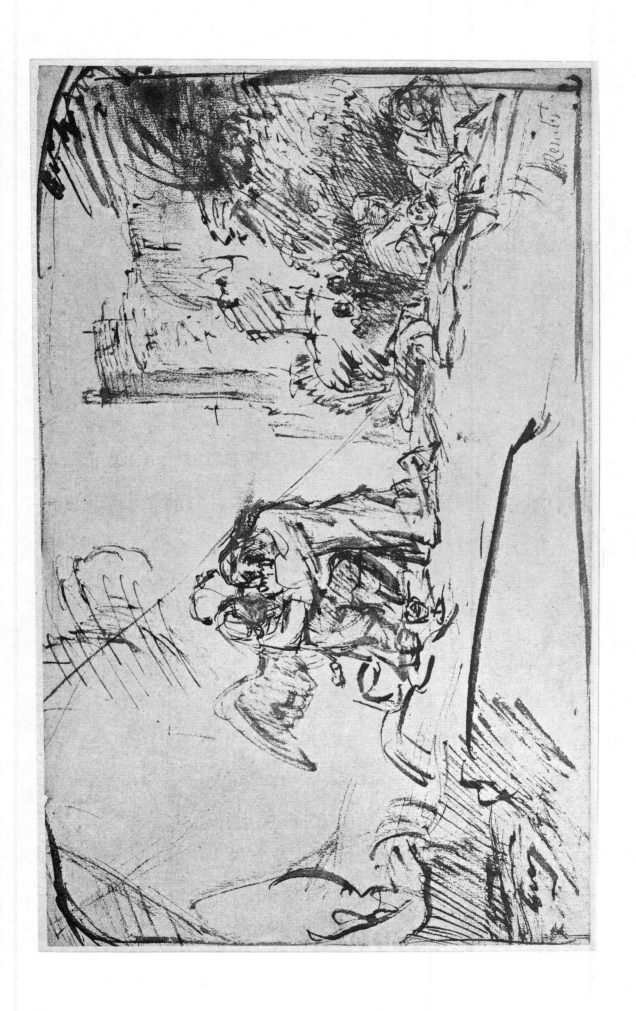

138 (I, 134). *Christ Consoled by the Angel on the Mount of Olives. (Kunsthalle, Hamburg)*

Pen and bistre, white body color: 184 × 301 mm. Inscribed by a later hand: Rembt.

About 1655–57. Study for the etching (Bartsch 75) of 165? (last digit illegible); the figures of Christ and the angel are not reversed in the print.

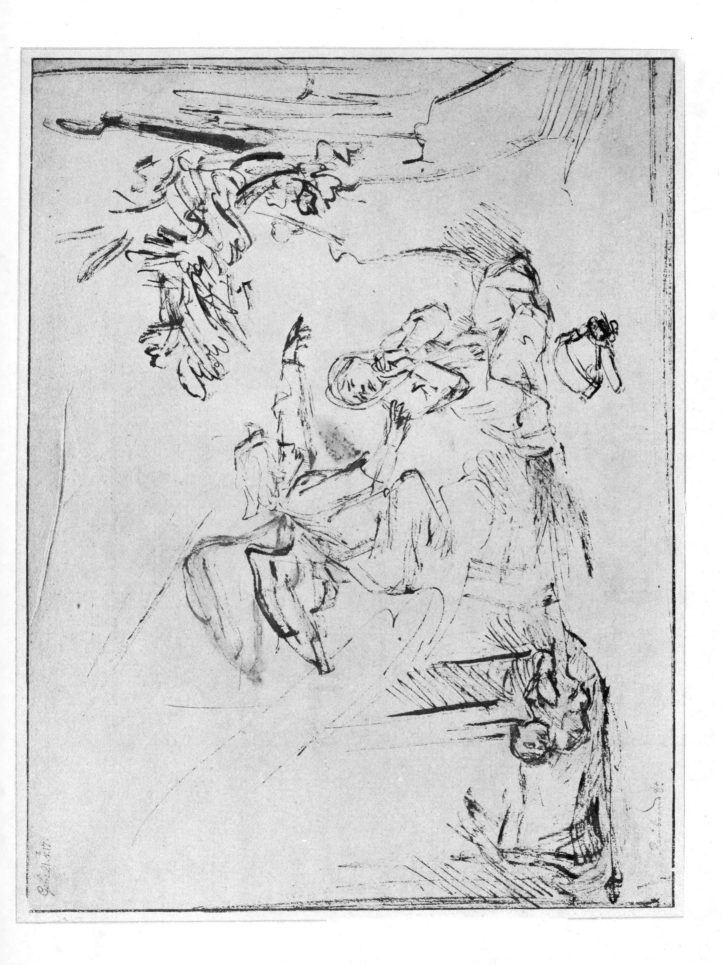

139 (I, 135). *The Angel Appearing to Hagar in the Desert. (Kunsthalle, Hamburg)*
Reed pen and bistre, white body color: 182 × 252 mm.
About 1655–57.

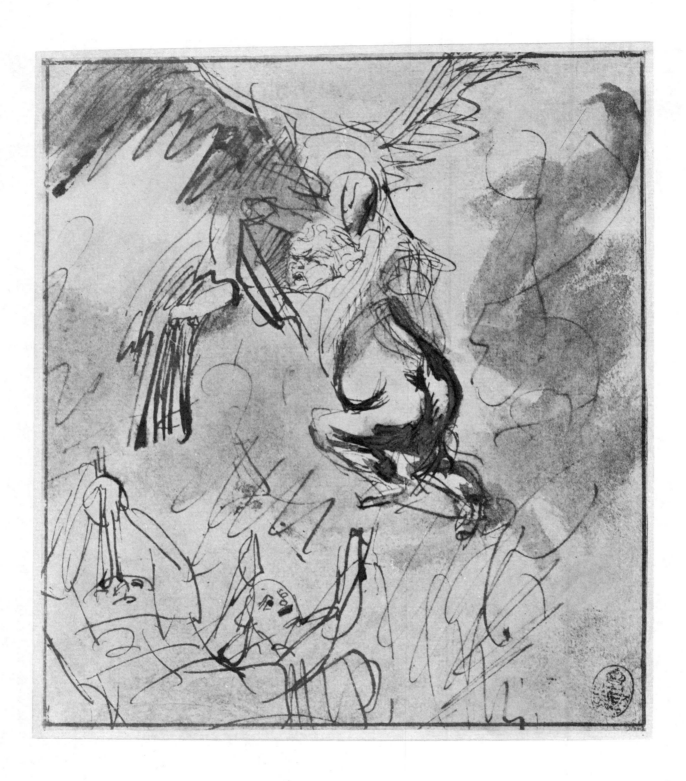

140 (*I, 136*). *Ganymede Carried Away by the Eagle of Zeus.* (*Kupferstichkabinett, Dresden*)
Pen and bistre, wash, white body color: 183 × 160 mm.
About 1635. Study for the painting of the same subject at the Gemäldegalerie, Dresden, of 1635 (Bredius 471).
Rembrandt's original interpretation of this mythological subject was inspired by a scene of everyday life; see 9 (I, 9).

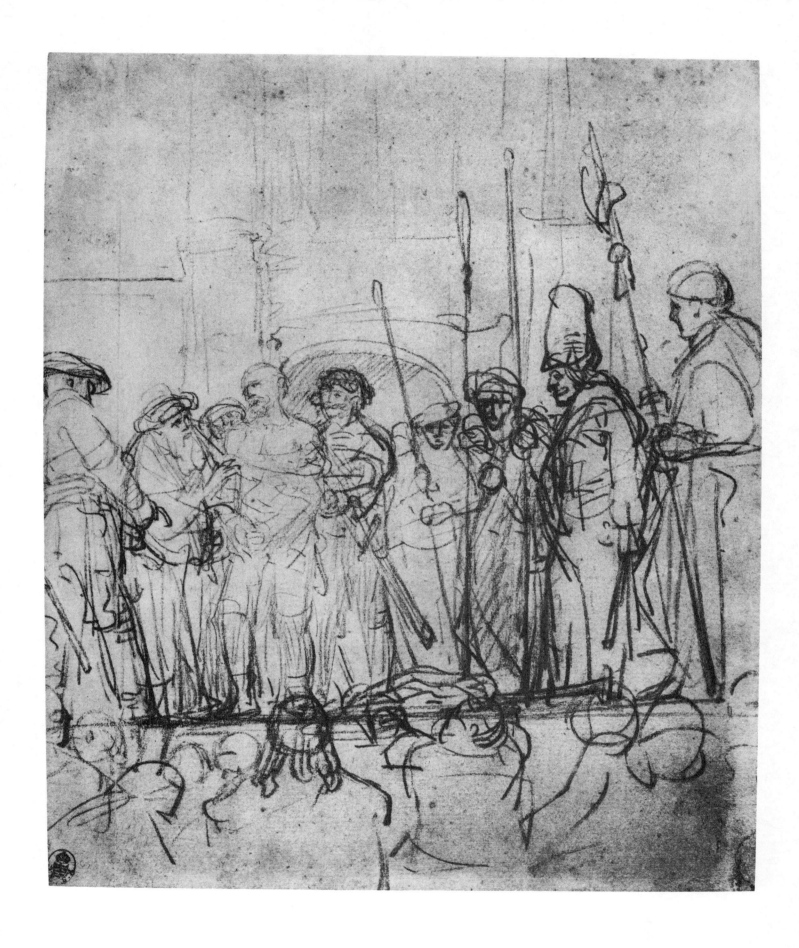

141 (*I, 137*). *Ecce Homo.* (*Kupferstichkabinett, Dresden*)
Red chalk: 334 × 270 mm.

*About 1637. Although the man shown to the people bears little resemblance to the type Rembrandt used for the
figure of Christ during the 1630's it seems reasonable to accept the traditional title of this exceptionally large chalk
drawing. It can be said to contain the germ of Rembrandt's large* Ecce Homo *etching of 1655 (Bartsch 76). See
544 (IV, 94) for a pupil's variant on the drawing.*

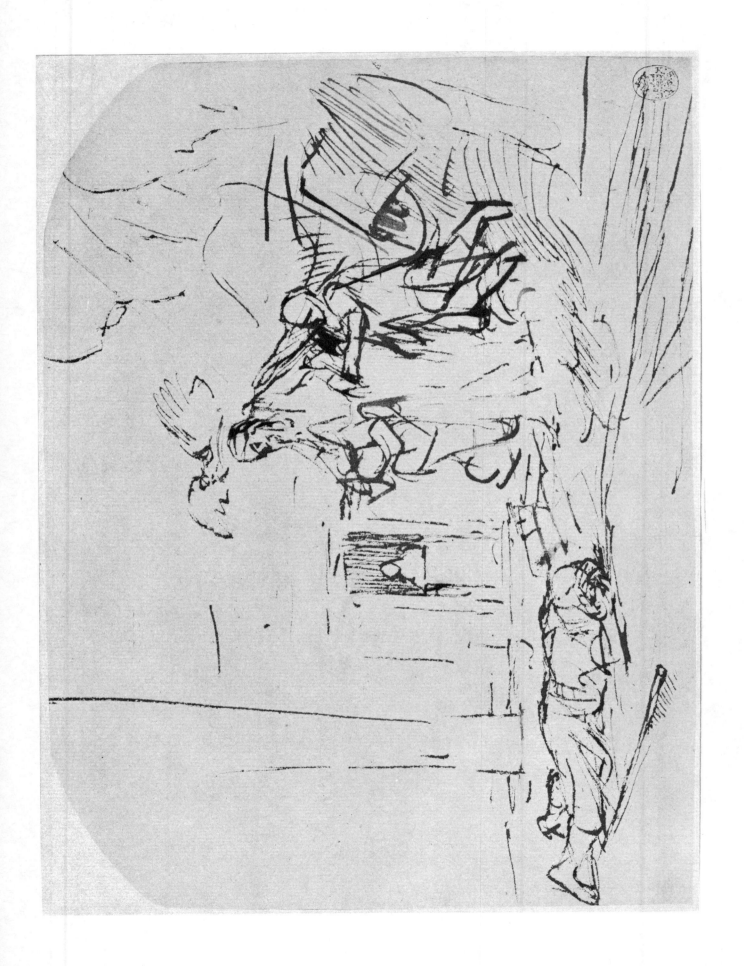

142 (I, 138). *God Announces His Covenant to Abraham.* (*Kupferstichkabinett, Dresden*)

Pen and bistre: 197 × 266 mm.

About 1657. The correct interpretation of the subject (Genesis 17) of this moving drawing was made by Valentiner (9).

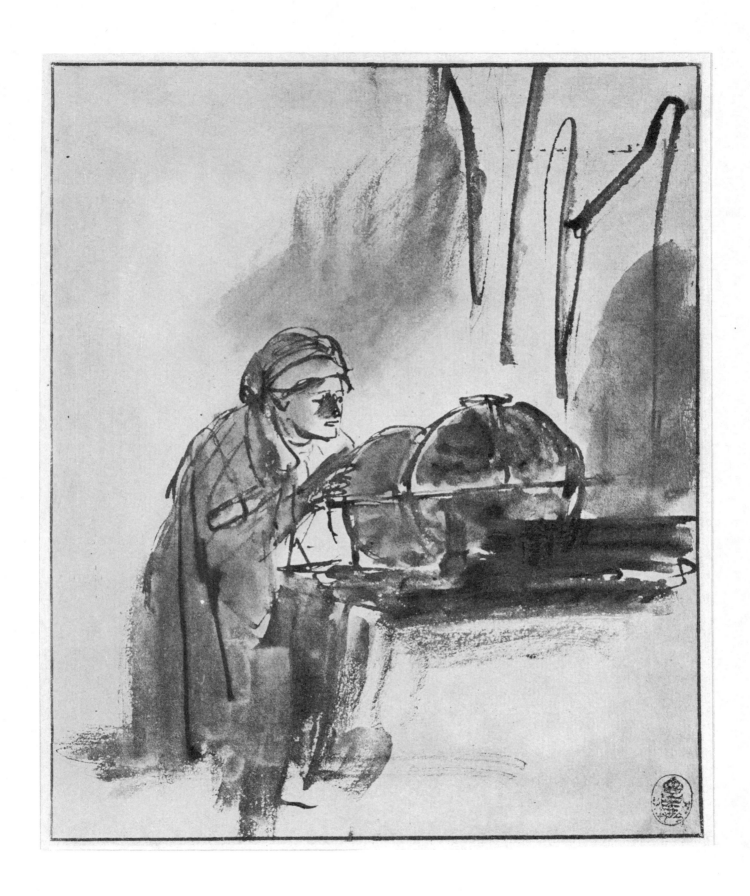

143 (*I, 139*). *The Geographer.* (*Kupferstichkabinett, Dresden*)

Pen and brush in bistre, the background lightly washed with a greenish blue tint (by a later hand?): 215 × 173 mm.

Woermann (see Hofstede de Groot 251) ascribed it to Vermeer; an understandable, but unconvincing attribution.
The sheet is probably an authentic work made around 1640–45 and can be considered one of the series of studies of
scholars which culminates in the Faust *etching (Bartsch 270). Not listed in Benesch.*

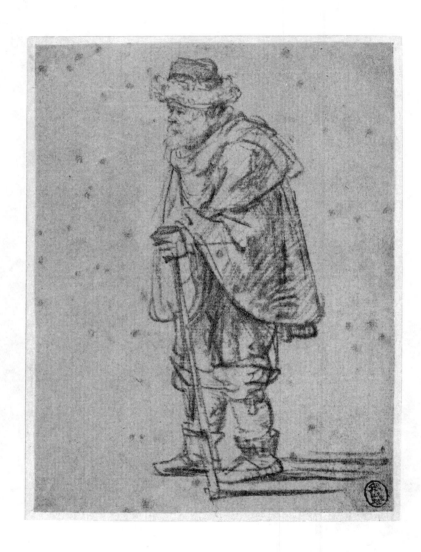

144 (*I, 140a*). *An Old Man in a Fur Cap Walking with a Stick, Turned to the Left.* (*Friedrich August II Collection, Dresden*)
Black chalk: 129 × 95 mm.
About 1648.

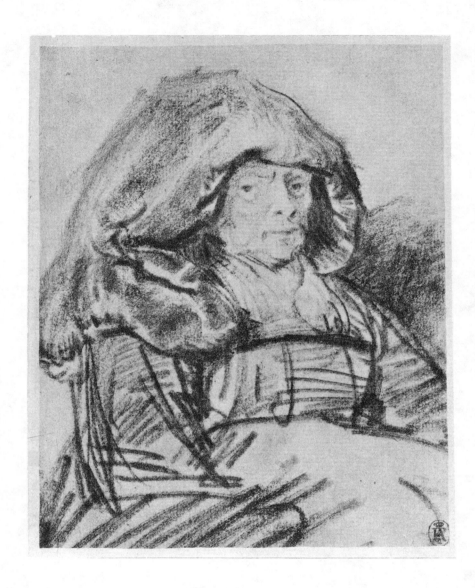

145 (*I, 140b*). *Seated Old Woman, in a Large Head-dress, Half-length, Turned to the Right.* (*Count Antoine Seilern Collection, London*)

Black chalk: 140 × 110 mm.

A vigorous study by the master from life. It has been called a preparatory study for the painting Old Woman with a Book, *Hermitage, Leningrad, of 1643 (Bredius 361). This date fits the style of this drawing. However, the Leningrad picture lacks the vitality of this remarkable drawing; it was probably painted by Rembrandt's pupil Abraham van Dijck.*

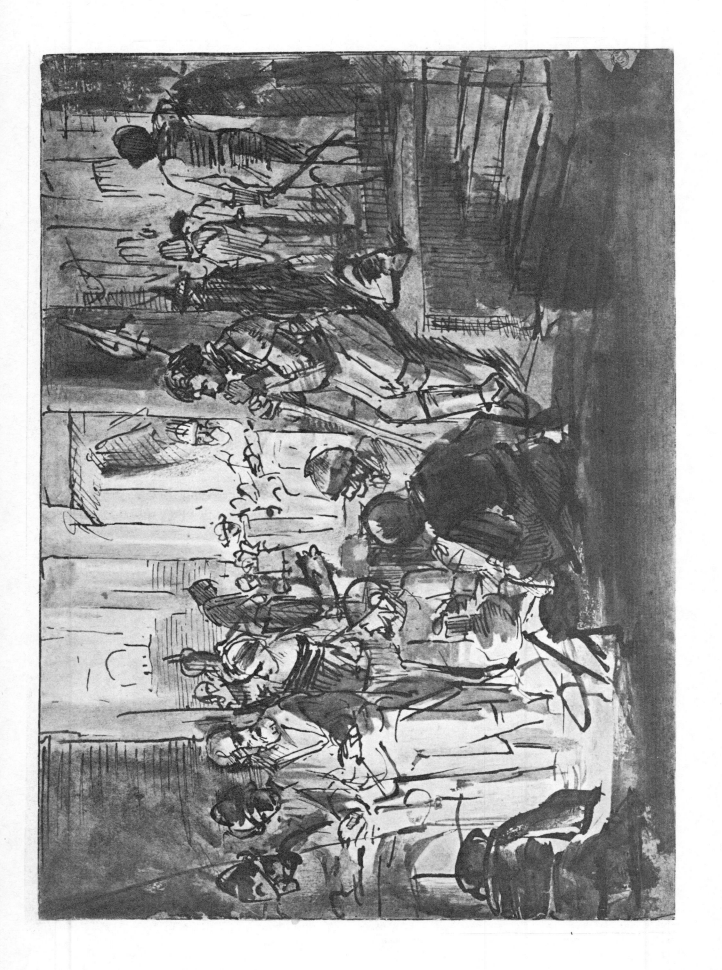

146 (I, 141). *St. Peter Denying Christ. (École des Beaux–Arts, Paris)*
Pen and wash in bistre, white body color: 180 × 255 mm.

Lugt (1950, no. 480) considers it an authentic study for the painting of about 1660 now in the Rijksmuseum (Bredius 594); Benesch (see note to his 1050) calls it a school piece.

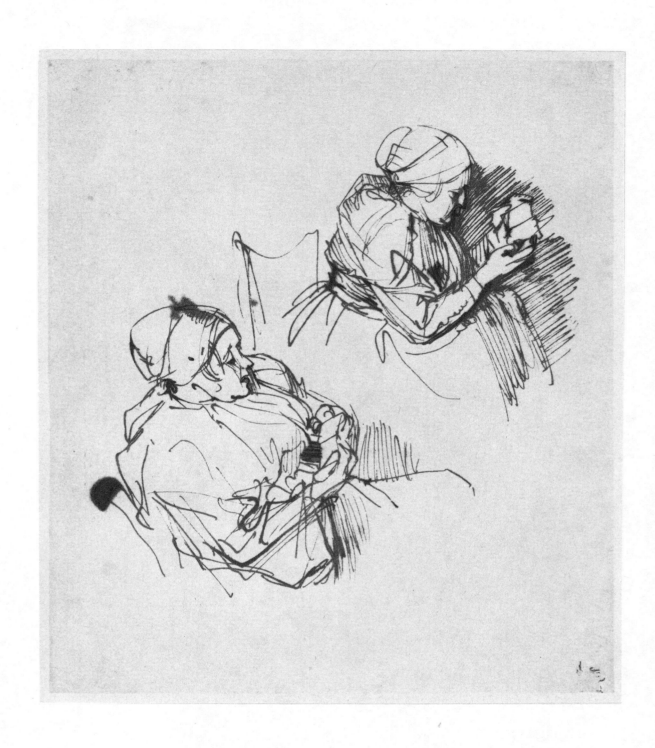

147 (*I, 142*). *Two Studies of a Woman Reading.* (*Metropolitan Museum of Art, New York*)
Pen and bistre: 173 × 150 mm.

About 1636–39. For the opinion that the sheet was made about 1633–34 see Benesch 149. It has been plausibly suggested by Valentiner (*Jahrbuch für Kunstwissenschaft, 1, 1923*) *that this stout woman was Saskia's nurse during an illness or confinement. She appears in drawings of domestic scenes which can also be dated during the second half of the 1630's* (*see Benesch 194, 374, 425, 426*).

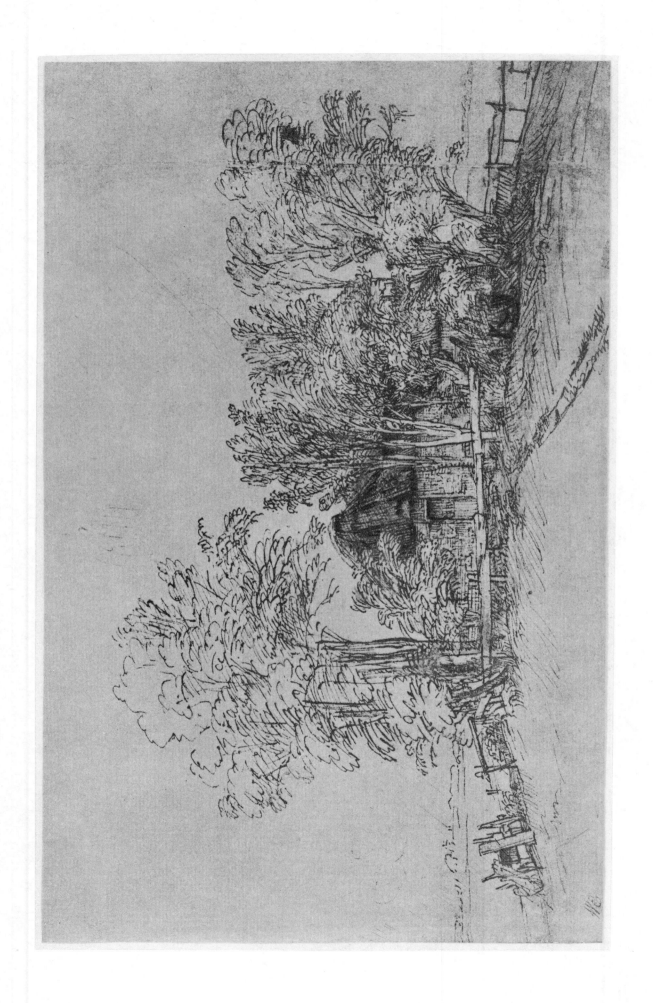

148 (I, 143). *A Thatched Cottage Among Trees. (Metropolitan Museum of Art, New York)*
Pen and bistre, wash: 172 × 271 mm.
About 1650.

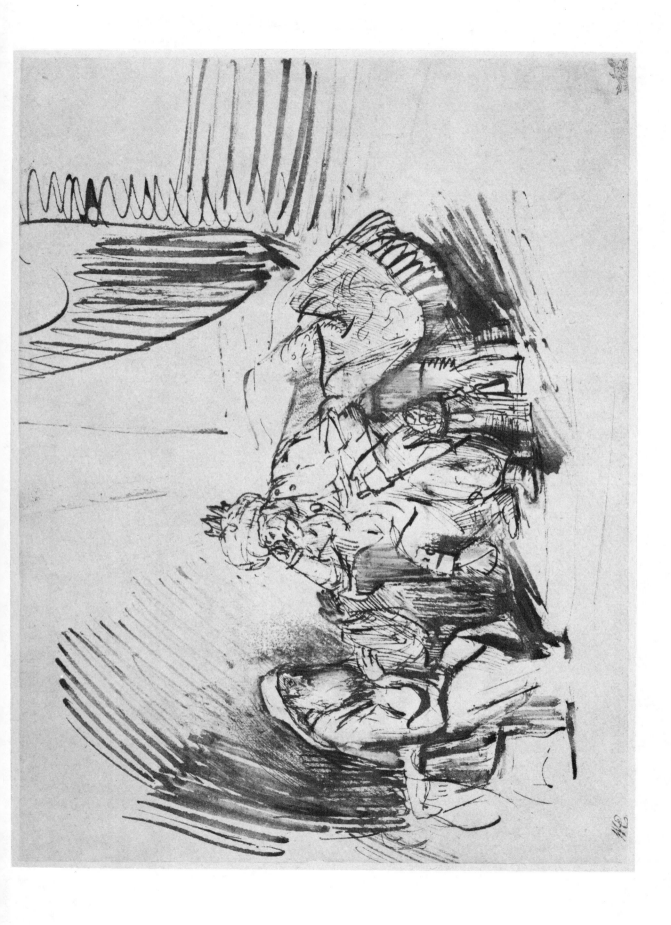

149 (I, 144). Nathan Admonishing David. (Metropolitan Museum of Art, New York)

Reed pen and bistre, wash, white body color: 183 × 252 mm.

About 1655–56. The most moving of Rembrandt's four known drawings of this subject (II Samuel 12, 1–14); another study of this composition is reproduced 211 (I, 194). Valentiner ("Ein Altersentwurf Rembrandts," Genius, 2, 1920, pp. 44 ff.) suggested that Rembrandt planned a painting of this subject as a pendant to his David Playing Before Saul (Bredius 526) now in the Mauritshuis, The Hague.

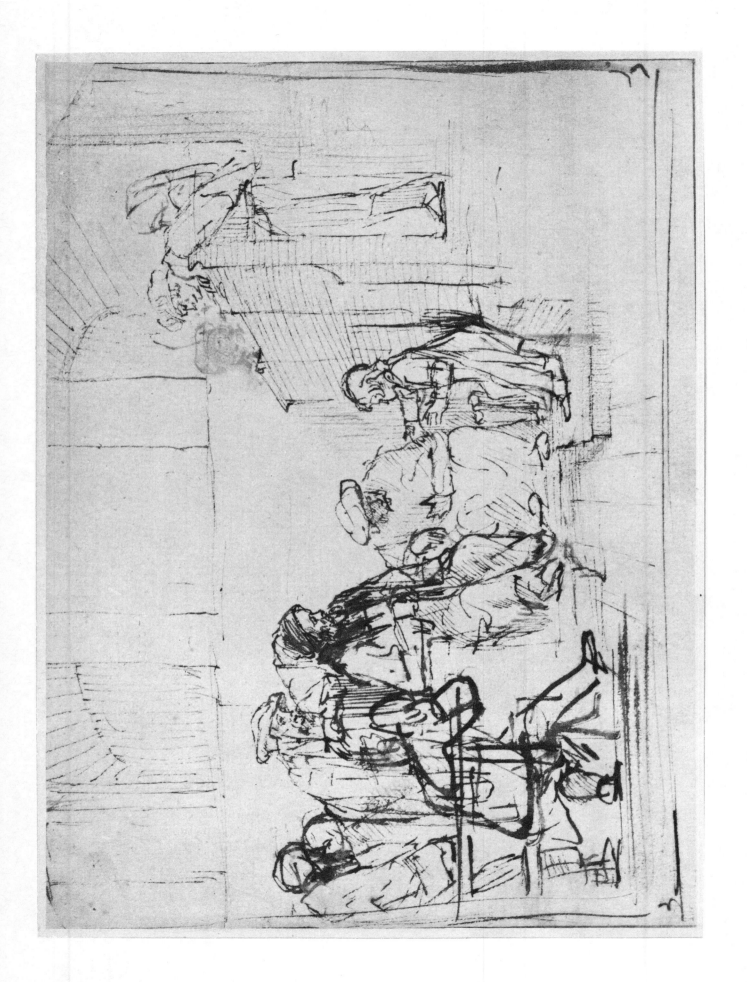

150 (*I, 145*). *Christ in the Temple Disputing with the Doctors. (Louvre, Paris)*

Reed pen and bistre, corrections in white body color: 189 × 259 mm.

About 1652. A copy in the Albertina, Vienna (Valentiner, 348b), shows that the drawing was once somewhat larger.

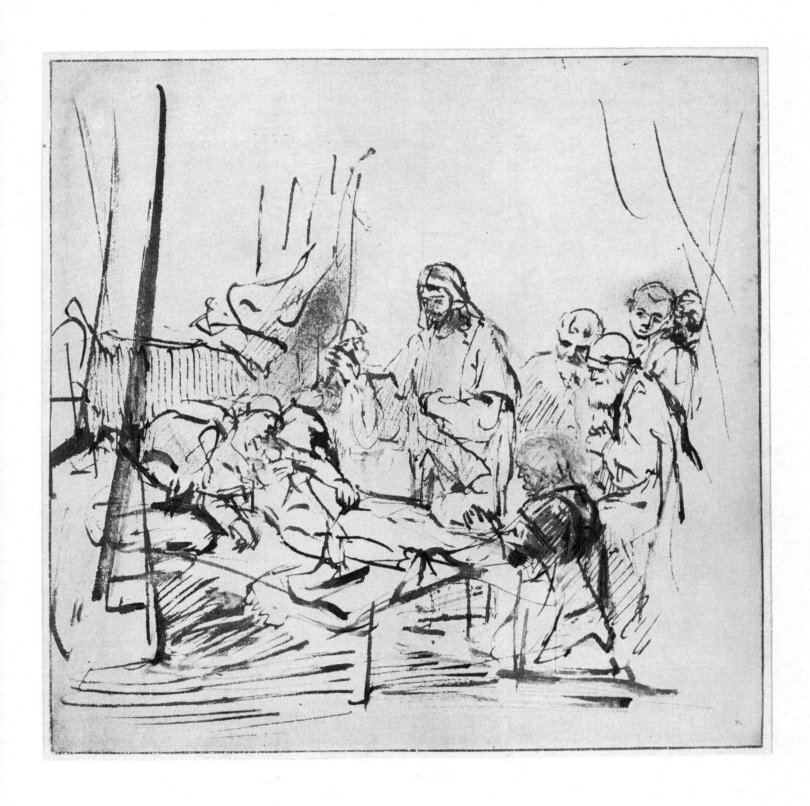

151 (*I, 146*). *The Raising of the Daughter of Jairus.* (*Kupferstichkabinett, Berlin*)
Pen and bistre, wash, white body color: 198 × 198 mm.
About 1655–60.

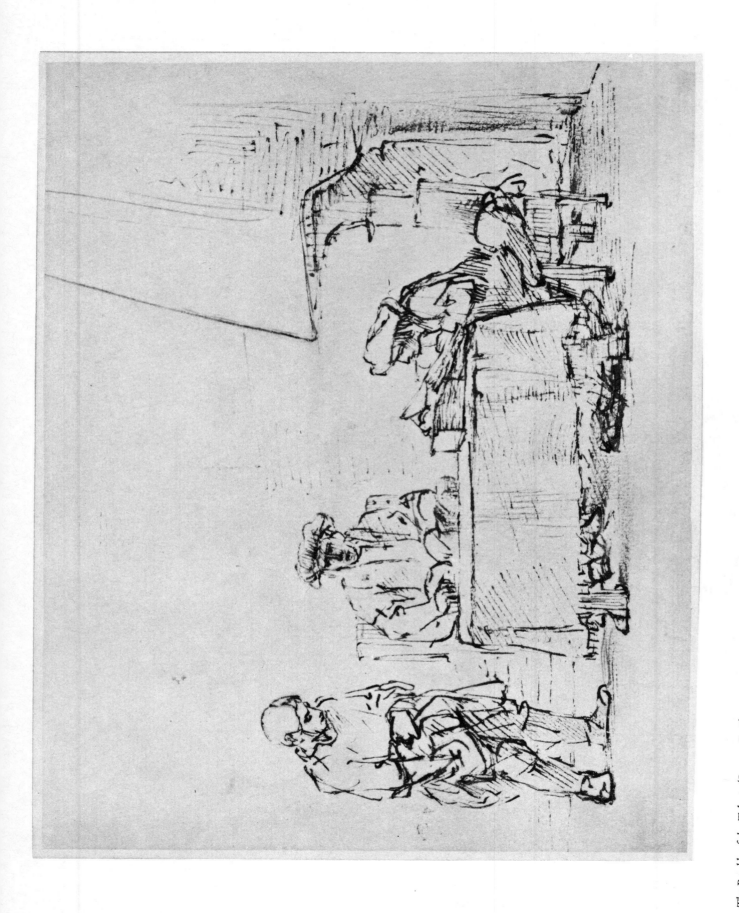

152 (I, 147). *The Parable of the Talents.* (Louvre, Paris)
Reed pen and bistre: 173 × 218 mm.

About 1652. Few drawings match the dramatic subtlety of this depiction of the lord who said to his servant, "For unto every one that hath shall be given, and he shall have abundance: but from him that hath not shall be taken away even that which he hath" (Matthew 25, 29).

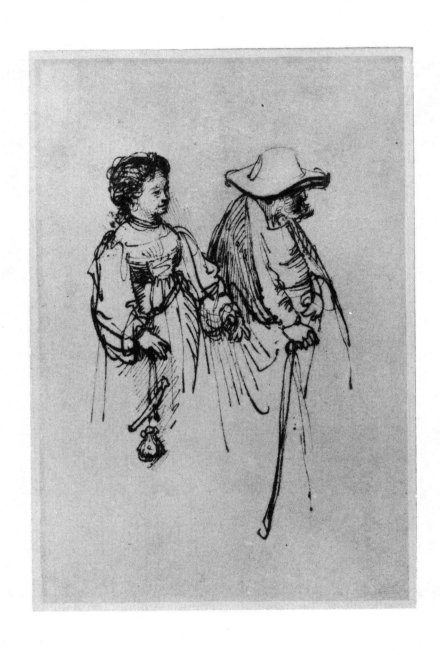

153 (*I, 148a*). *An Old Man and a Young Lady Walking.* (*Kupferstichkabinett, Dresden*)
Pen and bistre: 149 × 98 mm.
About 1633–35.

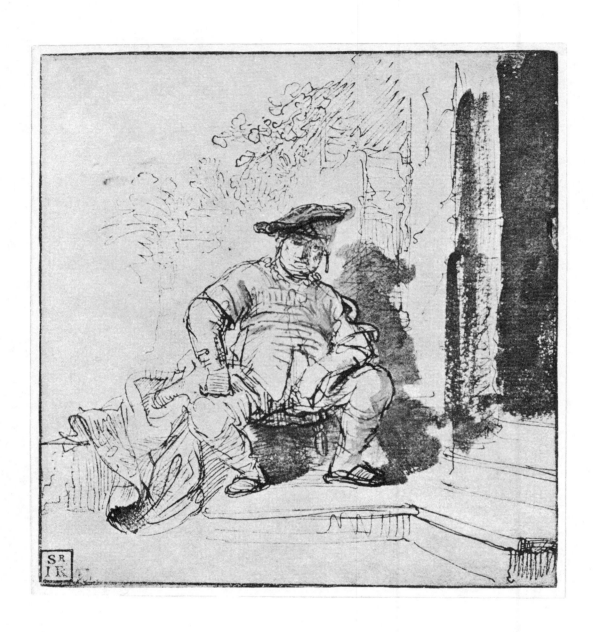

154 (*I, 148b*). *Man in a Flat Cap Seated on a Step.* (*Metropolitan Museum of Art, New York*)
Pen and wash in bistre: 146 × 138 mm.
About 1637.

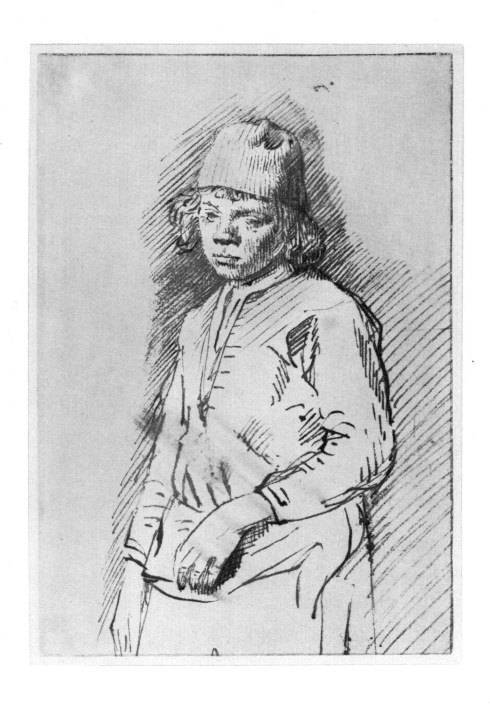

155 (*I, 149*). *A Young Man Standing.* (*Frits Lugt Collection, Paris*)

Pen in bistre: 167 × 111 mm.

About 1655. Similarity to the rare etching of Titus (Bartsch 11) suggests that Rembrandt's son posed for this beautiful drawing. Lugt (1933, no. 1151) rightly noted the Mantegnesque quality of the sheet; for a note about Rembrandt's interest in Mantegna see the comment to 121 (I, 119). Benesch refers to it as a school piece (see his note to 1184).

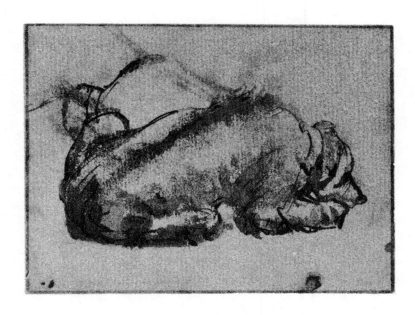

156 (*I, 150a*). *A Dog Lying on the Ground with a Collar Around His Neck.* (*Paul Cassirer Collection, Amsterdam*)

Pen and brush in Indian ink: 74 × 97 mm.

About 1648. Benesch (784) catalogues the animal as a bear.

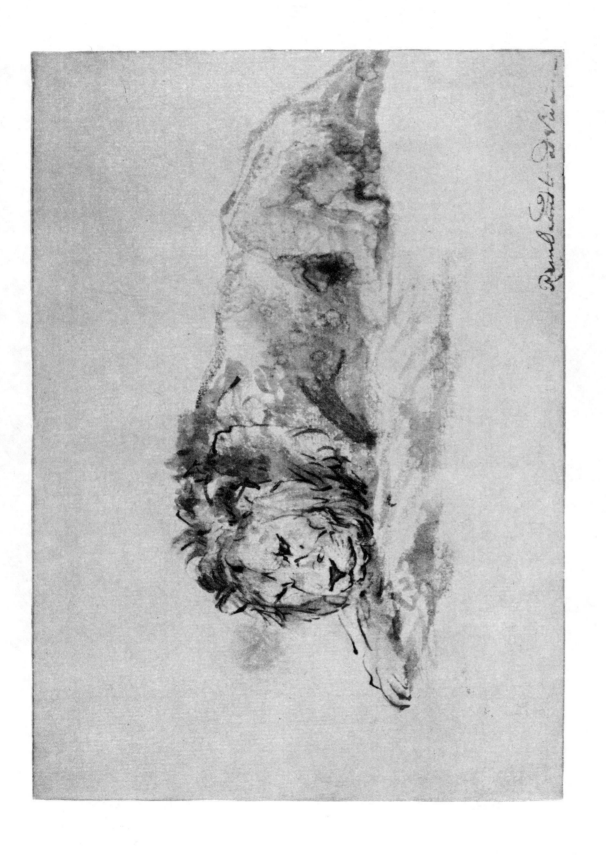

157 (I, 150b). *A Lion Resting, Turned to the Left.* (Rijksprentenkabinet, Amsterdam)

Pen and brush: 140 × 205 mm. Inscribed by a later hand: Rembrandt ad Vivum.

About 1650–52. This study, which captures both the grace and power of the noble beast, is primarily a brush drawing. See 244 (II, 27) for a later drawing of a lion done with a reed pen.

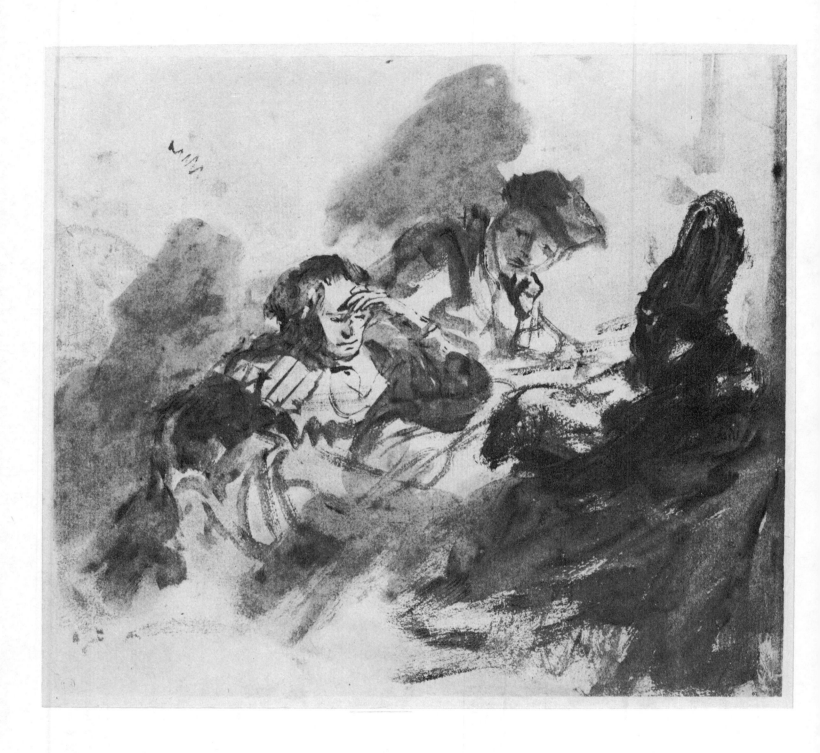

158 (*I, 151*). *Study of a Group of Figures.* (*Musée, Bayonne*)

Pen and brush: 173 × 190 mm.

The subject has been variously interpreted. It has been suggested that the shadowy figures are a group of chess-players (in the first edition of this work), the Holy Family with Simeon in the Temple (Hofstede de Groot 682), Saskia looking in a mirror (J. Q. van Regteren Altena, Holländische Meisterzeichnungen des siebzehnten Jahrhunderts, Basel, 1948, no. 19), and members of Rembrandt's family listening to a reading (Benesch 52). Benesch writes that the young man in the center seems to be the artist himself. The composition, strong chiaroscuro effect and broad brush work suggest a date around 1630.

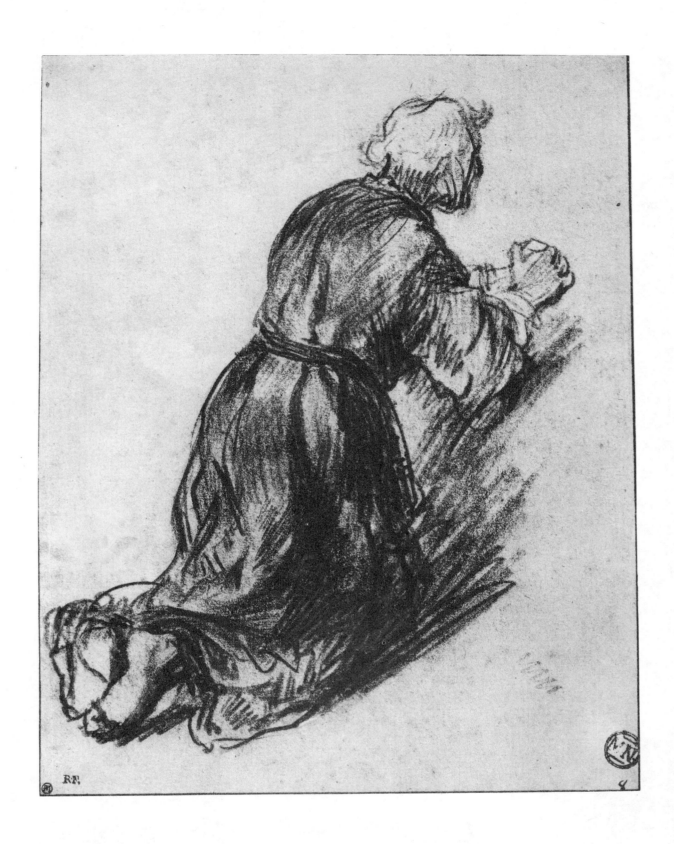

159 (*I, 152*). *St. Jerome.* (*Louvre, Paris*)

Red and black chalk: 206 × 161 mm.

About 1630. A preparatory study for a lost painting which was etched by J. G. van Vliet in 1631 (Bartsch 13; reproduced W. Fraenger, Der junge Rembrandt, *Heidelberg, 1920, figure 13, and Kurt Bauch,* Die Kunst des jungen Rembrandt, *Heidelberg, 1933, figure 99*).

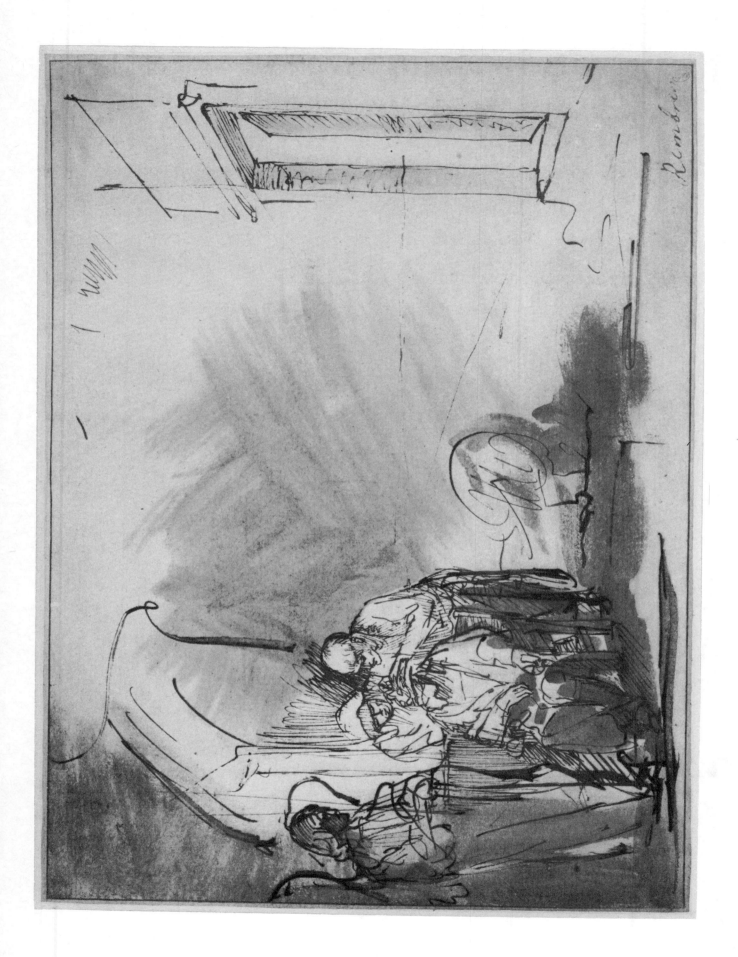

160 (I, 153). *The Healing of Tobit.* (*Louvre, Paris*)

Pen and bistre: 185 × 255 mm. Inscribed by a later hand: *Rimbren.*

About 1638. On the right the beginning of a perspective construction.

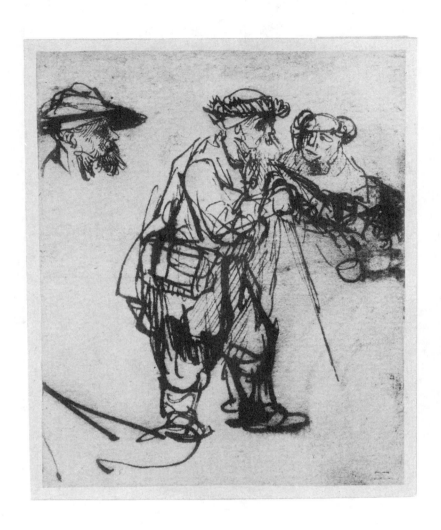

161 (*I, 154a*). *Blind Man Guided by a Woman, and a Study of a Head in Profile on the Left.* (*Louvre, Paris*)
Pen and bistre: 122 × 98 mm.

About 1640. Rosenberg (Zeitschrift für Kunstgeschichte, 4, 1935, Heft 1–2) pointed out that the study was used by Rembrandt for his Hundred Guilder Print (*Bartsch 74*). *The etching was finished around 1649.*

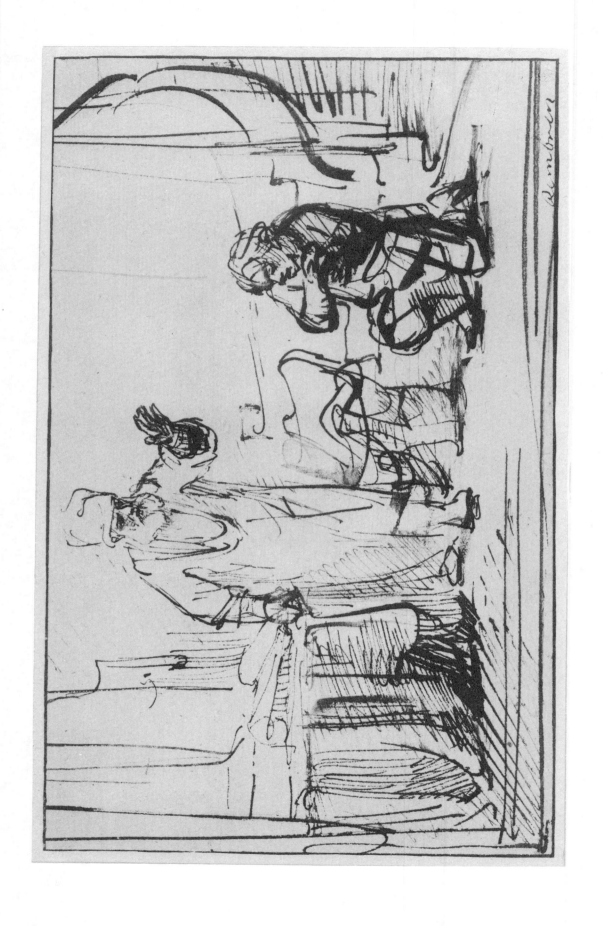

162 (I, 154b). *The Wicked Servant Begs for Pardon. (Louvre, Paris)*

Pen and brush in bistre, corrections in white: 150 × 243 mm. Inscribed by a later hand: Rembren.

About 1640. Benesch (A49) ascribes the sheet to Rembrandt's school. A copy of the drawing is in the Albertina, Vienna (Valentiner, 366b).

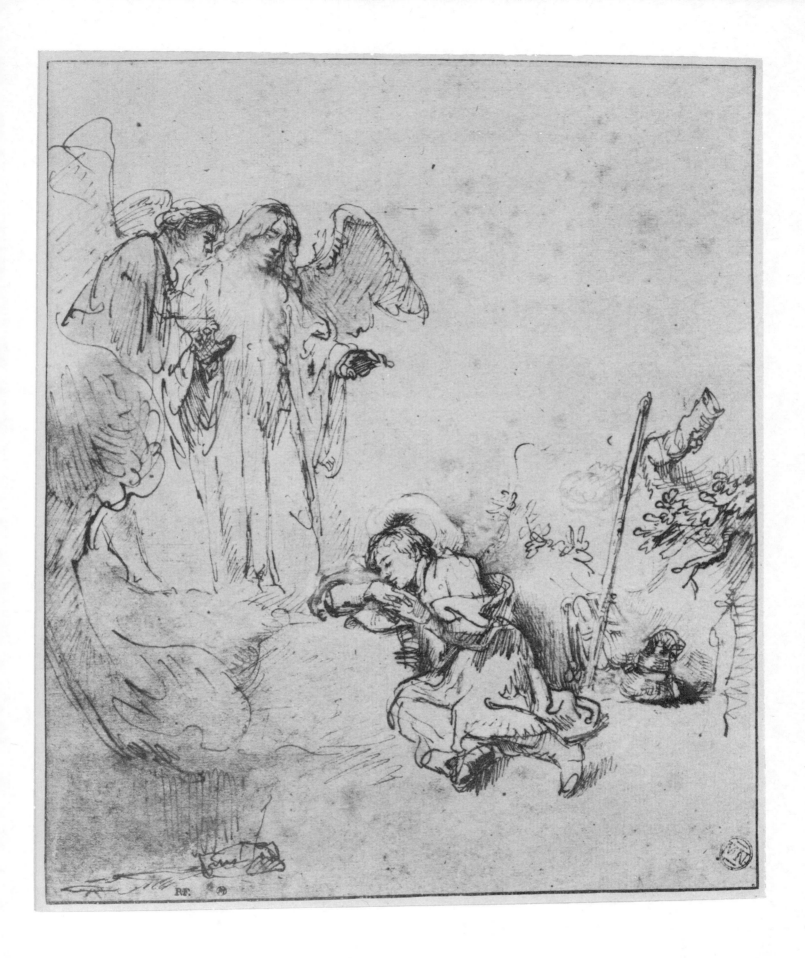

163 (*I, 155*). *Jacob's Dream. (Louvre, Paris)*

Pen and wash in bistre, corrections in white body color: 250 × 208 mm.

About 1640. The unorthodox omission of the ladder makes the connection between the angels and Jacob more intimate than it is in more literal representations of the subject.

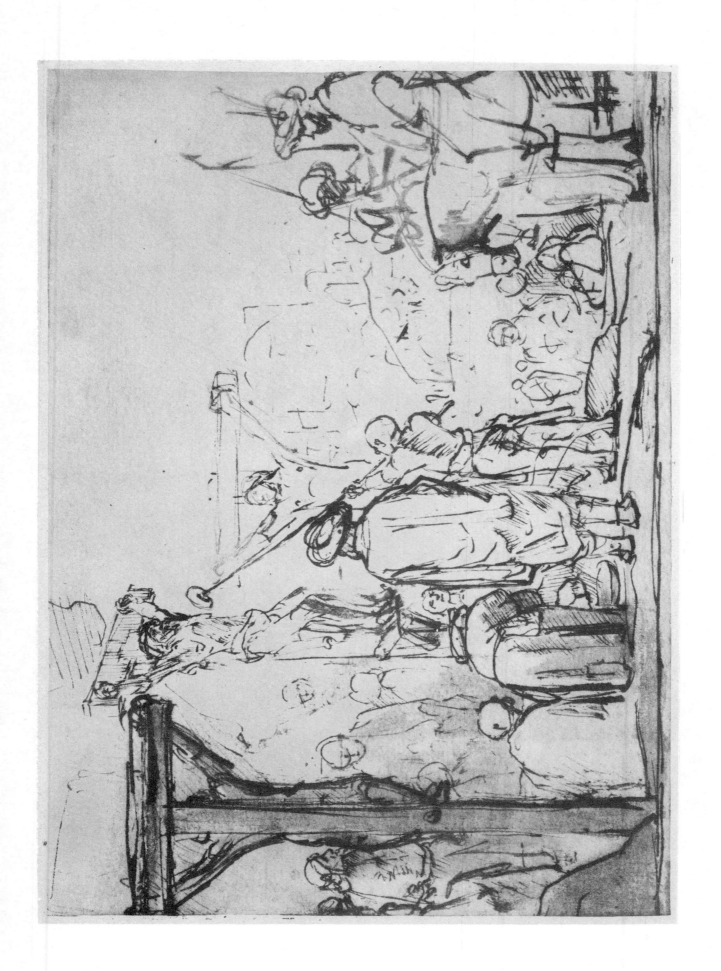

164 (I, 156). *Christ Crucified Between the Two Thieves. (Louvre, Paris)*
Pen and wash in bistre, white body color: 205 × 285 mm.
About 1650–55.

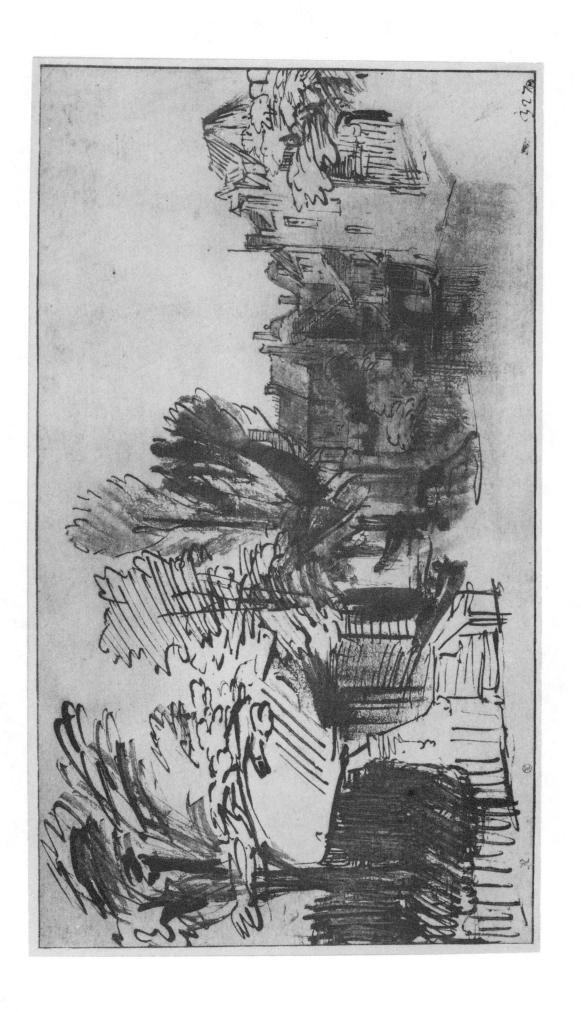

165 (I, 157). *The Singel in Amersfoort.* (Louvre, Paris)
Pen and bistre, wash: 153 × 277. Inscribed by a later hand: R.
About 1648–50. The site was identified by Lugt (1920).

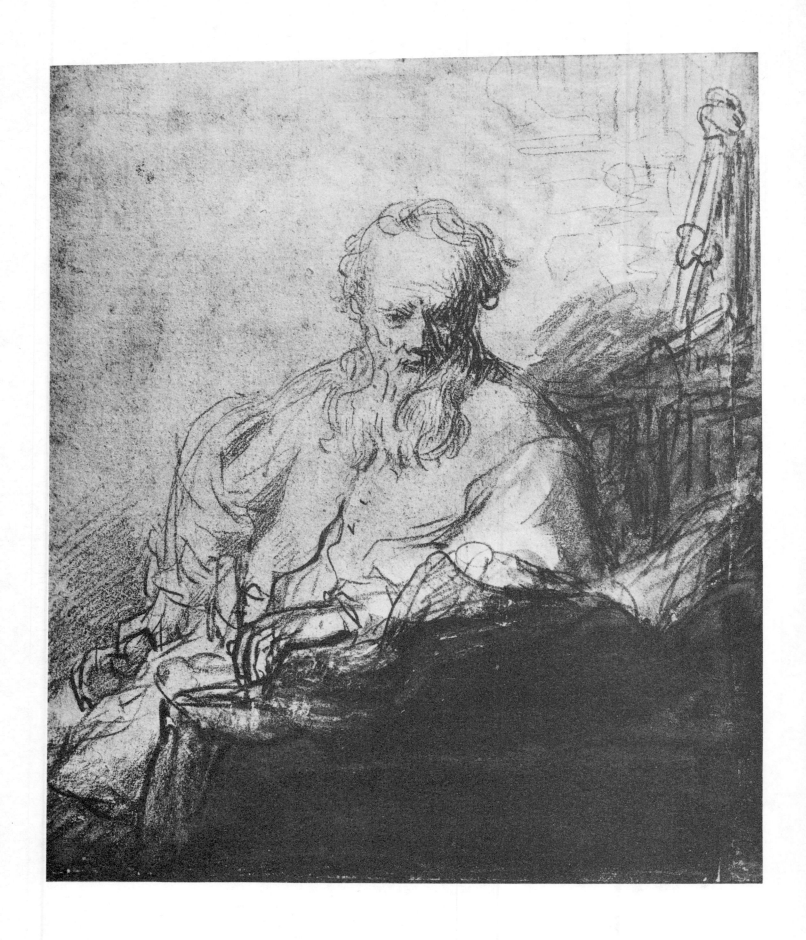

166 (*I, 158*). *St. Paul. (Louvre, Paris)*

Red chalk and wash in Indian ink, white body color: 236 × 201 mm.

About 1629; study (in reverse) for the etching of the same subject (Bartsch 149) which can be assigned the same date.

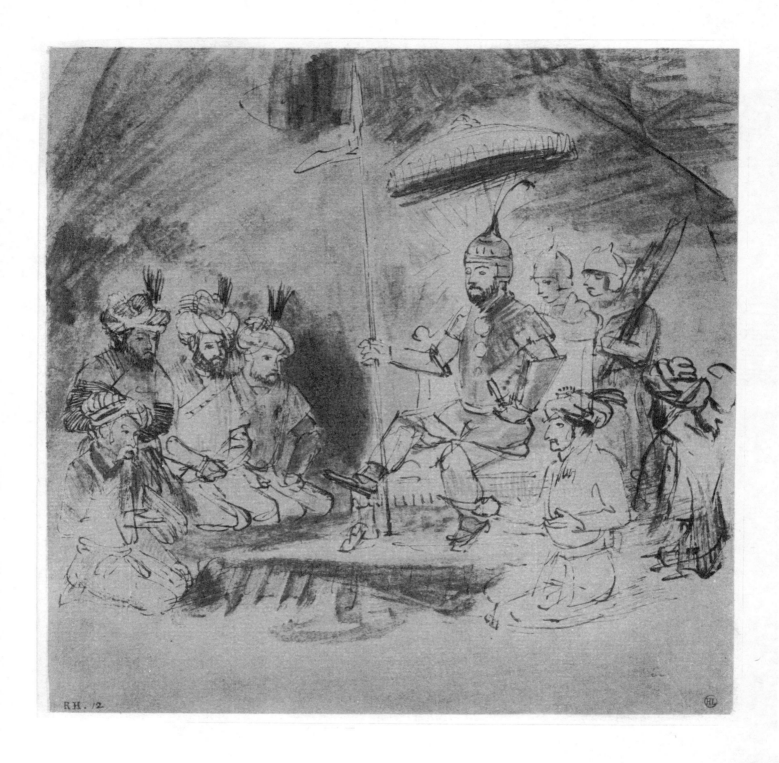

167 (I, 159). *The Emperor Tamerlane (1336–1405) Enthroned, Surrounded by Five of His Followers.*
(*Louvre, Paris*)

Pen and wash in Indian ink, on Japanese paper: 186 × 187 mm.

*About 1655. One of Rembrandt's twenty-one copies after Moghul School miniatures, now scattered among
various collections. The miniature which served as the artist's model is now divided into two parts (see J. Strzygowski,*
Die indischen Miniaturen im Schlosse Schönbrunn, *Wiener Drucke, 1923, Pl. 55F, and J. Strzygowski-H.
Glück,* Asiatische Miniaturenmalerei, *Klagenfurt, 1933, p. 23). This mutilated Moghul miniature, as well as some
others copied by Rembrandt, are in Schönbrunn Castle, where they decorate a rococo room.*

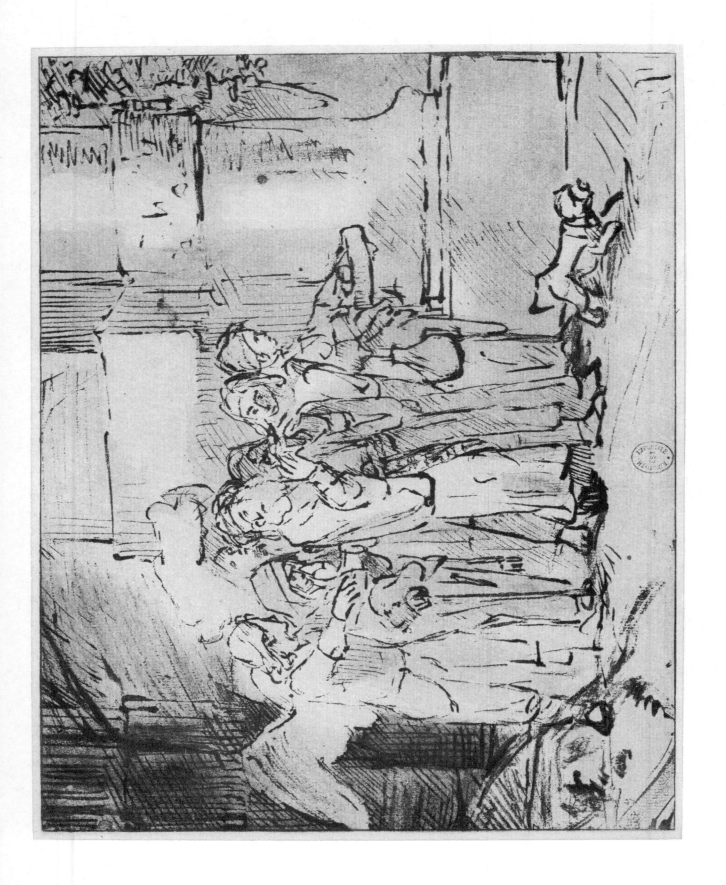

168 (I, 160). *Lot and His Family Led by the Angel Out of Sodom. (Bibliothèque Nationale, Paris)*

Pen and bistre, wash: 192 × 243 mm.

About 1655. Benesch (C89) considers it a copy, but it is justly praised by Valentiner (39), Lugt (1936, p. 64, no. 246) and Rosenberg (1959, C89) as a masterful original.

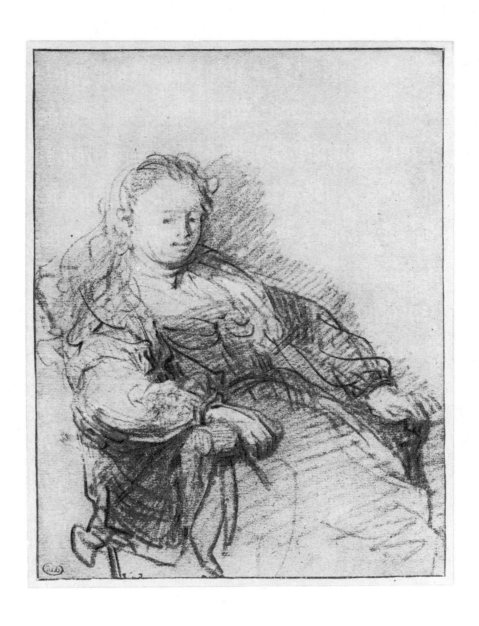

169 (*I, 161a*). *Saskia Seated in an Armchair.* (*Louvre, Paris*)

Red and white chalk: 147 × 110 mm.

About 1635. The drawing shows what vitality Rembrandt could give to the stock pose of a three-quarter-length portrait of a woman seated in an armchair.

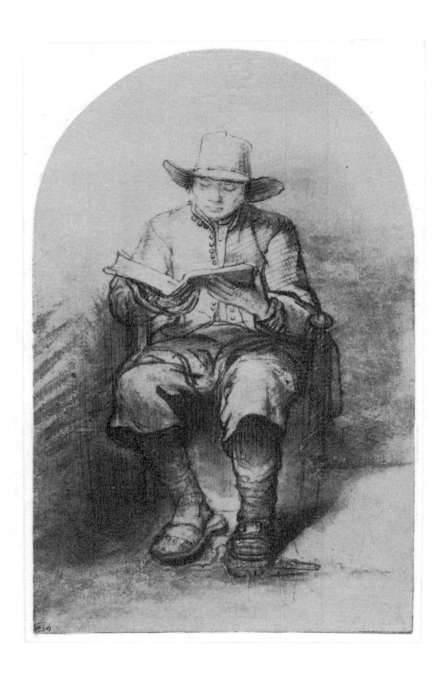

170 (*I, 161b*). *A Man in a Broad Hat, Seated, Reading a Book.* (*Louvre, Paris*)

Pen and wash in bistre, white body color: 163 × 103 mm.

In Rembrandt's manner of about 1645 by a pupil or a follower. Lugt (1933, no. 1154) expresses reservations about ascribing it to Rembrandt; not listed by Benesch.

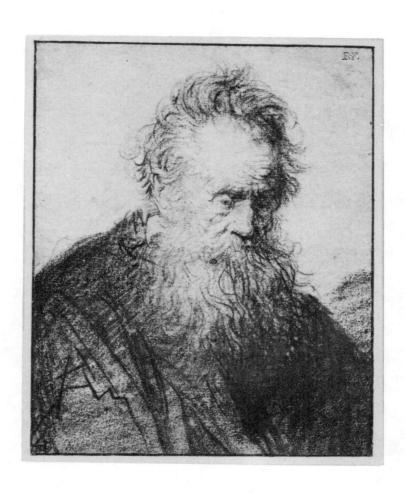

171 (*I, 162a*). *Bust of a Bearded Old Man. (Louvre, Paris)*
Red and white chalk: 114 × 91 mm.
One of a group of drawings of this bearded model made around 1630.

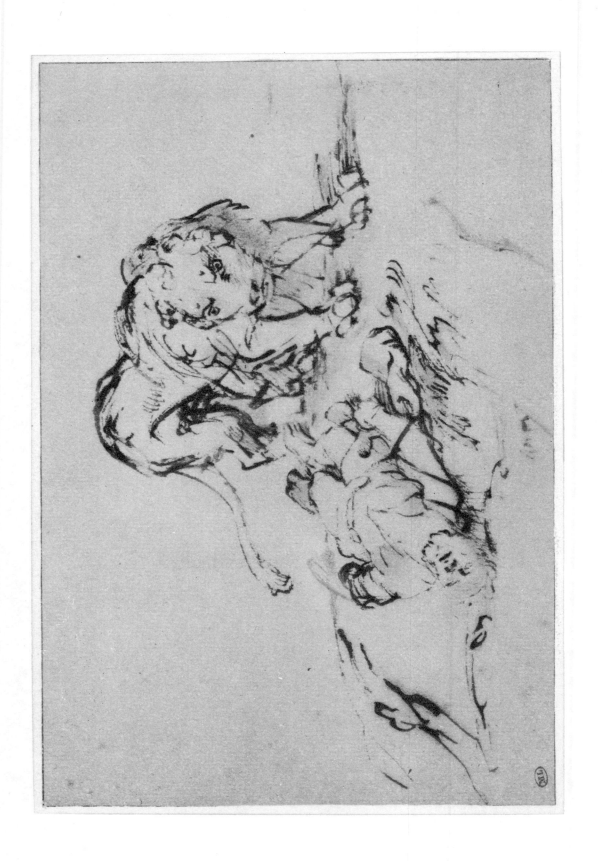

172 (I, 162b). *The Lion by the Body of the Disobedient Prophet. (Louvre, Paris)*
Pen and bistre, white body color: 137 × 205 mm.
About 1655.

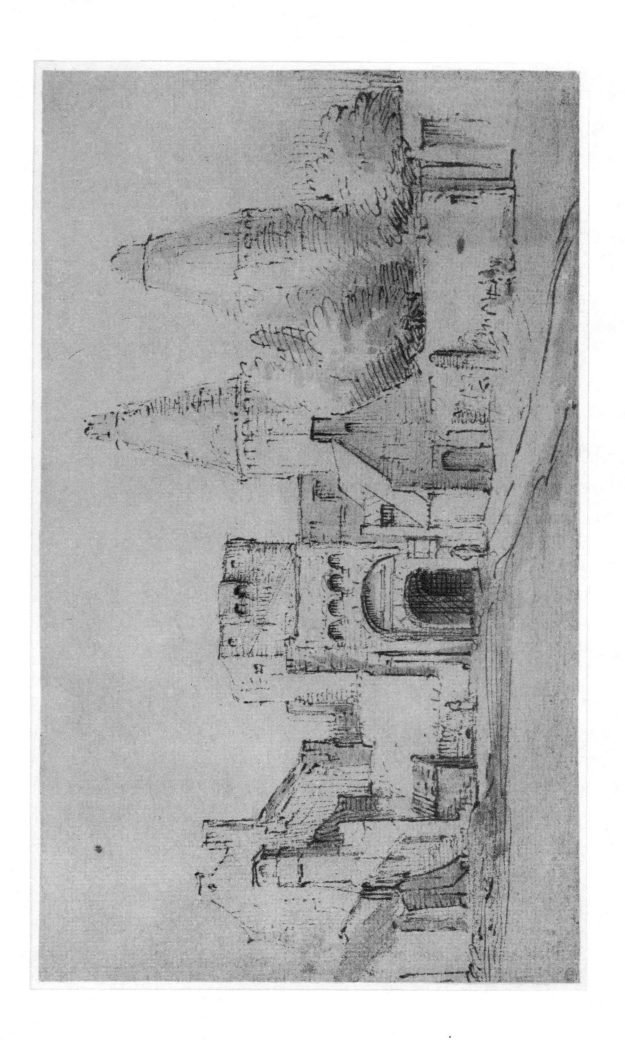

173 (I, 163). *The Rijnpoort at Rhenen.* (Louvre, Paris)
Pen and wash in Indian ink: 146 × 252 mm.
About 1648. See the comment to 72 (I, 72).

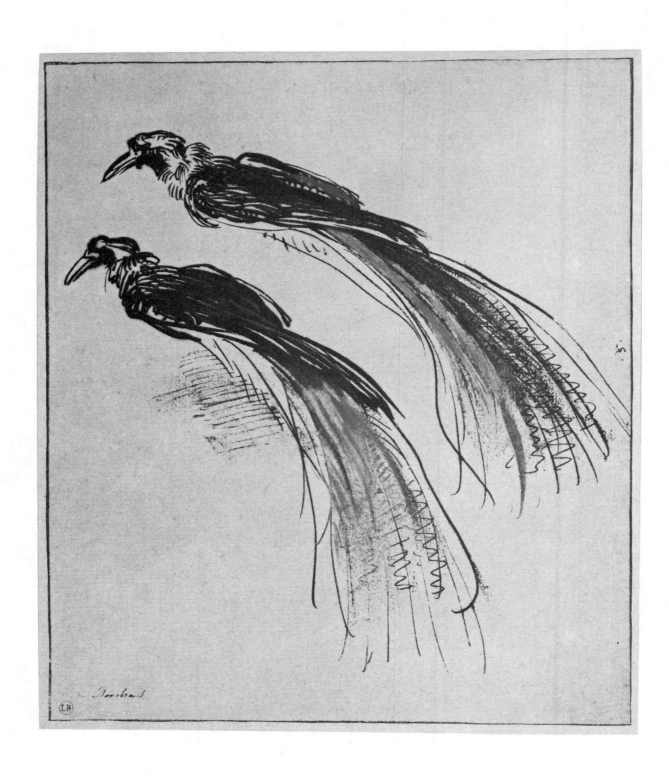

174 (*I, 164*). *Two Studies of a Bird of Paradise.* (*Louvre, Paris*)

Pen and wash in bistre, white body color: 181 × 154 mm. Inscribed by a later hand: Rembrant.

About 1637. The way these exotic birds fill the page is as admirable as Rembrandt's depiction of the different weights and textures of the feathers on their heads, necks, bodies and great tails.

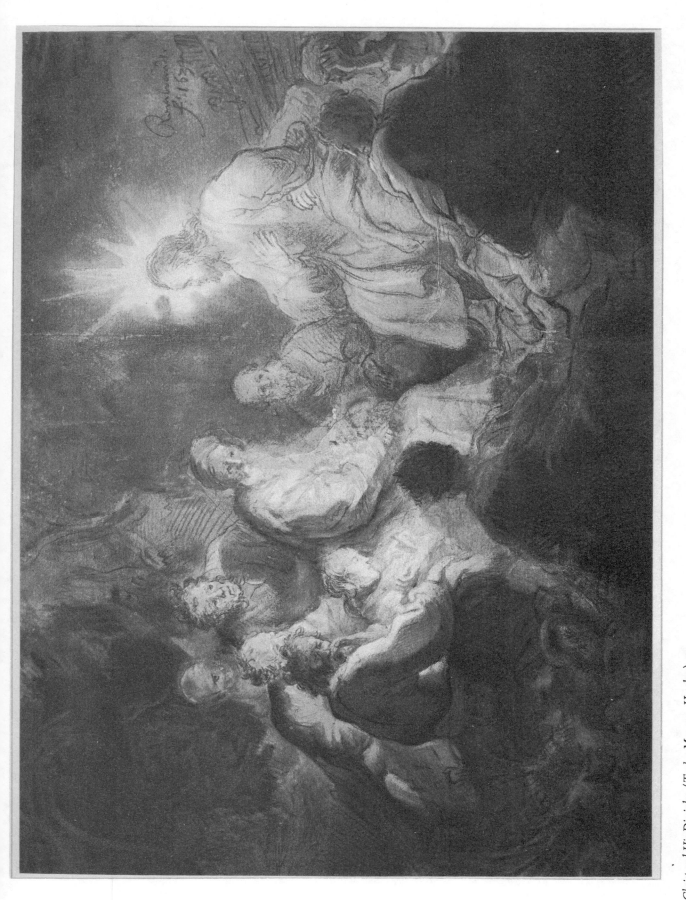

175 (I, 165). *Christ and His Disciples.* (Teyler Museum, Haarlem)

Red and black chalk, pen and brush in bistre, heightened with brown, yellow and red, white body color: 355 × 476 mm. Signed and dated: Rembrandt f. 1634.

The disciple in the middle is drawn on a separate piece of paper which was pasted upon the sheet by Rembrandt. The precise subject of this large drawing has not been determined. The unusual size, the high degree of finish and the full signature and date suggest it was not a preparatory study, but was designed to be viewed as an independent work.

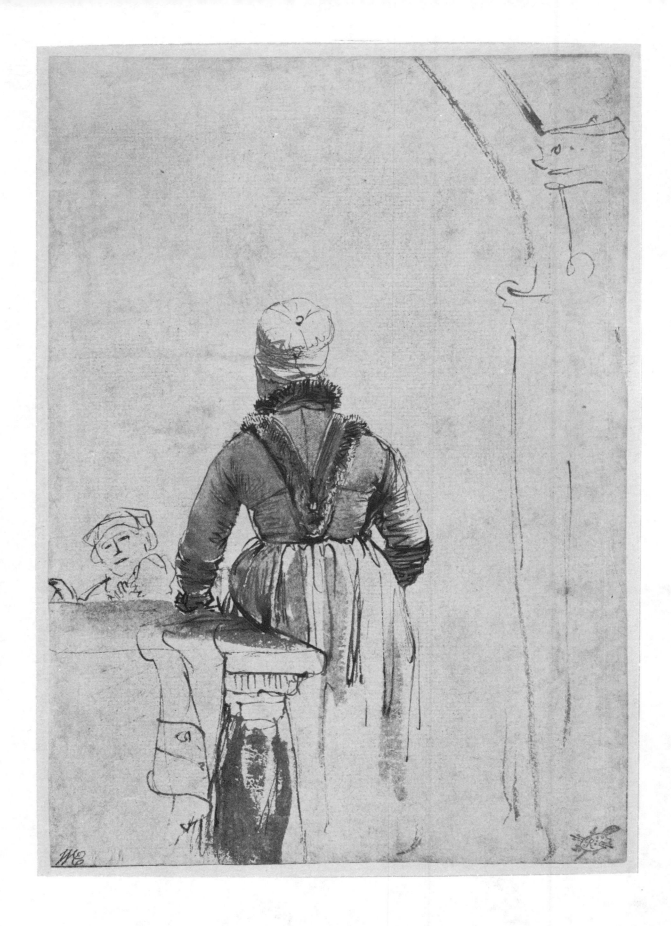

176 (*I, 166*). *Woman Wearing a Costume of North Holland, Seen from the Back.* (*Teyler Museum, Haarlem*)
Pen and wash in bistre: 220 × 150 mm.

About 1642. On the obverse of the drawing is an inscription in a seventeenth-century hand: De minne moer van
Titus (*The wet nurse of Titus*). *Nothing about the style of the drawing contradicts this assertion that the
sheet represents Geertje Dircx, the trumpeter's widow who cared for Titus after the death of Saskia in 1642.
However, a contemporary document expressly states that Geertje's duties in Rembrandt's household did not include
that of a wet nurse (see C. Hofstede de Groot,* Die Urkunden über Rembrandt, *The Hague, 1906, no. 117).
The same model is represented in a drawing at the British Museum; see 538 (IV, 89a).*

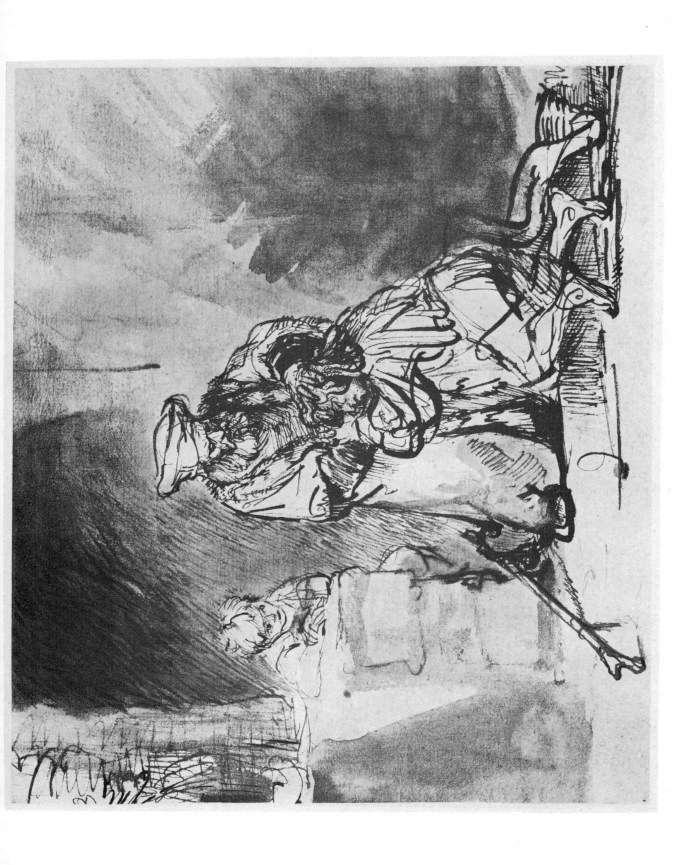

177 (I, 167). *The Return of the Prodigal Son. (Teyler Museum, Haarlem)*
Pen and wash in bistre: 190 × 227 mm.

About 1642. The drawing was etched in reverse by I. J. de Claussin and dated 1642. The style fits that year better than 1636, the date given by Valentiner (388) and others who attempt to relate the drawing to Rembrandt's 1636 etching of the subject (Bartsch 91).

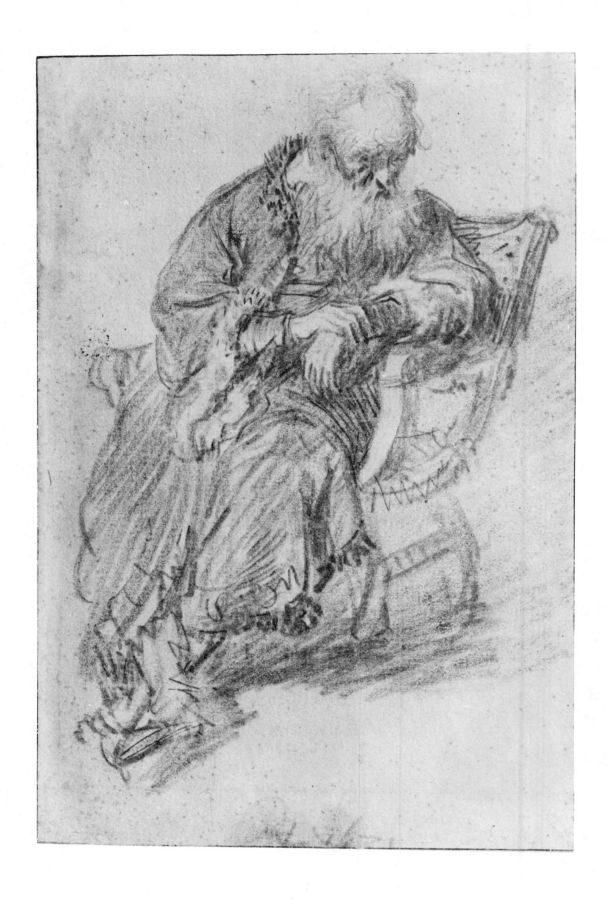

178 (*I, 168*). *Bearded Old Man Seated in an Armchair, Turned to the Right, Full-length.* (*Teyler Museum, Haarlem*)

Red and black chalk: 225 × 145 mm. Signed with a monogram and dated: Rt 1631.

Belongs to a series of chalk studies of old men made during Rembrandt's last years in Leiden.

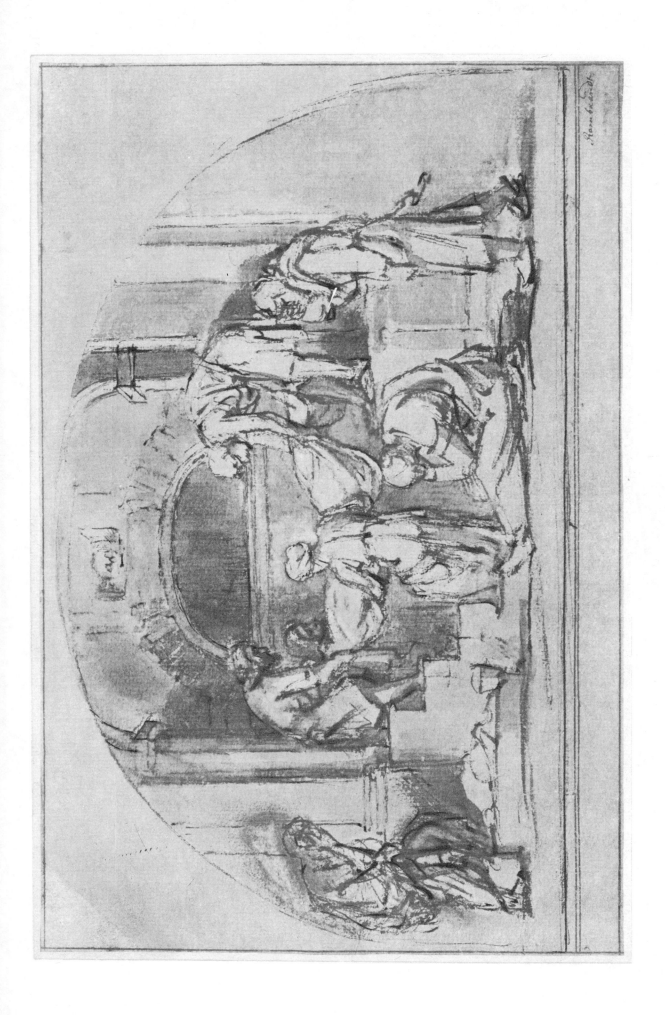

179 (I, 169). *The Entombment of Christ. (Teyler Museum, Haarlem)*

Pen and wash in bistre, white body color, in the shape of a lunette (the upper corners added later): 180 × 283 mm. Inscribed by another hand: Rembrandt.

About 1655–60. The drawing is yet another proof of Rembrandt's interest in High Renaissance art. It is a free copy of a drawing, variously attributed to Polidoro da Caravaggio and to Perino del Vaga, which is now at the Fogg Art Museum, Cambridge, Massachusetts; a variant of the Fogg drawing is at the Louvre, Paris. A second free copy by Rembrandt of the same composition is reproduced 210 (I, 193).

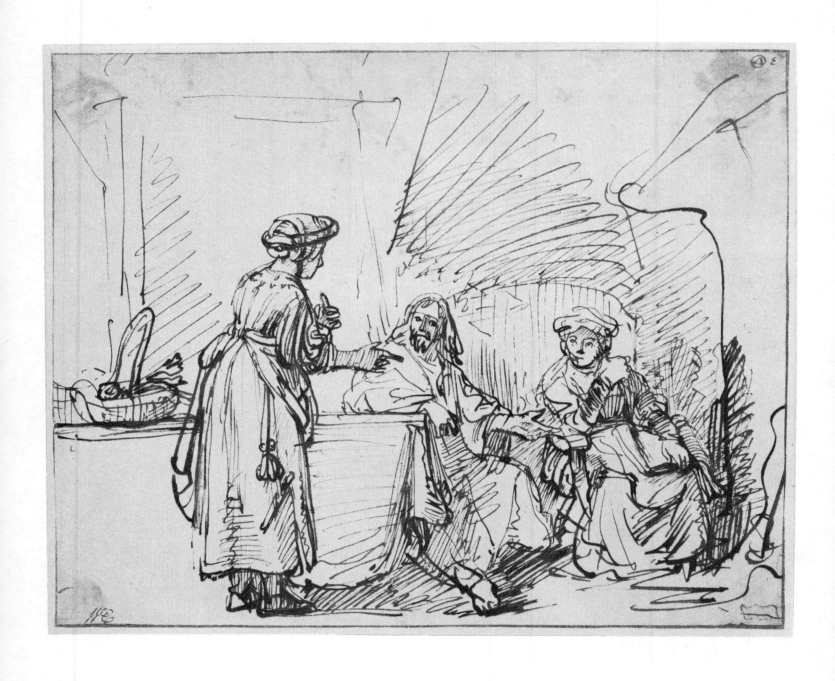

180 (I, 170). *Christ in the House of Mary and Martha.* (Teyler Museum, Haarlem)

Pen and bistre: 160 × 190 mm.

Gestures and expressions make clear in this rapid sketch of around 1633 the story of Mary's role, Martha's complaint and Christ's response.

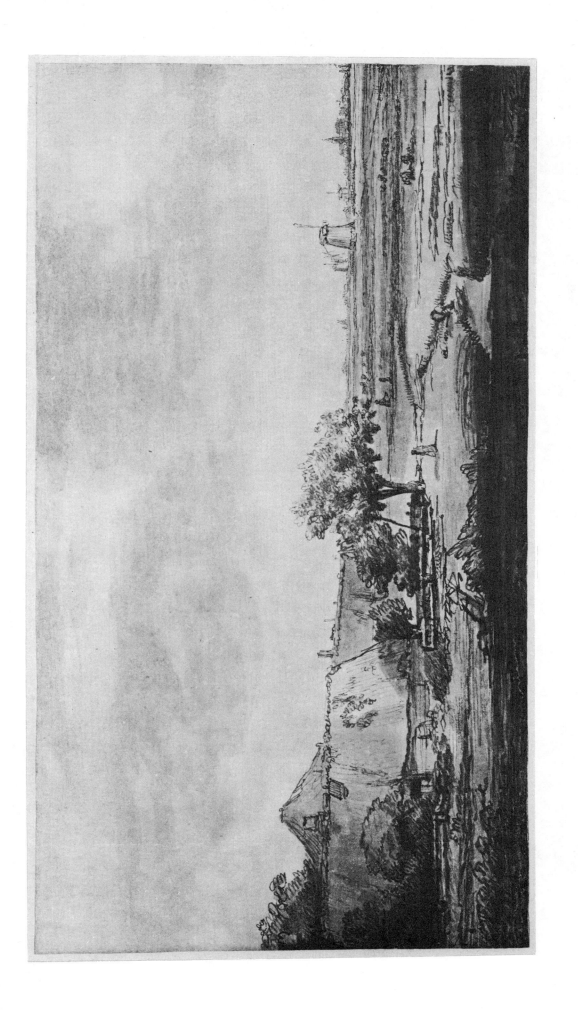

181 (I, 171). *View of a Wide Plain, with Windmills in the Distance on the Right.* (*Louvre, Paris*)

Pen in bistre, washes in bistre and Indian ink: 165 × 305 mm.

Not autograph. Lugt (1933, no. 1348) writes that it may be an early eighteenth-century imitation. Attributed to Philips Koninck by
 H. Gerson, 1936, p. 146, Zeichnung 73.

182 (I, 172a). *St. John the Baptist Preaching. (Louvre, Paris)*

Pen and wash in bistre, white body color: 145 × 204 mm. Inscribed in a later hand: Renbrant.

About 1655. A design for a frame for Rembrandt's own painting of about 1637 now at Berlin-Dahlem (Bredius 555). Lugt made the plausible suggestion (1933, p. 11, no. 1131) that Rembrandt made the sketch for Jan Six when he acquired the painting.

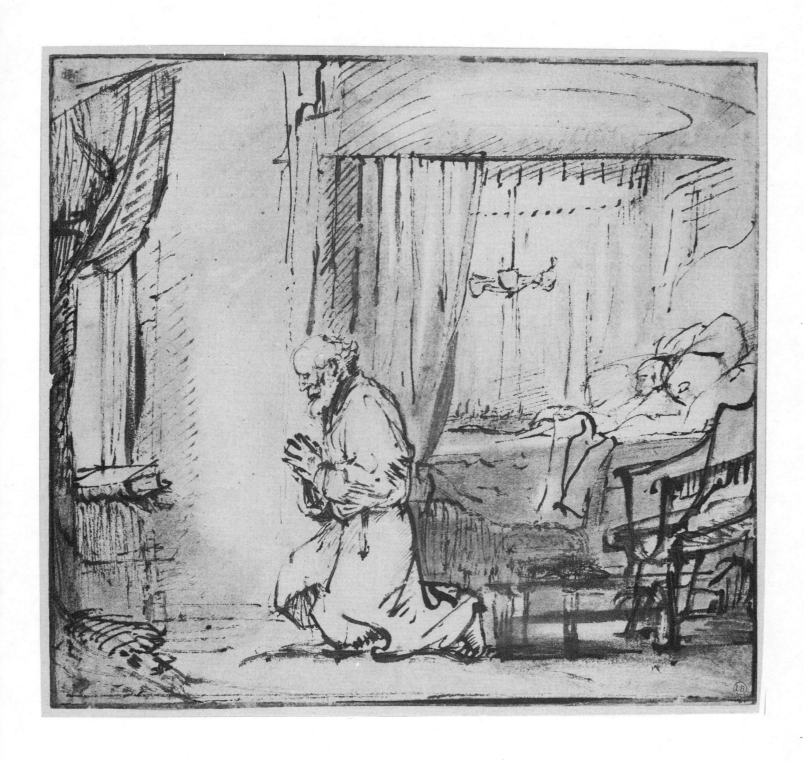

183 (*I, 172b*). *St. Peter's Prayer Before the Raising of Tabitha.* (*Musée, Bayonne*)

Reed pen and wash, white body color: 190 × 200 mm.

*About 1655–60. Young Rembrandt would have shown the dramatic climax when Peter said, "Tabitha, arise,"
but it was characteristic of the mature Rembrandt to choose the most restrained moment of the story. Here he shows
Peter after he put forth those who called him "and kneeled down, and prayed" (Acts 9, 40). The result is one of the
artist's most moving works.*

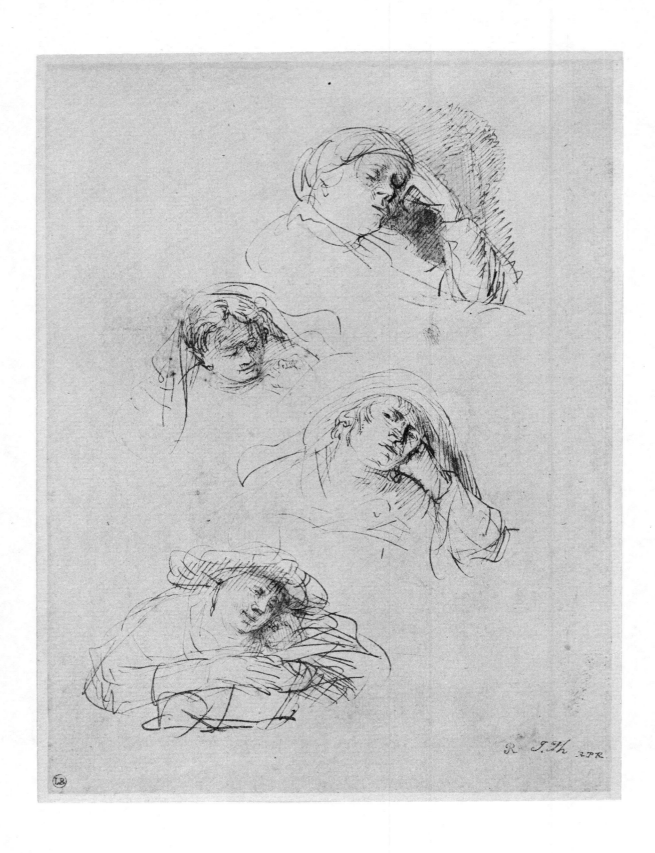

184 (*I, 173a*). *Four Studies of Saskia.* (*Boymans–van Beuningen Museum, Rotterdam*)

Pen and wash in bistre: 200 × 150 mm.

About 1636. Rembrandt made similar etched studies of Saskia around the same time (Bartsch 365, dated 1636; Bartsch 368, dated 1637). The prints are remarkable because they transfer the sketchy informal quality of this page to the art of etching. See the following number for the verso.

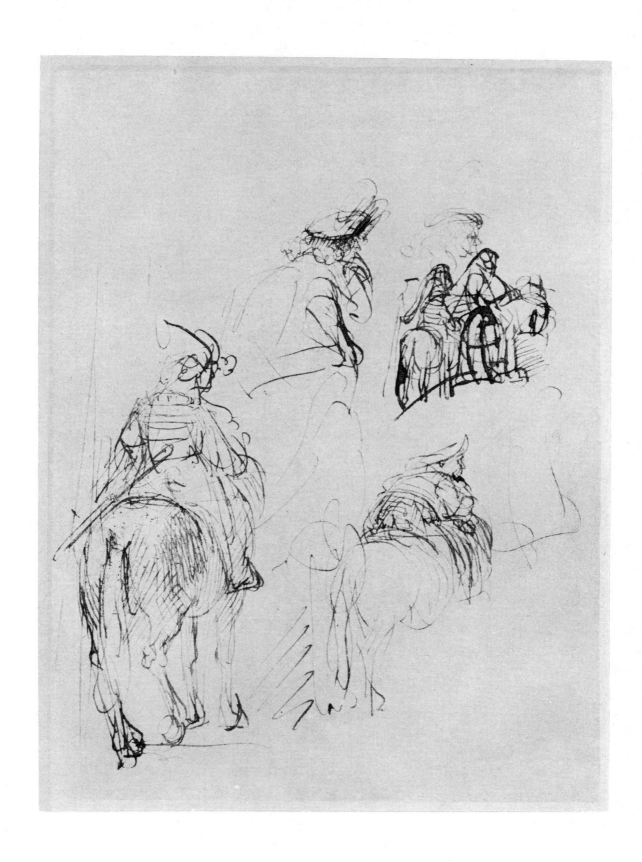

185 (*I, 173b*). *Studies of Men on Horseback.* (*Boymans–van Beuningen Museum, Rotterdam*)
Pen and bistre: 200 × 150 mm.
Verso of the preceding number.

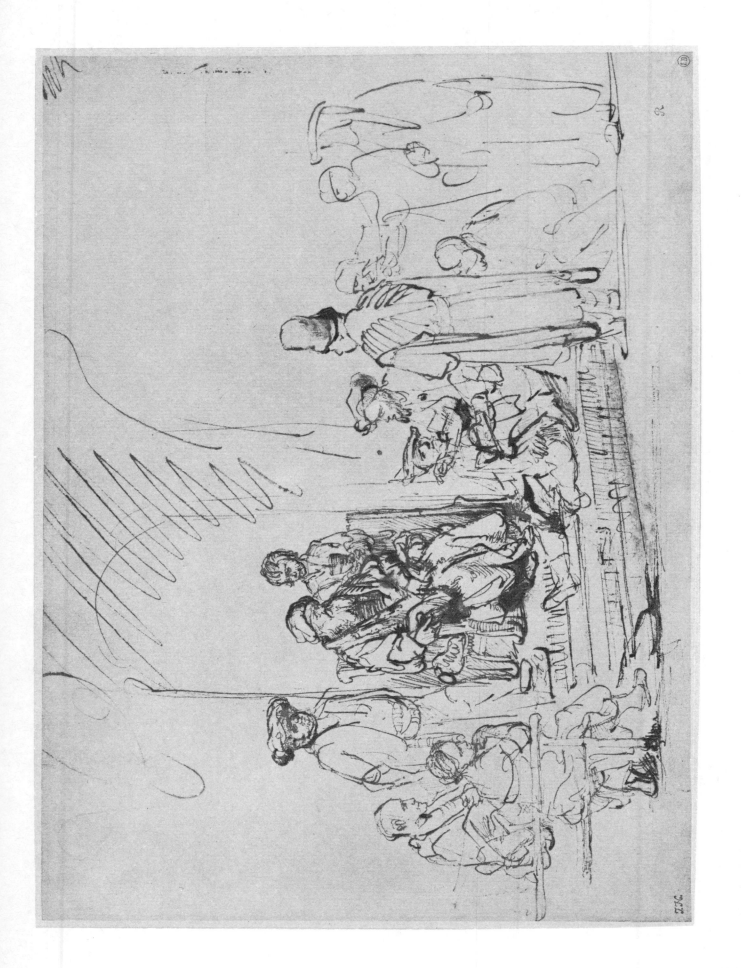

186 (I, 174). *Joseph's Brothers Requesting Benjamin from Their Father.* (*Louvre, Paris*)
Pen and brush in bistre: 200 × 277 mm.

About 1638–40. Another elaborate study made around the same time for this scene from Genesis 43 is reproduced 300 (II, 70).

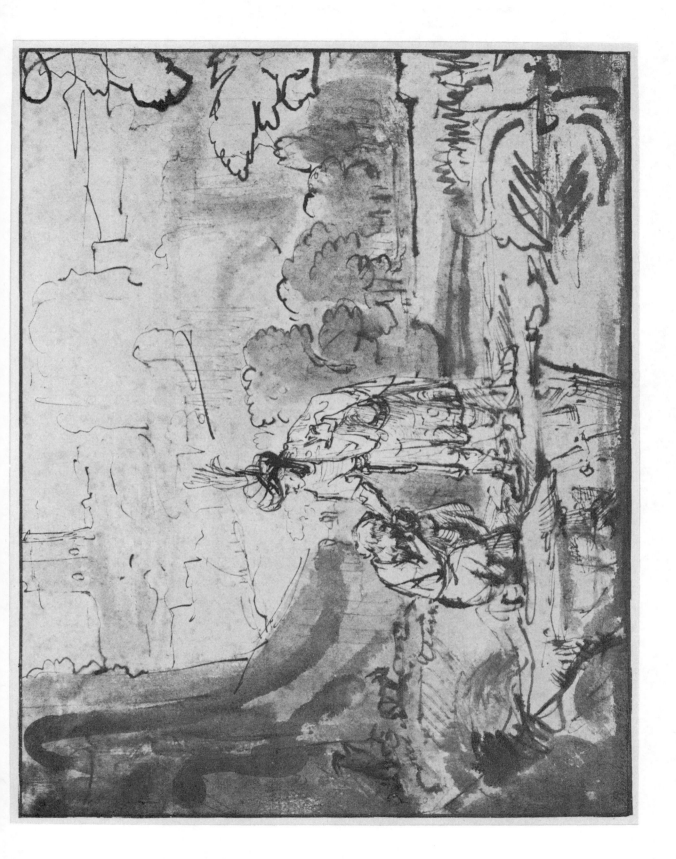

187 (I, 175). *David Taking Leave of Jonathan. (Louvre, Paris)*

Pen and wash in bistre: 180 × 235 mm. Inscribed by a later hand: Rembrant 1634.

About 1642. Lugt (1933, p. 4, no. 1115) lists other interpretations which have been given of the subject. The drawing is related to Rembrandt's painting The Reconciliation of David and Absalom of 1642 at The Hermitage, Leningrad (Bredius 511); it should be noted that the Hermitage painting was catalogued as David and Jonathan in a 1716 inventory of pictures belonging to Peter the Great. For a school drawing which has been called David Taking Leave of Jonathan see 375 (III, 42).

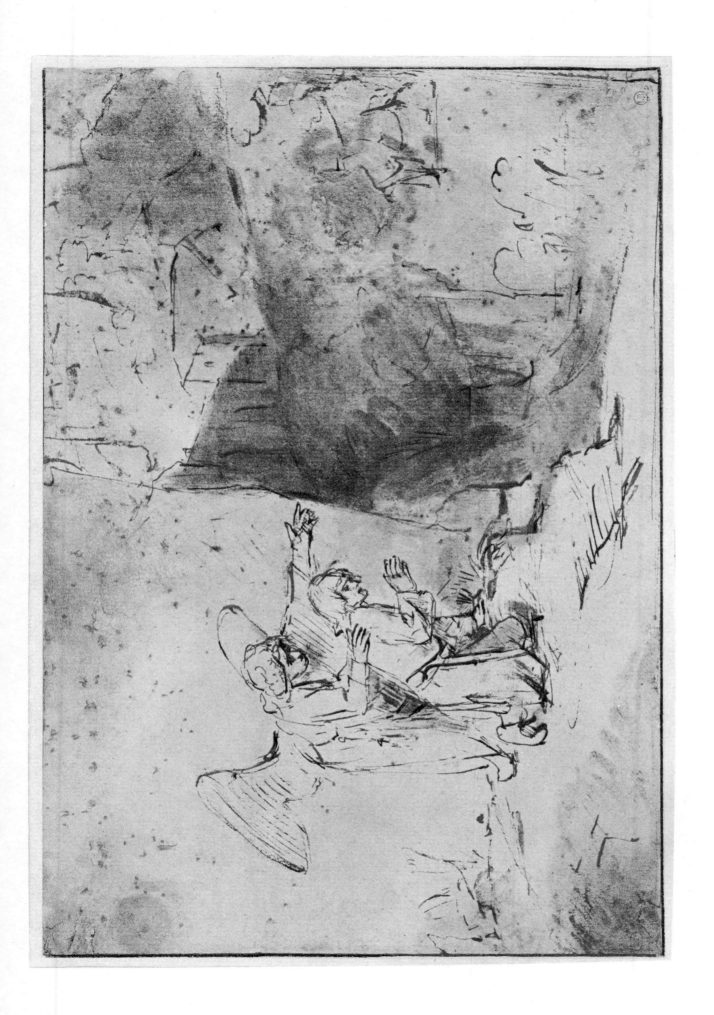

188 (I, 176). *The Vision of Daniel. (Louvre, Paris)*
Reed pen and wash in bistre: 165 × 243 mm.

About 1652. Study for the painting at Berlin-Dahlem (Bredius 519). One of the rare extant Rembrandt drawings which can be called a preparatory study for one of the master's paintings. Others, of course, can be related to his pictures, but few approximate them as closely as this one.

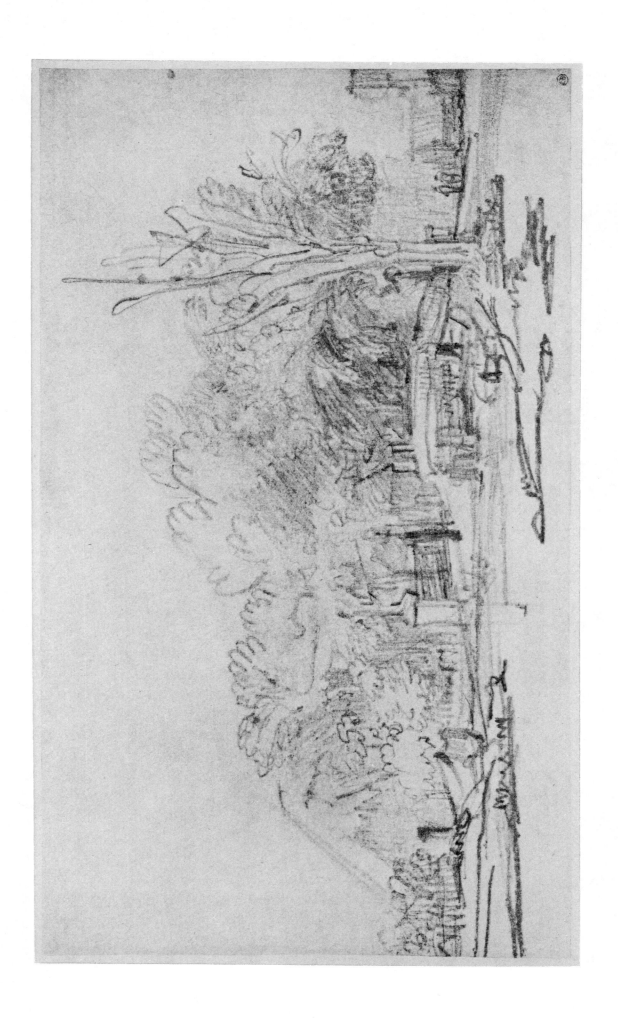

189 (I, 177). *House Amidst Trees. (Musée, Bayonne)*

Black chalk: 175 × 297 mm.

About 1642–45. Lugt (1920) suggests the drawing may have been made along the Amstelveensche Weg.

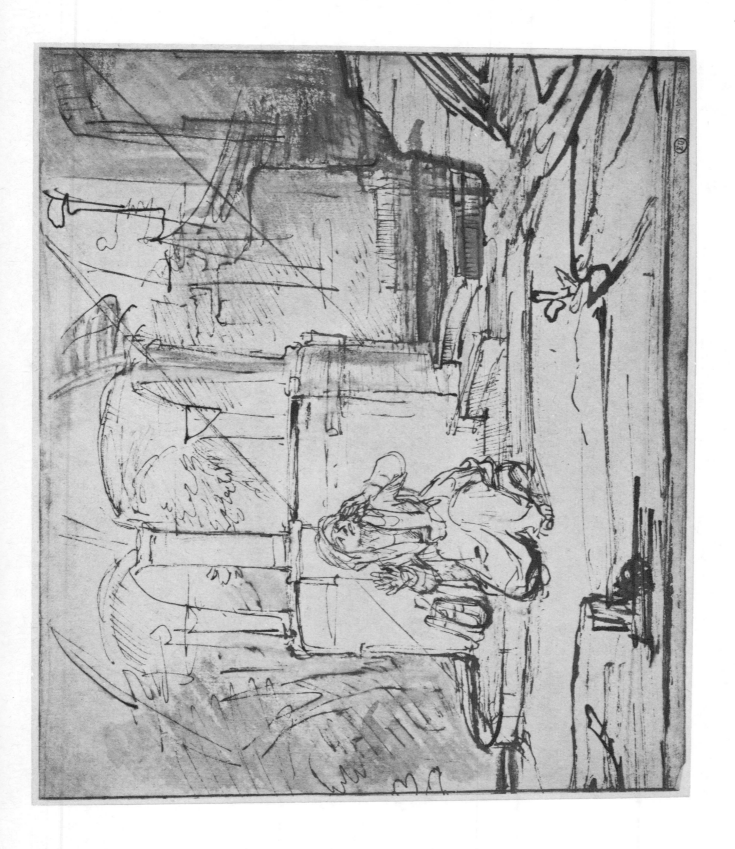

190 (I, 178). *Hagar by the Fountain on the Way to Shur.* (Louvre, Paris)

Pen and wash in bistre, white body color. Sepia washes by another hand in the cupola of the fountain and on the right: 191 × 227 mm.

About 1642–45.

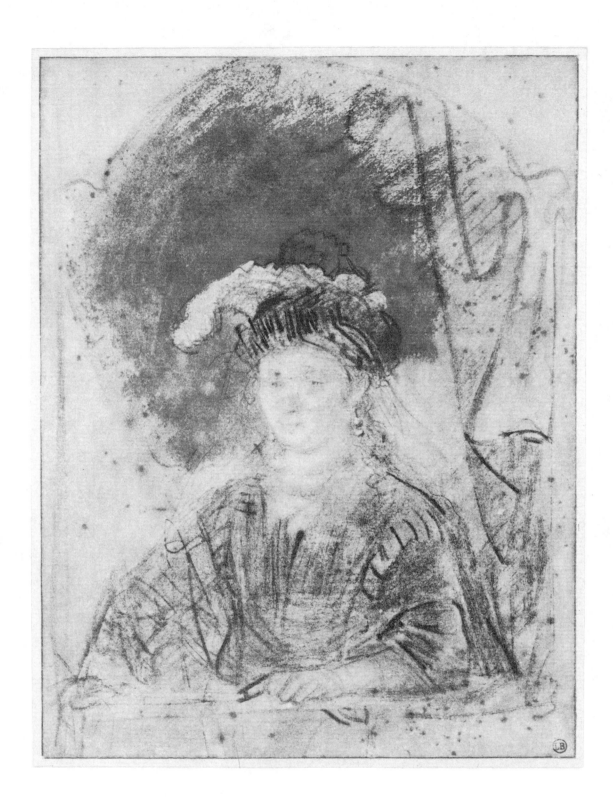

191 (*I, 179*). *Portrait Bust of a Lady in a Cap Plumed with an Ostrich Feather.* (*Musée, Bayonne*)
Black chalk and wash: 195 × 140 mm.

About 1640. Rembrandt and the members of his circle frequently portrayed their sitters behind a window to heighten the illusionistic effect of their portraits.

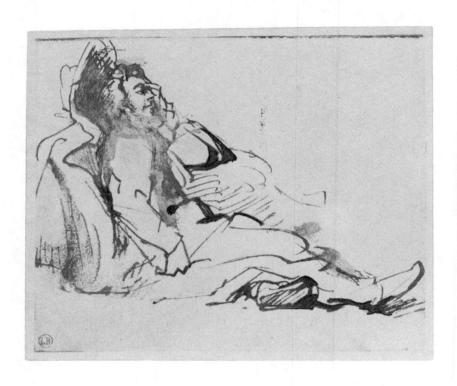

192 (*I, 180a*). *Study of a Man Asleep, Seated on the Ground.* (*Louvre, Paris*)

Pen and brush in bistre, white body color: 86 × 103 mm.

About 1650–55. Probably a study for a Dream of Jacob; *a drawing in Berlin (27 [I, 27]) includes a similar figure.*

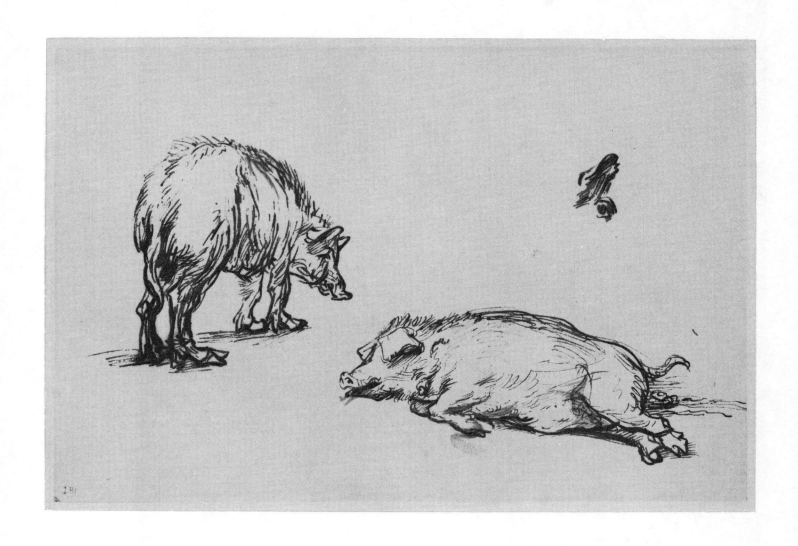

193 (*I, 180b*). *A Study of Two Pigs.* (*Louvre, Paris*)

Pen and bistre, white body color: 126 × 182 mm.

A pig's coat is particularly suitable for a quill-pen sketch and it is not surprising that Rembrandt's two other undisputed drawings of pigs are pure pen drawings. (The others are at the British Museum; see Hind, 1915, nos. 41 and 42.) This one is related to Rembrandt's etching of a hog dated 1643 (Bartsch 157).

194 (I, 181). *Rest on the Flight to Egypt, a Night Scene. (Louvre, Paris)*

Pen and wash in bistre: 165 × 240 mm.

Probably a copy after a lost original made around 1640-45 (see Lugt, 1933, no. 1259).

195 (I, 182). *Christ Among the Doctors. (Louvre, Paris)*
Pen and wash in bistre: 175 × 250 mm.

Doubts about the authenticity of the drawing have been frequently expressed (see Lugt, 1933, p. 9, no. 1129). The superficial resemblance of the decoration above the throne to the famous Phoenix etching of 1658 (Bartsch 110) should not lead one to assign the invention a late date. The style and composition point to a copy after a lost original made around 1635.

196 (I, 183). *Tobias and the Angel. (Louvre, Paris)*

Reed pen and bistre: 179 × 263 mm.

About 1652. A painting by a pupil or follower of Rembrandt based on the drawing is at Berlin–Dahlem (reproduced W. R. Valentiner,
Rembrandt: Wiedergefundene Gemälde, 1921, p. 62).

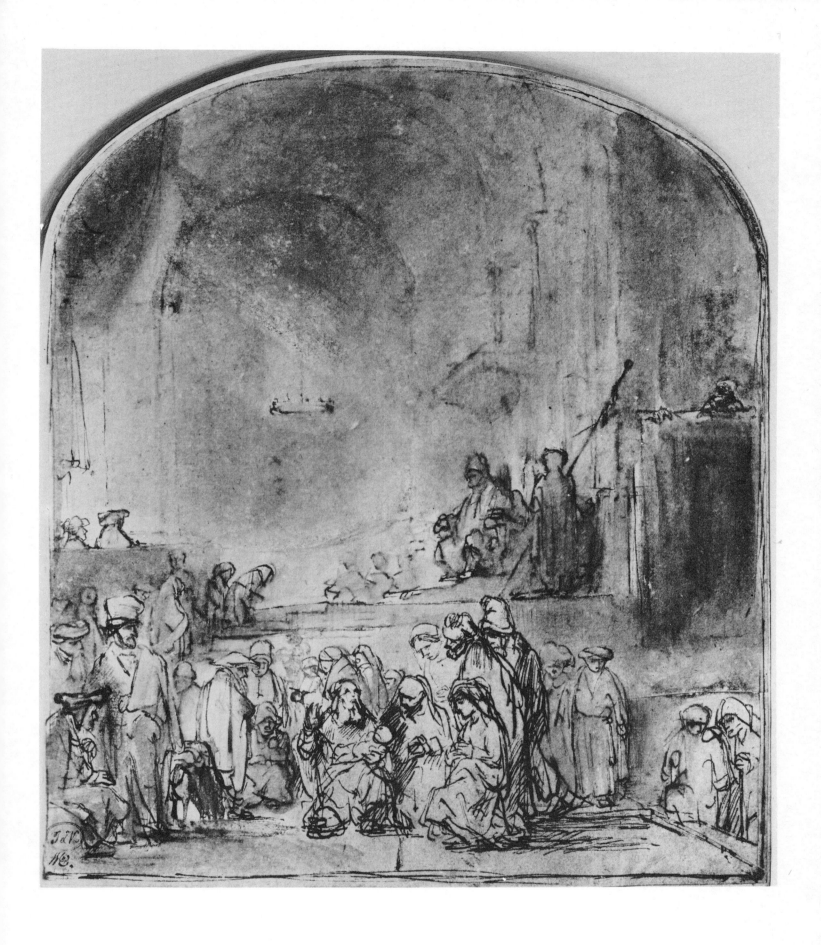

197 (*I, 184*). *The Presentation in the Temple. (Louvre, Paris)*

Pen and wash, black chalk, heightened with white: 238 × 208 mm.

About 1647. The setting is similar to the one Rembrandt used for his painting Christ and the Woman Taken in
Adultery *of 1644 now at the National Gallery, London (Bredius 566).*

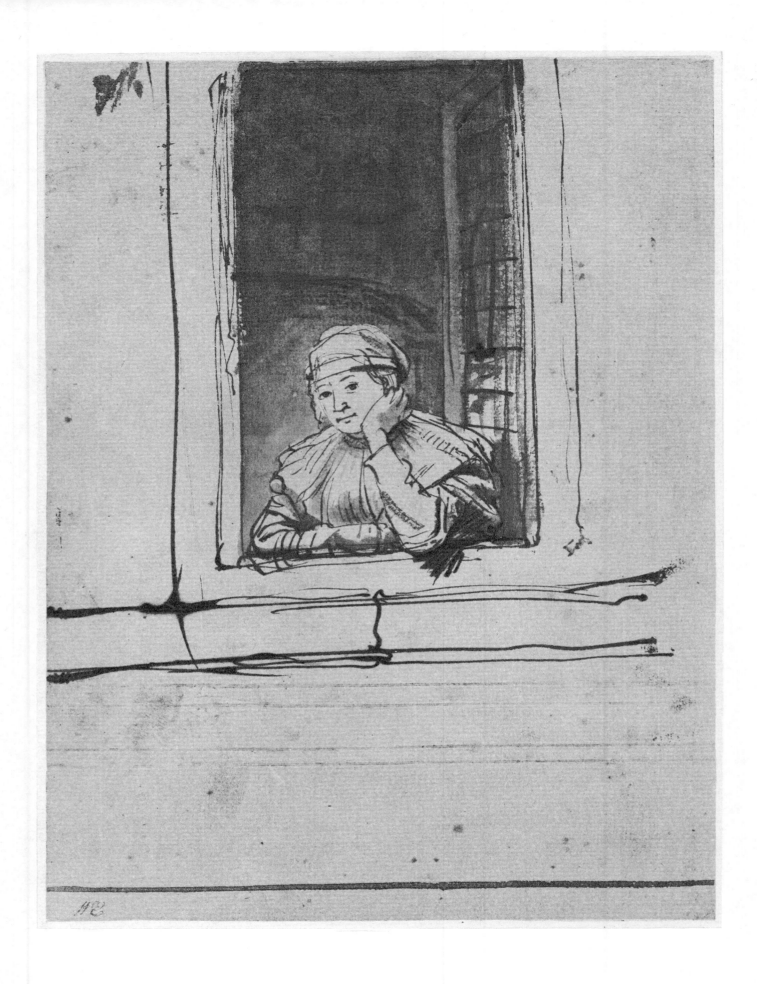

198 *(I, 185). Saskia Looking Out of a Window. (Boymans–van Beuningen Museum, Rotterdam)*
Pen and wash in bistre: 236 × 178 mm. The lowest horizontal is a later addition; four above it have been erased.
About 1633–34. The identification is based upon the similarity of the sympathetic model to other portraits of Saskia.

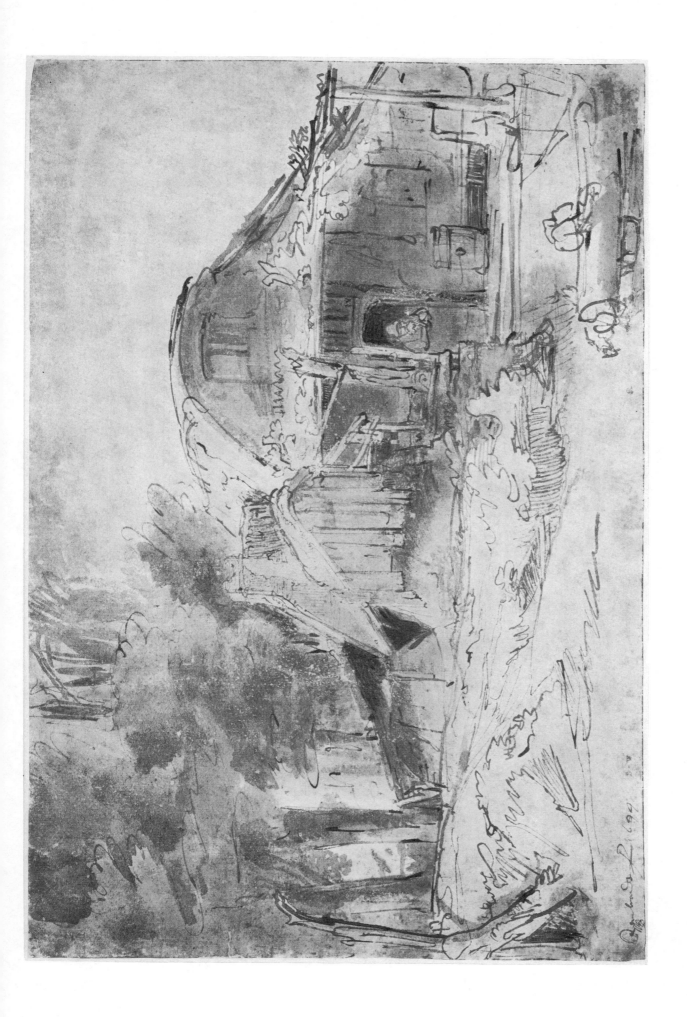

199 (I, 186). *Cottage near the Entrance to a Wood. (Robert Lehman Collection, New York)*
Pen and bistre, wash, some black and red chalk: 298 × 452 mm. Signed and dated: Rembrandt f. 1644.

This exceptionally large sheet—it is Rembrandt's largest landscape drawing—is one of the master's most powerful studies after nature. It is also one of the rare landscape drawings he signed and dated—an indication that he was probably pleased with the result and viewed it as a finished work.

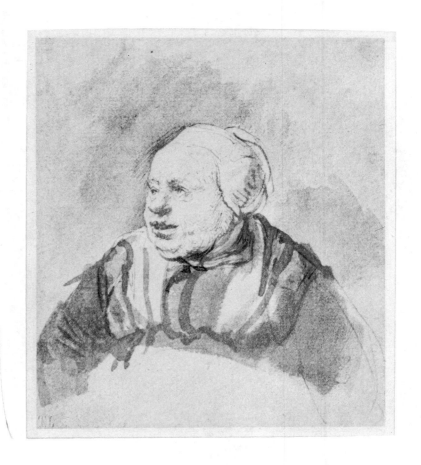

200 (*I, 187a*). *Portrait of a Woman.* (*Rembrandt Huis, Amsterdam*)

Pen and wash in bistre: 108 × 93 mm.

Not listed in Benesch; Begemann (1961, p. 14) rightly defends it as an original. The model bears a strong resemblance to St. Anne in Rembrandt's Holy Family (*Bredius 563*), *1640, Louvre, Paris, and the drawing can be dated around the same time. A similarity between the sitter and the woman in Rembrandt's painting at Buckingham Palace called* The Ship Builder and His Wife, *1633 (Bredius 408), has also been noted. The drawing, however, can hardly be dated around 1633. There are two other drawings of the same model: one in the Wilczek Collection, Vienna, Benesch 261; and another at the École des Beaux-Arts, Paris, Benesch 262.*

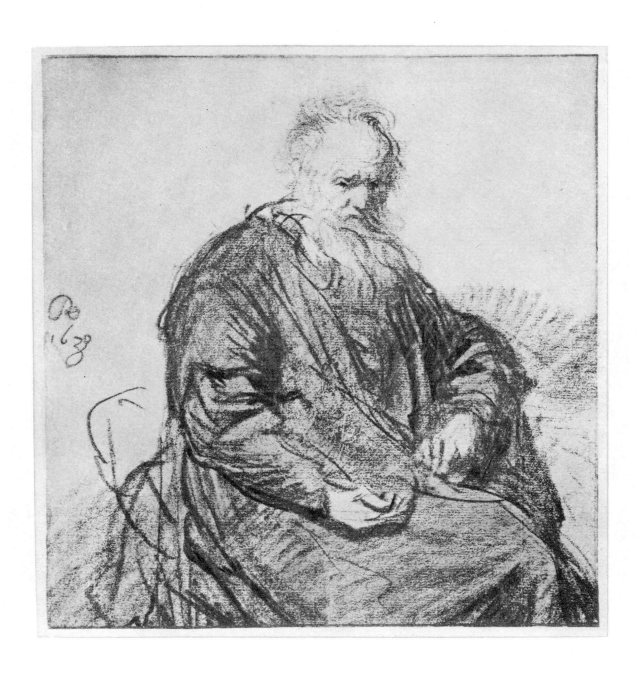

201 (*I, 187b*). *Seated Old Man.* (*Rosenwald Collection, National Gallery of Art, Washington, D.C.*)
Red chalk: 157 × 147 mm. Signed with a mònogram and dated: Rt 1630.

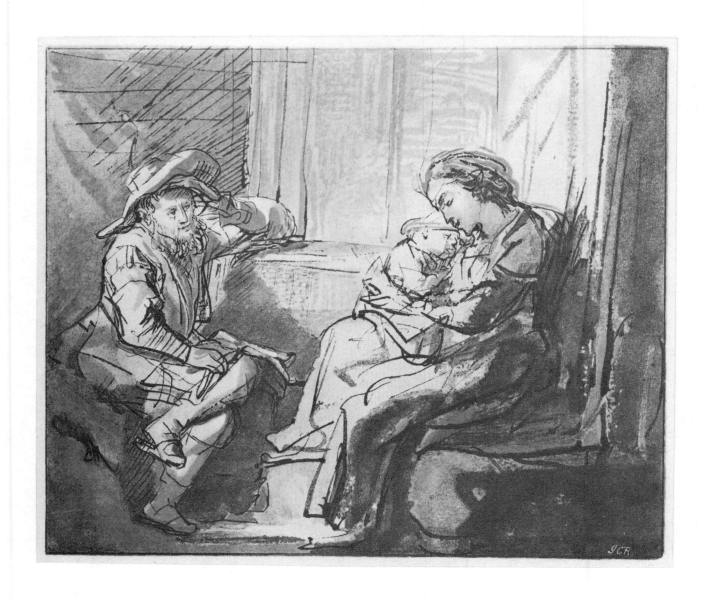

202 (*I, 188a*). *The Holy Family Seated by a Window.* (*O. Gutekunst Collection, London*)

Pen and bistre, washes in bistre and Indian ink: 140 × 163 mm.

About 1635–37. The figures of Mary and the Child were probably drawn from life, then Rembrandt added Joseph to make a religious composition. The Indian ink washes are later additions.

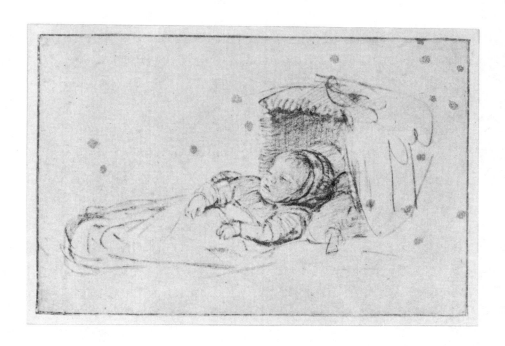

203 (*I, 188b*). *A Baby Sleeping in a Wicker Cradle.* (*Heirs of Henry Oppenheimer*)

Black chalk: 75 × 113 mm.

About 1645. A similar motif (*in reverse*) *appears in* The Holy Family in the Carpenter's Workshop *of 1645 at*
The Hermitage, Leningrad (*Bredius 570*).

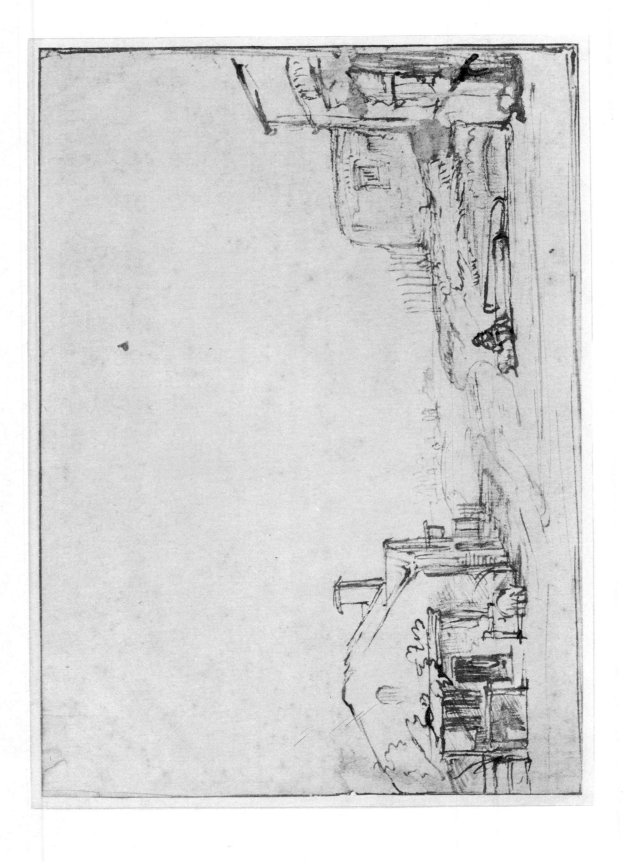

204 (I, 189a). *Landscape with an Inn Beside a Road.* (Boymans–van Beuningen Museum, Rotterdam)

Pen and bistre, wash: 141 × 202 mm.

About 1644. Benesch (814) points out that the drawing is a copy of a drawing by Jan Pynas in the Czartoryski Museum, Cracow (reproduced Benesch, Vol. IV, p. 215). It is singular that at this stage of his career Rembrandt still found reason to copy a work by an artist who had had a certain impact on him during the early years of his career.

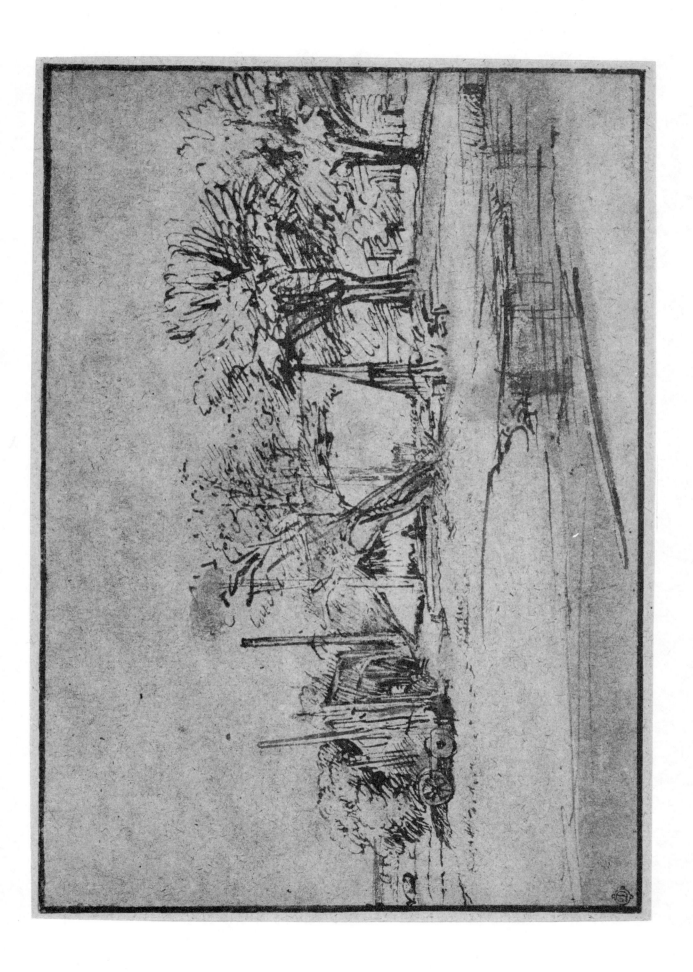

205 (I, 189b). *Farm Amidst Trees.* (Frick Collection, New York)
Reed pen and wash in bistre; grey wash by a later hand: 156 × 226 mm. Inscribed by a later hand: Rembrant.
About 1650–53. See 250 (II, 30b) for a more distant view of the same farm.

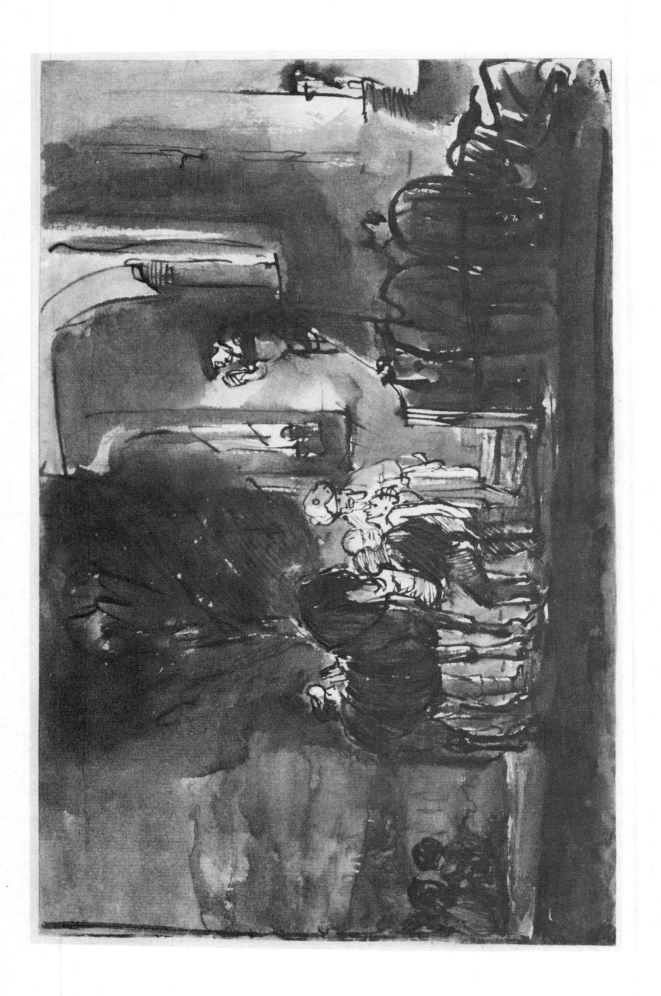

206 (I, 190). *The Good Samaritan Bringing the Wounded Man into the Inn.* (British Museum, London)

Pen and wash in bistre, white body color: 184 × 287 mm.

About 1641–43. Another version of this composition is at Rotterdam (383 [III, 50]). A close follower based a painting of the subject, now in the Louvre, on these drawings (Bredius 581); the painting was formerly accepted as a genuine work by Rembrandt (see C. Brière-Misme, Musées de France, V, 1949, pp. 122 ff.).

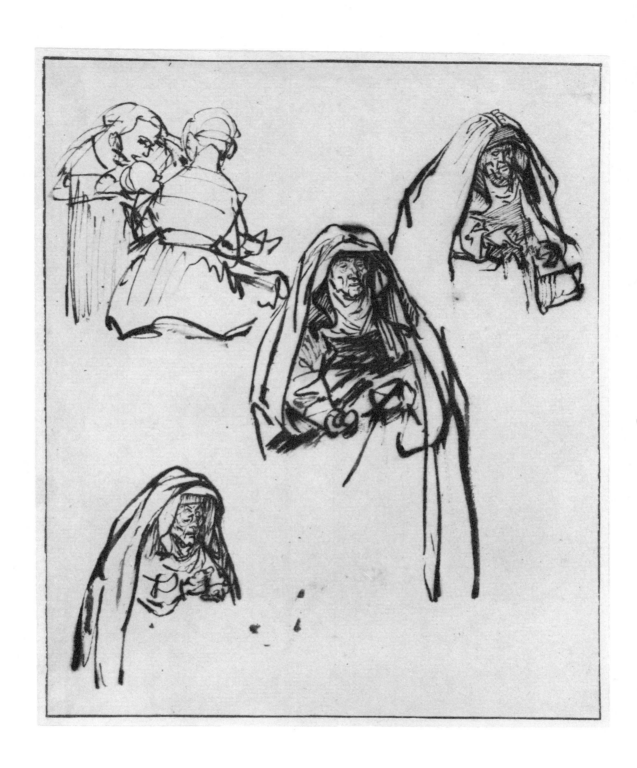

207 (*I, 191*). *Sheet of Studies of an Old Woman and of Two Women with a Child. (Goethe National Museum, Weimar)*

Pen and bistre: 178 × 146 mm.

About 1636.

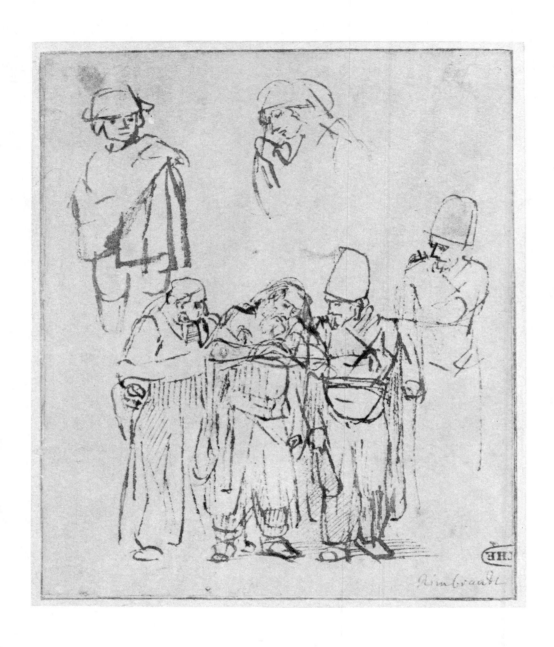

208 (*I, 192a*). *A Sheet of Studies Including Two Figures Supporting an Old Man and a Mourning Woman.*
(*Goethe National Museum, Weimar*)

Pen and bistre: 150 × 125 mm. Inscribed by a later hand: Rimbrandt.

About 1652. Hind (1923, no. 270) noted that the drawing can be called one of the rare extant preparatory studies for Rembrandt's etching of The Three Crosses (*Bartsch 78*). *The fragment of a collector's mark in the right corner is Goethe's.*

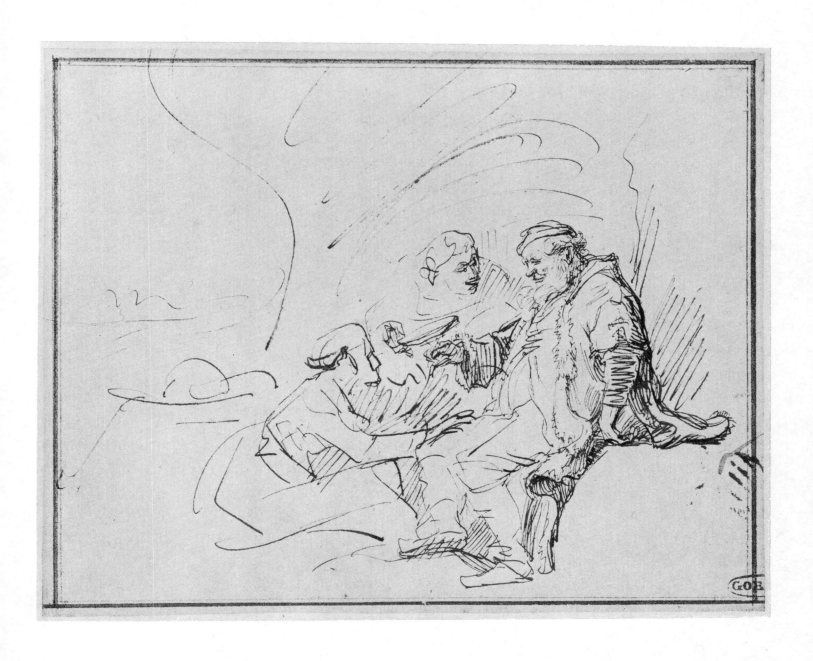

209 (*I, 192b*). *Lot and His Daughters.* (*Goethe National Museum, Weimar*)

Pen and bistre: 152 × 191 mm.

*About 1635. Speedy, sweeping pen strokes as well as the characteristic diagonal arrangement of the baroque knit
this group together. A fragment of Goethe's collector's mark is in the lower right corner.*

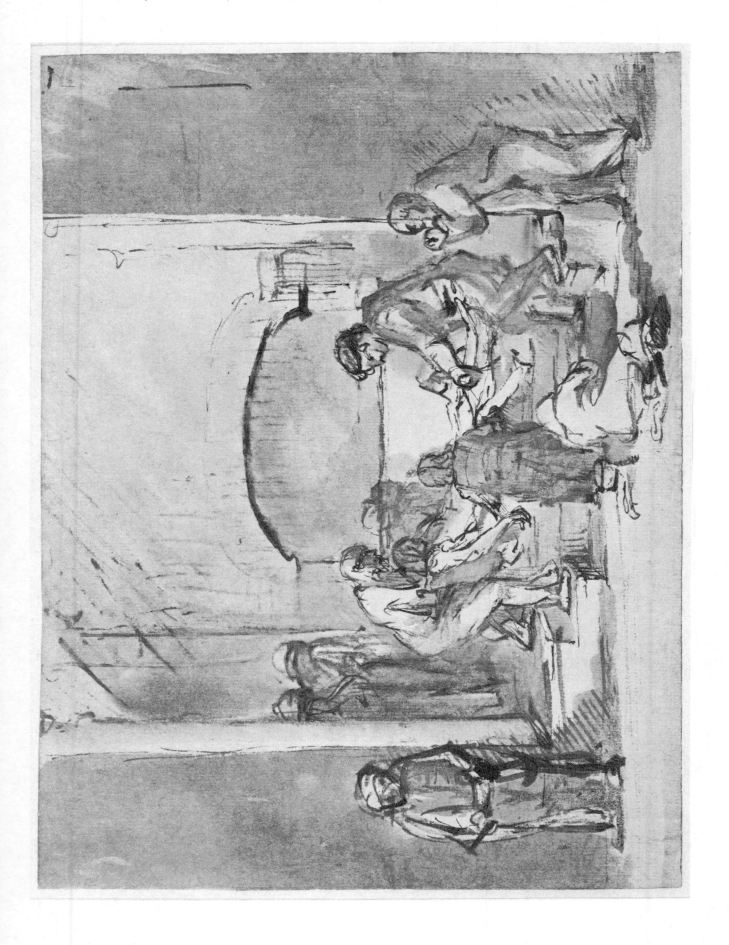

210 (I, 193). *The Entombment of Christ.* (Kupferstichkabinett, Berlin)

Pen and wash in bistre, white body color: 169 × 228 mm.

About 1655–60. A free copy after a drawing, variously attributed to Polidoro da Caravaggio and to Perino del Vaga, now at the Fogg Art Museum, Harvard University, Cambridge, Massachusetts. Rembrandt's other copy after this composition is reproduced 179 (I, 169).

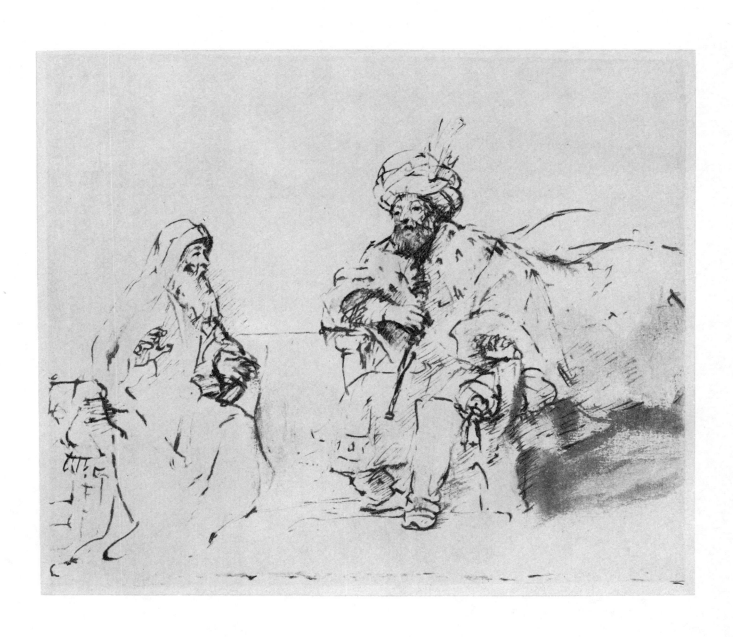

211 (*I, 194*). *Nathan Admonishing David.* (*Kupferstichkabinett, Berlin*)
Reed pen and wash in bistre: 146 × 173 mm.
About 1655. See 149 (I, 144) for a slightly later version.

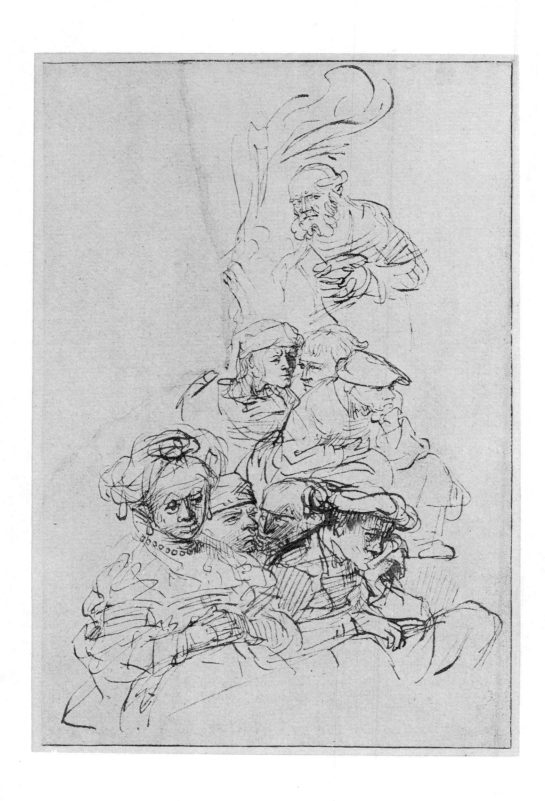

212 (*I, 195*). *Sheet of Studies of Listeners.* (*Kupferstichkabinett, Berlin*)

Pen and bistre: 190 × 125 mm. A large piece of blank paper on the left side of the sheet has been restored.

About 1637. A study for the painting St. John the Baptist Preaching, *now at Berlin–Dahlem (Bredius 555).*
Other studies for the painting are reproduced 16 (I, 16) and 78 (I, 78).

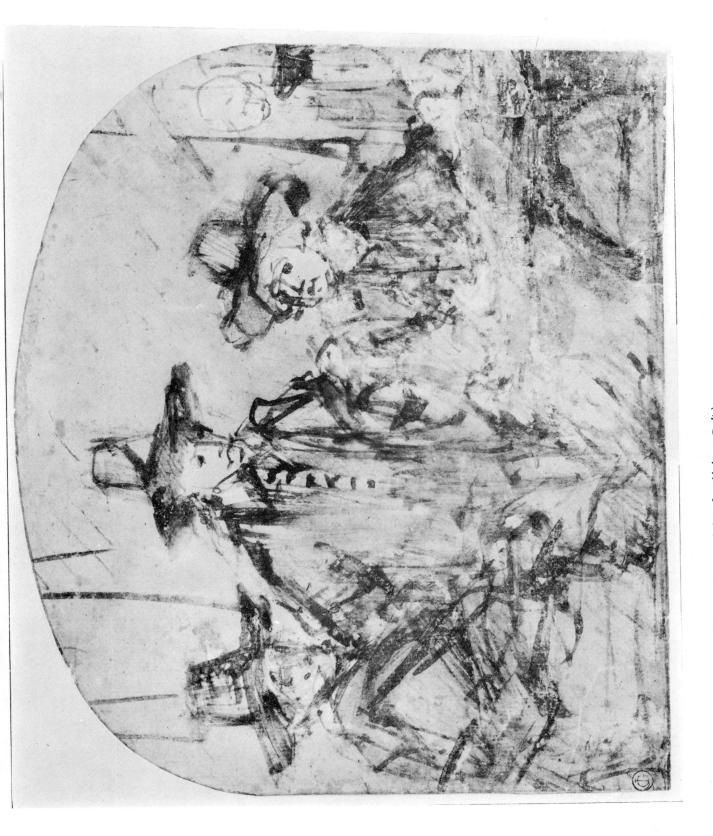

213 (I, 196). *Study for* The Syndics of the Clothmakers' Guild (De Staalmeesters). (*Kupferstichkabinett, Berlin*)
Reed pen and wash, white body color: 173 × 205 mm.

About 1662. One of the three extant studies for Rembrandt's great group portrait of 1662 (Rijksmuseum, Amsterdam, Bredius 415). Traces of a hat on the right indicate that the drawing has been cut. See 243 (II, 26) for another study of the figure at the left.

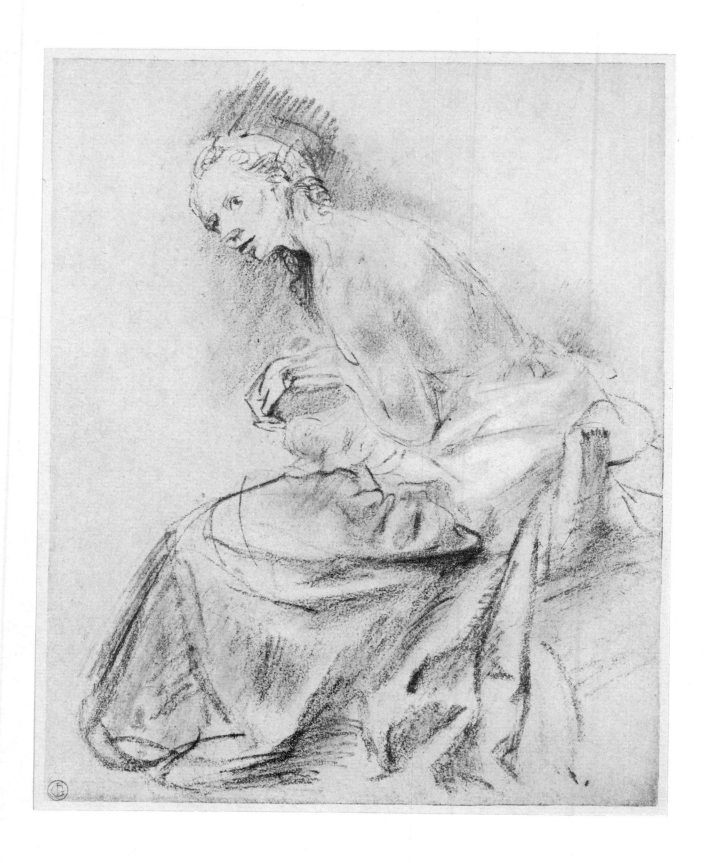

214 *(I, 197). Study for the Figure of Susanna. (Kupferstichkabinett, Berlin)*
Black chalk: 203 × 164 mm.
About 1647. Study for the painting Susanna and the Elders of 1647 at Berlin–Dahlem (Bredius 516).

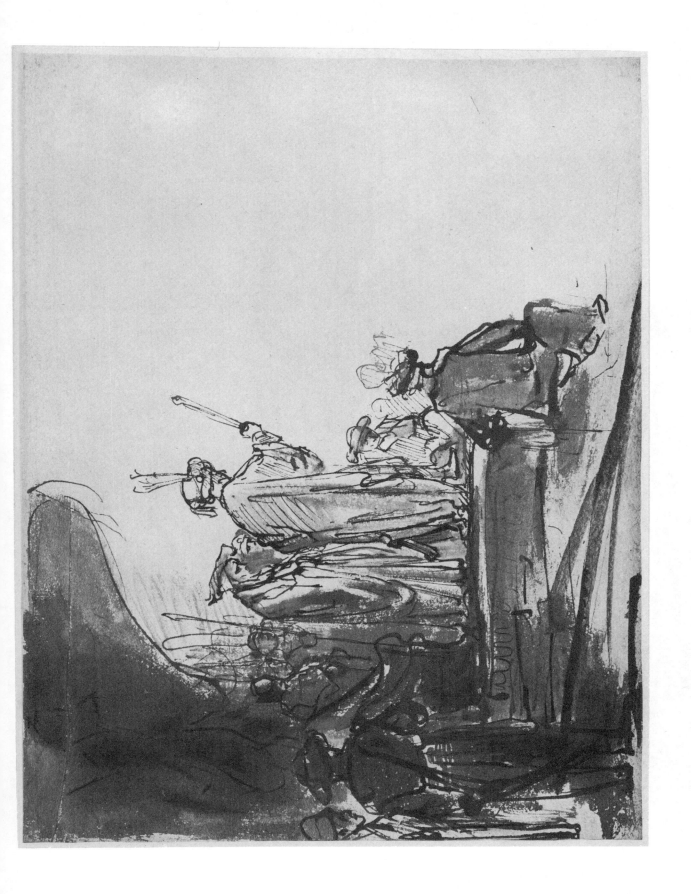

215 (I, 198). *An Oriental Noble with His Retinue. (Kupferstichkabinett, Berlin)*

Pen and wash in bistre: 201 × 263 mm.

The fact that only one side of the sheet is worked up supports Rosenberg's view (1930, p. 227, no. 8510) that it is a copy after a finished work. Kruse (1920, p. 13) offered the name of Salomon Koninck. The blank right side makes it difficult to determine the subject. Hofstede de Groot's suggestion that it is Pilate Before the People can be rejected.

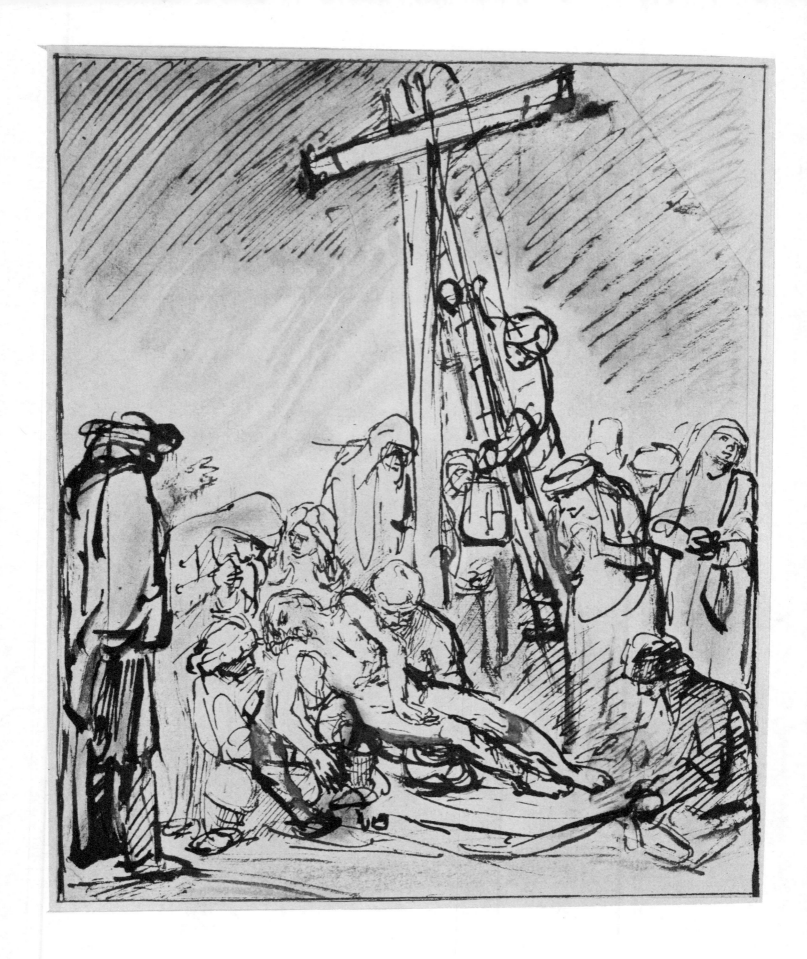

216 (*I, 199*). *The Deposition from the Cross. (Kupferstichkabinett, Berlin)*
Pen and wash in bistre, white body color: 259 × 210 mm.
About 1647–50. For Rembrandt's representation of this theme see W. Stechow, Jahrbuch der preussischen
Kunstsammlungen, *50, 1929, pp. 217 ff.*

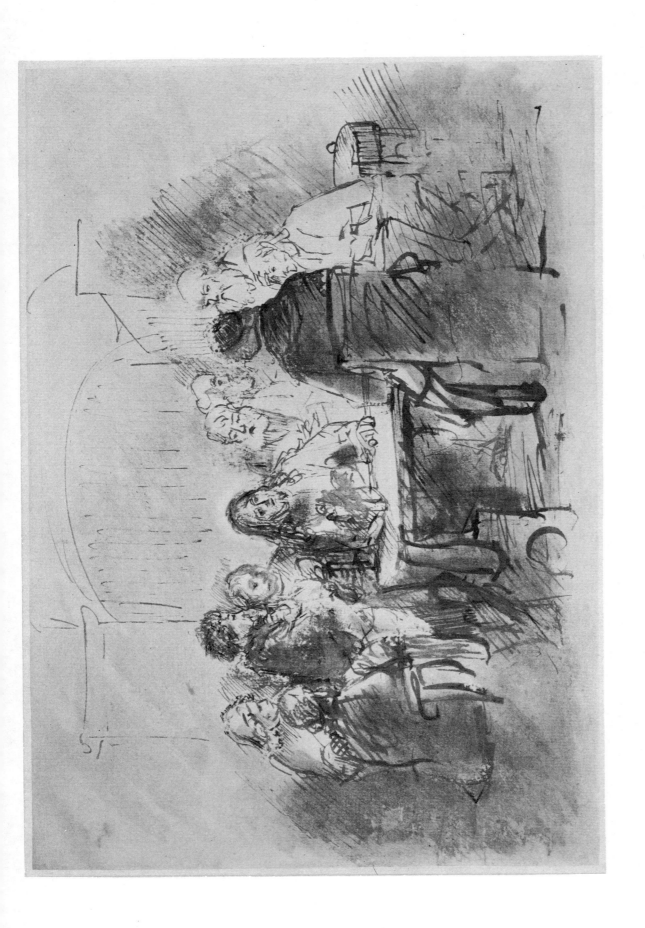

217 (I, 200). *Christ Among the Disciples.* (Kupferstichkabinett, Berlin)

Pen and wash in bistre, white body color: 205 × 298 mm.

A disputed work. Accepted by Rosenberg (1930, p. 225, no. 5279, with a summary of earlier views about authenticity, date and subject). Rosenberg, who dated it about 1660, noted the drawing was not without coarseness and some weak parts. Lugt (1931, p. 58, no. 5279) expressed some doubts and wrote that the wash appears to be by another hand. W. Sumowski ("Nachträge zum Rembrandtjahr 1956," Wissenschaftliche Zeitschrift der Humbolt-Universität zu Berlin, Gesellschafts und sprachwissenschaftliche Reihe, 7 [1957/58], no. 2, p. 234) says it is by Gerbrand van den Eeckhout and labels it a preliminary study for Eeckhout's painting of The Last Supper of 1664 at the Rijksmuseum, Amsterdam. Also see W. Sumowski, "Gerbrand van den Eeckhout als Zeichner," Oud Holland, 77 (1962), p. 32.

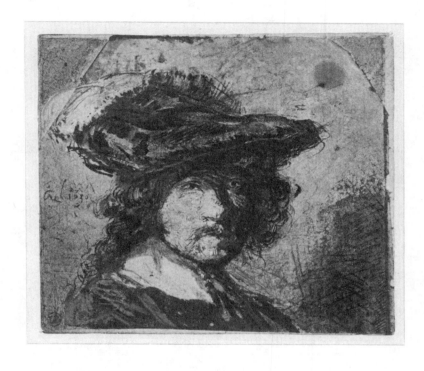

218 (*II, 1*). *Self-portrait.* (*Louvre, Paris*)

Pen and red chalk, bistre, wash, white body color: 81 × 92 mm. Signed with a monogram and dated: RHL 1630.
A preparatory study for the etching Bartsch 363. Considered a work of the school by Benesch (A18a).

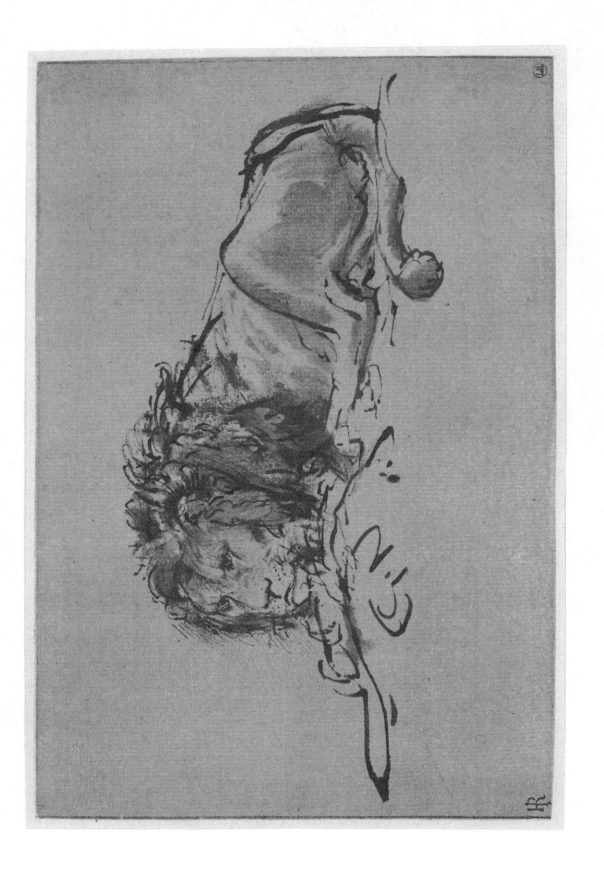

219 (II, 2). *Lion Resting, Turned to the Left. (Louvre, Paris)*

Pen and brush in bistre: 138 × 204 mm.

About 1650–52. One of the most splendid of Rembrandt's studies of lions. On the reverse, in a seventeenth-century hand in red chalk: van rem[nt]: *na't leven 10 gld (by Rembrandt: from life, 10 guilders—a reference to a price).*

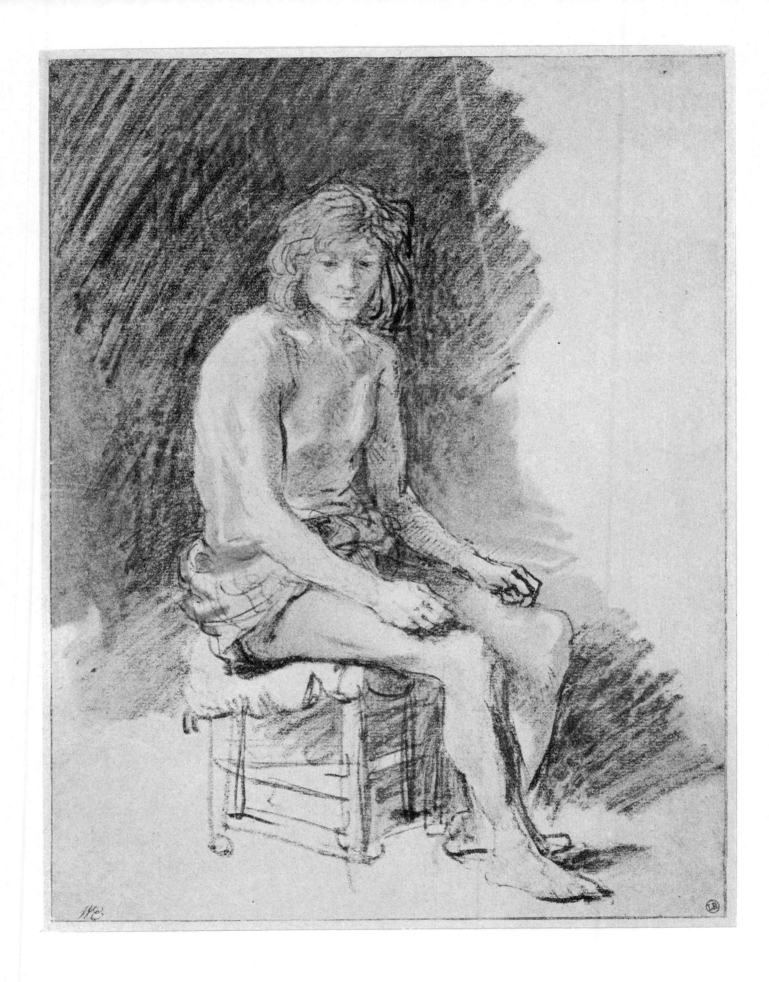

220 (*II, 3*). *Seated Male Nude.* (*Musée, Bayonne*)

Black chalk: 250 × 190 mm.

*About 1646. Related to the etchings of seated nudes (Bartsch 194 and 196); the latter etching is signed and
dated 1646.*

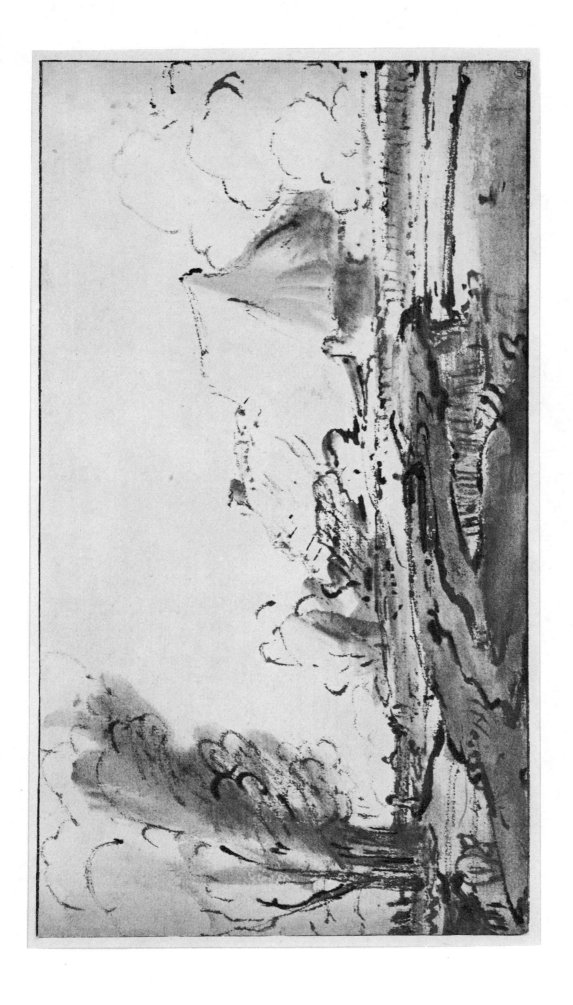

221 (II, 4). *Landscape with Peasant Cottages and Trees.* (*Louvre, Paris*)
Brush in bistre: 160 × 296 mm.

At first glance the drawing appears to have the power and brilliant atmospheric effect of Rembrandt's latest landscapes (see 12 [I, 12]), but
as Lugt (1933, p. 68, no. 1343) has shown, this work belongs to a group of drawings by a pupil (perhaps Anthonie van Borssom). See
293 (II, 64) for another drawing which has been ascribed to the same hand.

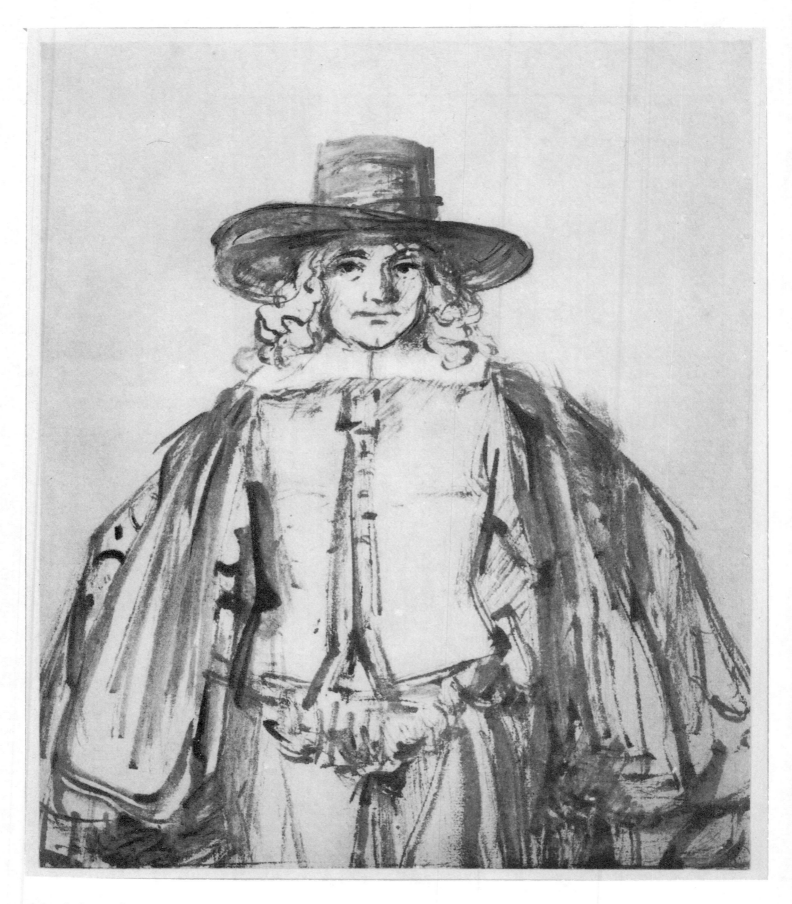

222 (*II, 5*). *Portrait of a Young Man.* (*Six Collection, Amsterdam*)
Reed pen and bistre: 232 × 194 mm.

About 1655–60. An imposing late portrait study in which the reed pen is used with daring boldness. The frontal attitude is characteristic of the mature artist's portraits. The model has been identified as Jan Six and as Titus, but neither identification is secure. Similar reed pen portrait sketches by the master are at the Louvre, Paris (Benesch 1182), and at the Fogg Art Museum, Harvard University, Cambridge, Massachusetts (see catalogue Rembrandt Drawings from American Collections, *Pierpont Morgan Library, New York, and Fogg Art Museum, Cambridge, Massachusetts, 1960, no. 71).*

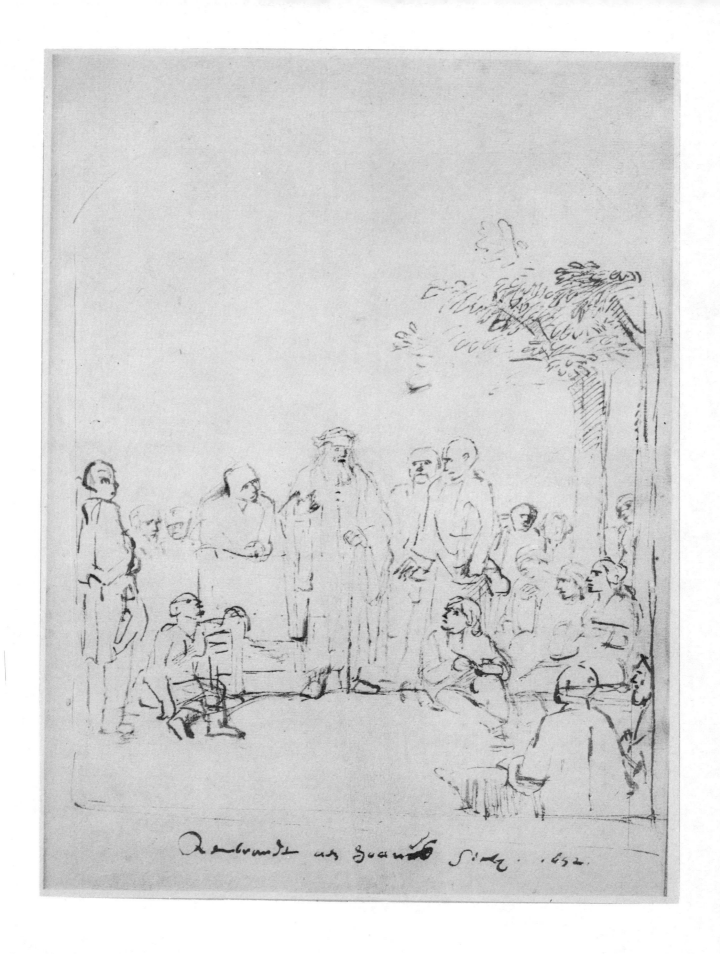

223 (*II, 6*). *Homer Reciting Verses.* (*Six Collection, Amsterdam*)

Reed pen and bistre: 255 × 180 mm. Inscribed and dated in the artist's hand: Rembrandt aen Joannus Sicx. 1652.

The drawing, which suggests with a few summarizing strokes the audience attentively listening to the blind poet,
was made for the Six family's Album Amicorum entitled "Pandora." An engraving of Raphael's fresco
Parnassus in the Stanza della Segnatura probably served as a model for the composition, but as usual Rembrandt
translated the work into his own idiom. See 279 (II, 54) for another Rembrandt drawing in the same album.

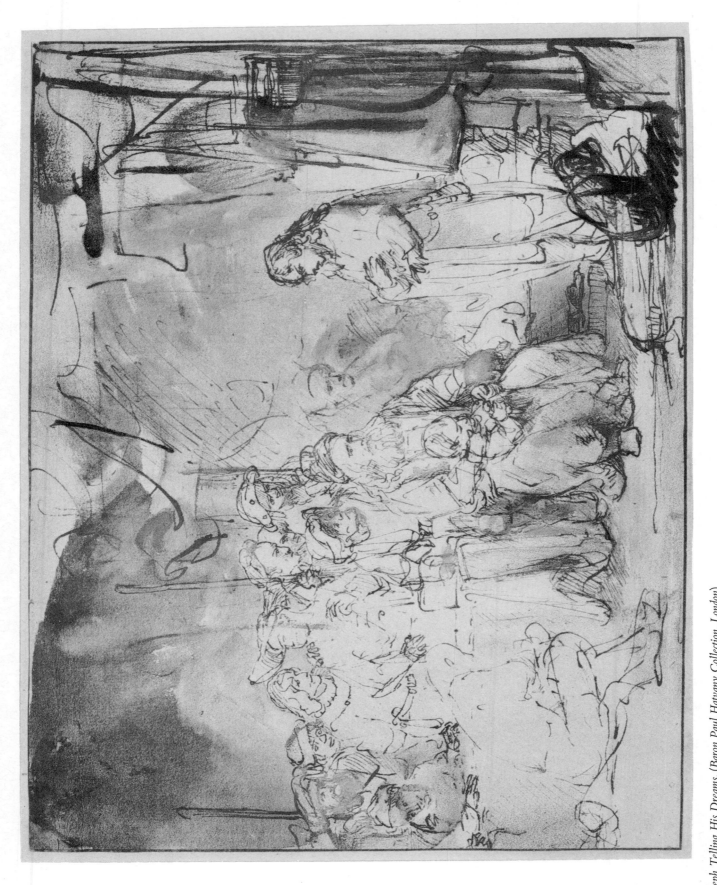

224 (II, 7). *Joseph Telling His Dreams.* (Baron Paul Hatvany Collection, London)

Pen and wash in bistre: 175 × 225 mm.

About 1638. The drawing is closely related to the 1638 etching (Bartsch 37) and the grisaille (Bredius 504) of the subject; see also 111 (I, 109).

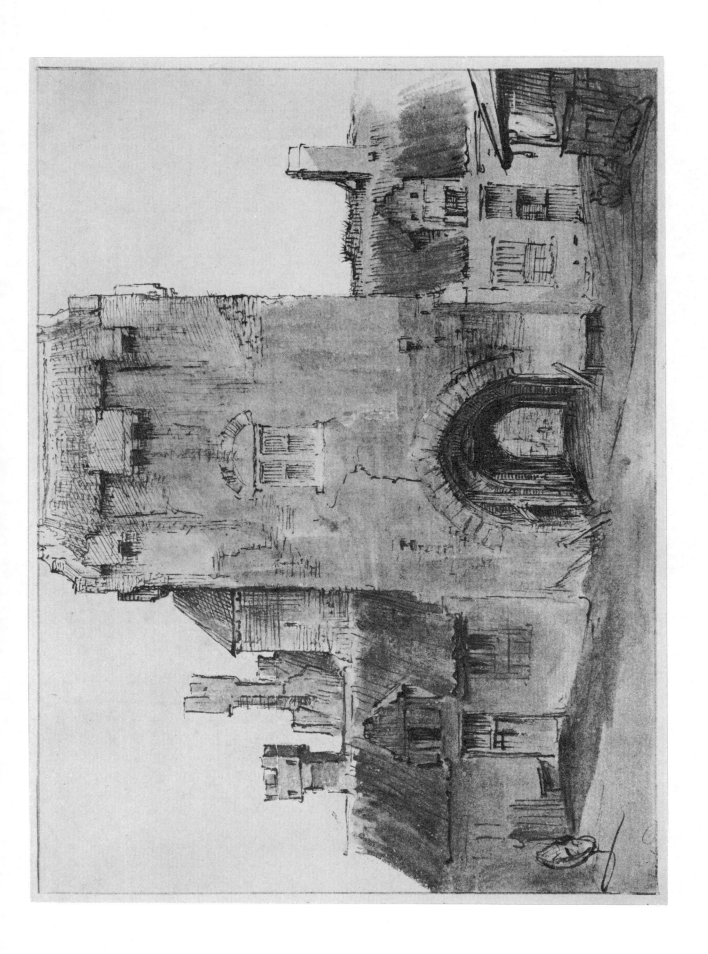

225 (II, 8). *The "Westpoort" Gate at Rhenen. (Teyler Museum, Haarlem)*
Pen and bistre in wash: 165 × 226 mm.
About 1648. See the comment to 72 (I, 72).

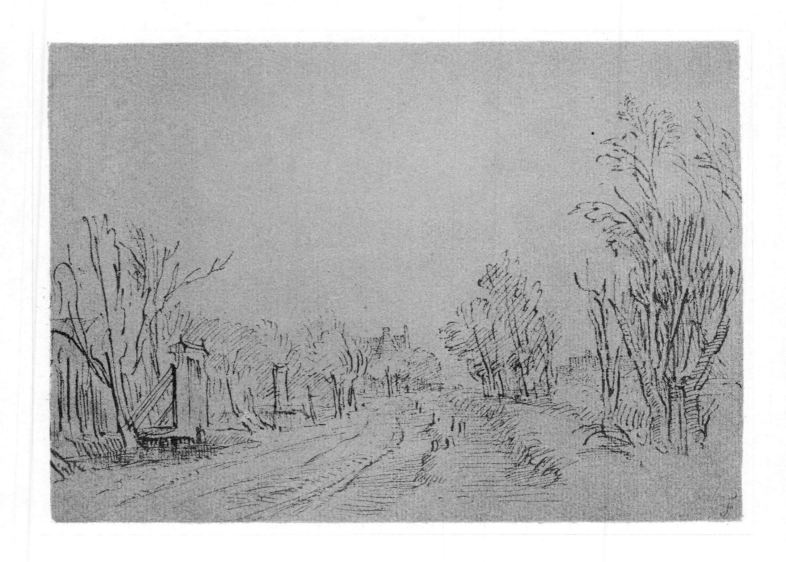

226 (*II, 9*). *Village Street Beside a Canal.* (*Chatsworth Settlement*)

Pen and bistre: 133 × 184 *mm.*

About 1650. See 515 (IV, 68) for another drawing of the same street. The delicate study, as so many other Rembrandt landscape drawings at Chatsworth, came from N. A. Flinck's extraordinary collection (see the comment to 51 [I, 51]).

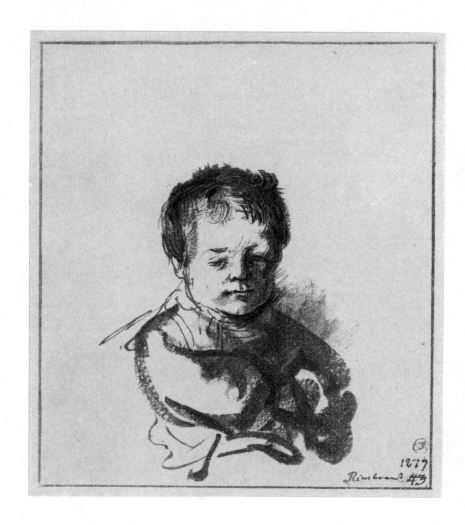

227 (*II, 10*). *Portrait of a Boy.* (*Nationalmuseum, Stockholm*)

Pen and wash in bistre: 122 × 104 mm.

About 1640. The boy has been frequently called Rumbartus, the eldest son of Rembrandt. This identification is an error. I. H. van Eeghen, "De Kinderen van Rembrandt," Amstelodamum, 43, 1956, pp. 144 ff., established that Rumbartus only lived about two months; he was baptized 15 December 1635 and died 15 February 1636. The boy portrayed here is obviously more than two months of age. The dates of baptism and burial of Saskia's other children are: Cornelia I, 22 July 1638–14 August 1638; Cornelia II, 29 July 1640–probably 12 August 1640; Titus, 22 September 1641–buried in 1668.

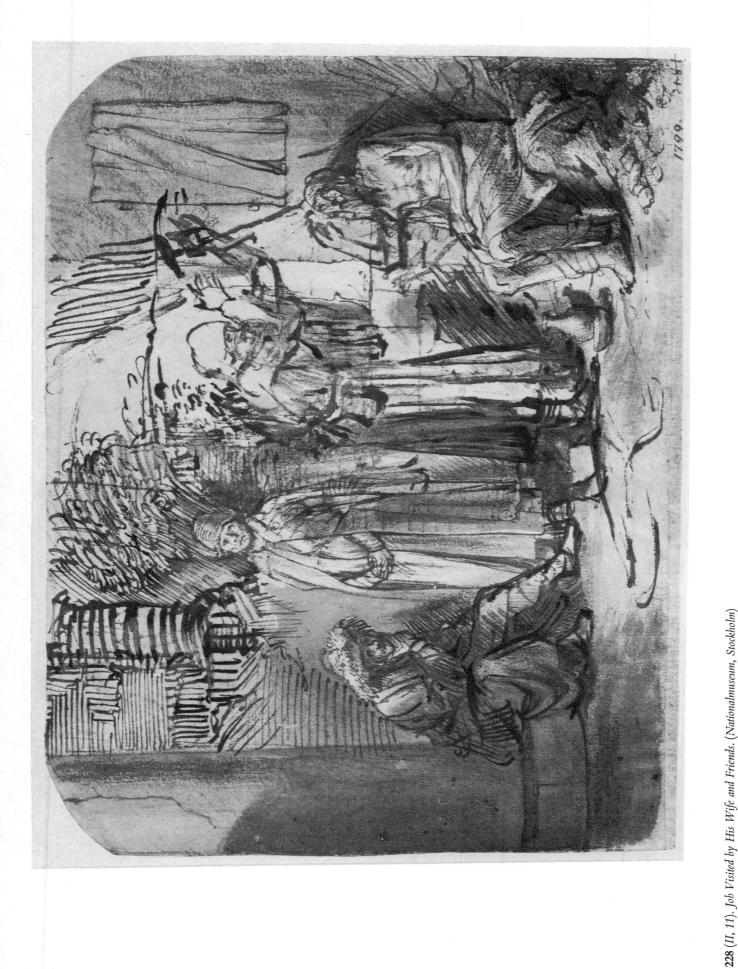

228 (II, 11). *Job Visited by His Wife and Friends.* (Nationalmuseum, Stockholm)

Pen and wash in bistre, white body color, black chalk: 180 × 238 mm.

About 1650–55. The drawing is by a student—probably Constantijn van Renesse (see Falck, 1924, p. 195)—and was corrected by Rembrandt. The difference between the pupil and master can be seen in the expressive changes made in the figures of Job and his wife.

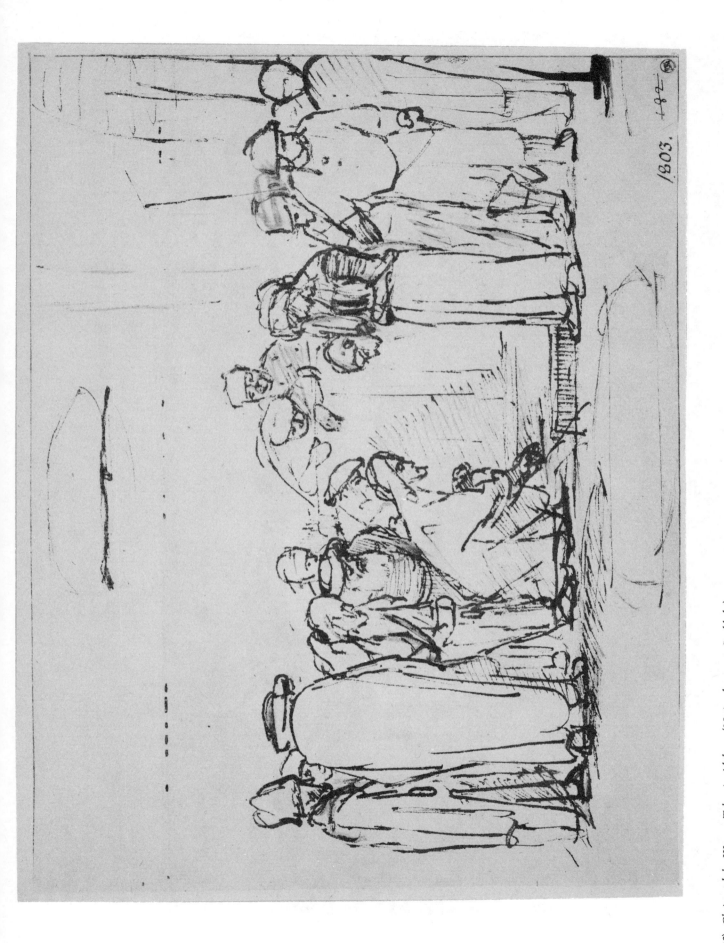

229 (II, 12). *Christ and the Woman Taken in Adultery.* (Nationalmuseum, Stockholm)

Pen and bistre: 189 × 248 mm.

About 1655. *A classic example of the simplicity and strong tectonic design of the 1650's.*

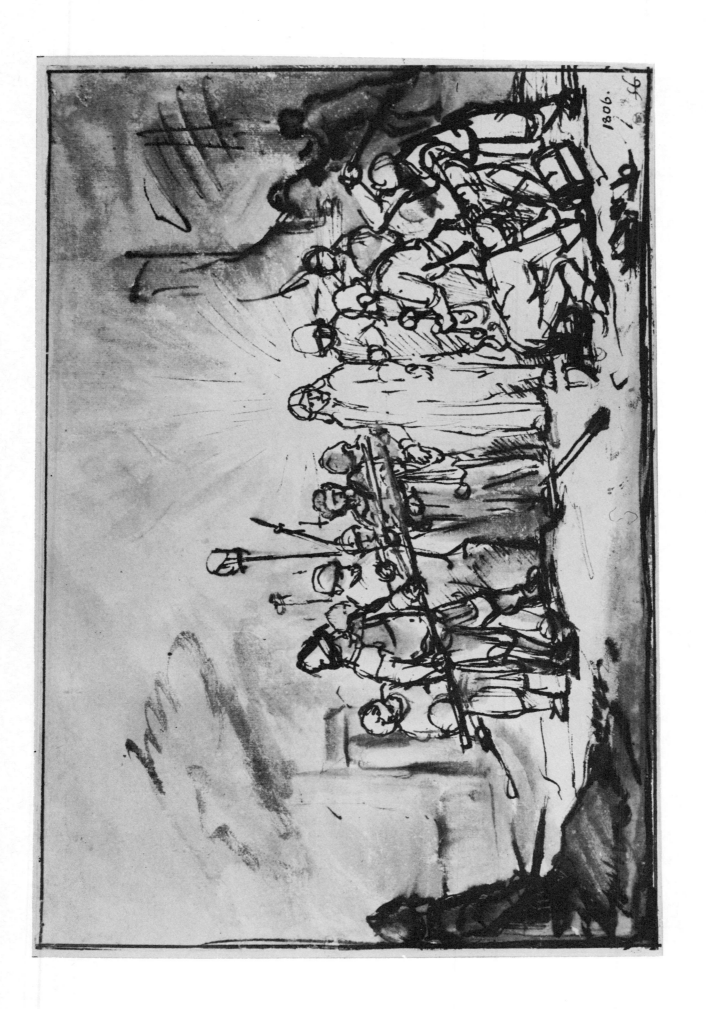

230 (II, 13). *The Arrest of Christ. (Nationalmuseum, Stockholm)*
Pen and wash in bistre: 205 × 298 mm.

About 1655–60. Here the radiance from Christ's figure seems to have immobilized all those who have come to take Him. See 271 (II, 47)
for another drawing of this theme made around the same time.

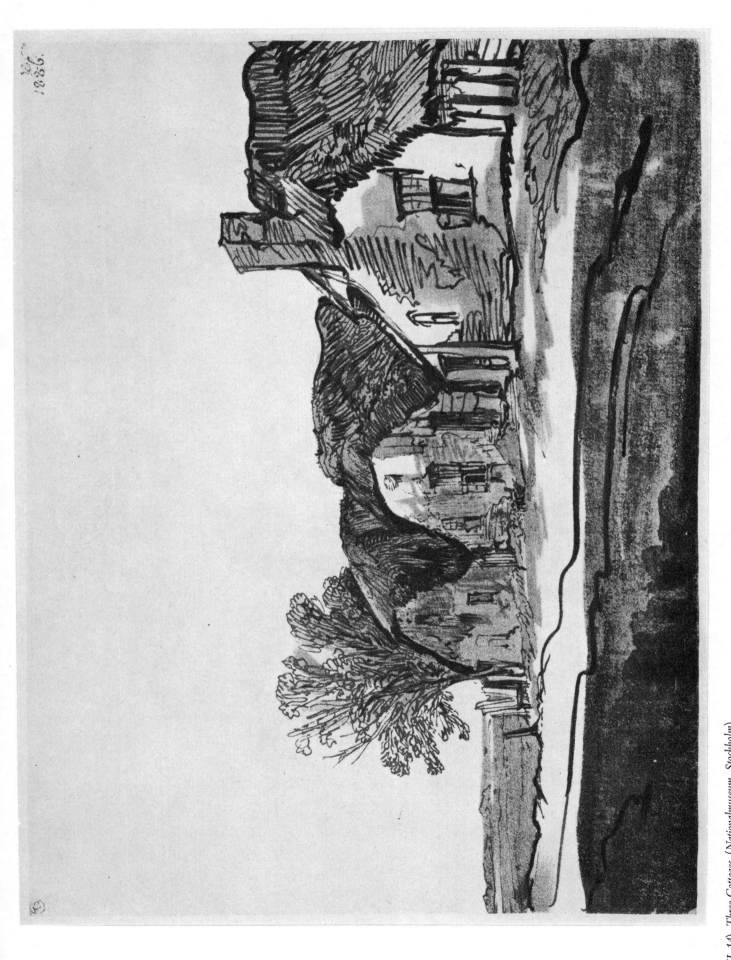

1881

231 (II, 14). *Three Cottages.* (Nationalmuseum, Stockholm)
Pen and wash in bistre: 180 × 241 mm.
About 1641. The style of the drawing has been rightly compared with the etching of 1641 (Bartsch 226).

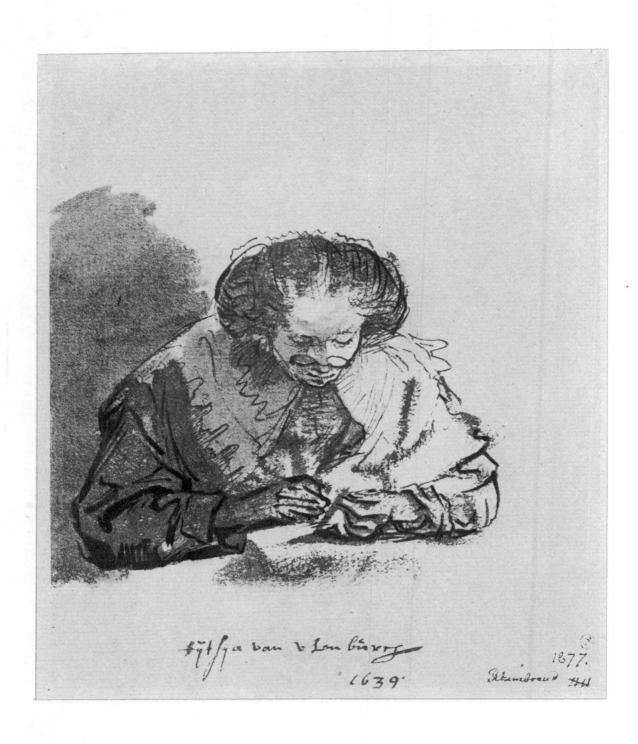

232 (*II, 15*). *Portrait of Titia van Uylenburch.* (*Nationalmuseum, Stockholm*)

Pen and wash in bistre: 178 × 146 mm. Inscribed and dated by the artist: Tijtsya van Ulenburch 1639. The signature "Rhimbrand" is by a later hand.

The intimate study is a portrait of the sister of Rembrandt's wife Saskia.

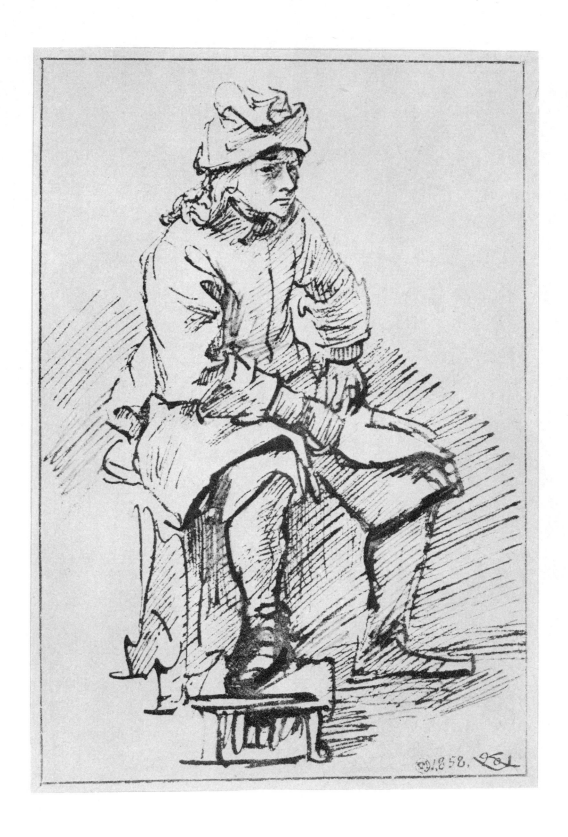

233 (*II, 16*). *A Seated Youth.* (*Nationalmuseum, Stockholm*)

Pen and bistre: 198 × 129 mm.

*About 1655. If Titus served as the model, as some critics suggest (see Valentiner 717), the drawing should be dated
a few years later. Valentiner dated the work about 1657, but noted the style suggested a date around 1652.
Benesch refers to it as a school piece (see his note to 1184).*

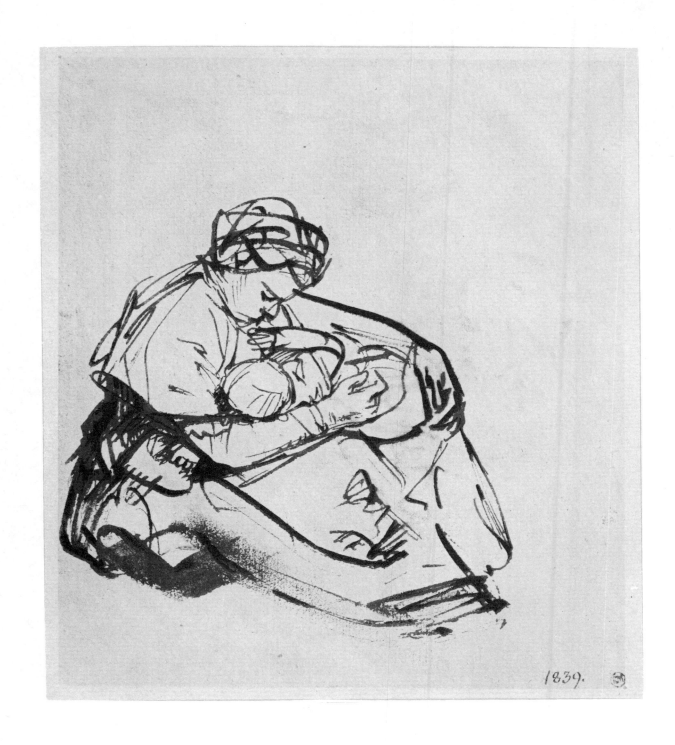

1839.

234 (II, 17). *A Woman Seated on the Ground Suckling a Child. (Nationalmuseum, Stockholm)*

Pen and bistre: 175 × 153 mm.

*About 1635–40. On the verso there is a study of a woman with a baby in her arms and the head of a man wearing
a turban (reproduced Benesch, figure 849). See 135 (I, 131) for a drawing done around the same time which is also
in Stockholm. 316 (II, 84) and 337 (III, 5) appear to be related to this group.*

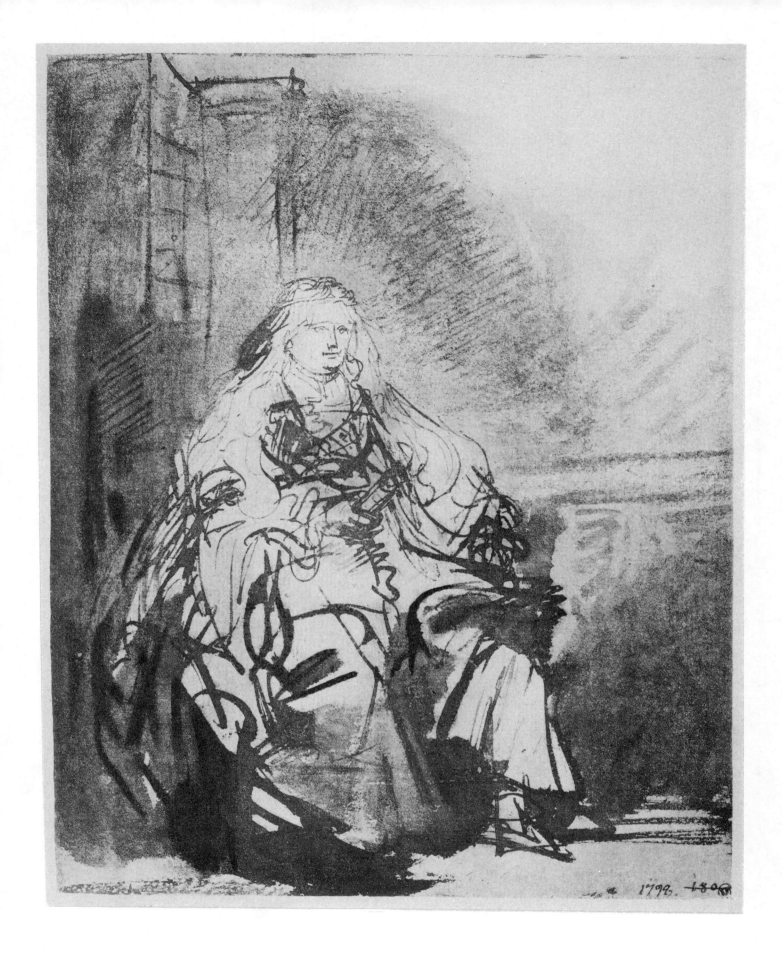

235 (*II, 18*). *Study for the Etching Called* The Great Jewish Bride. (*Nationalmuseum, Stockholm*)

Pen and Indian ink, wash: 232 × 182 mm.

About 1635. Study in reverse for the etching dated 1635. The traditional title of the etching is based on the erroneous assumption that it represents the daughter of Ephraim Buëno. The subject has also been identified as a Sibyl, Minerva and St. Catherine.

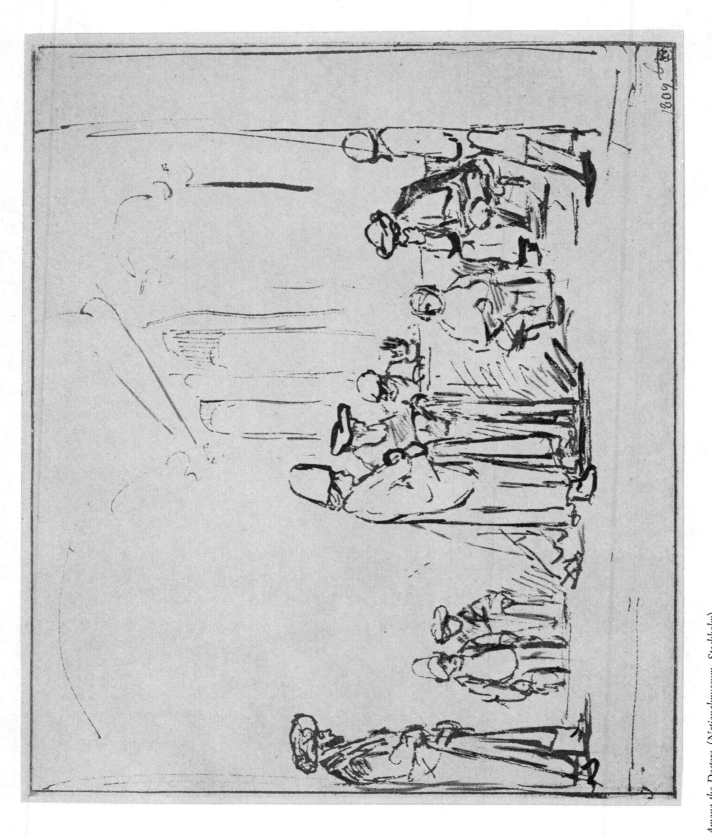

236 (II, 19). *Christ Among the Doctors.* (Nationalmuseum, Stockholm)

Reed pen and bistre: 188 × 225 mm.

About 1654. The drawing can be related to the etching dated 1654 of the same subject (Bartsch 64). Münz (1952, no. 230) favors a later date for the drawing.

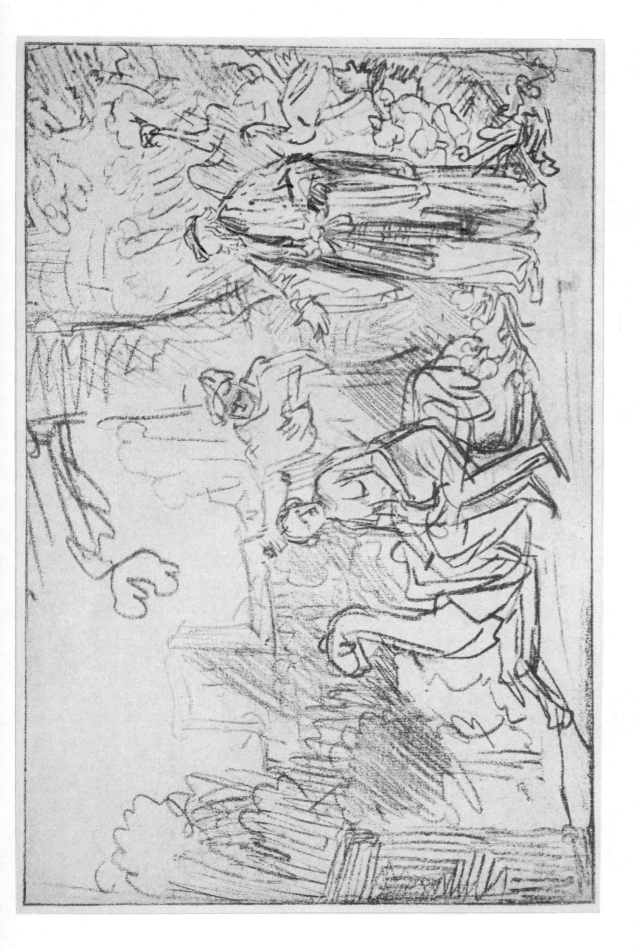

237 (II, 20). Susanna and the Elders. (Kupferstichkabinett, Berlin)

Red chalk: 235 × 364 mm. Signed: Rf.

About 1630–33. A copy of a painting now at Berlin–Dahlem, by Rembrandt's teacher Pieter Lastman. The drawing seems to mark the transition between the large chalk drawings made in Leiden around 1630, in which powerful hatched strokes play such an important role, and the highly ornamental line of the studies made soon after Rembrandt moved to Amsterdam. An interesting inscription by Rembrandt on the back of the drawing, dated 1635, lists the prices Rembrandt received for his own works and the rather low ones he procured for those by his pupil Ferdinand Bol and the unidentified student Leendert Cornelisz van Beyeren (see Hofstede de Groot, Die Urkunden über Rembrandt, The Hague, 1906, no. 39). Benesch (448) dates the drawing 1637. Any conclusion about its date must of course rest on stylistic arguments and not the inscription on the verso. Rembrandt may have made his notes on the back of an old drawing.

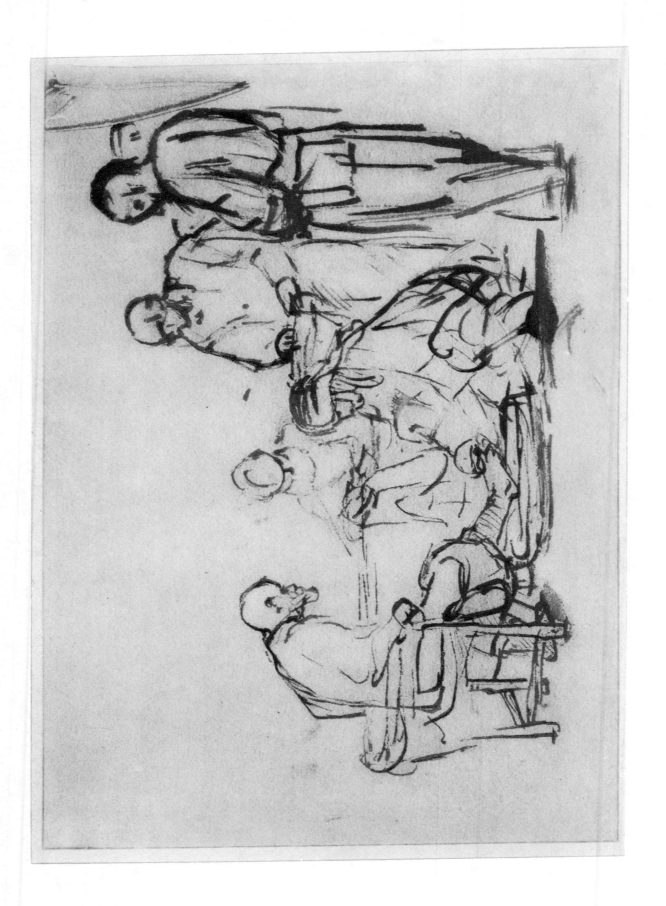

238 (II, 21). *Christ Washing the Feet of the Disciples.* (Rijksprentenkabinet, Amsterdam)

Reed pen and bistre: 156 × 220 mm.

About 1655. The attentive tenseness of the seated disciple served by Christ balances the heavy figures on the right of this drawing, which ranks with the most expressive made by Rembrandt.

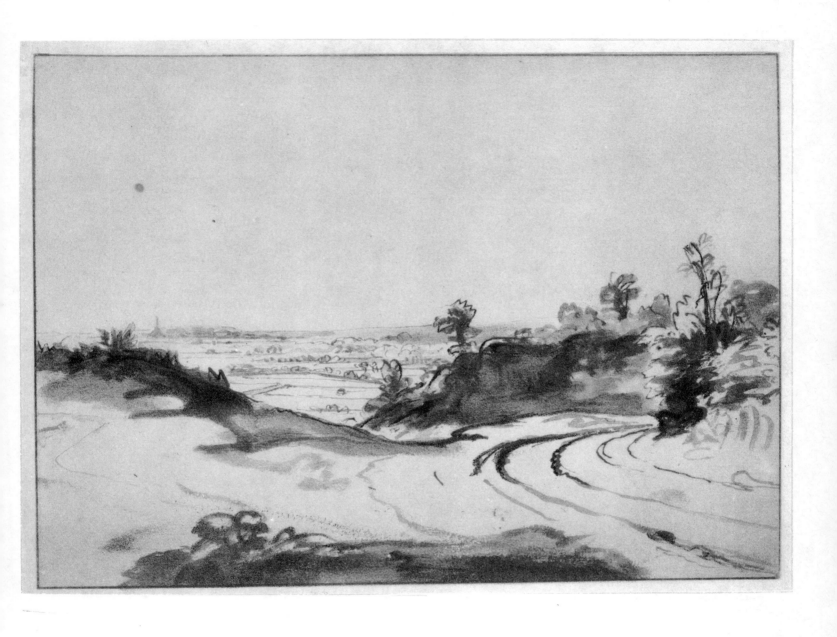

239 (*II, 22*). *View in Gelderland. (Rijksprentenkabinet, Amsterdam)*

Pen, brush and wash in bistre: 145 × 196 mm.

*There is agreement that this view of a plain from a hill shows a landscape in Gelderland, but not everyone agrees
that it is an autograph work by the master (see Begemann, 1961, no. 829). Benesch (829) sees later additions on
the left, but the whole drawing seems to be the work of one hand. Begemann notes it is a hand which does not
coördinate pen and brush work as successfully as Rembrandt did in the late 1640's—the date generally assigned to
the work.*

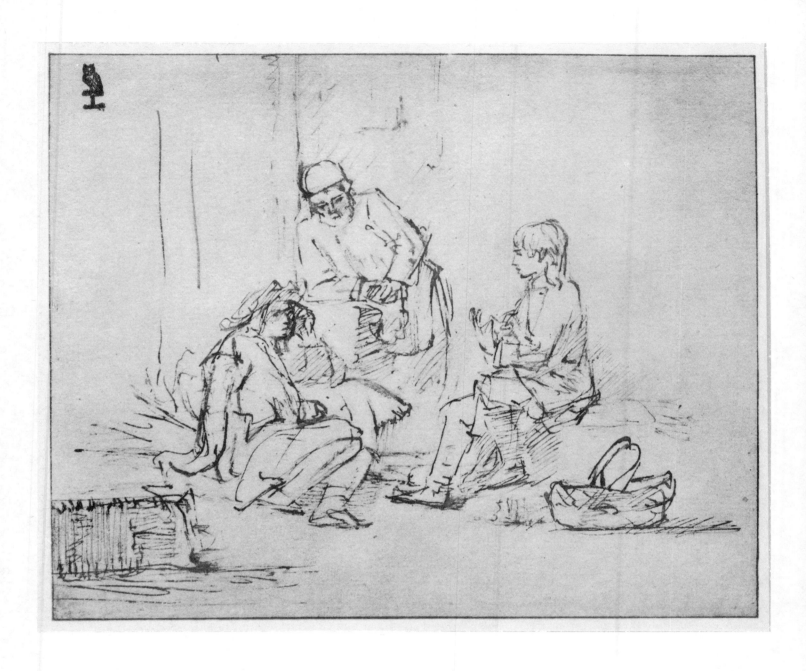

240 (*II, 23*). *Joseph Interpreting the Prisoners' Dreams.* (*Rijksprentenkabinet, Amsterdam*)
Reed pen and bistre: 157 × 189 mm.
About 1652.

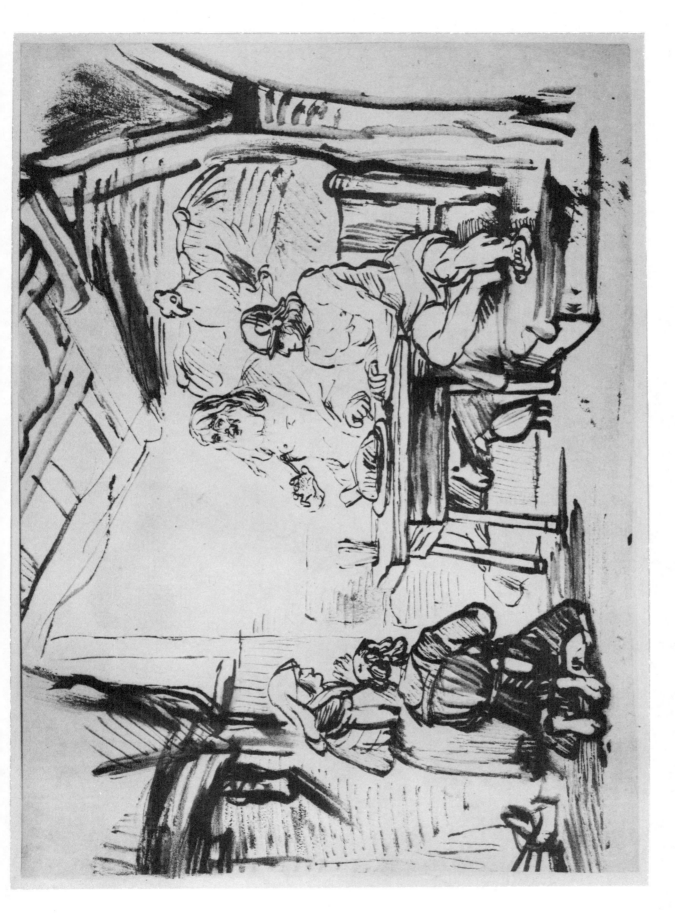

241 (II, 24). *Jupiter and Mercury with Philemon and Baucis. (Rijksprentenkabinet, Amsterdam)*
Pen and brush in bistre, wash: 185 × 258 mm.

A school drawing attributed to Samuel van Hoogstraten by Valentiner (Vol. I, p. xvi) and Henkel (1943, p. 87, no. 3); to Jan Victors by Lugt (1933, no. 1281). The suggestion made by Wichmann (Cicerone, 1924, p. 778) that it is by Nicolaes Maes can be dismissed. The artist must have been familiar with Rembrandt's various studies of the theme, and his painting of the subject now in the National Gallery, Washington, D.C. (Bredius 481).

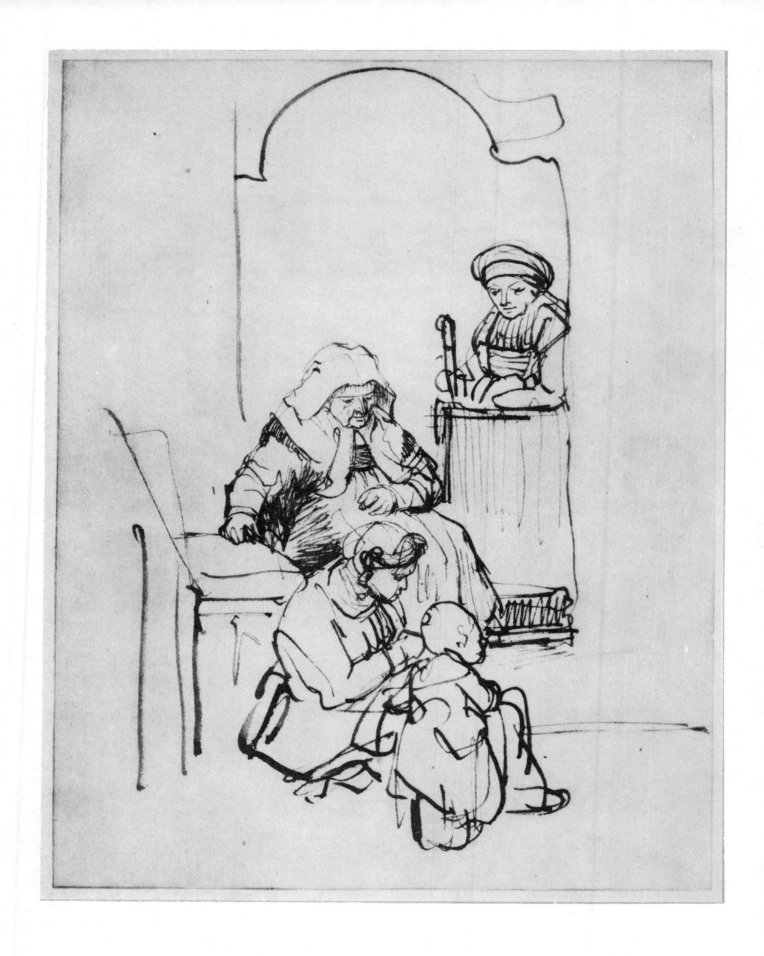

242 *(II, 25). Three Women and a Child at the Entrance of a House. (Rijksprentenkabinet, Amsterdam)*
Pen and bistre: 232 × 178 mm.
About 1635–40. Other genre scenes by Rembrandt in a similar setting are known; see 351 (III, 19).

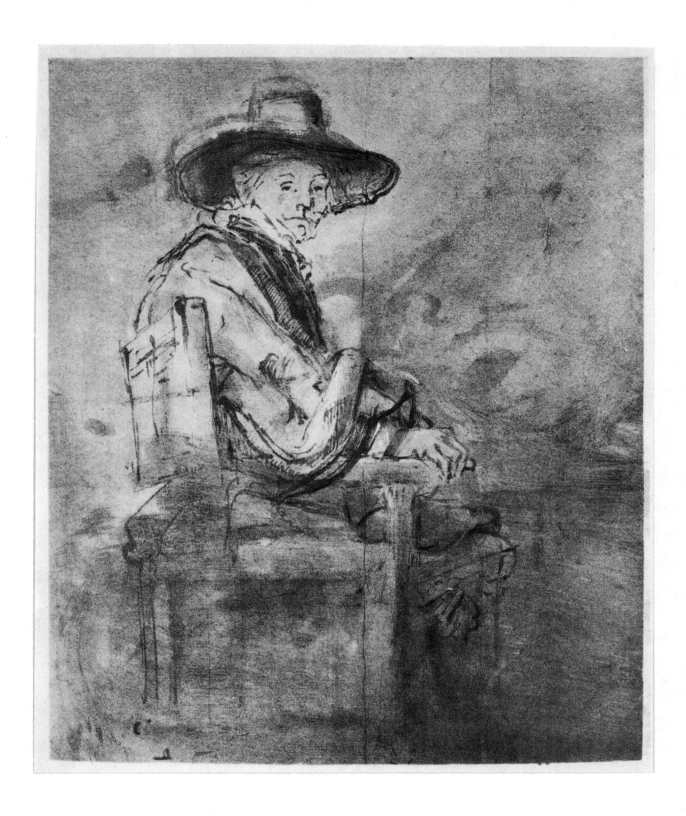

243 (*II, 26*). *Study of a Syndic.* (*Rijksprentenkabinet, Amsterdam*)

Pen and brush in bistre, wash, white body color: 193 × 159 mm.

About 1662. Study for the man seated at the left in The Syndics of the Clothmakers' Guild (De Staalmeesters, *1662, Rijksmuseum, Amsterdam, Bredius 415). This beautiful drawing, which seems to have been made primarily as a chiaroscuro study, also captures the psychological penetration of the finished portrait of the figure. See 213 (I, 196) for another study for the group portrait.*

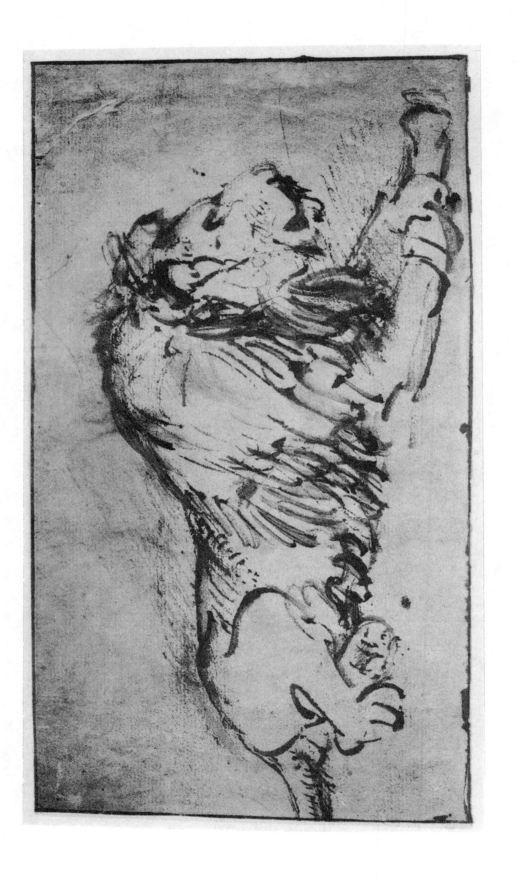

244 (II, 27). *A Recumbent Lion, Turned to the Right. (Rijksprentenkabinet, Amsterdam)*

Reed pen and bistre: 119 × 212 mm.

About 1660. Generally recognized as Rembrandt's latest and most vigorous study of a lion. Other studies of lions are reproduced 157 (I, 150b); 219 (II, 2); 491 (IV, 46).

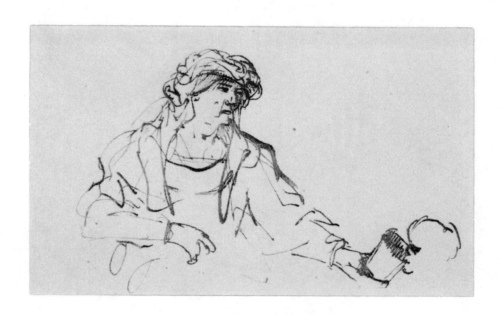

245 (*II, 28a*). *An Old Woman Giving Drink to a Child.* (*Rijksprentenkabinet, Amsterdam*)
Pen and bistre: 72 × 119 mm.
About 1633–35. Similar tangled lines, which always manage to suggest form, can be seen in passages of 18 (I, 18).

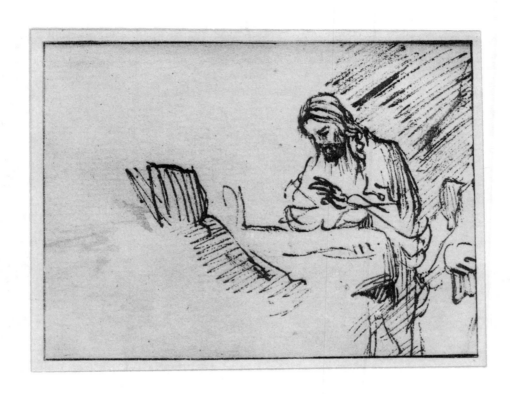

246 (*II, 28b*). *Study for a Figure of Christ.* (*Rijksprentenkabinet, Amsterdam*)

Pen and bistre: 87 × 117 mm.

A follower's copy of the figure of Christ from a drawing of Satan Tempting Christ to Change Stones into Bread, *formerly in the C. Hofstede de Groot Collection, The Hague. The latter is accepted by some students as an original Rembrandt and rejected by others as a school piece (see Valentiner 354a; Benesch A88). Henkel (1943, no. 104) suggests the name of Rembrandt's pupil Willem Drost for the Amsterdam sheet.*

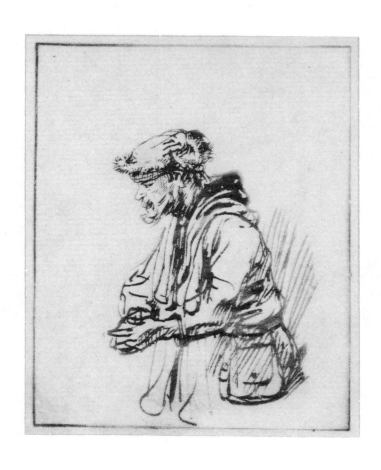

247 (*II, 29a*). *A Beggar with a Leather Bag, Turned Toward the Left.* (*Rijksprentenkabinet, Amsterdam*)
Pen and bistre: 105 × 83 mm.
About 1637–40.

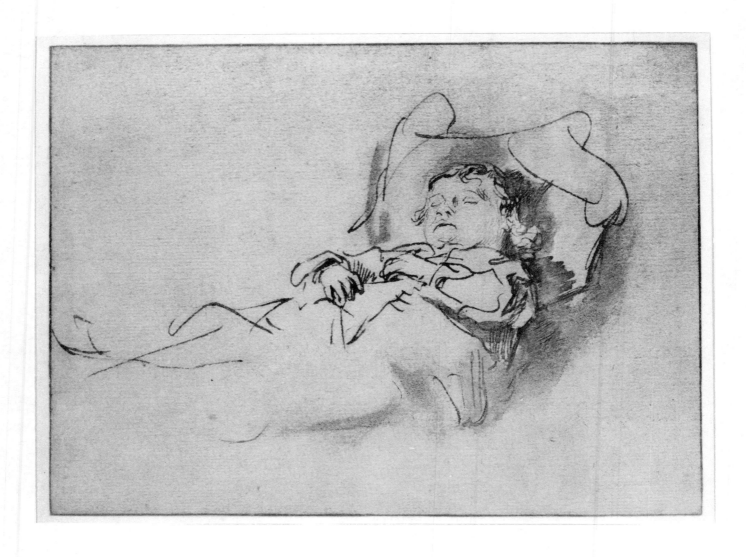

248 (*II, 29b*). *A Sleeping Child.* (*Rijksprentenkabinet, Amsterdam*)

Pen and bistre, wash: 130 × 175 mm.

About 1638. The subject of this drawing has been identified as little Rumbartus (Rembrandt's first son) on his deathbed. Since the child is clearly older than about two months—the age at which Rumbartus died (see the comment to 227 [II, 10])—this romantic identification is wrong. On the verso there is a red chalk sketch of Saskia in bed.

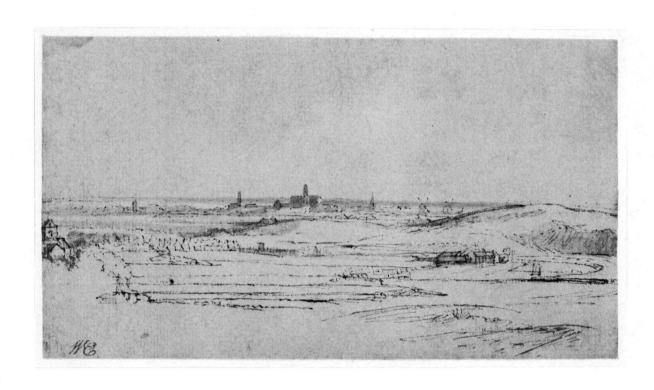

249 (*II, 30a*). *View of Haarlem Seen from Overveen. (Boymans-van Beuningen Museum, Rotterdam)*
Pen and bistre, wash: 89 × 152 mm.

About 1651. J. Q. van Regteren Altena (Oud Holland, LXIX, 1954, pp. 1–17) has shown that this view of
Haarlem was sketched during a visit to the estate of the merchant Christoffel Thijsz. The drawing, which was
made from a hill called "Het Kopje" that overlooked Thijsz's estate, served as a study for the well-known etching
of 1651, The Goldweigher's Field (Bartsch 234), and for a landscape painting published by van Regteren Altena
(op. cit.).

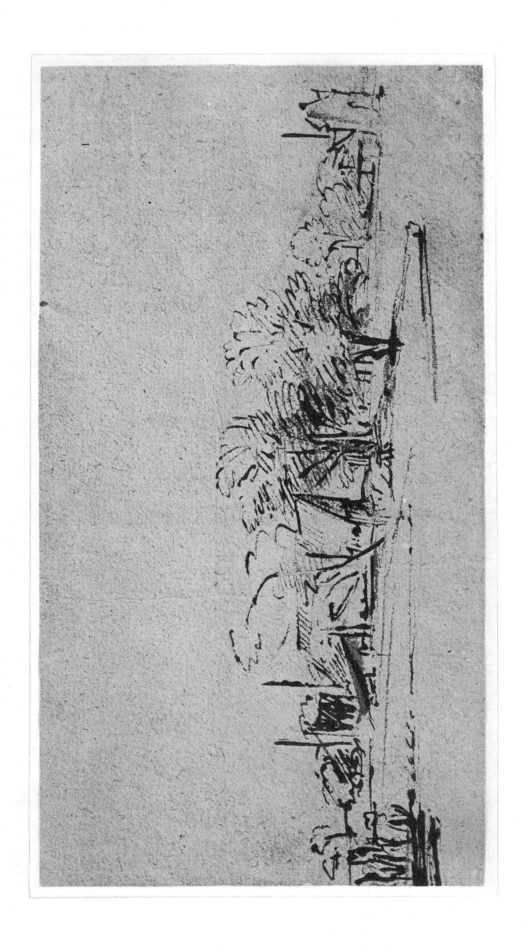

250 (*II, 30b*). *Farm Amidst Trees.* (*Boymans-van Beuningen Museum, Rotterdam*)

Pen and bistre: 120 × 226 mm.

About 1650–53. The same farm is depicted in 205 (I, 189b).

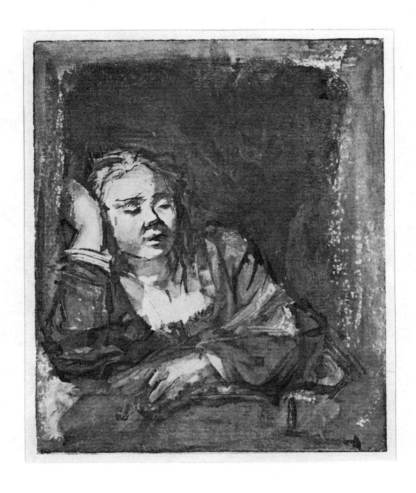

251 (*II, 31*). *A Sleeping Woman at a Window.* (*Formerly J. P. Heseltine Collection, London*)
Reed pen and bistre, wash: 82 × 73 mm.

Perhaps a portrait of Hendrickje Stoffels made around 1655–57. Similar in style and spirit to the drawing of a sleeping woman at Dresden (458 [IV, 16b]), but here the rich shadows are set off by a few patches of bright sunlight. The combination of broad, bold penwork and luminous washes, and just a few finely hatched lines can be found in other drawings of this period. Accepted by Valentiner (709). Not listed by Benesch.

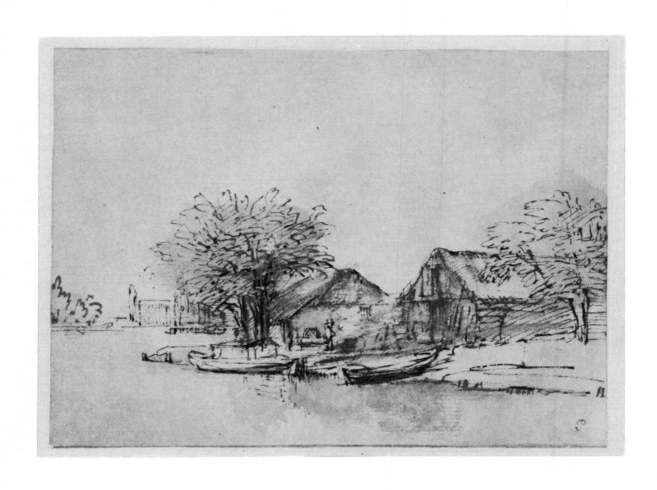

252 (II, 32a). Cottages by the Water. (Museum, Groningen)
Pen and bistre: 110 × 149 mm.
About 1652.

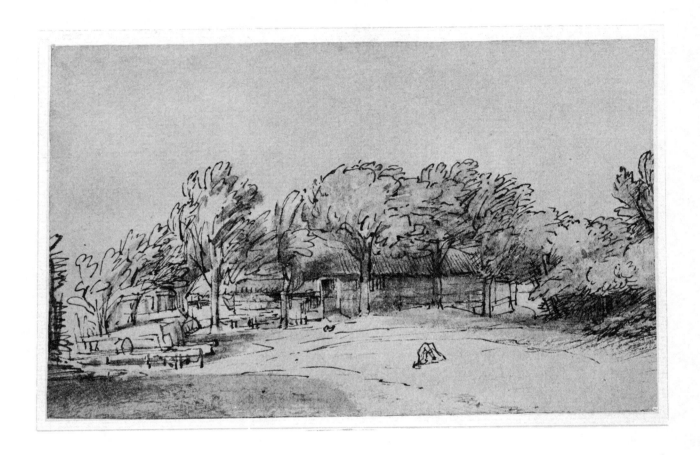

253 (*II, 32b*). *A Cottage and Barn Surrounded by Trees.* (*Boymans-van Beuningen Museum, Rotterdam*)
Pen and bistre, wash: 102 × 161 mm.
About 1652. Lugt (1920) notes that Rembrandt used the site for his etching of 1652, Clump of Trees with a
Vista (*Bartsch 222*).

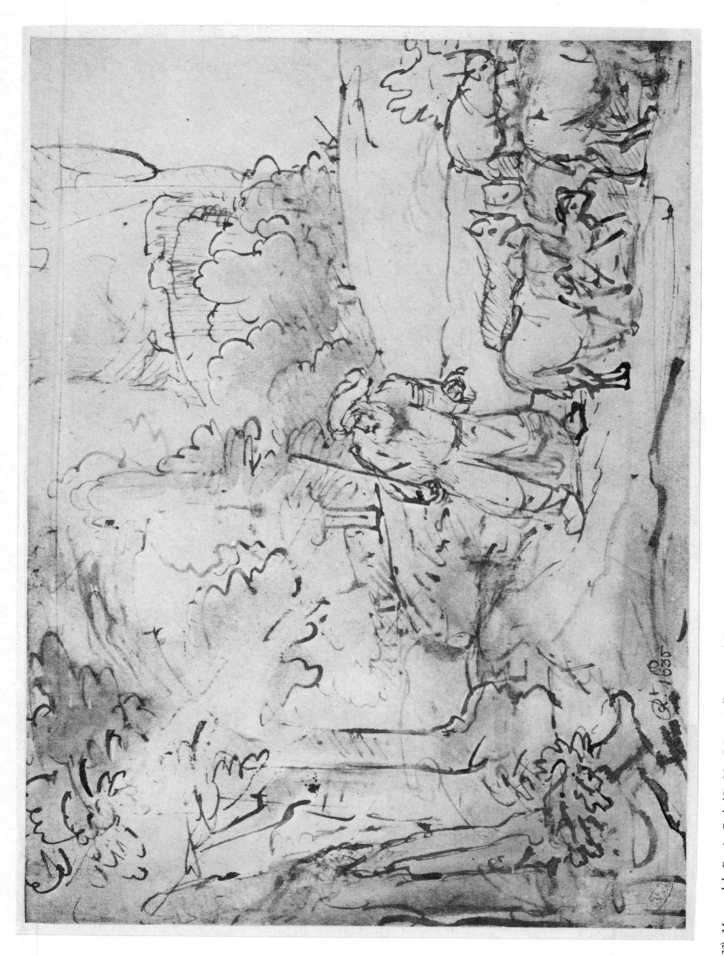

254 (II, 33). *Moses and the Burning Bush.* (Sir Max J. Bonn Collection, London)
Reed pen and wash in bistre, white body color: 175 × 247 mm.
About 1655. Divine presence is suggested by the stream of light and by Moses' awesome reaction to it.

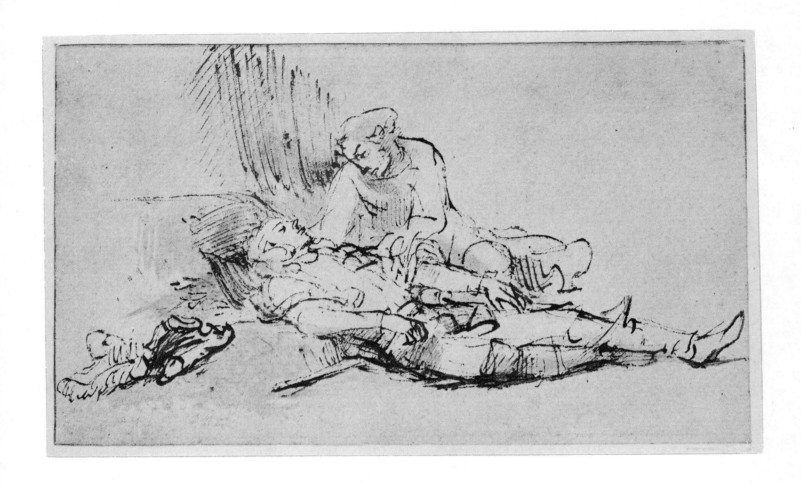

255 (*II, 34*). *Thisbe Lamenting Pyramus.* (*Kupferstichkabinett, Berlin*)

Pen and bistre: 112 × 187 mm.

About 1650–52. Once identified as Hagar and Ishmael. F. M. Haberditzl (in F. Wickhoff, Seminarstudien, 1906, p. 30) gave the correct interpretation.

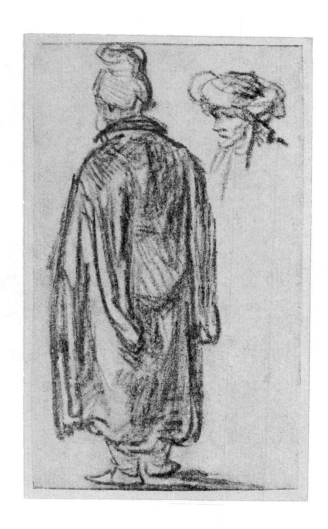

256 (*II, 35a*). *Oriental Seen from Behind, Another Head Above on the Right.* (*Kupferstichkabinett, Berlin*)
Black chalk: 123 × 72 mm.

About 1648. A comparison of this figure with the following early drawing shows some of the changes which have taken place in Rembrandt's style. The emphasis has shifted from an interest in the picturesque character of a figure's silhouette to simpler and more regular forms. This new attitude helps account for the monumentality the mature Rembrandt can achieve in a simple rapid study of a standing figure.

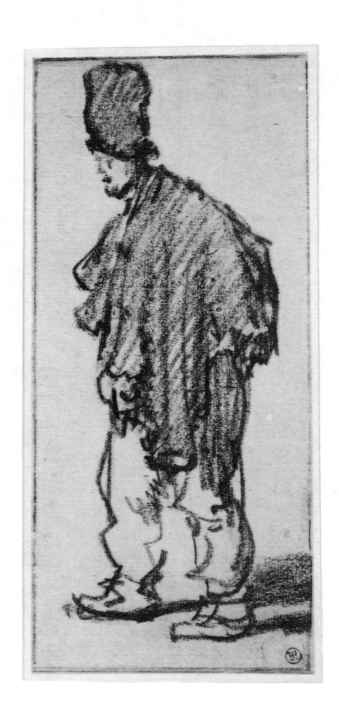

257 (*II, 35b*). *Standing Beggar in a High Cap.* (*Kupferstichkabinett, Berlin*)
Black chalk: 171 × 76 mm.
About 1630. See the comment to the preceding drawing.

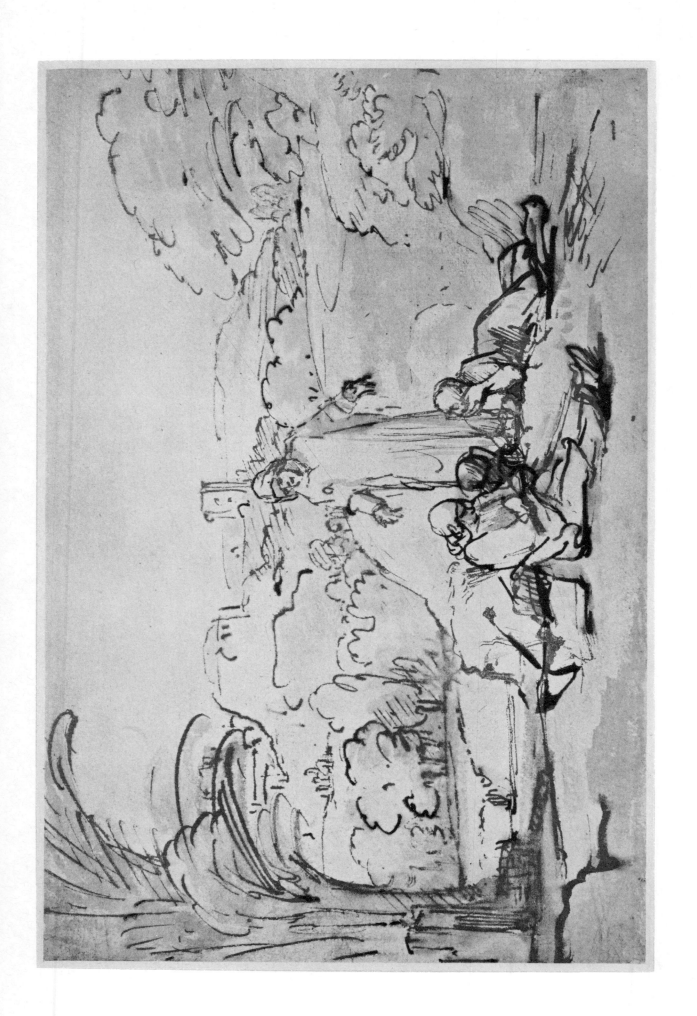

258 (II, 36). *Christ Finding the Apostles Asleep in Gethsemane. (Formerly J. P. Heseltine Collection, London)*
Pen and wash: 185 × 280 mm.

About 1655. Benesch (941) rightly emphasizes that the landscape in this drawing is an important example of Rembrandt's late style of free landscape composition.

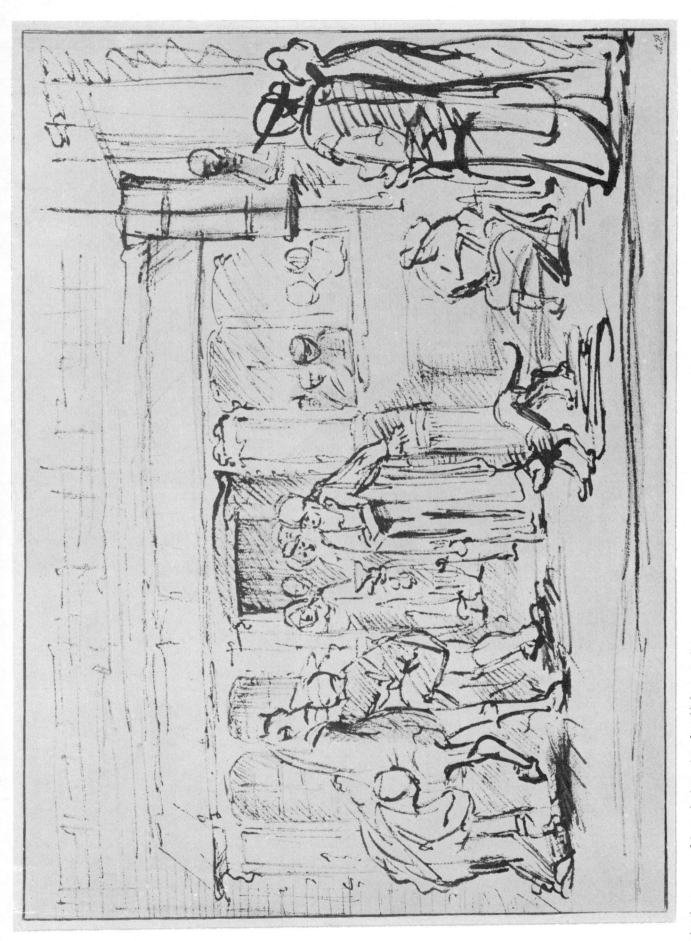

259 (II, 37). The Departure of the Prodigal Son. (Kupferstichkabinett, Berlin)

Pen and bistre: 193 × 274 mm.

Traces of a careful preliminary crayon drawing under this free and rather disorderly pen drawing support the conclusion that this is a copy after a lost original of the 1650's. Rembrandt's pen drawings were almost invariably made directly on the paper without the aid of a preliminary drawing.

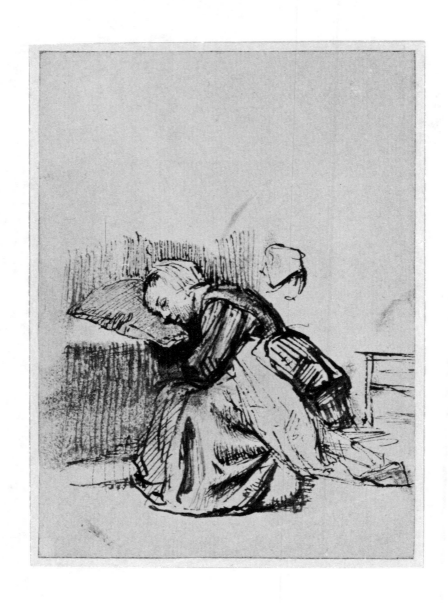

260 (*II, 38a*). *A Sleeping Girl.* (*Rembrandt Huis, Amsterdam*)
Pen and bistre, wash: 139 × 99 mm.
About 1655. The fine, closely hatched lines are characteristic of the mid–1650's.

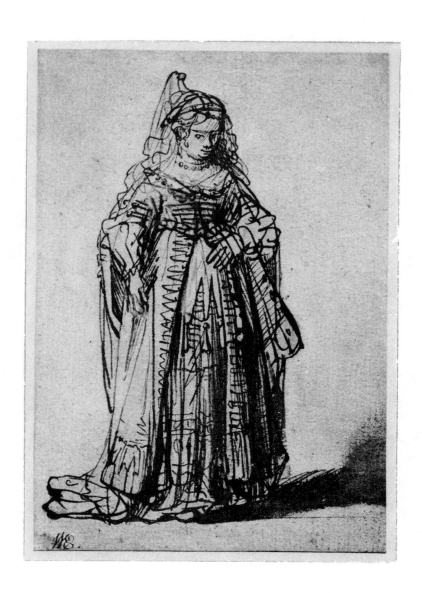

261 (*II, 38b*). *Figure in a Rich Costume. (Kupferstichkabinett, Berlin)*

Pen and bistre, wash, white body color: 139 × 95 mm.

About 1636–38. Related to a group of other drawings of richly dressed women (Benesch 316, 318–321). All of them appear to have been made in the theatre. If these sheets are drawings of theatrical performers, there is good reason to believe they represent men dressed in women's costumes because during Rembrandt's time women hardly ever appeared on the Amsterdam stage. In seventeenth-century Holland, as in the rest of Europe, women's roles were usually played by men. (See 79 [I, 79] for a drawing close in style which has been called a study of an actor.)

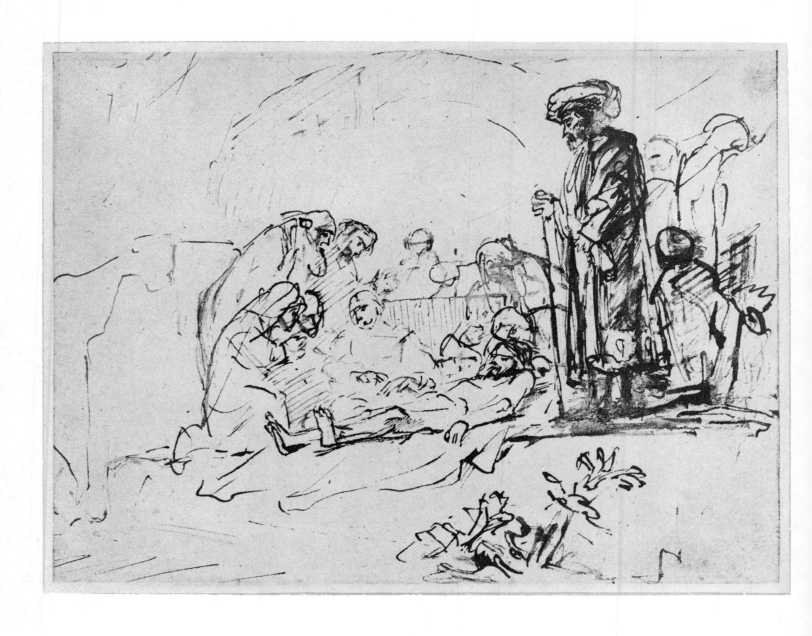

262 (*II, 39*). *Lamentation Over the Body of Christ.* (*Kupferstichkabinett, Berlin*)

Pen and bistre, wash, white body color: 149 × 195 mm.

About 1655–60. The powerful vertical of the erect figure holding a staff and the curve formed by the mourning group on the left make an emphatic contrast with the dead figure of Christ.

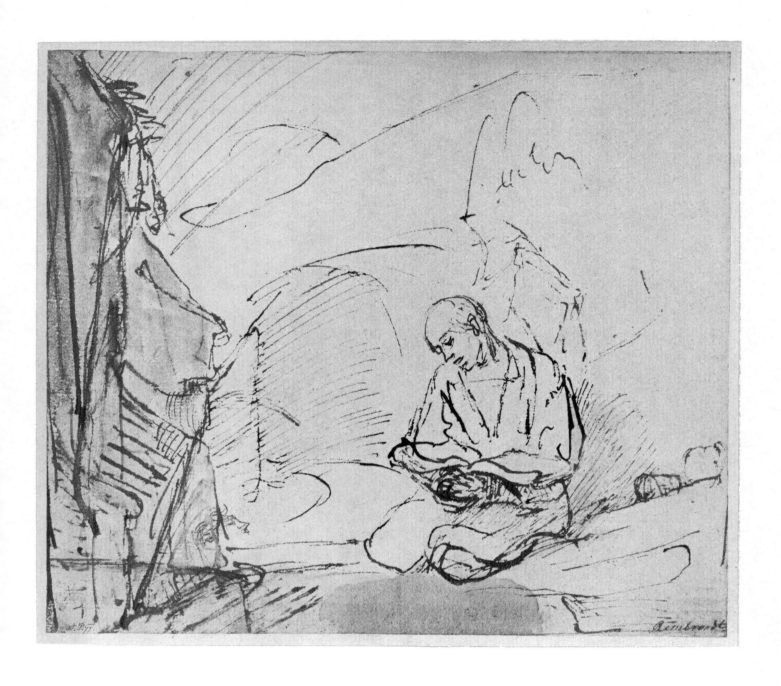

263 (II, 40). *A Man Reading on His Knees (St. Jerome?). (Kupferstichkabinett, Berlin)*

Pen and bistre, wash, white body color: 159 × 179 mm. Inscribed by a later hand: Rembrandt.

*About 1650. F. M. Haberditzl (in F. Wickhoff, Seminarstudien, 1906, p. 29) suggested that the drawing
represents St. Jerome. The portion of a head in the lower left of the drawing was part of an earlier study made on
the sheet and is not related to this composition.*

264 (*II, 41a*). *A Child's Head.* (*British Museum, London*)
Pen and wash in Indian ink: 65 × 52 mm.
About 1655–58.

265 (*II, 41b*). *A Youth Drawing.* (*British Museum, London*)
Pen and wash in bistre: 65 × 52 mm.
About 1655–58.

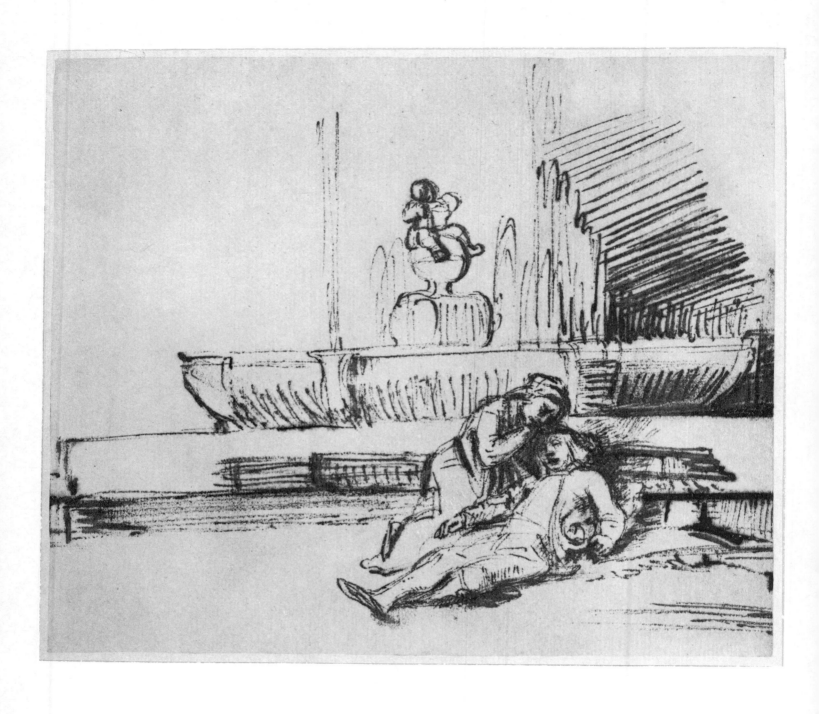

266 (*II, 42*). *Thisbe Weeping Over the Body of Pyramus.* (*Kupferstichkabinett, Berlin*)
Pen and bistre: 165 × 192 mm.

This fine school drawing, as well as another version formerly in the Liechtenstein Collection, Vienna, was attributed to Samuel van Hoogstraten by G. Falck (see Rosenberg, 1930, p. 229, no. 2691).

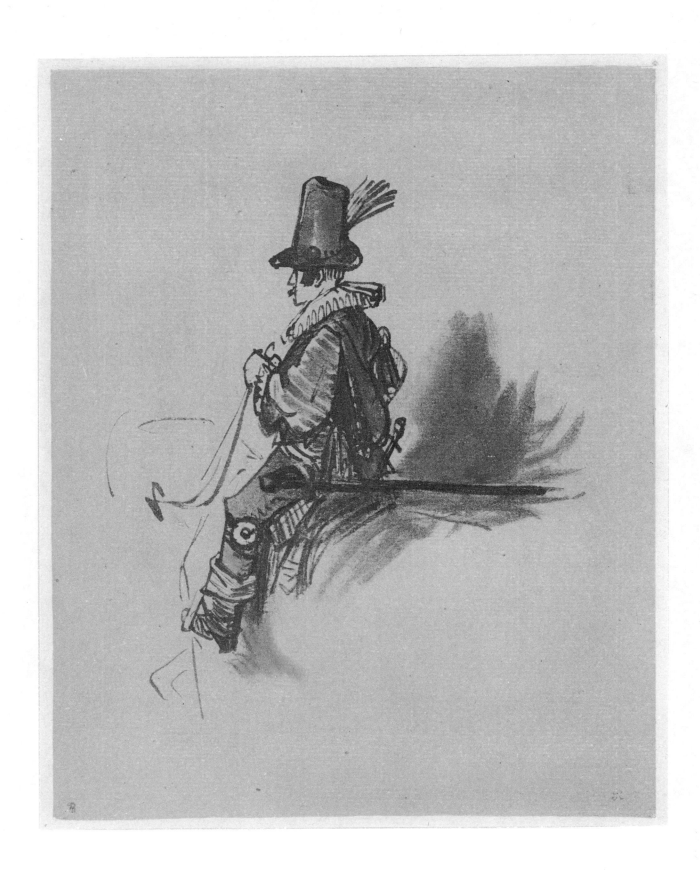

267 (II, 43). *A Mounted Officer.* (British Museum, London)

Pen and wash in bistre, red chalk, yellow water color, heightened with white and some oil color: 210 × 164 mm.

About 1638. See the comment to 119 (I, 117).

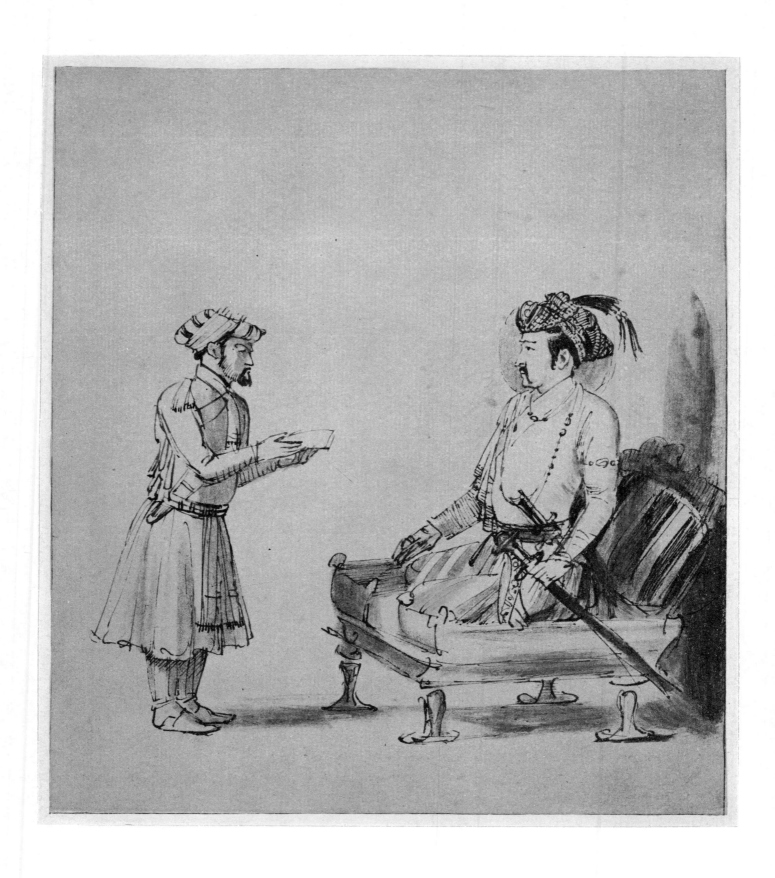

268 (*II, 44*). *The Emperor Jahangir (ruled 1605–1628) Receiving an Address.* (*British Museum, London*)
Pen and bistre, wash, on Japanese paper: 210 × 183 mm.
About 1655. Copy after an Indian miniature; see the comment to 167 (I, 159).

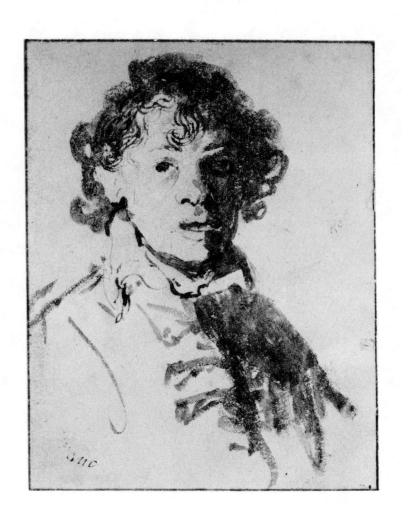

269 (*II, 45*). *Self-portrait.* (*British Museum, London*)

Pen and bistre, brush and Indian ink: 127 × 95 mm.

About 1629. Young Rembrandt's bold touch, which never fails to integrate pen stroke and brushwork, and his daring use of sharp contrasts of light and shadow are seen in this amazingly candid early self-portrait.

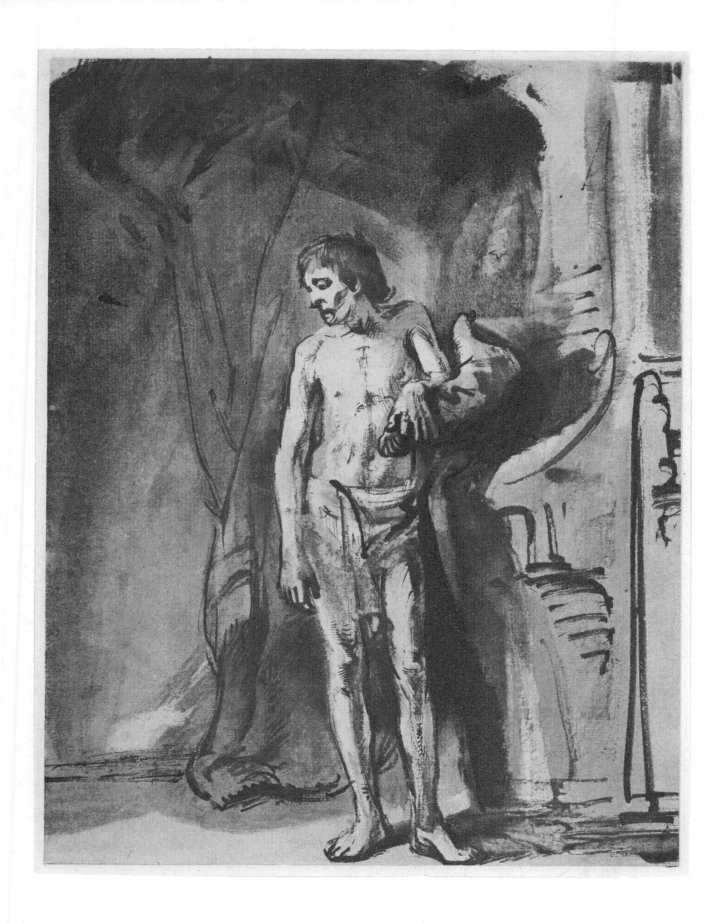

270 (II, 46). *Standing Male Nude. (British Museum, London)*

Pen and wash in bistre, white body color, over traces of red and black chalk: 252 × 193 mm.

The drawing and two others (Benesch 709 and A55) are closely related to Rembrandt's etching of 1646 (Bartsch 194). However, each drawing shows a different character and it is difficult to relate the style of any of them to Rembrandt drawings made in the mid-1640's. Perhaps they were made in the master's studio by different pupils while Rembrandt himself was working from the model on the plate for his etching. The sharp contrast between the rather timid hatching and the bold accents of the reed pen suggests that the later strokes may be corrections by the master on a student's drawing. For the view that this sheet is authentic see Benesch (710).

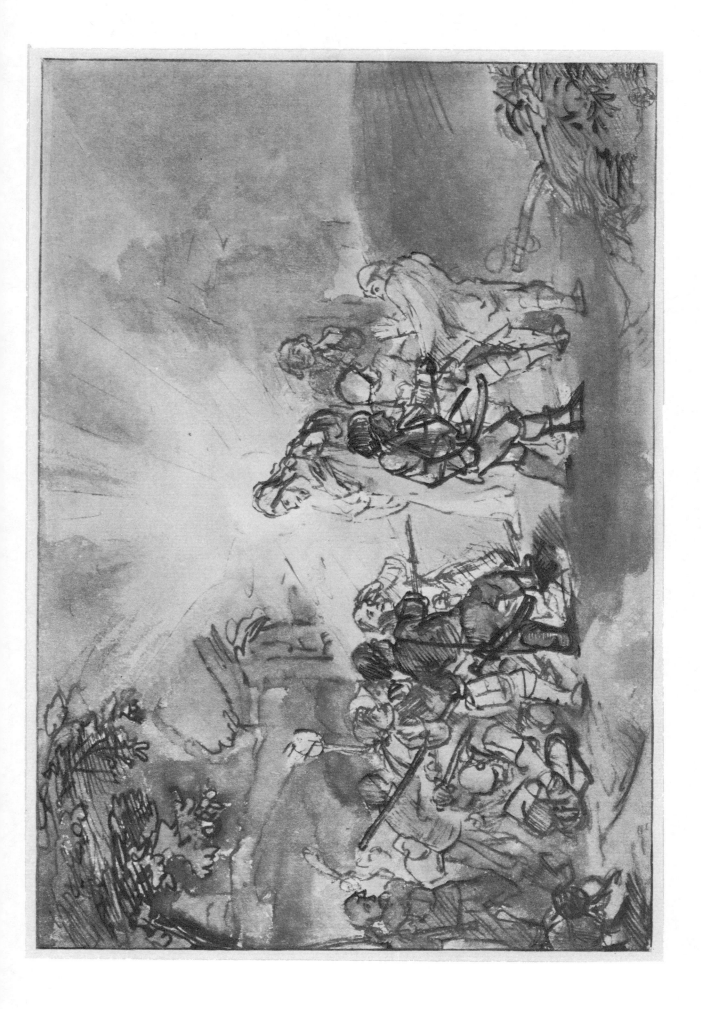

271 (II, 47). *The Arrest of Christ.* (Count Antoine Seilern Collection, London)

Pen and bistre, wash: 175 × 260 mm.

About 1655–60. The use of size to help indicate the relative importance of personages is an anachronism which Rembrandt did not hesitate to employ. In this drawing Christ is almost twice as tall as the dwarf-like soldiers who are about to arrest Him. They are as awed by His supernatural size as by the divine light which radiates from Him. See 230 (II, 13) for another conception of this episode.

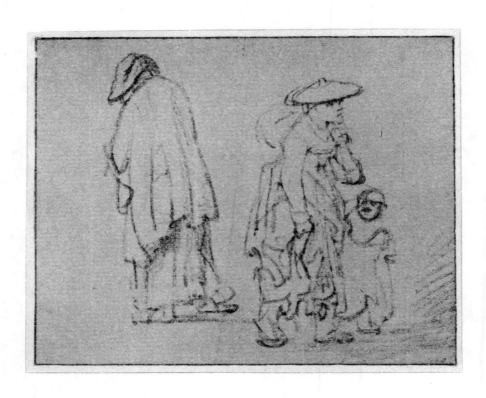

272 (*II, 48a*). *Studies of Walking Figures.* (*Kupferstichkabinett, Berlin*)
Black chalk: 90 × 111 mm.
About 1637–40.

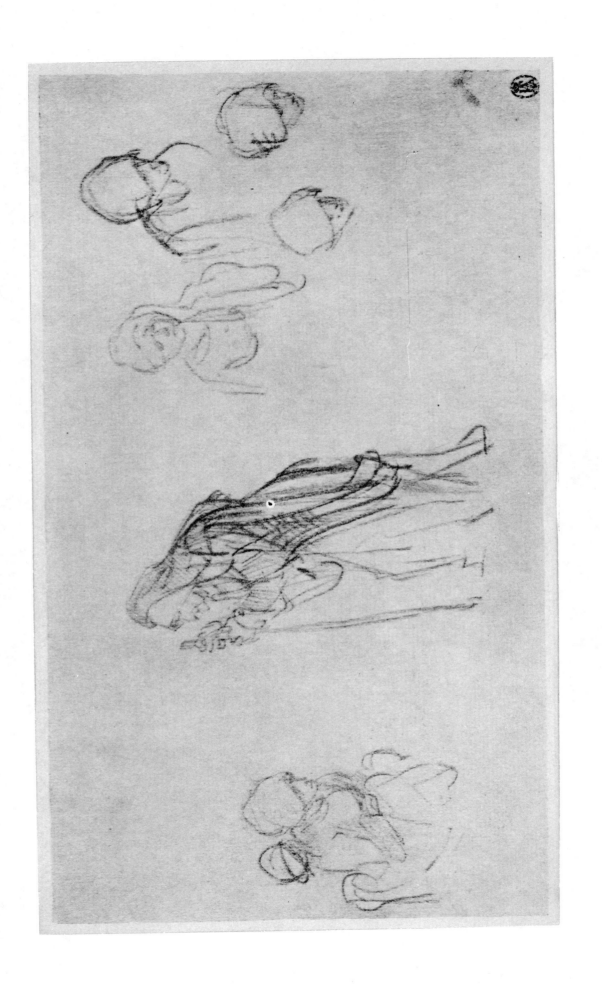

273 (II, 48b). *Sheet of Studies of Women. (Rembrandt Huis, Amsterdam)*
Black chalk: 133 × 231 mm.
About 1637–40.

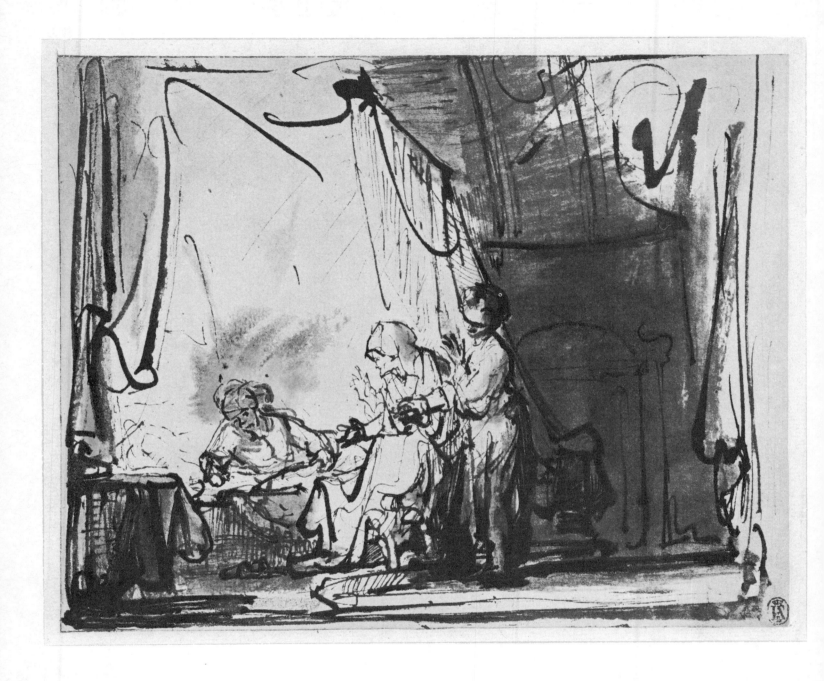

274 (*II, 49*). *Sarah Presenting Hagar to Abraham.* (*Friedrich August II Collection, Dresden*)

Pen and wash in bistre, white body color: 158 × 195 mm.

About 1640–42. Another version of the drawing is at the Louvre, Paris (Benesch, A51). Both fall below the standard of Rembrandt's drawings; Lugt (1933, no. 1205) suggests both are by Ferdinand Bol.

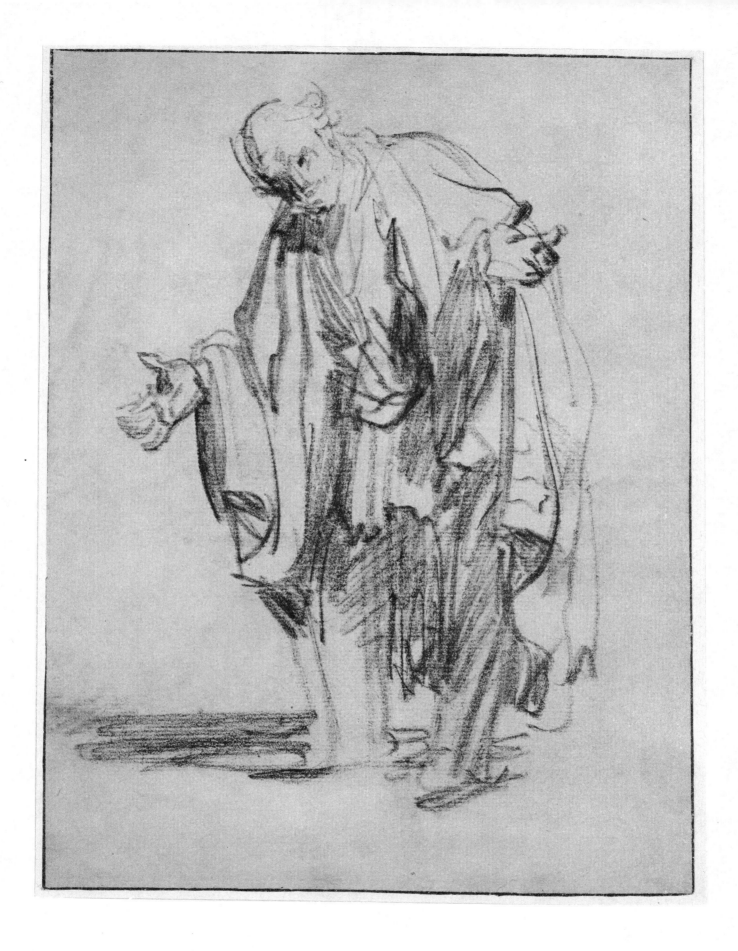

275 (*II, 50*). *Study for St. Peter.* (*Kupferstichkabinett, Dresden*)

Black chalk: 254 × 190 mm.

About 1629. Study in reverse for the etching of St. Peter and St. John Healing the Cripple at the Door of the Temple (*Bartsch 95*). *An outstanding example of Rembrandt's early mastery of gesture and expression. His attempt to translate the rapid chalk sketch into an etching was less successful because he failed to control the biting of the acid in his plate.*

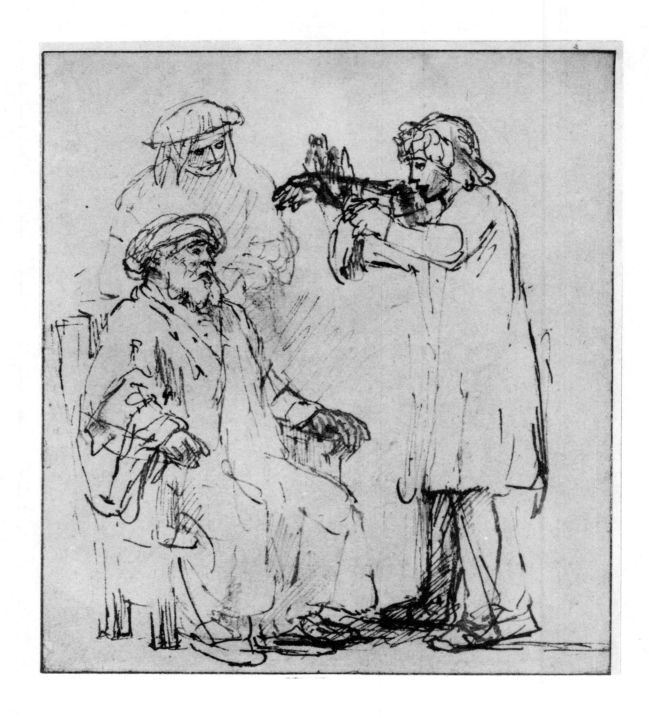

276 (*II, 51*). *Joseph Telling His Dreams*(?). (*Bredius Museum, The Hague*)

Pen in bistre: 168 × 151 mm.

The subject is not clear. It has been interpreted as Joseph telling his dreams to his parents (Genesis 37, 10–11),
Jacob deceiving his father Isaac, with Rebekah watching (Genesis 27), and as the healing of Tobit (see Kruse,
1920, p. 3). None of these identifications is completely satisfactory. The drawing, which is a characteristic work of
about 1650, is not listed in Benesch.

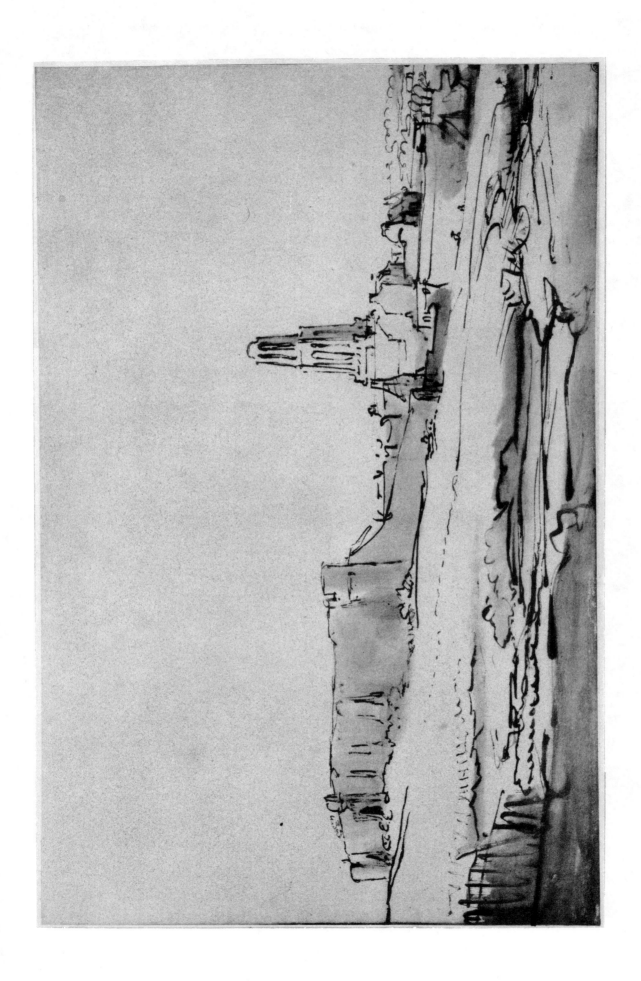

277 (II, 52). *View of Rhenen. (Bredius Museum, The Hague)*
Pen and wash in bistre: 210 × 324 mm.
About 1648. See the comment to 72 (I, 72).

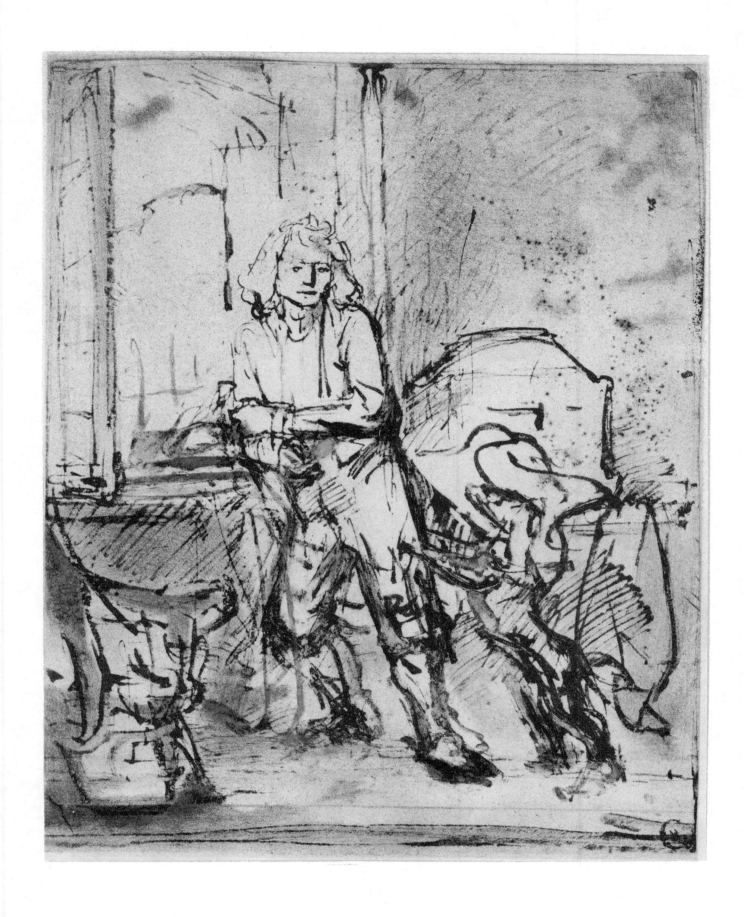

278 (II, 53). *Jan Six with a Dog, Standing by an Open Window. (Six Collection, Amsterdam)*
Pen and wash, white body color: 220 × 175 mm.
About 1647. Preliminary study in reverse for the 1647 etching of Six (Bartsch 285). In the finished work
Rembrandt made considerable changes. He portrayed Six reading, he eliminated the dog, changed the furniture and
omitted the view from the window. The final drawing for the etching is also in the Six Collection (Benesch 768).

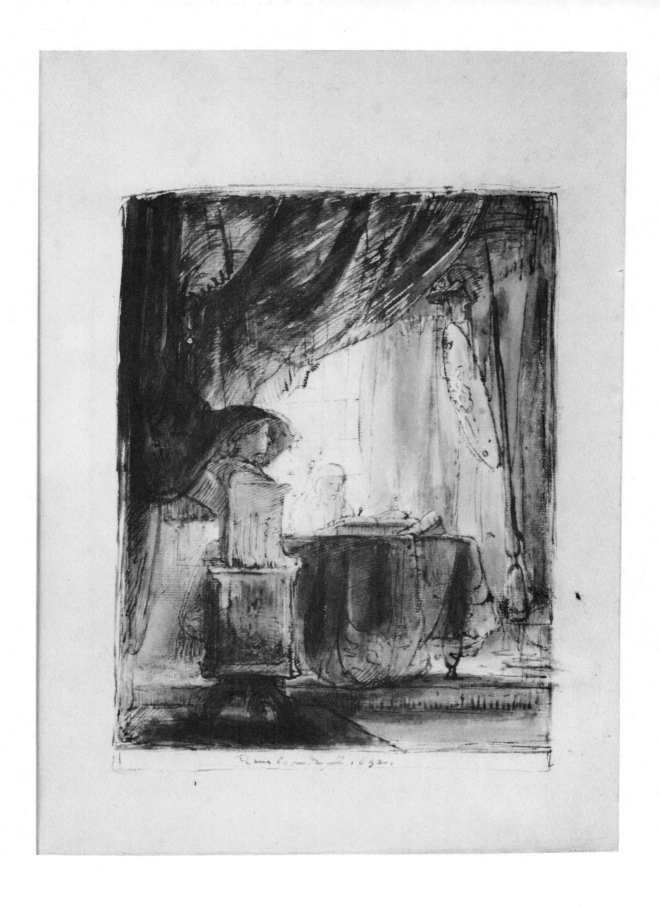

279 (*II, 54*). *Minerva in Her Study.* (*Six Collection, Amsterdam*)

Reed pen and wash in bistre, white body color: 190 × 140 mm. Signed and dated: Rembrandt f. 1652.

Made for the Album Amicorum *called "Pandora" which belongs to the Six family. The traditional identification of the model as Anna Wijmer, Jan Six's mother, in the guise of Minerva, is without foundation (see E. Haverkamp-Begemann, "Rembrandt's So-called Anna Wÿmer as Minerva,"* Acts of the Twentieth International Congress of the History of Art, *Princeton, 1963, Vol. 3, pp. 59 ff.). The other drawing Rembrandt made for the same album also depicts a classical subject (reproduced 223 [II, 6]).*

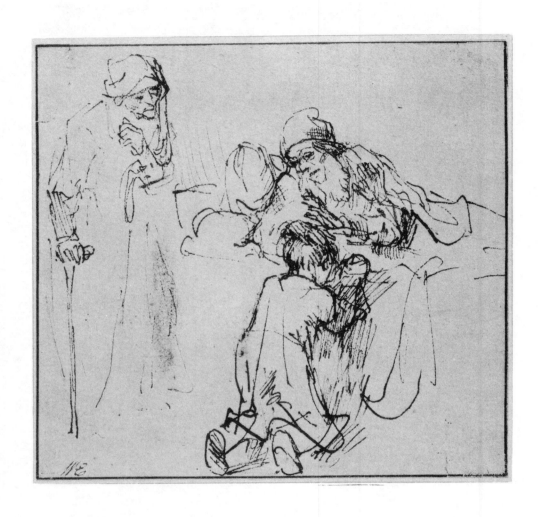

280 (*II, 55*). *Isaac Blessing Jacob.* (*Lady Melchett Collection, London*)
Pen and bistre: 120 × 125 mm.
About 1652. See 76 (I, 76) for another version of the composition.

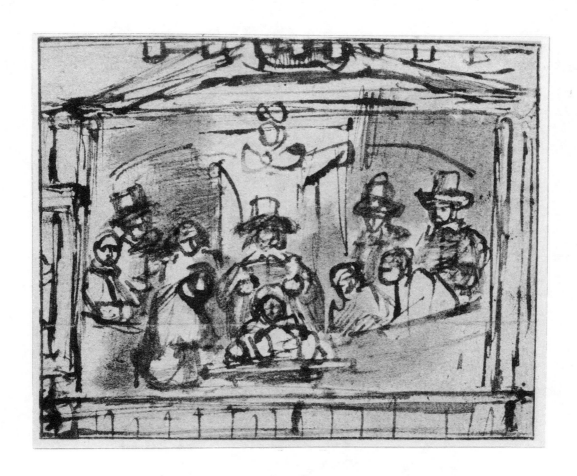

281 (*II, 56*). *The Anatomy Lesson of Dr. Deyman.* (*Rijksprentenkabinet, Amsterdam*)

Pen and bistre: 110 × 133 mm.

There is reason to believe that the drawing is not a preliminary compositional sketch for the 1656 group portrait or merely a design for a frame, but was made to show how the picture would look—or how it did look—in the room for which it was designed (see J. Q. van Regteren Altena, Oud Holland, 65 [1950], pp. 171 ff.). The squares at the top of the drawing can be interpreted as the beams of the room where the picture hung; on the left there is an indication of the open window on the lateral wall. The drawing is the only record of the whole painting which was severely damaged by fire in 1723; the remaining fragment is at the Rijksmuseum, Amsterdam (Bredius 414).

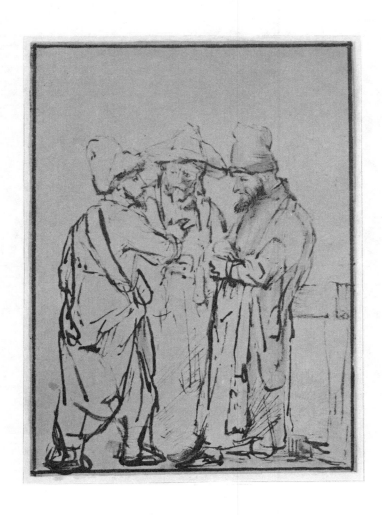

282 (*II, 57a*). *Three Jews Conversing.* (*Kupferstichkabinett, Berlin*)
Pen and bistre: 119 × 87 mm.
About 1650.

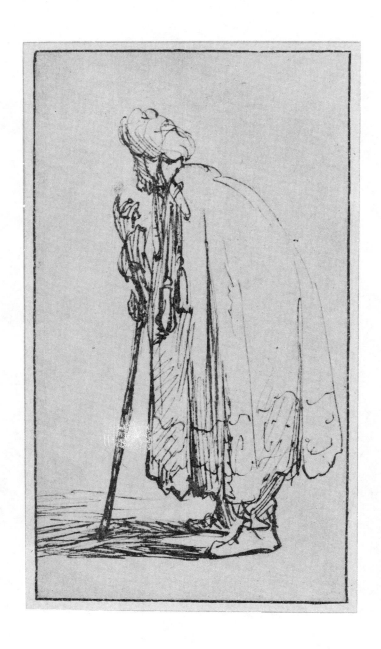

283 (*II, 57b*). *An Oriental Leaning on a Stick.* (*Kupferstichkabinett, Berlin*)
Pen and bistre: 150 × 84 mm.
About 1629.

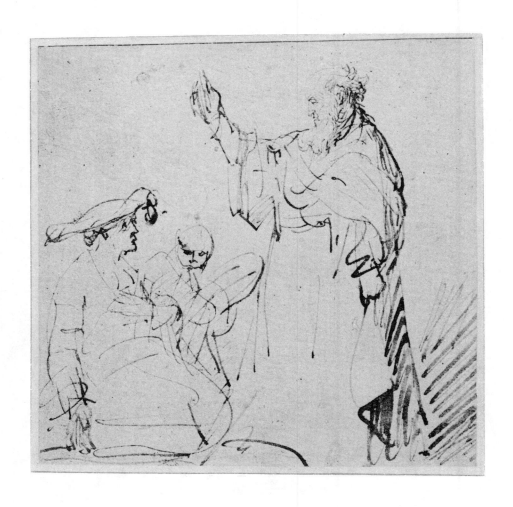

284 (*II, 58a*). *Boaz and Ruth.* (*Kupferstichkabinett, Berlin*)

Pen and bistre: 119 × 119 mm.

About 1635. The subject of this drawing has been much discussed. The best identification of the subject (Ruth 2, 4–10), which was made by Rosenberg (1930, p. 222, no. 1101), is based on a similar composition in Berlin (Benesch 162). It has also been suggested that the drawing represents Elijah and the Widow of Zarephath, Elisha and the Shunammite, and the Dismissal of Hagar.

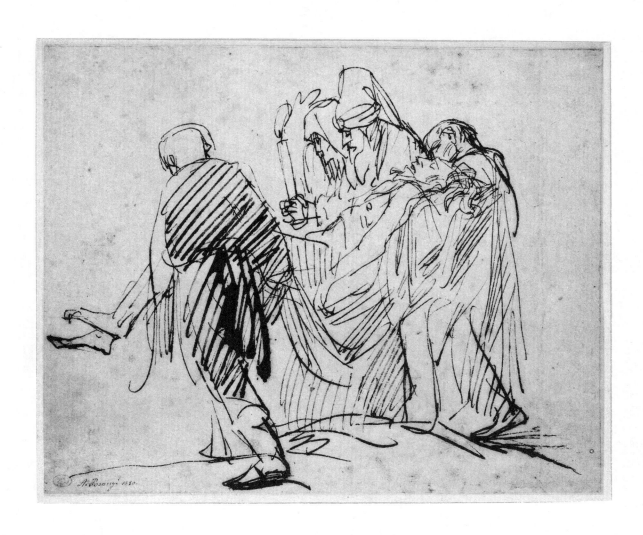

285 (*II, 58b*). *The Entombment of Christ.* (*Kupferstichkabinett, Berlin*)

Pen and bistre: 124 × 149 mm. (A strip of paper has been added on the right.)

About 1633. Perhaps a study for the Passion series commission made for the Stadholder in the 1630's.

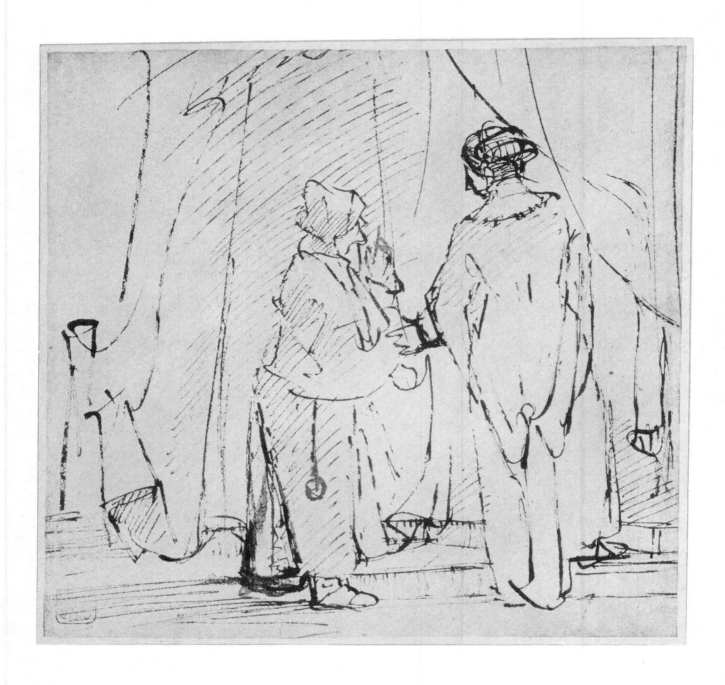

286 (II, 59). *Judith and Her Servant Before the Tent of Holofernes.* (*Kupferstichkabinett, Berlin*)

Pen and bistre: 163 × 168 mm.

About 1650–53. The old interpretation of this composition as Sarah bringing Hagar to Abraham is difficult to accept because here the young woman appears to be leading the way; she has drawn back the curtain and turns to her aged companion. In the Hagar story, old Sarah always takes the lead. She gives her young maid to her husband to be his wife (Genesis 16, 1–3).

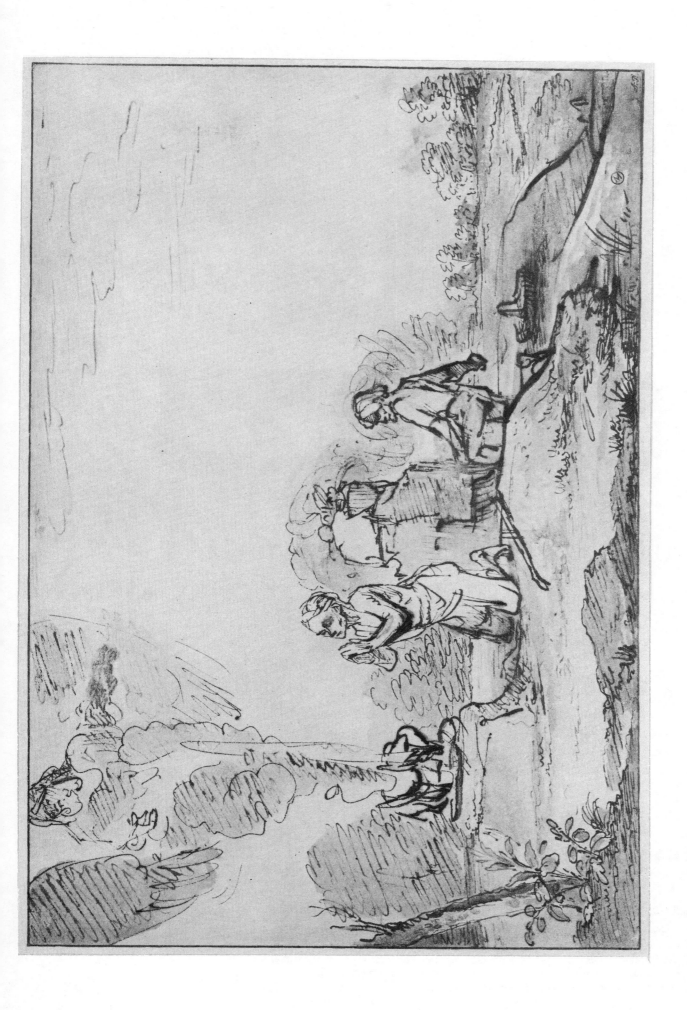

287 (II, 60). *The Offerings of Cain and Abel.* (*Kupferstichkabinett, Berlin*)
Pen and wash in bistre, white body color: 197 × 295 mm.

About 1650. Valentiner (2) noted that in this genuine drawing another hand added the entire landscape in the background, the tree trunk and piece of ground at the left, the clouds in the upper right, and part of the clouds around God the Father.

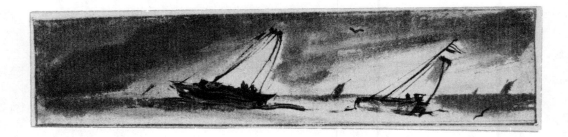

288 (*II, 61a*). *Two Sailing Boats in a Gale.* (*British Museum, London*)

Pen and brush in bistre: 32 × 136 mm.

The small sketch strikes an unusual note in Rembrandt's œuvre; however, one hesitates to exclude this bold, fresh seascape from it. Hind (1915, no. 128) calls it doubtful and ventures the name of Renier Zeeman, but adds that his drawings seldom possess such a rapid touch. Lugt (1920, p. 146) ascribes the drawing to Rembrandt without reservation and suggests it shows boats on the Zuider Zee. Not listed in Benesch.

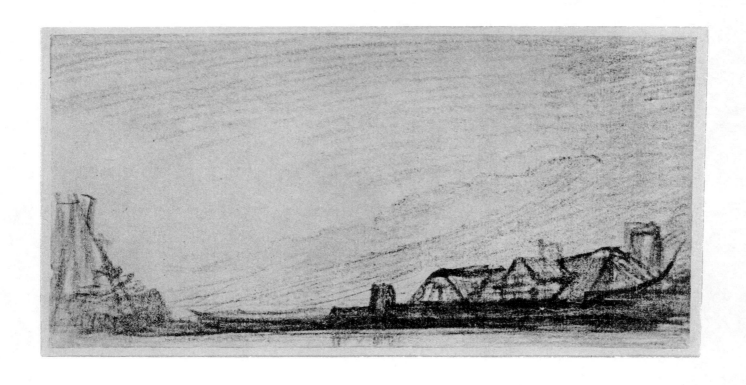

289 (*II, 61b*). *View of Cottages.* (*Kupferstichkabinett, Berlin*)
Black chalk: 86 × 172 mm.
About 1640. It is difficult to decide whether this is a view over roofs or over a canal.

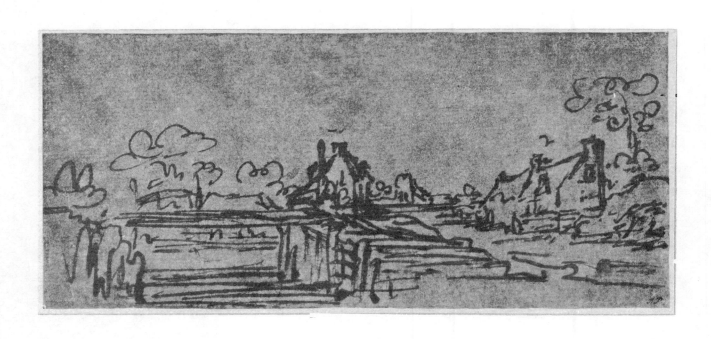

290 (*II, 61c*). *Village Street Along a Canal.* (*Kupferstichkabinett, Berlin*)
Pen in bistre on red tinted paper: 77 × 167 mm.
Doubtful. Rosenberg (1930, p. 244, 3091/3376) suggests Peter de With.

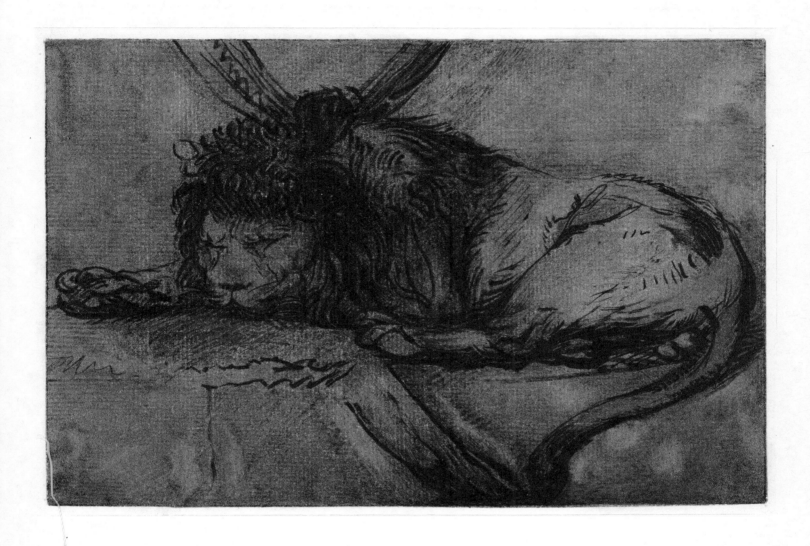

291 (*II, 62*). *Sleeping Lion, Chained.* (*British Museum, London*)

Pen, brush and wash, red chalk, yellow water color: 131 × 194 mm.

About 1648–50. Benesch (857) recognized this as a pupil's drawing corrected by Rembrandt around the head and legs. Rembrandt's drawing of the same lion in virtually the same position is at the Louvre, Paris (Benesch 781).

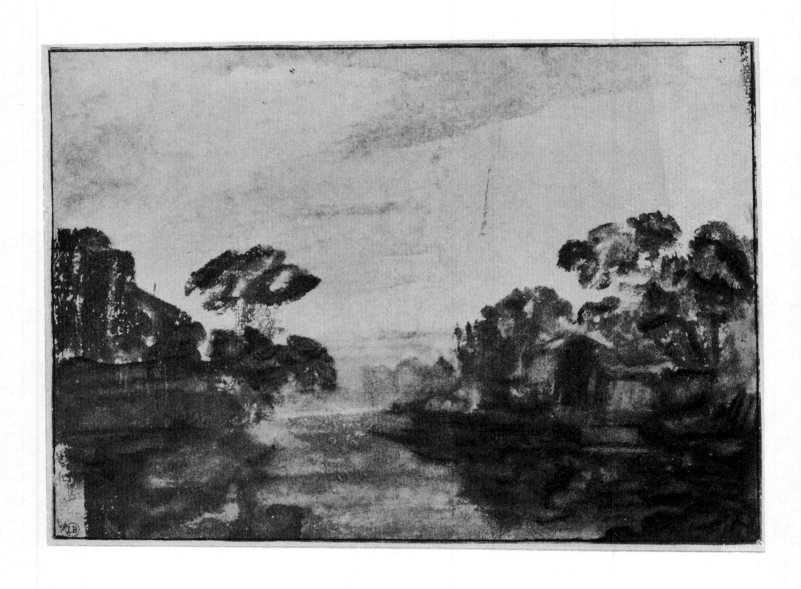

292 (*II, 63*). *River with Trees on Its Embankment at Dusk.* (*Louvre, Paris*)

Brush and bistre: 136 × 187 *mm.*

About 1655. One of Rembrandt's rare landscape drawings executed entirely with the brush. The effect recalls Claude Lorrain's late wash drawings. On the verso, an etching recipe written by Rembrandt in red chalk.

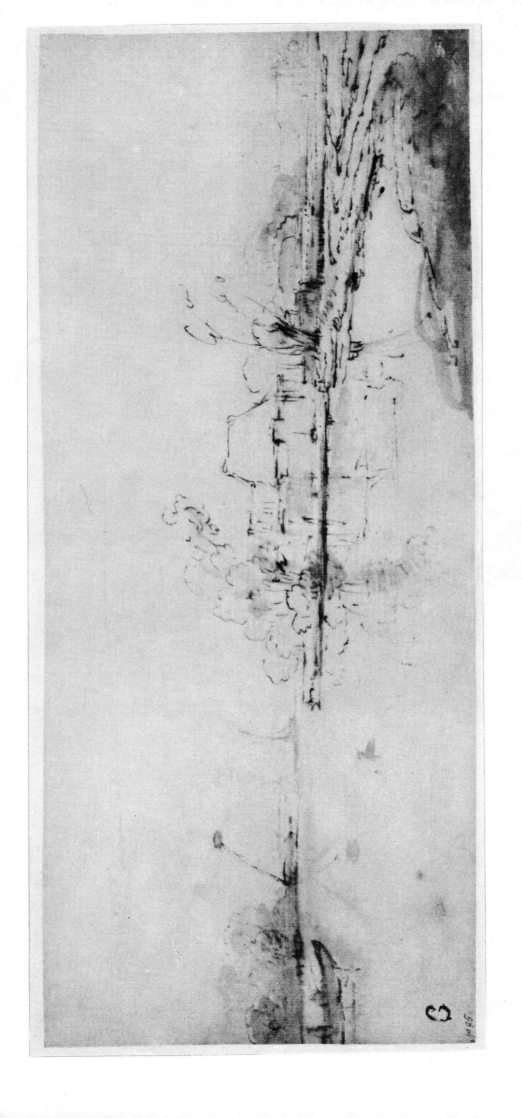

293 (II, 64). *River Landscape with a Cottage. (Formerly Henry Oppenheimer Collection, London)*
Pen in bistre, wash: 135 × 315 mm.

The drawing is listed twice by Hofstede de Groot (770 and 1051). Lugt (1933, p. 68, no. 1343) suggests it belongs to a rather large group of school drawings which are very close in style to Rembrandt's late studies of nature. See 221 (II, 4) for another drawing which belongs to the same group. Lugt tentatively ascribes these landscapes to Anthonie van Borssom.

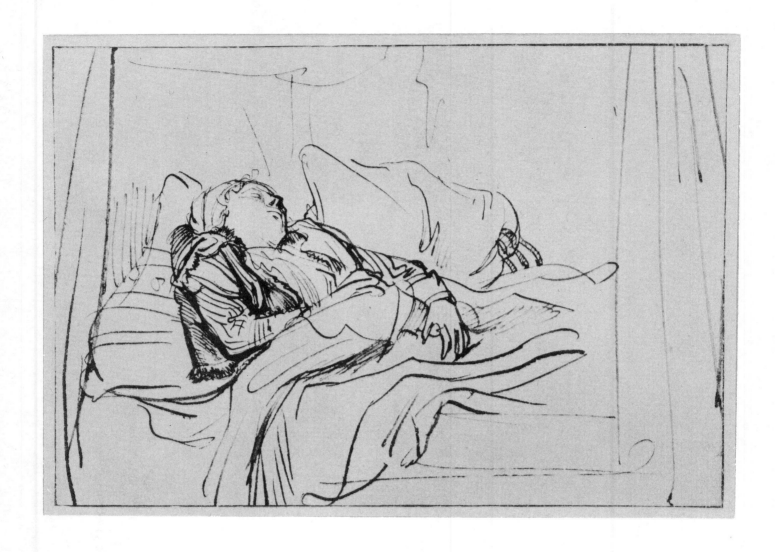

294 (*II, 65*). *Saskia Asleep in Bed.* (*Formerly J. P. Heseltine Collection, London*)
Pen and bistre: 126 × 178 mm.
About 1635.

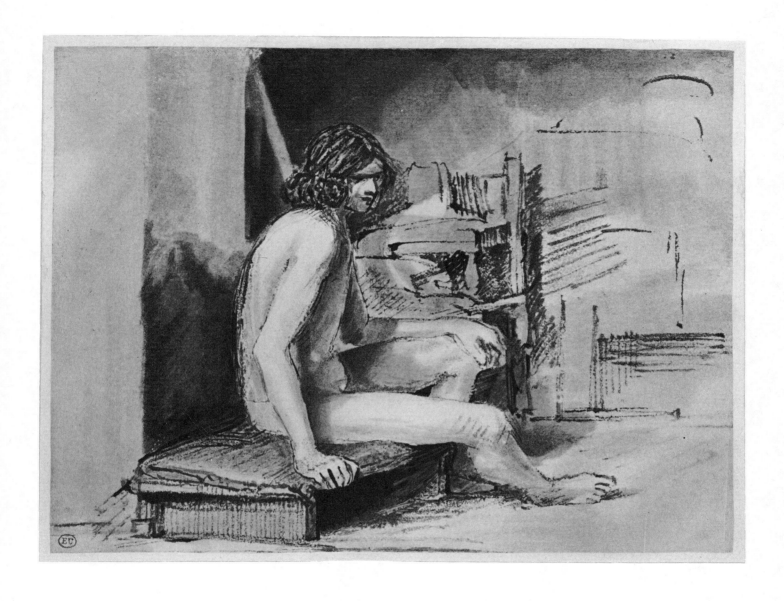

295 (*II, 66*). *Male Nude Seated on a Low Bench.* (Formerly J. P. Heseltine Collection, London)
Pen and bistre, red chalk: 140 × 181 mm.
By a weak pupil or follower working in the style of the 1640's. Not listed in Benesch.

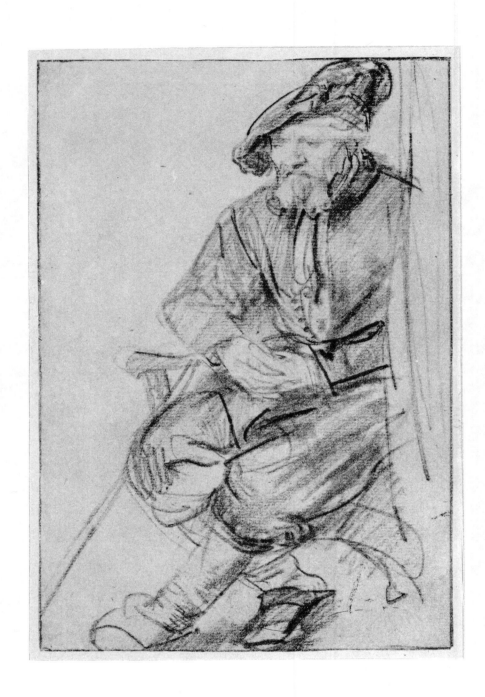

296 (*II, 67*). *Bearded Man Seated in an Armchair.* (*Louvre, Paris*)
Black chalk: 162 × 110 mm.
About 1645–48.

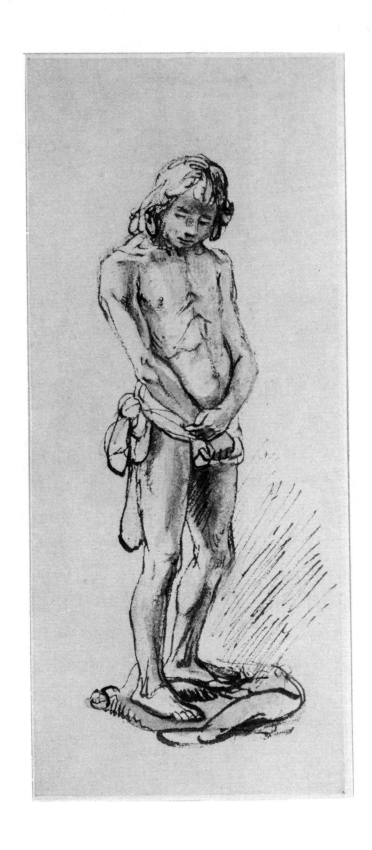

297 *(II, 68). Male Nude Standing on a Cushion. (Formerly J. P. Heseltine Collection, London)*

Pen and wash in bistre: 205 × 84 mm.

*A school piece made around 1645. Benesch (A54) notes that it seems to be particularly close to the extraordinary
naturalistic drawing of a female nude now at the Louvre, Paris; see 92 (I, 91). A school drawing of the same male
model in the same pose, but seen from the side, is in Budapest, reproduced C. Hofstede de Groot, "Rembrandt's
Onderwijs aan Zijne Leerlingen," Bredius Feest Bundel, Amsterdam, 1915, figure 38.*

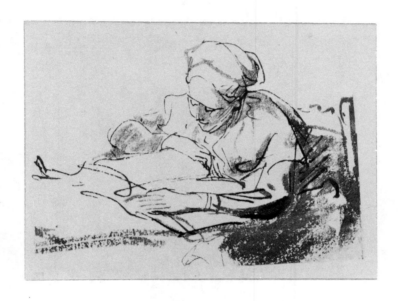

298 (*II, 69a*). *Seated Woman Reading.* (*Metropolitan Museum of Art, New York*)
Pen and wash in bistre: 67 × 89 mm.
About 1637–40.

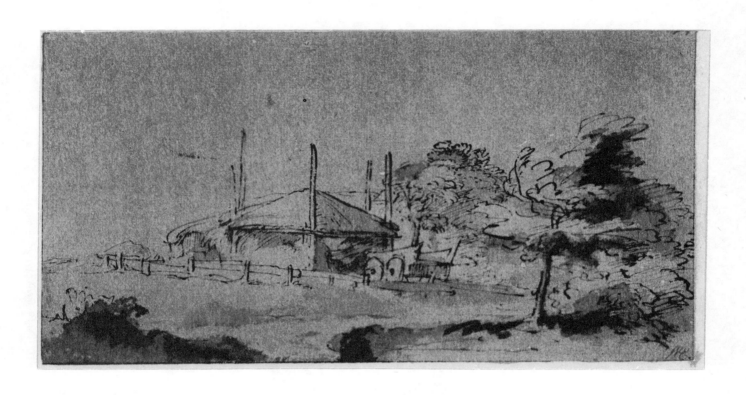

299 (*II, 69b*). *A Farm Amidst Trees.* (*Rijksprentenkabinet, Amsterdam*)
Pen and wash in bistre on paper tinted brown: 95 × 176 mm.
About 1648–50. The drawing is closely related to 478 (IV, 33).

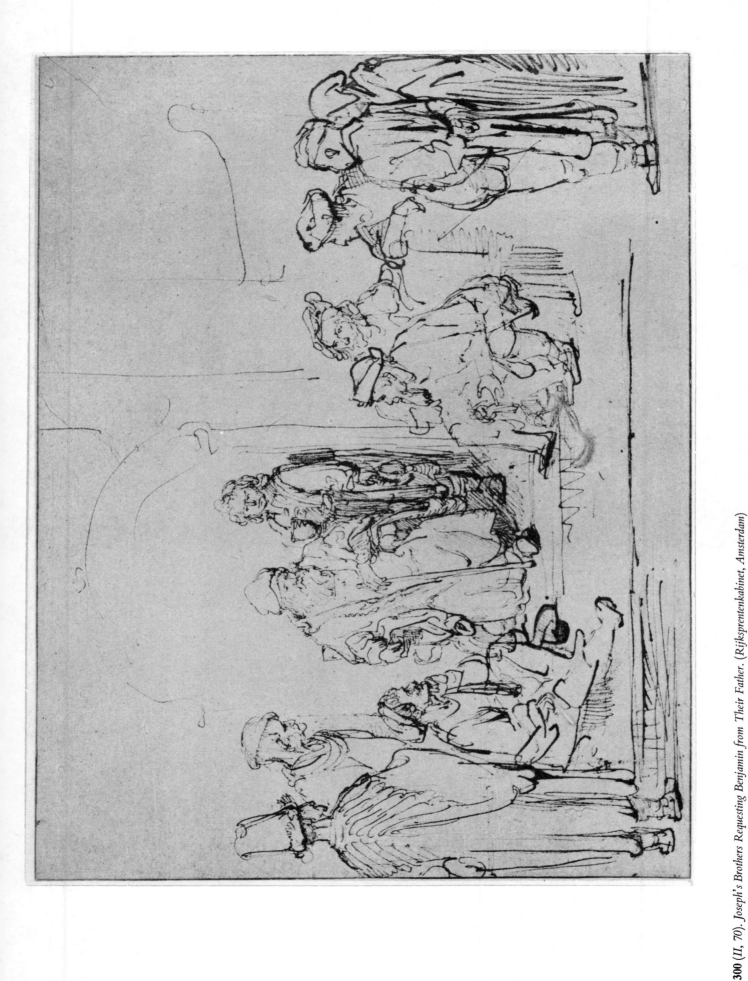

300 (II, 70). *Joseph's Brothers Requesting Benjamin from Their Father.* (Rijksprentenkabinet, Amsterdam)

Pen and bistre: 176 × 231 mm.

About 1638–40. The man seated on the left was superimposed on the sheet by Rembrandt. See 186 (I, 174) for another version of the composition.